*The Artist
in American Society*

THE *Artist* IN
American
Society

THE FORMATIVE YEARS
1790-1860

Neil Harris

GEORGE BRAZILLER · NEW YORK

To My Mother and Father

Preface

THIS IS AN INQUIRY into the relationship between a community's values and its culture. It emphasizes not American art but American artists and their position in the life of the nation. If nineteenth-century artists in the United States did not succeed in matching the achievements of other contemporaries, their activities, nonetheless, were subjected to the most explicit and fundamental criticism. The legitimization of artistic energies in America was a lengthy and articulate process. It reveals a great deal about the character of our national life.

In Colonial America, art's existence seemed to depend entirely on personal decisions; American artists began their work in a condition of prevailing cultural scarcity, and community interest or support was not assumed to be either inevitable or beneficent. In the professional meaning of the word, European artists themselves were but recent specialists; semantic confusions still entangled artist and artisan at the start of the nineteenth century. Industrialism, urbanization and nationalism helped dissociate art from its craftlike connotations and granted it dignity and honor among civilized men. But nationalism, industrialism and urbanization were all lacking in Colonial America, and with them the need for art.

Although the Revolution established a cause, the debate about the nation's future invited caution. For the issue of art involved an ancient problem: How could human and natural values be resolved, and a balance maintained between the established and the contrived? In political terms, Americans made their decision easily enough; states were contrivances designed to meet human needs. National governments were not gifts of a benevolent deity or a well-meaning monarch, but

vii

human conveniences and social necessities. Political debate worked out the best solutions, but never assumed them to be absolutely final.

If the state was a temporal convenience, dependent, tentative and even fragile, all the more reason for the community to discover more ancient, enduring and metaphysical reasons for existence, purposes which stood above the special institutions manufactured by the statesmen of the 1780s. Much of America's sense of mission and historical destiny was the product of this need, the compensation for a political system which lacked the prescriptive rights of conventional polities. A natural, unspoiled, benevolent society was the condition which justified such a government.

Under such circumstances artistic energies seemed perilous. Those who create the fine arts are committed to nurture rather than nature, to contriving, articulating, stimulating and denouncing. The artistic imagination is marked by consciousness and purpose; artists are emotional conspirators who satisfy and generate needs at the same time. Were artists useful in a society which met all needs but feared the discovery of new ones? Were the discriminations of taste, wealth, consumption and opinion which the fine arts always left in their train dangerous for such a community? Americans asked such questions precisely because art did not seem socially inevitable.

Defenders of the act of creation turned to specific and pointed justifications, and the language of moral rationalization continued to inform artistic questions throughout the nineteenth century. The enjoyment, production and consumption of art was tinged with guilt for Americans, not because it was wasteful, but because it was dangerous and irrelevant. Why would a society which began with perfection require improvement? Improvement, to be sure, summed up the purpose of art. But who was to improve whom, and why? Art, like government, was a badge of shame, its consumption an outlet for superfluous wealth, its expression an opening for undisciplined energies, its enjoyment a relief for unsatisfied cravings.

In the early nineteenth century, art had no natural defenders in America, no establishment of professionals and connoisseurs to guide its youthful destiny. The profession itself was weak and undermanned; its members had to sell their

paintings, and then justify their act as such. Instruction rather than entertainment became their purpose, and set off professional artists from primitivists and popularizers. A Barnum amused; an Edward Hicks or Erastus Field communed; an artist instructed.

But of all pursuits, pedagogy is most vulnerable in a democratic society. Where political existence rests on agreement and voluntary restraint, the lessons of the teacher are either sources of union and strength or invitations to suspicion and division. Artistic instruction had to be of the right kind. Conceptual abstractions in sculpture or the neutrality of landscape in painting provided the only refuge for the dissenting yet dependent creator.

To justify artistic energies more specifically, artists and patrons had to point out the needs art fulfilled and the heights it attained. Europe became their schoolroom and laboratory. The Old World was a vast demonstration chamber for the uses of art; it instructed artists and patrons in the power of their discipline. Americans discovered that sensory delights were weapons as well as pleasures, and the manipulated environments of empires and kingdoms provided platforms for New World reformers. By harnessing art's abstractions to conservative social goals, by invoking the power of institutions, these publicists sought to press the artist into the service of their moralistic ideals. Grappling with the excesses of democratic energies, they offered willing artists alliances and benefits.

Such direction, of course, implied control. In return for their aid and comfort, supporters of the artistic enterprise expected disciplined respectability, commitment to their own life goals and adherence to the national ethic. Artists moved with unconscious ease to second the opinions of their patron friends. Their success orientation justified such attitudes and American publicists and biographers tamed images of the romantic artist until they operated safely within the context of the self-help tradition. By the time of the Civil War, American Vasaris found little to delete from their published renderings; poverty seemed the only artistic sin.

The divorce between art and reality in nineteenth-century America was not the result of plots or conspiracies, nor was the vernacular a sanctuary of aesthetic simplicity. Art was a con-

trivance which required the interposition of the intellect be-
tween man and object. Purchasers therefore demanded the most
obvious indications of skill and imagination. As the century
progressed, furniture, architecture and painting developed finer
detail, larger scale and higher cost. In the process, purposes
and objectives were buried beneath the efforts to increase the
nation's cultural achievements, and the joy of production min-
gled with the status concerns of American academicians.

By the 1860s art had finally been legitimized in America,
without, however, the millennial results that had earlier been
anticipated. The costs of forging an artistic ideology and of
raising unrealistic expectations in a utilitarian society would
eventually become clear. The cultivation of the arts and the
possession of masterpieces became just that private sort of act
which the democratic patrons of the early nineteenth century
hoped would disappear. But to some extent, the balance sheet
seemed better on the eve of the Civil War, and the disappoint-
ments of the Gilded Age must form another story.

To bring together the elements of this narrative, I have
concentrated on three separate levels: social attitudes toward
the visual arts as communal enterprises; the status, achieve-
ments and ideals of artists themselves; and public conceptions
of the artist's person and role. The cultural expectations and
crises in early America were shaped by a legacy of English
values and the problems and opportunities which the Revolu-
tion presented. Against that background it is possible to focus
upon the young artist communities, to study the artist's educa-
tion, choice of residence, objectives and institutional support.
This discussion provides a basis for an assessment of the influence
of European travel on American patronage, the ecstatic pleas-
ures or burdensome frustrations which encounters with art left
behind, and the serious efforts to comprehend the meaning and
scope of sensory appeals.

It is then possible to treat the justifications America's most
profound aestheticians offered for the energies of art, and to
summarize the beautification campaigns which resulted from
travel, reflection and social anxieties. Ultimately, conservative
eulogists tear the artist figure itself away from the control of
romanticizers and make it serve majoritarian ideals. The artist

is now within reach of material success in the new, more mature artist communities established by 1860. IIis dependence on the Old World lessens as he wins the final approval of moral America through clergymen friends who identify religious and aesthetic interests.

I wish here to record my thanks for the aid and efficiency of library staffs in the Harvard College Library; Fogg Art Library, Harvard University; Houghton Library, Harvard University; the Boston Public Library; the Historical Society of Pennsylvania; the New-York Historical Society; the New York Public Library; and the Archives of American Art in Detroit. W. E. Woolfenden, the director of the Archives, and Garnett McCoy, archivist, were particularly hospitable and helpful. Miss Christine Sullivan typed the manuscript with skill and intelligence, and my students and colleagues in Adams House were stimulating and responsive at critical times. My friend, Dr. Arthur L. Prensky, read the manuscript carefully and offered many perceptive suggestions; I am grateful for his aid. Most of all, I appreciate the wisdom and patience of Oscar Handlin, who remains an inspiration and exemplar.

N. H.

Contents

List of Illustrations

Illustrations follow page 242.

13. "America," by Hiram Powers. Photograph courtesy of the Fogg Art Museum, Harvard University.

14. Portrait of Luman Reed by Asher B. Durand; photograph courtesy of the New-York Historical Society, New York City. Portrait of Marshall O. Roberts by G. P. A. Healy; photograph courtesy of the New-York Historical Society, New York City. Reverend Edward N. Kirk. Reverend Orville Dewey.

15. First building of the Pennsylvania Academy of the Fine Arts; photograph courtesy of the Pennsylvania Academy of the Fine Arts. "New York University and Washington Square," lithograph by Henry Hoff, c. 1850; photograph courtesy of the New-York Historical Society, New York City.

16. Studio Building, New York City; photograph (1906) courtesy of the T. J. Burton Collection, New-York Historical Society, New York City.

To the Aid of Necessity

CHAPTER ONE

BEFORE AMERICANS MADE PICTURES they used words. This unusual sequence, one of many anomalies of colonization, is in part responsible for the extraordinary anxiety later generations experienced about national creativity. The seventeenth-century heritage tended to be non-visual, for the settlers were not concerned with preserving the physical appearance of their society, on canvas or in brick and mortar. Some of their faces remain, but very little else does, and this little was often distorted into the familiar by bewildered Europeans; savages masqueraded as Greek athletes and landscapes were clothed in the language of fantasy and allegory.[1]

As time passed, guilt-ridden Americans grew fond of explaining that the earliest settlers had no art because they lacked the time to create one; the effort of subduing a wilderness demanded a total commitment of energy. Certainly this was a plausible reason; it was not, however, a sufficient one. Societies faced with the problem of survival in the most elemental fashion have often, nonetheless, expended time and labor in visual representation, occasionally for recreational but more usually for religious purposes.[2] And seventeenth-century Americans did manage, despite the pressures of material existence, to produce hundreds of treatises concerned with free will and the nature of conversion. An unbiased observer would be hard-put to see how these expenditures of energy helped cope with the needs of physical survival any better than would the creation of art.

An adequate explanation for the failure of a widespread art production to develop through a century and a half of Colonial life must rely therefore on human values and assumptions. Since colonists generally strive to re-create some facsimile of the only society they know, their values are usually the product of a more mature mother culture.[3] The absence of

art expectations in Colonial America was related directly to the status of artistic cultivation in the seventeenth-century Britain which so many of the emigrants remembered. American art, like American independence, awaited the Revolution; both required aims and intentions born after decades of gestation and nourished in the warmth of popular concern.

The England that the early settlers abandoned was a community curiously indifferent to native painting, sculpture and architecture—curious because of the high status of other arts in the same era. The very concept of the great artist, the man of individuality and genius, the archetype of those proud, sensitive figures who crowd the pages of Vasari, had barely entered the English imagination when the small groups of dissidents and adventurers began their Atlantic migration. Practically none of the gigantic visual achievements of the Continental Renaissance had yet penetrated the British Isles. The appearance of the cities and villages which the early emigrants retained in their memories was characteristically medieval: the walls and great gates marking the origins and extent of the fortified town, the confused clusters of flimsy dwellings, the rambling, narrow streets and lanes, the dominating church or guild hall with its pointed arches and lancet windows. Englishmen who had traveled on the Continent returned to condemn London as a foul and congested accumulation of grotesques; few of the city's redeeming qualities lay in its physical appearance.[4]

Wealthy Englishmen began to visit Italy in numbers by the early years of the seventeenth century, though it took some time for their tours to produce dramatic changes in taste. Things improved when James I exchanged ambassadors with a number of Italian states, and the memorable trip of Thomas Howard, Earl of Arundel, quickened the tempo. Howard's 1613 journey remains famous largely because of his architect companion, Inigo Jones. Later Jones would translate the architectural concepts of the Renaissance for England, and provide, in the Banqueting House at Whitehall and a majestic portico for St. Paul's Cathedral, the Kingdom's first major neoclassic structures. Inspired by the competitive atmosphere of court life, wealthy nobles like the Duke of Buckingham were soon dispatching agents all over the Continent in search of master paintings. Charles I, both as Prince of Wales and King, graced this

4 THE ARTIST IN AMERICAN SOCIETY

flowering of connoisseurship by his enormous purchases in Spain and Italy; whole collections disappeared in one gulp.⁵ And when Continental painters like Daniel Mytens, Paul van Somer and the great Stuart propagandist Van Dyck settled in England, the court enjoyed a continuous and energetic source of art production.

With kings and lords pursuing their new enthusiasm, it was no wonder that Peter Paul Rubens, visiting England in 1620 on a diplomatic mission, noted the "incredible quantity of excellent pictures, statues and ancient inscriptions," both at court and in private establishments.⁶ The problem lay not in their quality but in their nationality; few, almost none, of the recipients of this admiration (and wealth) were Englishmen. Besides the great names, lesser-known Continentals, like the painters Belcamp, Van der Doort and Gentileschi, or the sculptors Le Sueur and Fanelli, enjoyed the favors of the aristocracy and the fragrance of blossoming reputations.

Europeans, by contrast, knew little of English art achievements. Only the miniaturists, led by Samuel Cooper, enjoyed Continental respect, and their home support was barely adequate. English artists remained medieval in outlook and conservative in technique through most of the seventeenth century; they were organized into the Painter-Stainers' Company, a survival, as its name implied, of the craft traditions of Elizabethan portraiture. The Company protested against the preference shown foreigners and tried in vain to control strangers who disobeyed its ordinances.⁷

Patronage of the great artists was confined to a small but highly placed group of peers, centered in the King and his Whitehall favorites. Such fortunate connoisseurs treated their artists with deference and admiration; Rubens was knighted in 1630 and Van Dyck lived as well as the most extravagant cavalier. Their network of friendships formed a close approximation to the prestigious intimacies Italian artists attained, but such attentions were confined to so small and so foreign a group that their effect on the larger community of artists was probably debilitating, arousing envy and bitterness.

But there lay ahead more dangerous threats to this brief explosion of sophistication and cosmopolitanism. Tradition credits the austerities of Puritan rule with the choking-off of

English art interests, and there is some justification for this view. To those not in the center of court life or already alienated by the pomp and extravagance of Church and State, the lavish expenditures on decoration, and the paintings themselves which sometimes approached the wanton and invariably idealized royal favorites, exemplified the waste and danger of high art. Religious scruples already existed; suspicions of the sensory pleasures the old masters afforded had been expressed by sixteenth-century Englishmen as orthodox as Sir Thomas More.[8] In the following century political motives intensified the antipathy of English Puritans to the visual delights the Stuarts commissioned. So pervasive were these antagonisms that personal critics of the King could exploit this discontent in descriptions of the "nonesuch Charles," an extravagant ruler spending huge sums of the national treasure on old, useless pictures and mutilated marbles.[9] It was easy to associate art with the vanity and immorality of court life, and easier still to protest its uses in the hands of priests and popes bent on enticing man away from his proper relationship with God.

But too much has been made of this hostility. Artistic antipathy was never a central theme in Puritan statements about English government; it was a peripheral issue brought forth occasionally to add color to other charges.[10] Opposition, moreover, hit the instrumental values of art, not its inherent nature. Puritans abused not the creative act or the artist himself, but the specific content if the art seemed immoral or was placed within churches, and the cost if it appeared extravagant. Individual acts of wanton atrocity committed in the Civil War did not demonstrate in themselves an inveterate hatred of works of art, but often satisfied social resentments, aroused by noble or clerical patronage. The absence of a sense of art-works as national possessions allowed such acts of destruction. Paintings, statues and great buildings were almost always individually owned and—with the exception of religious art—designed for private enjoyment. Thus the sale of the Stuart art collections, which generations of English art lovers have regretted and condemned, was not an act of aesthetic hostility. Economic necessity seemed a sufficient justification to many contemporaries, and the Commonwealthmen tried occasionally to buy back particularly cherished works of art.[11]

Finally, art activity in England did not cease with the coming of the Commonwealth; one art historian finds it significant that "the official Commonwealth portraits should all echo the designs of absolutist court painters."[12] Robert Walker, the parliamentary favorite, may have lacked Van Dyck's genius, but his patrons were well satisfied with his adequate imitations. Lely and Cooper, both miniaturists, continued to do nicely during the Interregnum.

Nevertheless, the Puritan environment did not favor the visual arts. Limitations on the Church establishment removed a wealthy and aesthetically sophisticated client and helped destroy both a traditional source of patronage and a natural setting for lay patrons to display proofs of their material success or personal piety. No other arena existed to house the competition of artist or customer. The state itself recognized neither the responsibility to spawn nor the need to foster artistic creativity. Seventeenth-century England contained no art schools, art academies or national competitions, and its artists retained the education and position of master craftsmen. Guilds remained the typical form of artist organization, and only the rare native enjoyed the respect due a colleague of Raphael or Titian.

Since Puritan hostility was practical rather than theoretical, it needed to be fed by the presence of art works. Seventeenth-century English emigrants took with them across the Atlantic not an opposition to art achievement but a lack of familiarity with art objects, and an indifference to their importance or their relationship to the life of the community. In that respect they differed from the Spanish in New Spain, who took precautions to develop native art under proper supervision, despite great expense.[13]

In British North America, aside from portraiture which was commissioned for family enjoyment or political distinction, art activity was minimal during the Colonial period. Sermons protesting the production of art were rare, for a condition could not be condemned if it was not perceived. Puritan silence about art in America was a consequence, not a cause, of the artistic vacuum. The fact that the nation's most famous pre-Revolutionary painters, West, Copley and Peale, grew up in centers

of Puritan culture, shows how difficult it is to measure the effect of religious conservatism on the development of individual genius. Indifference, not hostility, was pervasive in Colonial America.

The number of portraits—by artisans, amateurs, and occasional limners—which have been discovered in recent years, cannot disguise the contemporary lack of interest. Portraits were not then catalogued as objects of art, products of creative minds which could be evaluated by a set of abstract standards; they were mementos of the dead or gestures of respect and affection for the living. In many instances the name of the sitter survives, while the authorship does not. This anonymity reflected the colonists' medieval-like indifference to the claims of individual creation, and the absence of any special category for the painting as an original, individualized production capable of shedding as much fame upon its creator as upon its subject. The portrait was a craft product, not intrinsically different from a chair or a set of candlesticks; only in exceptional cases did the craftsman achieve his immortality. It was the increasing concern with authorship rather than the growing number of paintings which indicated, in late eighteenth-century America, a more modern attitude toward the importance of artistic creation.

A lack of art consciousness did not, however, consign Americans to drabness and austerity. Furniture, clothing and buildings were appropriately (and as the sumptuary laws reveal, inappropriately) elegant. Fine silver, wallpaper, crystal, carpets, furs and jewelry were possessed by the rich and desired by the poor. Luxuries of the table were imported when necessary, and Colonial wine-cellars were stocked with delicate vintages. Finery, particularly in costume, possessed great physical attractiveness for men deprived of much of the visual variety eighteenth-century Europeans took for granted.[14] Only when the beautiful was appropriated by those in questionable social circumstances was there discussion and debate before the Revolution.

Through most of the Colonial period Americans spent little time reflecting abstractly about the fine arts. Though certain men purchased old masters or oil copies, the value of art did not form a common topic of conversation. It was an Englishman, after all, who popularized the wondrous vision of the arts moving steadily westward to an American destiny.[15] A Colonial

might well prefer a beautiful object to an ugly one or a handsome house to an ungainly building, and he might pursue an architect like Peter Harrison who was able to satisfy the need for visual delight. But Americans did not think of the arts in social terms, or as a human enterprise demanding particular courtesies for growth, and peculiar deference for survival.

The exceptions to this generalization were painters who, like Copley, West and Peale, came to maturity in the last half of the eighteenth century. The dispute over dignity between American artists and their patrons began almost immediately. American painters conceived of art in the most grandiose terms, and insisted upon its ennobling effects. When Benjamin West was growing up, the social status of English artists was not yet notable—their great leader, Sir Joshua Reynolds, was still unknown—but the boy West was shocked at the lack of a playmate's ambitions. Because the boy hoped to become a tailor, West refused to play with him; such a companion was beneath the dignity of a future artist, a man who walked with kings and emperors.[16] This notion might well have derived from the European art histories which West read before leaving Pennsylvania.

Copley was another who dreamed great things for the artist. In the 1760s he voiced his famous complaint that Americans scorned paintings and regarded the art as "no more than any other useful trade . . . like that of a carpenter, tailor, or shoe maker, not as one of the most noble arts in the world. Which is not a little mortifying to me."[17] By "mortifying" Copley meant not merely humiliating but destroying. For the nurture of his talents he required a grander popular vision, one acknowledging the artist's dignity. A few years later, in clumsy yet wistfully touching prose, itself reflecting in its cumbersomeness the intensity of his ambitions, he spoke of Benjamin West's "successful progress towards the summit of that mighty mountain where the everlasting laurels grow to adorn the brows of those illustrious artists that are so favored of heaven as to be able to unravel the intricate mazes of its rough and perilous ascent."[18] Copley needed no lectures on the dignities of his profession.

But those few Americans aware of the glories of high art before the Revolution were also quite certain that the country would require very little of it for some time to come. Charles

Willson Peale, sent by a group of gentlemen to study art in Europe, had his ambition and his tastes expanded by the sight of the old masters. One of his patrons, Charles Carroll, cautioned the painter to restrain his hopes and avoid the production of miniatures and history paintings. Not only did they require great skill, he wrote Peale, they were also expensive and not suited to the customs of the country. Carroll concluded tolerantly, however, that the boy would be better off as "a good painter in miniature, than an indifferent one in either of the other branches."[19]

Peale, like many who went after him, returned somewhat chastened from his European studies. He was proud of the attention heaped on him by New Yorkers, who compared the young Pennsylvanian with the great Copley and brought him plenty of commissions. But still, "how far short of that excellence of some painters," seemed his own poor abilities. "My enthusiastic mind forms some idea of it, but I have not the execution . . . What little I do is by mear [sic] imitation. . . . A good painter of either portrait or history must be well acquainted with the Grecian or Roman statues, to be able to draw them at pleasure by memory. . . . These are more than I shall ever have time or opportunity to know."[20] As a result Peale tried to moderate his ambitions, and invoking the name of his hero, Rembrandt, turned his attention to the life and figures he saw around him. He retained his optimism about the American future and made an adjustment Copley found impossible. People are growing steadily more fond of the arts, he wrote hopefully in 1771, and possibly one day they might find an asylum in America "when oppression and tyranny shall perhaps banish them from seats where they now flourish."[21] Unlike many of his colleagues, Peale was prepared to wait.

Actually, American artists who became attached to the heroic ideals of high art, to the painting of history and great allegorical lessons, did not have too long to wait for more favorable conditions. Events in England—and America—which culminated in the 1770s, would prove momentous for their cause. The English changes had been anticipated much earlier in the century. The infancy of the Royal Academy, the *Discourses* of its president, Sir Joshua Reynolds, and the stunning successes Benjamin West capped with his appointment as

historical painter to George III in 1772 were built on older
interests and institutions. The works of foreign art theorists
like Du Fresnoy and Roger de Piles had been translated and
widely circulated in the early decades of the eighteenth century,
and Englishmen would no longer endure the slurs which
visitors like the Abbé Du Bos and J. A. Rouquet offered.
Jonathan Richardson, Hogarth, Burke, Hume and Locke wrote
on the psychology of taste or the nature of beauty. Schools
and academies made sporadic appearances throughout the cen-
tury, often sponsored by artists like Sir Godfrey Kneller, Sir
James Thornhill and Hogarth. James Barry's 1775 pamphlet,
*Inquiry into the Real and Imaginary Obstructions to the Ac-
quisition of the Arts in England,* pointed up the subject of
interest. In the years since the first American migrations the
visual arts had assumed a more meaningful role in British life,
and Americans who traveled to England in the last quarter of
the century were confronted with a sophisticated body of aes-
thetic theory and a growing number of successful artists.

The situation had not changed completely. Despite mount-
ing concern, the flow of foreign art works was not stemmed, and
artists were aided by only a few institutions. The Church of
England was still reluctant to employ painters and sculptors,
while professional picture sellers, eager to exploit a new market,
sprang up everywhere, their salesrooms funneling precious
customers away from native artists. Though Englishmen grew
more interested in art, their own artists remained less appealing
than Continentals, and foreigners like Van Loo continued to
prosper at the expense of native painters, returning to their
homelands loaded with spoil. As late as the 1760s a Swiss painter
took home more than six thousand pounds from the fat purses
of British clients. Portrait manufacturers of Kneller's magnitude
(though not his talent) crowded out the history painters, and
James Barry pointed with shame to the failure of Giles Hussey,
a promising talent driven to portraiture by his inability to sur-
vive as a history painter.[22]

The new class of British connoisseurs endured vigorous
satire; William Hogarth condemned the taste for the dark,
gloomy daubings they thought old masters, and described the
would-be Lorenzos as ignorant, foppish monkeys whose lack of
intelligence and discrimination was disguised by total affectation.

Hogarth's aggressiveness led him to mobilize a new mass market, appealing to bourgeois customers through auctions, lotteries and distributions of his engravings. Hogarth's popularity and wealth were new to the British art world, and he laid the foundations for a revolution in patronage.[23]

But the most important figure in this renaissance, though native-born like Hogarth, was much more urbane. Sir Joshua Reynolds, polished, wealthy, traveled, befriended by royalty and patronized by the great, sat at ease with London's wits and epitomized the glories which even an English painter could attain.[24] His example made it difficult for contemporaries to place painters on a social level with carpenters and joiners, a common charge of the previous century.[25] Reynolds introduced to his countrymen the Grand Style prevailing on the Continent and grafted it onto British art. His fame made him the Georgian heir to Titian and Rubens, and his fortune helped the status of even the portraitist; the one hundred thousand pounds he left at his death had accumulated from his fabulous two-hundred-guinea fees, and a number of his rivals, like West and Gainsborough, achieved similar princely incomes.

Reynolds' personal success sharpened the appetites of visiting Americans, hungry for similar glory, and his broadly based theories of the value of art exerted even greater power. Though he built on the categories which French and Italian theorists had used to methodize the study of art, Reynolds presented to young ambitions not the etiquette-book advice of a pedagogue, but a vast moral function, far greater than the task of entertaining for a day.[26] The artist's job was to outline the great truths which lay hidden in nature, to express the ideal, objective beauty inherent in all natural forms, and thereby to make virtue attractive and vice repellent. Such beauty, "if it does not lead directly to purity of manners," Reynolds wrote, "obviates at least their greatest depravation," by cleaving the mind from its appetites and leading it to excellence. That "which began by taste," he contended, "may conclude in virtue."[27] No mere artisan could meet these great demands; it called for a philosopher rather than a craftsman; to a clever hand and a good eye he must unite moral insights and the strengths of a pure life.[28]

Painters seeking these heights were warned by Reynolds

that they must avoid the particular or the accidental, and ex-
clude the purely exotic. Any specificity which diluted a picture's
general principles was dangerous. The true artist was concerned
with the species and not the individual. It was therefore in-
evitable that Reynolds should have ranked subject material as
carefully as he graded particular excellences. The portraitist,
the man who habitually dealt with the specific and the personal,
could not hope to rival the artist who uttered general truths, and
this meant, obviously, the history painter. Only he stood above
the scenes of ordinary life, and beyond the lure of immediate
popularity. "Present time and future may be considered as
rivals," Reynolds declared, "and he who solicits the one must
expect to be discountenanced by the other."[29]

The true history painter, in fact, the beau ideal of Reynolds'
Discourses sanctified not history at all but poetry, not the things
that have been but the things that might be; this gave him
more scope for sublimity. Such a history painter could yield no
clue to time or individual appearances; he robbed the past of
what had been to invest it with what it should mean. The
situation controlled the visual character of the participants.
History-painting, in Reynolds' terms, celebrated not an event but
eventfulness itself; the episode articulated the operation of gen-
eral truths. And since it demanded a painter's skill in figure,
landscape and portraiture, it was truly the master calling, the
vestibule to immortality.[30]

This grand vision, emphasizing ethical objectives, techni-
cal training, universal truth and sublime subject matter was
the philosophy of art American painters encountered in England
at the end of the eighteenth century. Its ambitious thrust in-
creased their anxiety about the character of native patronage,
and intensified their frustrations with their limited market. The
physical conditions controlling art in the New World contrasted
sadly with the richness of this aesthetic philosophy. Outside of
several old masters, scattered about in the older Eastern cities,
the Colonies contained almost no examples of European paint-
ing and certainly none which would meet Reynolds' high
standards. It was an adventure to see even one old and usually
faded European picture. The few canvases which the painter
Nathaniel Smibert brought with him to New England in the
early part of the century were almost as important an artistic

legacy as his own instruction and achievements. Knowledge of art could come, to the few artists and amateurs who desired it, only through books and occasional engravings. These prints, usually uncolored, distorted the originals and emphasized only those qualities of line and shadow which could be transmitted through the engraving process.

Such isolation produced a conservative, traditionalist attitude toward works of art. With nothing of value on which to exercise the imagination, standard treatises, seventeenth-century French and Italian works, and some later English efforts were scrutinized with avidity. Americans learned what they were supposed to like about certain artists and dislike about others; which schools of art had particular strengths and which particular weaknesses; how to rank portraiture, genre, landscape and history; they even memorized anecdotes about great painters and their patrons—all this long before seeing a single example of the noble art. Whatever interest there was underwent a highly academic and intellectualized conditioning.[31]

Translation of an object's sensuous qualities into the written word and reliance on verbal description as a substitute for the physical encounter seemed, therefore, neither unnatural nor improper. It was the actual confrontation, the personal meeting with art, which became the problem in later years. The visual experience, that communion with the object which its creator had anticipated, came to seem like an assault, a conflict in which preparation was vital if the literary and moral qualities of the work were to remain dominant. The American stance toward art was thus bound to be both conservative and romantic: conservative because the authorities, for lack of anything else, had already been read, digested and accepted; romantic because the visual appeals, the constituent elements of the work of art, required translation into literary conventions which stressed narrative and dictated extravagant emotional responses.

The complex structure of neoclassical aesthetics was received by Americans in a passive manner; they engaged in little domestic debate about the theories of Hogarth, Reynolds or Barry. Conventions about the nature of art entered national thought but without any vigorous counterthrusting or measuring; there was little awareness of their implications and almost no directed argument about their meaning. Political theory, by

contrast, received a full-scale consideration in newspapers, pamphlets, debates and assemblies; in the political sphere argument and activity interacted with benefits for both theory and practice. Thought was hewn out and shored up by empirical needs, and, as a result, American political assumptions achieved a balance, integrity, and subtlety denied to American art theory. Much of the confusion detectable in nineteenth-century discussions can be traced back to this early passivity.

The few American artists who traveled to Europe in the eighteenth century, and their generous patrons, were not rebels against an orthodoxy which had outlived its day. They were provincials, cautious and conservative if a little overambitious and naïve. They hoped to revive the glories of Athens, not by propounding new theories, but by obeying the old ones. The program of Reynolds pleased because it was familiar and orderly, and arranged activities in a logical pattern. These newcomers welcomed definition and abhorred the vague; vacuums were dangerous because confusing. Benjamin West changed his skating pond when Londoners told him just where the socially prominent took their exercise; the knowledge of which sorts of painting enjoyed the highest repute seemed just as important as an awareness of technique or a mastery of production.[32]

The only innovation made by the early American painters— and it was a considerable one—involved the entry of particularity into history-painting. West, Trumbull and Copley all participated in this modification of neoclassical theory. Benjamin West's introduction of modern uniforms into his "Death of General Wolfe" caused a sensation in England, and within a few years Copley and Trumbull had introduced similar elements into their history pieces.[33] Whatever the reasons for West's successes, Americans felt it necessary to be visually specific. They realized, upon leaving the New World, that the most meaningful forms were not universal; their own novel visual experiences were proof of that. West himself must have discovered the value of visual specificity to communication when he saw the "Apollo Belvedere" for the first time. His remark, "How like a Mohawk warrior!" was the start of a learning experience by American artists, the realization that universals had to be translated into specific objects before they became truly meaningful.[34] This was not an abdication of art's didactic role but an intensification of

it; the moral lesson could be learned more effectively through the familiar. Since ordinary scenes, however, could not provide sufficient moral grandeur, it was necessary to rely on history or scripture. The Classic Ideal pursued through Romantic detail, the general revealed by the specific—history in the eighteenth century and nature in the nineteenth—this became the goal of the New World artist.

But even with such an innovation, the contrast between European theory and the practice of art in America depressed artists. The simplest materials—paint, brushes, canvas—were difficult to obtain, and homemade substitutes often had to be used instead. The painting of faces assumed a menial and mechanical status under their philosophy of art, a task for artisans and technicians, for sign painters and house painters (which in many instances it was). The likeness of a local merchant or cleric bore few links to the ideal ends of art, yet this was the only kind of work clients called for. "I find it extremely difficult to procure Subjects fit and pleasing to entertain the Public with," Copley complained in 1770.[35] The alternative to portraiture was history, yet what history, or whose history, would be desired in America? What had man accomplished in this huge wilderness which began its endless stretches only a few miles away from the eastern seaports?

Then came the great political crisis. For some painters, like Peale and Copley, the Revolution boded ill. In Peale's case it meant that an increasing amount of his energy would be devoted to military and political affairs; decisive stands on controversial issues alienated many of his more conservative patrons, and threatened a profitable career.[36] Copley anticipated this problem, and brooded about the spirit of party; he found that painting the faces of some political leaders irritated others. The artist, Copley reflected, must remain apolitical, for political struggles were "neither pleasing to an artist or advantageous to the Arts itself."[37] He left for Europe.

But Copley was wrong. His tactics were sound but his strategy was not. The Revolution proved a godsend to art and the artist life; it created an alternative to the menial tasks and craft objectives to which American art had seemed doomed. The Revolution created a History, marked with a great event the

beginning of an epoch, and introduced the factors of time and specific creation into the consciousness of a people. Indeed, by producing that consciousness, the Revolution created the people in the first instance. It made private events public events, and private figures public men; it shed an air of importance on a thousand actions, and placed the seal of destiny on individuals who otherwise would have been inconsequential and forgettable. It brought to the life of the larger community a sense of purpose and provided a pattern for the minutiae of daily existence.

Forecasts of this movement occurred even in the 1760s, when crises triumphantly surmounted suggested the bounty of divine providence. After news of the fall of Montreal reached New Englanders, desperately concerned lest their French and Catholic enemies outdo the forces of their king, thanksgiving sermons filled the air. Ezra Stiles, for one, saw in the event an indication of future greatness and was spurred on to make an early prediction of artistic glory. In a few years, he promised his enthusiastic congregation, "we shall have, tho' not manufactures, yet Painting, Sculpture, Statuary, but first of all the Greek Architecture in considerable perfection among us."[38] Great happenings fertilized the seeds of art.

A vast amount of subject material was suddenly thrown within the artist's orbit; men and events had achieved the universal appeal which demanded their reproduction, and reproduction in realistic terms. With the Revolution the particular, the peculiar and the local had rocketed to heights requiring perpetuation by the artist's skill. Some painters, notably Peale and Trumbull, achieved popularity merely by prolonged if repetitive artistic comment on the great event itself, painting heroes like Washington or Adams from life, or depicting crucial events like the signing of the Declaration of Independence or the surrender at Yorktown.[39] No American could call the portraitist's job a menial one when he set about to record the features of patriots for posterity. The audience for such work had suddenly increased.

The change in architecture is probably easiest to trace. The fact that most official buildings before the Revolution, like Independence Hall in Philadelphia, had little except size and some elaborate decoration to distinguish them from private dwellings may have owed something to the homogeneity of

Georgian design.[40] But the turn to purer classical forms for government buildings in the decades after the Revolution, the increase in scale, and the intensive search for an impressive mode of conveying the dignity of government through the design of its structures indicated something more than the breakup of stylistic uniformity. These changes owed much more to the new status of official functions and the new sense of nationhood.[41] The very concept of public buildings was a new one—buildings which, like the institutions they housed, were the property of the citizenry. No longer was government business carried on by small groups of favorites, meeting in private settings devoid of official markings. Debate, deliberation and direction required surroundings reflecting their public dimensions and the dignity of the new state they all served.

The creation of the American public portrait and history piece seconded the function of the novel public buildings. Art now had a clear mission: to present to a new people visible reassurances of unity and harmony. Even allegory had a place; when controversy called on the aid of the arts, all devices were appropriate. Ancient symbols were brought into service. A typical copperplate, published in Boston during the height of the Stamp Act crisis, bore elaborately drawn females representing France, Britannia and America.[42] Included also were older figures like Minerva (wisdom) and Mercury (commerce), while a Tree of Liberty, standing near Pandora's Box, added local color. With Liberty about to expire at the feet of America, Britannia mockingly offered her the Stamp Act. But Minerva, true to her gifts, issued a stern warning against acceptance. Liberty's decision could save the day.

Prints of this sort sold hundreds of copies and underlined the connection between political crisis and visual education. They exemplified, in addition, art's reliance on literary values, since such cartoons depended on their narrative context for full effect. Nonetheless, these allegories grew in number and complexity. In the 1790s Giuseppe Ceracchi, with the support of Washington, Madison, Hamilton and Burr, sought to raise a public subscription for a one-hundred-foot marble monument to Liberty.[43] Ceracchi's plans included a Goddess of Liberty descending to earth from the summit of a rainbow in a car drawn by four horses. Apollo, Clio, Saturn (the charioteer, and emblem

of "the return of the golden age") were placed in elaborate poses; rivers, butterflies and other symbols appropriate to the occasion completed the grouping. Whether or not most Americans could comprehend so highly intellectualized a scheme, thousands were expected to offer financial aid for its completion. Roman symbols like the eagle, the fasces and forked lightning were pressed into the interests of the State, and usually in a highly conservative and academic fashion. The Great Seal of the United States, for example, was unusual in its own era for perfect and detailed adherence to the traditional characteristics of the emblem.[44] In time there would be state seals, a national coinage, postage stamps, flags, all requiring original and appropriate designs. The polity had need of its artists.

Foreigners visiting the United States were quick to urge the application of the fine arts in the aid of legislation. The Marquis de Chastellux called on Americans to build statues, monuments and sculpture reliefs, to honor public offices by commissioning paintings of their incumbents. This would help the nation attract better citizens as governors, for the honors of public office, said Chastellux, "have been made too rare, and rewards too moderate."[45] The Count de Mirabeau pleaded with Americans to address themselves perpetually to the senses, to place before their own sight "the deplorable scenes of your servitude, and the enchanting picture of your deliverance. . . . Multiply your monuments, rites, and commemorative ceremonies."[46]

With the Revolutionary cause itself demanding the aid of the visual arts, patriots briefly threw themselves into their support. Anticipating Mirabeau, John Adams called on painting and sculpture to "assist in perpetuating to posterity the horrid deeds of our enemies,"[47] and drew up designs for medals commemorating Benedict Arnold's victory at Danbury and the British evacuation of Boston.[48] The immense number of portraits and engravings of Benjamin Franklin, surrounded by the symbols of the new republicanism—the liberty cap, the rattlesnake, the club of Hercules, the bearskin hat—helped popularize the American cause in France and stimulated public interest in military events.[49] Franklin himself had, decades earlier, designed the famous rattlesnake cut in pieces to encourage morale and unity within the Colonies.

That so many statesmen turned to visual forms as easily (though not so effectively) as words, emphasizes once more the didactic purposes Americans piled on their art works. Poets called on painters to join them in praise of the new nation; Colonel Humphreys' "A Poem on the Happiness of America" was filled with visual imagery of the Arcadian ideal. "Bid vivid colours into being start,/Men grow immortal by the plastic art!"[50] For all of this the arts were indebted to the Revolution.

There is, then, some justification for locating the beginning of American art at the moment of national formation, when visual needs elevated the artist to a more influential position and added to ancient though unacknowledged dignities a series of utilitarian tasks. But nationhood implied much more for the arts than great events to celebrate and new material needs to meet. It meant also that a non-utilitarian metaphysical need for art activity entered American consciousness.

For many centuries men had taken pride in the special talents of their countrymen; it was only natural to praise their accomplishments beyond those of strangers and foreigners. In seventeenth-century Italy, as in other cultures, an artist's birthplace had a great deal to do with his commissions. Popes and cardinals from Venice tended to employ Venetians; Bolognese prelates preferred Bolognese artists; local schools achieved prominence often through historical accidents.[51] Such preferences, of course, were not always binding, and Renaissance princes did not hesitate to reward excellence wherever they found it; a French king basked in the reflected glories Italian masters provided while the Stuarts were cosmopolitan in their art tastes. Nevertheless, when all other things were equal a man had a better chance among his countrymen than among foreigners.

But in the eighteenth century, particularly in England, something more than local favoritism began to mold desires for art. Writers stressed the need for artists as indications of national greatness, to show haughty Continentals that Britain was capable of surpassing them on any grounds. Under proper conditions Britain could produce painters to rival those of any country; David Hume blamed the number of Italian paintings Englishmen imported for extinguishing the hopes of native artists, and

thus decreasing their quality.[52] Others claimed that the reputation of the nation abroad was hurt by the "wild and neglected" state of the arts; *The London Magazine* for 1740 insisted that self-love alone should stimulate government patronage of the arts.[53] By 1784, when James Barry urged students at the Royal Academy to "do honour to yourselves, by acquiring for your country that superior reputation in the arts . . . which it has long since possessed in everything else," the coupling of national greatness with an outstanding art production was a common-place.[54]

Americans absorbed these assumptions; the spirit of competition forced response. Awareness that Europeans identified national greatness with artistic maturity led some Americans to argue that art must be the evidence to convince skeptical foreigners of the existence of an American nation. The charges made by European biologists, led by Buffon and the Abbé Raynal, that animal life declined in size, vigor and intelligence on being transported to the New World, angered and frightened Americans. Much of the impulse behind Jefferson's *Notes on Virginia* was rooted in a desire to silence such accusations. Other defenders soon followed. "If we are not the spurious offspring of our fathers, if we have not degenerated by transplantation," began one writer in 1807, then the new land must rival the mother country culturally, and not merely commercially.[55] Economic success would be empty unless the young nation could demonstrate its ability to excel in artistic expression.

To make their point clear, many Americans posited a universal equality of creative potential, extending the notions of cultural relativism which Enlightenment *philosophes* had espoused earlier. "No nation has the proud monopoly of genius," contended George Clymer, opening the Pennsylvania Academy of the Fine Arts in 1807, "or can make itself its exclusive seat; wherever there are men, there genius is to be found."[56] Others reacted more chauvinistically. *The American Museum,* supporting Jefferson in his fight against the degeneration thesis, wrote in 1787 that the time had come "to explode the European creed, that we are infantine in our acquisitions, and savage in our manners, because we are inhabitants of a new world, lately occupied by a race of savages."[57] The *Museum* emphasized the fact that Americans had already made rapid progress in the

arts and contained a proportion of talent at least equal to the Old World: an American, Benjamin West, painted for the King of England; Stuart, Trumbull and Copley rivaled London's greatest painters and showed signs of continual improvement. Art, then, was to be fostered not merely for its effects on the native population, but because it would demonstrate anew that America had entered the family of civilized states, and that she possessed an attachment to refined forms, the fruits of progress.

At first it was not very important to specify art activity for these nationalists; history, landscape, portraiture or engraving would serve equally well. Their presence alone would indicate the spiritual aspects of the new nation and its devotion to idealism. To a people upset by charges of materialism, this was important. A Frenchman, Alexander Marie Quesnay, made good use of this sensitivity. Opening an academy to teach French, dancing and drawing in New York, he prefaced his 1784 advertisement by telling Americans that all "Europe already view with astonishment, your abilities in the field of war and politics." Convince them as well, he argued, "of your taste for the polite arts and sciences."[58]

The same breezy abstractions floated through many other exhortations. John Swanwick, predicting a new golden age, allowed his muse to dictate the future:

> See quick approach, that time of renown,
> When painting, also with promethean fire,
> Shall deck her canvas, and her forms attire;
> When architecture shall erect the dome,
> Whose fame shall rival that of ancient Rome;
> When music's hand shall strike the silver lyre,
> And marble, grace, from sculpture's skill acquire.
> Then shall Columbia's artists seek no more
> For foreign smiles upon a foreign shore;
> But here combine together, to display
> The finish'd glories of her risen day.[59]

But this amiable prophecy and others like it would not suffice for too long; demands for art would soon grow more specific and discriminating, and visual forms would be required to bear both a distinctively national character and a quality high enough to compare with Europe's finest. The degree of

expectation soon reached, and the intensity of the need for the
reassurance art offered, created a hothouse atmosphere of forced
growth. Overestimations would become common, and artists
would be encouraged beyond any reasonable evaluation of their
talents. Many would fail to achieve the impossibly high and
intellectually oriented values which Americans took unquestion-
ingly from European art theorists. The artists would then re-
spond with disappointment and frustration when the heights
their fellow citizens blithely ordered them to ascend turned out
to be unattainable indeed.

The outcome of art's involvement with patriotism was not,
therefore, entirely happy; a confusion of standards bewildered
artists and their public. Newspaper criticism became notoriously
unreliable, filled with puffs and hearty pats on the back—and
occasional comments of personal ill will—but little in the way
of helpful evaluation. Since painting was in its infancy in
America, one writer explained, it was wrong to discourage it by
carping; the critic must "dwell on the good," and not stop to
"censure the bad" until all the virtues he could possibly think
of were exhausted.[60] Most critics managed to finish before ex-
hausting the "good."

The old hierarchical categorization of art, as codified by
Reynolds, remained in vogue, but it often proved of little help
in judging American paintings. Though critics insisted that rules
"are fetters only to men of no genius" and begged their country-
men not to "destroy the scaffold until we have raised the build-
ing," conservatives and traditionalists had to reshape categories
to admit the work of local favorites.[61] Artists did their best here
also. Archibald Robertson, an English emigrant, published his
Elements of the Graphic Arts in New York in 1802, and though
laying himself open to charges of special pleading, suggested
that while "Landscape takes an inferior rank in the art of
painting, when compared with the nobler style of history,"
yet it was much more useful.[62] A portrait of Washington, more-
over, could be subsumed under the heading of History, for was
it not holding up a great man as an exemplar?

The classics and great scriptural sequences continued to
obtain American respect, provided the viewer could make out
just what the scene represented. Approval still waited on sanc-
tion—most properly written authority. When his statue was

being modeled, Washington wrote Jefferson that he deferred to connoisseurs in the matter of his dress and attitude, despite a preference for modern dress. But the General admitted he would never even have dared to suggest the thought had not Benjamin West spoken about it to Houdon, and had not the taste for modern dress received prestigious critical approval. "I understand," Washington concluded gratefully, that a taste for modernity "is now received with applause and prevails extensively."[63]

So long as a precedent existed, personal preferences could be indulged, but not otherwise. The corncob and tobacco-leaf capitals Benjamin Latrobe employed in the Capitol at Washington, or the thirteen-star metopes distinguishing the frieze of New York's Federal Hall have often been singled out as inventive American modifications of classical forms (though in both cases the adaptation was worked by a foreigner). Much more significant was the feeling of daring with which these changes were enjoyed. A contemporary description of Federal Hall noted that while the new capitals "cannot be said to be of any ancient order, we must allow that they have an appearance for magnificence."[64] This was a grudging respect torn from scholarly allegiance, for changes that could hardly be termed major innovations.

The search for precedent could certainly be defended on the grounds that a new polity gained strength from its association with older, more stable visual forms. But authority could carry Americans only part of the distance they hoped to travel. When they demanded artistic activity to satisfy the conditions for natural greatness they were indeed following older traditions. When, however, patriots expected art to bear a physical relationship to the national character, they were breaking new ground. Certainly eighteenth-century Europeans seeking a national art production did not anticipate new styles to reveal the artist's national origins. The utilization of traditional forms and the avoidance of artistic crudities were sufficient for them.

As time passed, Americans demanded of their art continual proofs of paternity.[65] In literature, part of this desire could be met by the use of language alone; dialect, slang, expansion of the vernacular, appeased the hunger for national originality on the most immediate level. Painting and sculpture were different;

no separate national brush stroke, no special palette or chisel
or canvas was available to the patriotic artist. Foreign schools
had long been characterized by some particular skill, but each
suggested its own singular weakness. And Americans could not
aim self-consciously towards the perfection of any one tech-
nique because classical theory claimed as its objective the union
of all of them. Finally, it would have seemed menial, a hold-
over from the era of artisan status, to urge upon artists a special
technique as the foundation of a national school.

The encounter between art and nationality therefore in-
creased the emphasis on content and led to a search for the
subject matter to represent best the national life. The desire
for narrative which would characterize later art demands had
its origin in the physical conditions of Colonial America, but
it was reinforced by nationalist needs. The energy expended in
nineteenth-century debates on the relative patriotic values of
history, landscape, portraiture and genre was the legacy of these
early conditions.

The pursuit of the national in art, as distinguished from
the development of native artists, fluctuated in intensity accord-
ing to periods of larger nationalistic fervor. So far as art was
concerned, however, the nationalistic never merged into the
missionary impulse, an indication of the insecurity surrounding
American dreams of cultural fulfillment. Art, unlike politics,
never became an instrument to cleanse other nations' corrup-
tions; the physical weight of the European visual heritage and
the continued strength of its contemporary achievement proved
altogether too intimidating for this form of salvationism. Cul-
tural missionaries were still needed at home, and could not be
spared to spread the message abroad. Any exodus of artists, in
fact, was viewed as a leak which, if left unplugged, might allow
the carefully nurtured art spirit to escape the national boundaries.
Copley's departure from America, for example, was condemned
in later years as a betrayal, and the myth of his artistic deteriora-
tion in Europe was designed both as an appropriate punishment
and a salutary warning.[66] Every artist and every art object bore
a symbolic value, another evidence of refinement's victory over
materialism and philistinism. American painters, and their
paintings, belonged at home.[67]

Although nationalist impulses had important immediate

effects on artistic achievements, it is difficult to discover their specific aesthetic effects. Artists did appeal to public feeling for support, and one of the most vociferous among them was a chastened Copley, who interpreted his own flight as renunciation. "I shall stand amongst the first of the Artists that shall have led that Country [America] to the knowledge and cultivation of the fine arts," he wrote in 1775.[68] But this was penned in Rome where he found it easier to work. Save as a device to gain customers and commissions, most artists did not consider the problems of a national art before the 1830s, and the loudest cries before this time were made by laymen. Painters and sculptors sought merely to produce their art, make a living, and try to approach the standard set by foreign masters. It took a pietistic posterity to discover national characteristics in their work. Art demands, moreover, despite the grand rhetoric and neoclassical aesthetics, remained confined to portraiture during the first quarter of the century, and patrons accepted contemporary European estimates of their standard of value. Portraiture was an international style, and Americans like Stuart, Copley, Thomas Sully and Chester Harding achieved popularity on two continents without major changes of technique. But though few connoisseurs would commission native high art they refused to sacrifice the philosophy glorifying it. Their purchase patterns contradicted their intellectual commitments, but the only men disturbed by this were the artists themselves, doomed to labor in what they felt to be a menial department.

Early American nationalism, therefore, did not exert a memorable aesthetic effect on native artists. While the effort of nation-building rescued the cause of art from dull indifference, its influence, as has been shown, was quite ambiguous; its needs constrained while they stimulated, its adherents demanded more than they gave. And this was not all, for while the Revolution provided American art with its reason for birth, it also produced some very good reasons for a lengthy childhood. Threats and promises mingled intermittently in this formative period.

The Perils of Vision:

Art, Luxury and Republicanism

CHAPTER TWO

ALTHOUGH THE AMERICAN REVOLUTION nourished the muses, it also threatened their existence at the moment of birth. Heedless of the needs of nationalism, particularly once the military crisis was past, many wealthy and articulate citizens of the early republic condemned art and art patronage, both as efforts in themselves and as symptoms of profound social flaws. What appeared to contemporary Europeans as an innocent, even a conservative, form of human activity, seemed to members of this first generation a radical threat to the national future. American hostility to the arts was not simply the legacy of an ascetic Calvinism or the product of a brutalizing materialism but rather an outcome of the self-conscious rationalism that produced the new state. National philistinism owed its early strength to the power of native political culture in its golden age. Anxious patriots required reassurance before the arts could flourish. Eventually Americans were pacified and convinced, but this early period of anxiety permanently molded cultural assumptions. It was not the least irony of an age accustomed to paradox that an enlightened rationalism rather than Puritan superstition generated prejudices that would condition the American response to art for decades.

The men of the Revolutionary era were the conscious heirs of a tradition of European thought which perceived direct connections between the character of a people and the nature of its society. Plato, Machiavelli and Montesquieu had elaborated on the subject—a powerful source of imagery both for practical programs of reform and for jeremiads lamenting lost liberties. By the time the Constitution was adopted, this complex fusion of political, moral and social ideals had attained a highly stylized form. A source for criticism and a reservoir of ideals, it served as a means of interpreting the past and predicting the future.

These beliefs supported the conviction that a people characterized by habits which were virtuous, pious and restrained could maintain popular institutions and preserve a republican government as the creature and not the master of the national interest. By contrast, men dominated by depraved, vicious or sensual appetites would subvert the most intelligent and benevolent political plan, and become the ready prey of tyrants and despots. "It is wholly owing to the constitution of the people," wrote Thomas Paine, "and not to the constitution of the government that the crown is not as oppressive in England as in Turkey."[1] A Constitution maker agreed; no checks or balances could ever render America secure, James Madison explained. "To suppose that any form of government will secure liberty or happiness without any virtue in the people, is a chimerical idea."[2]

It was, therefore, absolutely essential for Americans to retain their simplicity and moral health: "Character is much easier kept than recovered."[3] "To be Free we must be virtuous," countless Fourth of July orators intoned.[4] This experimental society depended on the continuing presence of virtue. If impurities entered the national bloodstream, then the government organized so carefully was doomed to failure, a monument to the egotism and vanity of framers whose benevolence had outdistanced their realism. Anything which increased the chance of infection was to be fought and destroyed.

The fear of corruption was pervasive among Americans, oppressing optimists and pessimists, radicals and conservatives, Adams and Jefferson, Gerry and Morris. The historical analyses of Molesworth, Montesquieu and Rapin intensified the meaning of the drama Americans were witnessing in the Old World. Everywhere liberty seemed tortured and persecuted, expiring from a long and profound decay of manners, morals and tastes. Popular government rested on austerity and self-control; it demanded a curtailment of animal tastes and brutish pleasures. The success of the republic required devotion to principle, intellect and the rational laws of God.

Although most of the authors of the Constitution hoped to offset human egotism and self-interest by a set of counterpoised antagonisms, in the last resort popular government could not survive an atmosphere of greed and corruption.[5] A republic

was self-contradictory if it had to rely—as in Shays's Rebellion—on the use of troops to maintain its own integrity. If the popular will was to control its political agents rationally, it needed restraint and integrity. A suspicious people, jealous of the intelligent and wealthy, madly pursuing pleasure and booty, would soon destroy itself. No political remedy could cure so diseased a body politic.

American thinkers brooded about how to avoid loss of virtue. These observers of the death of empire studied those momentous points of history at which imperial power shifted from one people to another. These eras held the secrets of death, decay and the loss of greatness. Greece and Rome, Carthage and Venice, offered scope to inquiries concerning the dynamics of national decline. If this universal mystery were solved, then the new state might escape old age and death.

The lesson of history suggested that corruption of manners led to corruption of morals, and then to the subversion of freedom, independence and political power. When, wrote Edward Wortley Montagu in his popular *Reflections on the Rise and Fall of the Ancient Republicks*, we observe similar manners among ourselves and other free men just before the subversion of *their* government, "we may, at such a time, give a shrewd guess at the approaching fate of our constitution and country." No essential change could shake any government, "till the prevailing manners of the people" were ripe for it.[6] Montesquieu himself had postulated that just as honor was the basic principle of monarchical states, so virtue supported republics. Any decline in the level of national virtue would immediately affect republican government itself.[7] The epigram of Duclos summed up the belief of many: It was not tyrants who made slaves, but slaves who made tyrants.[8]

Since republics required personal restraint, the corruption most feared was associated with the passions. Anything which aroused them and increased personal pride or the love of material possessions threatened the health of society. "The character . . . of popular governments depending on the character of the people," Richard Price explained, "if the people deviate from simplicity of manners into luxury, the love of shew and extravagance, the government must become corrupt and tyrannical."[9] Luxury led to corruption because it meant gratifying

sensual passions. Since the passions could never be satisfied, the quest for such pleasure was endless. Once private fortunes were exhausted by new needs, all men would be ready to "enlist in the cause of faction for the wages of corruption." Further refinements would only introduce new desires while "the means of satisfying them" steadily lessened.[10] So vivid was the pattern that contemporaries easily blamed refinement for a host of disasters. "Luxury and extravagance, both in furniture and dress," charged Abigail Adams, had sapped ordinary virtue and caused Shays's Rebellion. "Vanity was becoming a more powerful principal [sic] than patriotism."[11]

The theme of Luxury the Corrupter was an old one, but it had taken on special significance for eighteenth-century theorists. According to Condillac it was the despot's favorite tool, even more effective than fear. Every superfluous need was "a chain which will serve to destroy us. Luxury has the means to blind the soul to the point where it values nothing and considers nothing but itself."[12] Destutt de Tracy moaned that luxury "renders the mind frivolous and affects the soundness of the understanding . . . it easily seduces women to depravity and men to covetousness . . . it enervates the soul by debasing the mind."[13] Poets and moralists like Mark Akenside and James Thomson, beloved in eighteenth-century America, had warned against the specious delights luxury presented: "On the soft beds of luxury," wrote Edward Young, "most kingdoms have expired."[14]

The word itself had long been associated with excessive pleasures and sumptuous superfluities of dress, table, furniture or bed.[15] Its earliest associations—with lechery and lasciviousness—reinforced images of effeminacy and spent vigor. Expenditures were luxurious because they were unprofitable; only the senses gained from such encounters with visual, sexual or olfactory delight. In an age accustomed to contrasting intellect and emotion, such stimuli threatened dispassionate reason; they formed a means by which monstrous deeds might overcome ordinary scruples. It was no wonder that men considered luxury "more baneful than pestilence or the sword."[16]

During the first years of independence many Americans perceived in their midst just such an increase in luxury. The Reverend James Dana claimed that military success was yielding profligacy and voluptuousness. And it would grow worse.

As America multiplied and extended its commerce, he predicted to the Connecticut General Assembly, there would be "luxury coming in like a flood—corruption and bribery invading all ranks."[17] By 1808 a Philadelphia detected it "gaining a great ascendancy over the human mind," and transmitting poison through the heart. "Gradual is its progress, but fatal is its effect. Luxury undermined the Grecian power and reduced to ashes the towering might of Rome."[18] Unless this threatening cloud dispersed, the great American experiment might be for nothing.

The problem lay in luxury's inevitability; it recurred regularly and inexorably. "Will you tell me how to prevent riches from becoming the effects of temperance and industry?" John Adams begged Jefferson in 1819. "Will you tell me how to prevent riches from producing Luxury? Will you tell me how to prevent luxury from producing effeminacy, intoxication, extravagance, vice and folly?"[19] Luxury was a disease of virtue itself.

Like patients absorbed in their own fever charts, Americans met any extravagance, any novelty, even any minor superfluity with outbursts of intense anxiety. Much as the actions of the British government had fitted within a carefully spun theory of conspiracy, so every sign of increased refinement appeared part of a gigantic, world-wide pattern of corruption. The organization in 1785 of a Boston Tea Assembly which allowed card-playing and dancing raised a storm of protests and involved in its wake Sam Adams, James Bowdoin, Rufus King and Elbridge Gerry. "We are prostituting all our glory as a people," cried one Bostonian, "for new modes of pleasure."[20] Calmer citizens pointed out the harmless character of these entertainments in vain; "Candidus" retorted that such clubs would destroy the republic, and "Sans Six Sous" exclaimed that Bostonians were "the most luxurious people in the history of the world."[21]

Equally strident abuse was hurled at wine-drinking, elaborate homes and fancy costume. Some complained of the scandalous expense fashionable clothing consumed, and urged a national dress.[22] In 1789 Tench Cox warned prospective immigrants that America welcomed all workmen except "those of superfluous or luxurious kinds." Manufacturers of gold, silver, embroidery and velvets, he wrote hopefully but inaccurately, "will find few wearers here."[23] Love of finery was merely the

symbol of selfishness, but it would stir up the envy, resentment
and emulation of the poorer classes. The pious turned to God,
praying that the "insidious and enervating influence of luxury"
would not make Americans "an effeminate and weak people."[24]

The dreaded category of luxury included the fine arts.
Josiah Quincy, traveling in Europe during the 1770s, recorded
in his journal an emotional interview with Colonel Barré.
After he proudly informed the Colonel that the Harvard Col-
lege library now owned a set of prints depicting the ruins at
Herculaneum, he was startled to be told to "keep them there."
If they got abroad, warned Barré, America was ruined.

> They will infuse a taste for building and sculpture,
> and when a people get a taste for the fine arts, they
> are ruined. 'Tis taste that ruins whole kingdoms, 'tis
> taste that depopulates whole nations. I could not help
> weeping when I surveyed the ruins at Rome. . . . Mr.
> Q., let your countrymen beware of taste in their build-
> ings, equipage and dress, as a deadly poison.[25]

Barré was elaborating a point outlined by Rousseau decades
before, in his classic analysis of the connections linking art,
luxury and national decay. Rousseau blamed art and luxury
for the fall of Rome and the downfall of the Renaissance city-
states.[26] John Adams, though he accepted few of Rousseau's
other ideas, agreed with this one. "Are we not in too great a
hurry in our zeal for the fine arts?" he asked Benjamin Water-
house in 1817.[27] Touring the great English establishments of
Blenheim, Hagley and Stowe, he remarked tartly that a "na-
tional debt of two hundred and seventy-four millions sterling, ac-
cumulated by jobs, contracts, salaries and pensions," might easily
produce such magnificence anywhere, after only a century of
effort.[28]

Adams had hit on one of the many ties between art and
luxury: both required money. Painting and sculpture, admitted
Benjamin Rush, "flourish chiefly in wealthy and luxurious
countries."[29] Only mature civilizations could afford art; until
then it was "highly pernicious and destructive."[30] Men who
wrote poems or drew pictures or carved images were unable to
plow fields or fight Indians. The materials of art—"Gold,
Marble, Silk, Velvet, Silver, Ivory and Alabaster"—summed up

by their very presence the mysterious and enervating wealth of the Orient.[31] Who had rooms large enough or walls high enough for the great allegorical dramas of high art? Only the very rich. If art was produced or imported it was a sure signal that great wealth was present or near-at-hand. Charles Bulfinch considered the Bingham mansion in Philadelphia a palace, "far *too* rich for *any* man in this country."[32]

And wealth itself, in large amounts, was as dangerous as luxury. For the opulence the arts required depended on great accumulations of gold and deep divisions of labor, both unhealthy social symptoms.[33] The only alternative was to extract such monies from the deserving or undeserving poor. For generations to come Americans visiting Europe coupled an admiration for artistic wonders with reflections on their social and economic costs. How was it possible, John Adams mused, that mankind could bear the taxes to build Notre Dame, St. Peter's or St. Paul's?[34] When wealth is monopolized by the few, reflected another traveler, we find "uncommon grandeur, then uncommon plainness, then uncommon woe. . . . You would look, therefore, for shoeless beggars and brilliant equipages. And you find them."[35] Others steeled themselves for long deprivation. If the "absence of ornament be an indispensable requisite against a grievous national debt," John Griscom scribbled, "long, long may it be before the fluted columns and the fretted domes of Europe, shall be considered as worthy of our imitation."[36] "Wealth," mourned the *Port Folio* on the death of the miniaturist, Edward Malbone, "wealth alone can requite the labours of the artist."[37]

Like other luxuries, works of art were superfluous, for they served no real need; they could not grow, be planted, or reproduce their own kind. These passive, inert and ornamental objects, the products of contemplation and leisured creation, had no place in a society which placed energy and physical effort at such a premium. Among a mobile people, art required a commitment to place. Like other luxuries it would reduce national activity and movement as it captured the senses and blinded men to their real interests.

Art seemed luxurious also because of its aristocratic associations. Popes, cardinals, peers and monarchs had been among its traditional patrons. To encourage art was to encourage class

divisions, for the ostentatious display it created would inevitably
fractionalize society and encourage would-be aristocrats. America
did not need the effeminate, Italianate connoisseurs, those para-
sites fattened by artistic pandering to their vanity and self-
esteem.[38]

Art, moreover, like other luxuries, was normally the product
of mature societies; it easily suggested age and decay. The very
appearance of large numbers of artists seemed to signal the be-
ginnings of national declension. As late as 1834 a Virginia con-
gressman declared that "those periods of the world when paint-
ing and sculpture were at their highest point of perfection were
not the periods of its highest character."[39] Painting and sculp-
ture were, after all, but little known during the virtuous years
of the Roman Republic, and the Greeks were conquered soon
after they had achieved their artistic sublimities. Everything
pointed to the fact that the arts were the attainments immedi-
ately preceding national decline.[40]

The connection between art and decay was made apparent
by more than the lessons of history.[41] The actual conditions of
many of the *objets d'art* themselves, the broken and mutilated
torsos, the blackened and age-worn old masters, suggested the
shattered state of the societies which had produced them. Art
activity throve by channeling energy away from more manly
pursuits, tempting a people to grow lazy, sedentary and fat, un-
fit for the military defense of hard-won liberties. The image of
Romans spending ever more time at their daily baths grew so
familiar and pervasive that some writers felt compelled to argue
that Americans were really not *quite* so dissolute as all that.[42]

Art was finally identified with luxury because almost all its
products were foreign and required importation, using up much
of the precious stock of currency. Cosmopolitanism and foreign
trade were by nature "subversive of the spirit of pure liberty
and independence."[43] They destroyed simplicity and equality,
industry and frugality. All forms of visual extravagance had to
be imported and could be lumped together as economically
luxurious and unpatriotic, foreign "fripperies" and "gew-gaws."

As luxury was the deadly corruption which could poison
national virtue, and as the fine arts—foreign, expensive, aristo-
cratic, superfluous—epitomized such luxury, many patriot hearts
were sealed against their American existence. The specific con-

tents of art works, both their overt messages and insidious appeals, contained more drastic dangers. John Adams voiced his fears again and again. The fine arts could never, he insisted, be enlisted in the cause of virtue and piety. From "the dawn of history they have been prostituted to the service of superstition and despotism."[44] The fine arts "which you love so well and taste so exquisitely," he told Jefferson, "have been subservient to Priests and Kings, Nobles and Commons, Monarchies and Republicks."[45] Every art had served a despot, and even the most admired masters like Raphael found nothing "too offensive to morals, delicacy or decency." The chisel, the burin and the pencil have, in all ages, "been enlisted on the side of Despotism and Superstition." The Protestant religion itself had come under attack because it was unfriendly to the arts, though "Sculpture, Painting and Poetry have conspir'd against the Rights of Mankind."[46]

To men like Adams, art (or history) was easily corruptible and reflected the passions of the hour. When Bolingbroke described how Romans placed images of their ancestors in their homes to recall glorious actions of the past, Adams scribbled angrily in the margin that "images of fools and knaves are as easily made as those of patriots and heroes. . . . the fine arts . . . promote virtue while virtue is in fashion. After that they promote luxury, effeminacy, corruption, prostitution."[47] This only echoed Rousseau, who insisted that artists would always lower their genius to match the prevailing level of taste. They sought the reward of applause. "It is thus that the dissolution of morals, the necessary consequence of luxury, brings with it in its turn the corruption of taste."[48]

Art aroused and then enervated the feelings; it was the grateful child of tyrannies, religious and political. To the devout Protestant, cherubs, angels, martyrdoms and visions, statues, stained glass and incense were sensory appeals designed to cloud intellectual perceptions and disguise the truth. The artist was a mercenary, employed for his propaganda value; by conjuring up scenes of delight he lulled away legitimate discontent. The vigilance necessary to the preservation of political liberty was easily distracted by the manipulators of sight, smell and sound.

John Adams was not the only American caught between art's attractions and his own assumptions. "I have no doubt,"

wrote John Griscom after a European visit, "that the pencil of Peter Paul Rubens has contributed to strengthen the doctrines of papal supremacy, and to lead the minds of hundreds and thousands, more deeply into the shade of bigotry and superstition."[49] Painting affected public feeling in Europe, he went on, almost as much as printing. The tenor of hundreds of comments was summed up by one traveler as he stood in the gardens at Versailles: "What taste,—what art,—what luxury,—what extravagance,—what sin!"[50]

These visual threats seemed greatest to the most articulate and cosmopolitan members of the American community, precisely the people who elsewhere supported the artistic enterprise. Wide reading in political history and an acquaintance with the classics had prepared them for the worst; European travel, by violently extending their sensory spectra, made them concede incredible power to artistic manipulators. The Europe they associated with art produced enormous physical shocks in the early nineteenth century. Even ordinary sights and sounds caused problems of adjustment. Who can estimate the effect of the noise or size of a city like London on a provincial whose image of a metropolis depended on his memories of Boston and Philadelphia? An excitement, a stretching of experience and a keyed-up sensationalism pervaded confused and emotional travel narratives of the era. Men were "stunned, confused, overpowered, heart-sick," "awed," "bewildered" and "amazed" by the excitement and confusion of European towns.[51] To an American whose ideas of visual grandeur rested on the engravings in Campbell's *Vitruvius Britannicus* or the sight of the Pennsylvania State House, the vision of a great cathedral or a palace filled with art treasures was both terrific and terrifying. Experience was often so overpowering that description itself was abandoned in favor of rapturous meanderings.

The combination of intellectual preparation and sensory astonishment produced intense fear and suspicion. The warnings read in Montesquieu and Rapin were supported by the evidence of one's eyes: side by side with the trophies of artistic greatness loomed the relics of political tyranny and physical misery. "While the people are struggling in very indigence for their bread, the churches are brilliant with all that wealth, genius, or taste can devise"; still, a "deluded populace" con-

tinued to venerate the symbols of its doom.[52] If a man like Adams, alert and forewarned, could not restrain his immediate feelings of delight, thousands of less sophisticated Americans would be taken in as completely as the Europeans. Discretion formed the only part of valor; prudence demanded that the glories of great art be sacrificed in the name of national virtue.

Americans were not, of course, the only people confronted by the ambiguous heritage of the arts; English and French critics had also grown alarmed at the message of corruption issuing from the studios of contemporary artists. The abuses artists of the past had perpetrated were re-emphasized by the eroticism in the work of court painters like Fragonard, Watteau, Boucher and Lancret. Rousseau, Grimm and Diderot had issued their denunciations. But surrounded as they were by centuries of accumulated treasures, stimulated by active artist communities, and aware of their national investments in honor and status, European critics responded to the problem in a manner much less sweeping and more selective than Americans had. It may have been "but a short step from revulsion against fashionable art to the notion of art as propaganda," but it was a short step only when the path was clear; few Americans took it in the late eighteenth century.[53] European evaluations of individual art works never led to condemnation of the medium itself, and the existence of art was rarely challenged as intrinsically dangerous to the public welfare.

Among French theorists, Diderot presented the most sophisticated and fully formed justification for artists as potential agents of morality and supporters of the honest state. He called upon artists to make virtue pleasing and vice odious by chastising the wicked while honoring the good. Painters could frighten tyrants by their ability to perpetuate in infamy unjust actions.[54] Works of art were essential for every nation, since there were always "prejudices to destroy, vices to prevent and absurdities to condemn."[55] With supervision and foresight the arts could be made to serve all sorts of interests vital to the health of society, educating and refining the citizenry on whose enlightenment depended those glorious prospects philosophers conjured up.

English discussion was less sharply directed toward the problem of luxury; critics ignored the possible dangers of artistic activity, and applied their energy toward improving native cul-

ture. Importation of foreign masterpieces was condemned only because it depressed the prices English artists received and so discouraged their ambitions. Art criticism was often the field of artists themselves, like Reynolds, Hogarth and Barry, or of philosophers concerned with problems of definition. Much of their concern lay with the ethical ends of art; Reynolds' glorification of history-painting was based on the moral ends it served, refining, purifying, restraining.

Concern with such ends raised the painter's status from the craft level.[56] Nonetheless, such positions did not penetrate America during the Revolutionary era; experience was a filter which screened out only the most appropriate theorizing. For Reynolds and Hogarth did not address the problem of legitimizing art, they simply assumed it. And Diderot, compared with most contemporary French thinkers, was practically ignored in America, his popularity wan beside the strength of Voltaire, Rousseau and Montesquieu.[57]

But, had Americans realized it, there existed at the turn of the century not merely a theoretical but a great practical example of the values artistic didacticism held for a republic. Revolutionary France had demonstrated innumerable possibilities for the wedding of visual imagery to new political forms, and its impressment in the cause of republican virtue. The French government had been active in the art world even before the Revolution, but radicals like Robespierre were far ahead of the conservatives in exploiting the political value of painters and sculptors.[58] The Mountain supported Jacques Louis David's destruction of the old Royal Academy, and helped him reorganize artistic life and plan a series of Revolutionary festivals. Monuments of art, by "penetrating the soul" would solidify loyalty and even "electrify" the national spirit.[59] David and his colleagues designed military uniforms, calendars, even crockery. Competitions encouraged monuments, political paintings and city plans. Artists were promised great sums for supporting the Revolutionary effort. Perhaps most impressive of all were the *fêtes,* huge extravaganzas involving monstrous parades, specially composed music, triumphal chariots, glorious banners and spectacular pageants. Members of the Revolutionary Convention debated the most effective means of using art to cement their victory.[60]

Little of this immense effort reappeared in America, except
for a pale imitation of the *fêtes*. In 1793 when news of the
monarchy's fall arrived in the New World, Americans planned
celebrations. Bostonians, New Yorkers and Philadelphians or-
ganized civic feasts, illuminated their buildings and marched
in processions.[61] But the celebrations were held on so reduced
a scale that they produced little emotional impact; representa-
tives of the French Republic in Philadelphia soon advised their
masters against encouraging such festivals. Americans were "cold
by nature," they explained, and small numbers turned the spec-
tacles into masquerades.[62]

Conservative Americans might well have been pleased at this
analysis of the native temperament—had they known of it—
but few Americans were aware of the uses Frenchmen had made
of the visual arts. There were many reasons for this failure to
grasp the implications of French practices. Despite the fact that
the France of the 1790s seemed ideologically closer to the United
States than England, royalist London attracted more Americans
than republican Paris. A lack of familiarity with the aesthetic
views of the *philosophes* left the few American witnesses un-
prepared for the meaning of the visual propaganda campaign;
and even had they been prepared, many might have objected.
For the point that Diderot and other critics had made—which
the Revolutionary government well understood—was that the
arts required close supervision if they were to yield propaganda
value. American hostility to centralization and public controls
would have cast suspicion on this message. It was still too early
for American democrats to confess their need for devices to re-
fine out human corruptions. Since America contained no
"cake of custom," such artistic didacticism would contradict the
optimists and confuse the pessimists; art pressed into public
service might have seemed a badge of shame.

Finally, the sweeping social and political significance of the
Revolution concentrated American attention on its central ac-
complishments and away from its tactics of persuasion; con-
servatives, alienated by its increasing violence, could hardly ap-
plaud the tasks the French government set its artists. This op-
portunity of reassessing the value of art to a republic was there-
fore lost. Later in the nineteenth century, American travelers
with sharpened perceptions and deeper anxieties would take a

more respectful notice of such devices, but for the moment traditional notions of art as luxury remained dominant.[63]

While most Americans remained unaware of the arsenal of arguments French democrats had created, the new country presented many needs. Buildings had to be constructed and decorated; wealthy men desired articles of beauty. Citizens required, if not a justification, at least some reassurance that they were not threatening the republic's security when they commissioned artists and architects to work for them. The first solution to this problem was not argumentative but stylistic. Somehow, neoclassicism met and conquered luxury.

Many brilliant analogies can be made relating the new political rationalism prevalent in America, its emphasis on law and its debts to Greek and Roman philosophy, to the visual style which came to dominate the early republic with its clear proportions, simplicity and rational organization.[64] But it is just as easy to connect this romantic idealization of the past, its monumentality and hierarchical character, with conservative and even reactionary political doctrines. The neoclassic was not bound to a democratic ideology; the three great totalitarian states of the early twentieth century pursued almost identical aesthetic aims, centering around realism in painting, and monumental Greco-Roman forms in architecture.[65]

In France itself, the movement toward neoclassicism antedated the Revolution, and some of its most radical practitioners, like Blondel, Boullée and Ledoux, opposed the new democratic principles.[66] The architects who transmitted French neoclassicism to America—Stephen Hallet, Maximilian Godefroy, J. J. Ramée—were actually *emigrés,* yet their conservatism proved quite compatible with their aesthetic preferences.[67] Many political persuasions made use of the classic vocabulary; that it came to be identified with the Revolution owes something to the iconographic skill of the Revolutionary artists and architects, but much more to the actual triumph of the Revolution itself. As an official style it reflected the official spirit, and in the 1790s that spirit was revolutionary democratic-republicanism.

In the United States, neoclassicism served another function; it made up the stylistic negation of luxury. To build in the classic, to stress the simple, to emphasize realism in por-

traiture and geometry in architecture meant an eschewal of
elaborate ornament and an avoidance of the visual richness
which, to Americans like Jefferson, hung over the decayed Con-
tinent like the evil breath of tyranny. The emphasis on form
in place of detail, the use of the linear as opposed to the more
sensuous curve, the substitution of the uncluttered outline for
the cragged picturesque—these presented purely visual alterna-
tives to luxury. Simplicity was less attractive for what it was
than for what it was not: the encrusted magnificence of court
rococo or the gloomy, superstition-ridden gothic. Decoration—
save for the tobacco-plant capitals or patriotic metopes—was
only a disguise for meanness.[68] The three commissioners charged
with supervising the construction of public buildings in Wash-
ington expressed this attitude concisely. Writing to the munici-
pality of Bordeaux, they requested permission to hire some
French workers. "We wish to exhibit," they explained, "a gran-
deur of conception, a Republican simplicity, and that true ele-
gance of proportion, which correspond to a tempered freedom
excluding Frivolity, the food of little minds."[69]

Jefferson, one of these three commissioners, disliked the
English baroque and considered painting and sculpture pursuits
too expensive for Americans. "It would be useless, therefore,
and preposterous, for us to make ourselves connoisseurs in these
arts. They are worth seeing, but not studying."[70] Despite his
vaunted cosmopolitanism, Jefferson feared an indiscriminate
development of the arts of design. Architecture held his fascina-
tion, not merely because it was a useful and necessary art, but
because it was desirable "to introduce taste into an art which
shows so much."[71] Its buildings placed American civilization it-
self on trial, since they were so readily available to foreign
travelers, and would be noticed by future historians. Justifying
his designs for the University of Virginia, Jefferson insisted that
his generation "owed it to do, not what was to perish with our-
selves, but would remain, be respected and preserved thro other
ages."[72] To base the Virginia Capitol on the Maison Carrée
would do "honour to our country, as presenting to travelers a
morsel of taste in our infancy promising much for our maturer
age."[73]

Public buildings were hostages to fortune and to the verdict
of posterity. Left to themselves men might choose forms which

would corrupt their era's image through many generations. In matters of taste Jefferson was no egalitarian, and his eagerness to promote his own suggestions revealed a fear that extravagance and ostentation might be attractive as well as corrupting. When Virginia seemed about to build a Capitol that departed from the Roman plan he had forwarded, Jefferson's protest was intense and dramatic. The commonwealth, he claimed, was missing a great opportunity if it did not erect "an object and proof of national good taste"; the result would be "regret" and "mortification" at such "a monument of our barbarism which will be loaded with execrations as long as it shall endure."[74] The judgment of the future was not to be toyed with.

Americans were frequently described, by themselves and foreigners alike, as "children" in the fine arts. The implication was not merely that they were more ignorant than adults, but also more sensitive. The first set of art accomplishments was therefore considered crucial, for it would set the pattern of the future. Americans had to be much more careful than Europeans whose national perceptions had been sharpened by centuries of experience or roughened by centuries of ill-usage. The classic, tested by time, free from sensual influences, again offered the safest solution. Its simplicity might even offer security to public virtue. A nation's public works, said Nicholas Biddle, displayed its character; patriots wished to see neither the "disproportioned and grotesque" marks of a "coarse and unlettered people," nor the "gaudy profusion" of wealthier but tasteless societies.[75] Classicism was a halfway point between the crudities of barbarism and the vulgarities of overrefinement, a perfect style to express the pastoral ideal exciting the American imagination.[76]

Because the choice of style became so important in America, art patronage and house-building, normally purely personal acts, quickly acquired a vast social significance; art indulgence became a subject of communal interest on which the prerogatives of citizenship were exercised as logically as on the ballot. Community needs were to guide private preferences. A 1790 essay began with the innocuous statement that the principles of American government required every citizen to protect the public happiness. The author proceeded from that premise until he reached the more questionable conclusion that true patriots would build their houses only of brick. These durable dwellings,

"in which more money has been spent and more of the refined taste gratified," increased popular affection for the soil, and this was socially valuable. "A habit of thought arises, favorable to population. . . . The great national fund . . . is augmented . . . emigration would be less easy and not so common were a finer spirit of building to prevail."[77] The expense of designing a handsome house seemed justified when the stakes were so high, even if the family's comfort or income were sacrificed on the altar of national survival.

The purchase of a questionable picture, like Adolph Wertmüller's controversially nude "Danaë" also became an antisocial act, because the connection between a corrupted moral taste and an unchaste style "was so strong."[78] Public buildings reflected the insistence on simplicity. The state capitols and the federal buildings at Washington were, with few exceptions, neoclassical, right up through the middle of the nineteenth century. The components of public architecture grew quickly recognizable as the colonnade, the portico, the pediment and the dome. Greek orders and Roman monumentality combined to set the nation's image; anything else seemed visually inappropriate.

In the early nineteenth century's Greek revival, when supporters justified the style by recalling its historical associations, the dominance of classical forms was natural; the political thought, the literary imagination and the political history of the Greeks and Romans made up every schoolboy's studies and oratory; nomenclature and education bore imperishable marks of this devotion.[79] But during the earliest years of the republic, artistic choices rested on something quite different. It was not the symbolism or the associations of the classic which pleased Americans first, but its visual purity. Traces of the feeling survived for decades. The only forms suitable for government buildings were "pure and severely simple Greek . . . strong, and calm, and cold, like Government and Law."[80] The reassurance the classic offered those frightened by artistic sensuality, and its instinctive satisfaction of their desire for the appropriate, formed the real basis of its great appeal.[81]

Jefferson may have been correct when he foresaw that whatever style dominated the visual arts first in America would be difficult to dislodge. The classic was quickly applied to al-

DAVIS & SCHORR ART BOOKS
1547 Westwood Blvd.
LOS ANGELES, CALIFORNIA 90024
(213) 477-6636

SOLD BY			DATE	9/5		19 81
NAME	E. Maurece Bloch					
ADDRESS						
CITY						

☐ CASH ☐ C.O.D.	☐ CHARGE ☐ PAID OUT	☐ MDSE. RETD. ☐ PD. ON ACCT.	PREVIOUS ▶ BALANCE		
	Harris :				
	Artist in Amer				
	Soc. 1966				
	(BM/I)		17	50	
	10%		− 1	75	
			15	75	
	6% TAX			95	
			16	70	

Thank You! | RECEIVED BY

FORM 350-1 Available from *NEBS* Inc., Groton, Mass. 01450

most everything, and observers like James Fenimore Cooper found the indiscriminate use of Greek and Roman forms intensely irritating. He gasped at rivers lined with temples, "children trundling hoops before their doors, beef carried into their kitchens, and smoke issuing . . . from those unclassical chimneys."[82] Markets resembling the Parthenon, breweries imitating the Temple of the Winds, churches and homes all presenting the same exteriors outraged Cooper's sense of propriety. Perhaps sumptuary laws were needed to restrain structures with illegitimate pretensions, as they had once controlled the dress of the overly ambitious.

One reason for such stylistic uniformity lay in the primacy of the official ideal. Early nineteenth-century America was preeminently a political culture, and visual forms sanctioned by governmental usage acquired tremendous popularity. In Colonial days public buildings had reflected domestic influences; without its steeple, Independence Hall had little distinctive character, while the palaces of the governors were simply elaborate private houses. With the new polity established, many Americans expressed their participation in the civic ideal by imitating its distinctive architectural vocabulary, and proclaiming their membership in the new society.

Indeed the consensus in art was even closer than in politics; Andalusia, Ashmont and The Hermitage, the homes of Nicholas Biddle, Henry Clay and Andrew Jackson, bore striking similarities to each other. If the temple style had any specific or overt political symbolism, separating radical from conservative or plebeian from aristocrat, such a wide section of the American political spectrum could hardly have displayed its visual unity.

Painting, like architecture, reflected the desire for directness, simplicity and clarity. There was little brooding melancholy or giddy femininity about the portraits by Peale, Gilbert Stuart or John Wesley Jarvis. The modesty of their work forestalled accusations of luxury and corruption. To preserve images of those far away or to transmit features from one generation to the next could scarcely arouse the hostility of the most orthodox defender of old-fashioned simplicity. Early critics admitted that home-bred painters lacked cultivation or grandeur, but they claimed for them truth and accuracy of representation.[83]

It became obvious to many that fears of art's sensuality had been
vastly exaggerated and that corruption, if, indeed, it was enter-
ing the national bloodstream, was using other channels.

Some Americans, of course, remained hostile to all visual
representation. A visiting Englishman encountered a clergyman
who objected to the eagle of the Order of the Cincinnati as
a graven image; the Decalogue forbade such. "It was the repre-
sentation of a bird. The emblem of some heathen deity. The
eagle was sacred to Jupiter, and perhaps was now in honour of
that false god."[84] But a pagan resurgence frightened few, and
foreign travelers congratulated Americans on the modesty and
simplicity of their aesthetic achievements. Godfrey Vigne noted
ambiguously that the President's house was the only "one in the
States that resembles the modern residence of a British noble-
man," but Frances Wright praised New Yorkers for building
modest public buildings, concentrating their wealth on com-
fortable homes.[85] Philadelphians, she hoped, would never swerve
from "the pure style of architecture to which they seem at pres-
ent to have attached themselves." As for Washington, she prayed
the day was far off when it would appear "a sumptuous metrop-
olis, rich in arts and bankrupt in virtue."[86]

Americans themselves, though not prepared to accept in-
discriminate criticism of their more important buildings ("the
City Hall . . . is the handsomest structure in the United States;
perhaps of its size, in the world."), usually made a virtue of
their necessary simplicity.[87] A New York City guidebook of 1817
suggested that the city's churches closely resembled "the temples
of the primitive Christians." No gigantic cathedrals, covered with
paintings and sculpture, "the fruit of superstition," violated the
scene. "Ostentation seems, indeed, to have been as much avoided
in the erection of the churches and chapels of this city, as that
of any other of her public buildings."[88]

Gradually, though very slowly at first, art forms began to
emerge as visible bulwarks to the established order; they could
encourage the virtue and patriotism which many once feared
they would threaten to destroy. Formal stylistic agreement was
reassuring in itself; eccentricity, aberrant individualism, these
were not yet tolerated in American visual productions. Rules,
familiar both to artist and connoisseur, had established and codi-
fied the means of expression; there could be variation but not

dissent. And community interest backed up such agreement. While the public had no legal right to control individual taste, "in a republican government," wrote Fenimore Cooper disgustedly, "it will rule in all things."[89] Neighbors felt they should be consulted about the building of a house, and few Americans could withstand such social pressures and support artistic idiosyncrasy.

It was, in fact, a highly literate audience for which artists and architects worked in America. In the years before photography or the wide dispersal of lithographs and engravings, verbal description was the only means of conveying visual images, and educated men of this generation knew well the differences distinguishing Doric, Ionic and Corinthian orders. They could describe buildings or illustrations accurately and concisely, making full use of the appropriate technical vocabulary. Dimensions and factual details meant more than they would in later years when some sort of visual reference became necessary for the projection of size and shape. Detailed guidebook descriptions were read and relished, and facility at verbal expression meant at least a superficial critical ability, an ease in recognizing improprieties. This situation produced some tendencies toward pedantry but it also produced a group of informed laymen who managed to commission a considerable number of stately buildings and an impressive series of striking portraits.

Verbal precision characterized European art description also, but there were some hints that Americans possessed particular visual sensitivity. If nations were distinguished by differing "corporeal powers," suggested one writer in 1815, the Italians might own a sweetness of voice and the English a sturdy muscularity. But Americans would be distinguished for their accuracy of sight. To demonstrate this, he pointed to the success of American painters, national skill in gunnery and the ability of ordinary citizens to gauge height, distance and size.[90] The building, surveying and measuring which went on in this new society depended on accuracy of eyesight; Benjamin Franklin's part in improving the design of spectacles was most appropriate in this context.

America provided, during these early years, an informed and alert audience for its artists and architects, and their achieve-

ments were solid and stable, substantial and objective in character. Buildings maintained their integrities as shapes against surrounding landscapes, sharply differentiated from the grounds about them. Portrait figures stood out against their backgrounds; the beholder could sense the irrelevancy of all but the personality of the subject. This was a human-dominated, civic-centered art; its conformity and substantiality provided a standing perceptual reply to fears of effeminacy, absurdity or vain display.

But qualms about luxury and corruption, while quieted by the stylistic solution the neoclassic offered, required a final, more systematic pacification before artists and their patrons could feel comfortable. A campaign of argument and invective was finally launched by art lovers themselves; at last they were able to tap their own intellectual reservoirs. A whole group of Europeans had taken positions countering the Rousseau argument. Dr. Johnson, in his insistence that fears of luxury were grossly exaggerated in eighteenth-century England, was one such source. Sensible men could draw comfort from his observations that England contained as many tall men as ever she had, and his explanation that "no nation was ever hurt by luxury," since it affected so few. Money spent on elaborate buildings supported the industrious poor, and a philanthropist was more certain of doing good when he paid wages to workers than when he gave money to charity.[91]

David Hume was another Englishman popular in the New World who had tried to outline a positive profile for luxury. The more "men refine upon pleasure," he wrote, the less will they indulge in excesses of any kind.[92] To indicate the absurdity which suspicions of sensory pleasure attained, Hume offered the monk who refused to glance out of his cell window because it overlooked a pleasing prospect.[93] As for that well-worn chestnut of moralists and philistines, the fall of Rome, Hume insisted that what critics ascribed to luxury was really the product of bad government. Progress in the arts favored liberty and had "a natural tendency to preserve, if not produce, a free government."[94]

To make Americans feel still more comfortable, the Marquis de Chastellux answered many of their objections to the fine arts in his famous letter to the Reverend James Madison, writ-

ten after a tour of the United States. Agreeing that luxury might indeed lead to dissipation, he saw an antidote in the arts themselves; Chastellux favored inoculation. "Erect altars, then, to the fine arts, if you would destroy those of fashion and caprice. Taste . . . nectar . . . if you are afraid of becoming intoxicated with common liquors."[95] Since some luxury was inevitable, far better that money be lavished on painting and sculpture than on plate and furniture. Chastellux was most persuasive just because he retained certain suspicions; it was "better to defer, even for a long time" patronizing the arts, he admitted, if they took "the slightest step" toward corruption.[96] But a rapid naturalization of foreign artists would be a certain precaution; American domesticity and morality would assimilate, in time, any contrary tendencies.[97] Chastellux justified art as a means of combating immorality and excess.

A variety of strategies soon became visible in the counter-attack. Some Americans denied that their country was luxurious; others insisted that physical luxury had little to do with virtue; while still others differentiated luxury and the arts. William Vans Murray constructed a vigorous apology for the arts along the second of these lines in his "Political Sketches" of 1787, dedicated, inappropriately enough, to John Adams. Like Chastellux, Murray denied the validity of analogical reasoning; the American Revolution was unique and could not be compared with any period of Roman history. He attacked Montesquieu's contention that virtue was impossible in a luxurious society, and added for good measure that virtue itself was not particularly necessary to a democratic state. As proof, Murray pointed to America at the time of its first independence. At that moment the nation possessed "all that luxury which is diversified by disparity of fortune and every elegance." "If virtue be peculiar to simplicity," he concluded, then America had relinquished both. But few could deny that those were heroic days.[98]

Benjamin Franklin also tried to calm fears of luxury. He echoed Dr. Johnson in suggesting that luxury might be a boon to labor and industry. "A shilling spent idly by a fool, may be picked up by a wise person."[99] Silly fellows ruined themselves by building great houses, but in the meantime masons, carpenters, smiths and painters made the profits. If foreign luxuries

could ruin a people, Franklin concluded, America's collapse
would have occurred decades earlier.[100]

Other writers pointed out that luxury was a relative noun;
"gilded ceilings, bronzes, porcelain," these were no more luxu-
rious than shoes—to a person who never wore any.[101] American
dissipation was actually quite moderate, William Tudor ob-
served, for it bore "a domestic air"; the *Penates* are always in
sight, or at farthest in the next room."[102] Even the national fear
of conspiracy was utilized. Some patriots charged that rumors
of degeneracy were products of a European plot to discredit the
new country. One of these conspirators, Volney, seemed to be-
lieve that wallpaper could ruin Revolutionary courage. "Are
republicans, then, to adopt the ferocious manners of banditti,
proscribing civilization and comfort," cried the *Port Folio*.[103]
Dissipation characterized all societies; the choice lay not between
luxury and simplicity, but "between the grosser and more refined
species" of overindulgence. "Where is the room, then, for hesita-
tion in the choice?"[104]

After admitting the inevitability of luxury and denying its
presence in America, these critics moved on to justify commerce
and the mercantile function. Enemies to the arts had earlier
attacked the merchant importers as responsible for the diffusion
of refinement and the new cosmopolitanism. But the attack
upon commerce tended to backfire, both in theory and practice.
Trade had been, after all, a guarantor of British liberty for
centuries; it was a pursuit offering men of obscure birth and thin
purses wealth and eminence. Commerce was the enemy of
oligarchy and aristocracy, the parent of the arts and sciences.
"Where commerce flourishes, arts, agriculture, and manufac-
tures will also flourish; the weak are protected, genius en-
couraged; revenue sufficient," so ran the odes to American mer-
chants.[105]

All of history was combed to point up the contribution of
traders, and to show that the great eras of world history—
and the most dazzling cultural periods as well—were dominated
by republican and mercantile societies. Nations grew wealthy
and powerful through trade: Egypt, Tyre ("whose merchants
were princes"), Venice and England among them.[106] It was
"trade," the exchange of manufactures for furs and tobacco,
"that caused Scotland's prosperity and intellectual renais-

sance."[107] Commerce inevitably "promotes a spirit of inquiry
. . . polishes manners, advances freedom, and widens the founda-
tions for happiness."[108] When freedom, happiness and manners
could be seen as advancing simultaneously, some of the luxury
argument had already been won.

Glorification of the commercial spirit as the nurse of liberty
and the arts included an apotheosis of the merchant himself
as a courageous, liberal-minded innovator.[109] The way was thus
prepared for the close identification of the mercantile func-
tion with the patronage of literature and art, and many Ameri-
can merchants would soon become active in the young academies
and literary societies.[110] Across the water the gigantic figure of
William Roscoe, philanthropist and patron of Liverpool, was
pointed out as an instance of the generosity and intelligence
which the commercial life could yield.[111] Roscoe's life of
Lorenzo da Medici, one trader's tribute to another, enjoyed an
enormous success in America.

Discussions of the compatibility of liberty, commerce and
art eventually produced heated aesthetic and historical con-
troversies. Those who claimed that classical art was greatest
while liberty flourished met opponents who swore that Greek
sculpture was finest in the period of degeneracy after Pericles'
death, adding that Rome also produced her greatest master-
pieces after the republic had disappeared, attempting to "spread
the gorgeous drapery of luxury and refinement around her
decaying form."[112] This battle between those claiming that
freedom was the necessary condition of great art and critics
who believed that only the forced feeding of despotism could
nourish creative genius raged on well into the nineteenth cen-
tury. Europeans had concluded much earlier that the arts were
mercenaries, agents of whatever powers sponsored them. The con-
spiratorial ideology prevalent in Revolutionary America, how-
ever, was not conducive to distinguishing between origins and in-
struments; artists appeared more like active participants than
paid agents in the war for men's minds. But as the nineteenth
century wore on, the view that the arts, "like mercenary troops,
do their duty well while well paid," achieved dominance in
America also.[113]

Negative arguments, however, were not wholly satisfactory.
The need to distinguish art from luxury, refinement from cor-

ruption and pleasure from sin was so intense that liberty became, in the eyes of American critics, the necessary and sufficient cause for the production of great art. Where "tyranny and slavery exist," cried William Dunlap, "the arts languish and die."[114] The hothouses constructed by European tyrants were incapable of yielding healthy fruit; great art was possible only in free nations like the United States.[115] Christianity and democracy would combine to prepare an art intellectual yet comprehensible, resolving all contradictions in its popularity and moral fervor.

The tone of these pronouncements grew steadily more strident, the hopes more extravagant and the critical judgments more exaggerated as the years passed and the need to defend the arts grew less real. The literate and sophisticated enemies who feared the corruption of art underwent conversion, and by the 1830s many had passed either to the other side or into silence. But rhetoric reached its height in the middle of the century, long after any objective need for it had disappeared. A swollen mass of intellectual and emotional justifications was allowed to balloon up unrestrained, as every American artist became a fighter in the war for patriotism, prosperity and religion. The view that freedom was a sufficient condition for art achievement was particularly attractive because it certified passivity; Americans needed but to perfect their political fabric, and genius would rise among them.[116] By this means great art became a symbol for political health—as it had once served to allegorize political disease—and evolved into a method for treating all national ills. Flourishing artists would indicate the full maturity of American civilization, and the triumph would be unspoiled by fears of decay.[117]

Though the luxury problem solved itself by the 1830s, defenders of the arts were probably aware that the artist's victory was only a paper one. Intellectual conviction often vanished when nudity or alien religious visions were encountered on canvas or in marble. But this was a problem rational argument could never solve; only the development of lithography and photography, coupled with the increase of travel, enabled Americans to enjoy art's sensory impact, while they diluted its eventual intensity.

The political philosophy of the Revolutionary era and the

dimensions of the luxury problem forced an enormous burden on the shoulders of the American artist, and helped place the arts permanently on the intellectual defensive in American life. To combat the implications of political and historical theories, publicists made art into a conscious contrivance to meet national needs, and inevitably involved it with prevailing ideologies. Conservative European standards were called into play by native critics, in order to gauge art's effectiveness. Universal measures were used to evaluate special experiences. The autonomy of art in the United States was thus lost long before the character of American art was itself compromised. The bombast, the aggressiveness and the boastful promises of American artists and their supporters become comprehensible only with the insight that their nursery was far from benevolent; the compulsiveness of their will to survive was a product of fear as well as hope, and of history as much as prophecy.

The Burden of Portraiture

CHAPTER THREE

WHILE LAYMEN ENGAGED IN a heated debate on the value of art, those most vitally concerned, the artists, faced distinctive problems of earning a living in an atmosphere of ignorance and indifference. Though American conditions had modified the structure of many professions, lawyers, physicians and merchants still followed traditionally prescribed courses of education or apprenticeship which supplied a basis for reasonable expectations concerning their work, their incomes, their community status and chances of success. It was a long time before similarly articulated career patterns were available to young artists. The need for extemporization and subterfuge, endless stratagems and disappointing delays, left behind an acute sensitivity to status, and ambiguous attitudes toward business values. The tensions produced when the needs of survival threatened desires for dignity were never completely resolved; and many of the problems which bedeviled the profession later in the century dated back to these difficult years. This heritage dominated even artists whose family wealth or social background exempted them from the worst severities.

In the eighteenth century America contained few professional artists. Limners, of course, would paint someone's face on wood or canvas, or produce a miniature for the proper fee. Occasionally the colonists ordered more elaborate portraits, full lengths with small landscapes in the background, or carefully worked interiors in the foreground. European emigrants like Nathaniel Smibert generally produced the more sophisticated art, or else such desires were satisfied by the paintings newcomers brought from Europe.

In any event, few men lived solely by portraiture; limners were also house painters, sign painters, blacksmiths and cameo cutters. They decorated furniture, designed family crests, engraved calling cards and incised tombstones. Ezra Ames of

Albany gilded mirror frames, painted sleighs and sold artists' materials before he graduated to portrait painting.[1] Such men were actually artisans, manual workers gifted with physical dexterity for providing visual enjoyment. Their secret lay in painfully acquired techniques, and anyone could join their ranks who was willing to give the time and money necessary for apprenticeship or who decided to try his luck with only his instincts and observation. Master carpenters built and designed houses, and clever wood carvers filled the place of sculptors.

Customers shopped and bargained for art just as they did for any commodity or service, and purveyors advertised their peculiar skills like other tradesmen. Alexander Stewart, informing the Philadelphia public in 1769 that he did landscapes, sought "gentlemen, either in town or country, who have picture pannels [sic] over their chimney pieces, or on the sides of their rooms, standing empty." He promised to fill all available space "at a very moderate rate."[2] Others, perhaps more versatile, listed history, scripture, landscapes and portraits. Fashion dictated the approved modes, and reputation suggested the artificer most capable of reproducing them.[3] The cunning among them added "in the latest European manner" or "late pupil to Sir Joshua Reynolds" to their publicity notices, trying to trap the socially ambitious into this unwonted expenditure.[4]

Many Americans who later became prominent artists lacked even the thought of higher things. Francis Alexander, a celebrated Boston portraitist, made up his mind to become an "ornamental or sign painter" because he thought it might promise more money than farming. "My ambition rose no higher. Indeed my reading had been so limited, and my birth so obscure, that I thought sign painting the highest branch of painting in the world."[5] Chester Harding, another New England backwoodsman destined for artistic success, reminisced that he had thought little of portraiture as a profession. "Indeed it had never occurred to me, that it was more honorable or profitable than sign-painting."[6] Harding and Alexander were more typical than West, Copley, and the Peales, who had been fired up by their reading of artists' lives. They accepted the notion—at least initially— that the artist's life was not basically different from any other craftsman's, nor deserving of special favor.

This soon changed. After education, travel and communica-

tion with fellow artists, the painter's or sculptor's task came to seem more important than the artisan's; new demands appeared. Harding and Alexander implied that they must have been naïve to place artists and artisans on the same level.[7] Through the first half of the nineteenth century, artists attempted to free themselves from the psychological and social shackles of a mere craft and to assume the dignities of an ancient profession, with its special functions, group consciousness, high standards and disciplined controls. In a society based upon equality of opportunity, the effort was extremely complicated. Artists were forced to make stilted pleas for special privileges; in later years many of them would find it easier to uphold their Americanism in Europe, where the contradictions were less oppressive.

The quest for dignity was arduous. Critics complained, even at mid-century, that many possessed artistic talent who dared not use it. The prejudice that "sees no difference between the occupations of a stone-mason and a Thorwaldsen, a sign-painter and an Allston," still seemed very much alive; the result was the direction of artistic talent into other channels, or its restriction to the amateur.[8]

A change of attitude toward the arts required improvement in the product. If art was a trade, the very least result of increased skill would be higher prices. Improvement for the early craftsmen meant usually a more literal and precise illusion of reality in portraiture, or a more flamboyant inventiveness in decoration and advertisement. Most commissioned art bore a strictly functional purpose. A store sign had to attract the consumer and inform him what he could purchase within. Those ordering portraits of distant friends or departed relatives wished for accurate images. Under such conditions Gilbert Stuart complained that American artistic judgment expected too much. In England his efforts were merely "compared with those of Vandyck, Titian and other great painters—but here they compare them with the works of the Almighty."[9] He advised a young Kentucky portraitist to keep his backgrounds relative to the character, profession or era of his subject, and above all not to distract "the attention from the main point."[10]

Customers, valuing accuracy more than artistic dignity, gave to painters the same careful instructions that they gave

to any artisan. John Allston of Georgetown, bemoaning the fact that he had paid out more than ten thousand dollars for family portraits, "not one of which can be said to be even a tolerable likeness," commanded Samuel F. B. Morse to decorate his work "with the most superb landscape" he was "capable of designing," and make it a "masterpiece of painting." His daughter, the subject, was to be represented "in the finest attitude you can conceive. I wish the drapery to be white."[11] Mrs. Trollope noted the emphasis on technique during her American travels. From all conversations on painting, she recalled, "the finish of drapery was considered as the highest excellence, and next to this, the resemblance in a portrait; I do not remember ever to have heard the words *drawing* or *composition* used in any conversation on the subject."[12] Patrons rewarded effort and intricacy rather than inspiration, and went to great lengths to make certain they were receiving their money's worth. A German painter complained to the visiting Captain Marryat that Americans would ask only how long it took to paint a painting, and then divide up the price by the number of days. Years of "invention and years of study go for nothing with these people."[13]

Just this sort of technical precision first attracted the attention of parents or friends to latent artistic talents: a child's sketch of a sleeping sister, a schoolboy's caricature of a master. Benjamin West gained his first fame when, at the age of six, he painted a little niece.[14] Asher B. Durand, excited by the engraved tickets of watchmakers, imitated them and even made his own gravers.[15] Henry Kirke Brown, the sculptor, sketched the head of an aged neighbor without ever having seen a portrait.[16] And Edward Malbone, fascinated by theatrical scenepainting in Newport, saw his imitations proclaimed by his neighbors "a juvenile miracle of scenic art."[17] The flood of nostalgic reminiscences by artists' parents grew so large that a disgusted John Neal explained that children do many things: whittle, sing, paint and fly kites. Only in later years, he protested, do parents find indications of genius. "Be he 'painter, poet, auctioneer'—when a man, if he be distinguished by either, there will be enough to remember that he was so, in his boyhood."[18] And William Dunlap, whose scholarly researches gave him particular authority, bemusedly noted that "every painter or engraver began to scrawl, scratch, pencil, or paint as soon

as he could hold anything wherewith he could make a mark."[19]

Artistic precocity produced varying reactions in parents. Some saw this early sketching as a symptom of idleness and frivolity, boding ill for a boy's future respectability. Worthington Whittredge, a landscapist, recalled that his father considered the very word "artist" an anathema: "Any man who proposed to spend his life dabbling with crayons and paints was, in my father's estimation, a lost soul, and, in addition, a very foolish one."[20] Chester Harding's father, while not as obdurate, told his son that it was "very little better than swindling" to charge forty dollars for a picture. He urged him "to give up this course of living, and settle down on a farm and become a respectable man."[21] And Henry Dexter, a sculptor, was discouraged from modeling, portrait-making and fiddle-playing; his elders explained that "poets were always poor shiftless fellows."[22]

Most of these criticisms centered on the problem of making a living and the visual trickery or sleight of hand which the artist exploited. The physical effort bore little relationship to the price. But not all families were hostile to art careers, and the instances where they did offer opposition usually involved reasons more compelling than suspicions of art. In rural, agricultural circumstances, there was always more work to be done than hands available; the time taken to draw was stolen from household labor or from the all too few hours allotted for schoolwork. Even so, some parents took pride in precocity and encouraged with their approval—or an ill-concealed admiration—the magical ability to reproduce the eye's vision. The same mother who forbade Henry Dexter to draw or sculpt, also told him that there was a mystery about painting, "and that no one could do it who was not born under a particular star."[23] The mother of another sculptor conspired with the boy against his father, and finally managed to place her son under the guidance of a sign painter.[24] And Samuel Morse wrote gratefully that if it was ever his destiny to become great, "my biographer will never be able to charge upon my parents that bigoted attachment to any individual profession."[25] In a society where many children avoided their father's calling, artistic hopes were tolerated more easily than in Europe.

When talents were demonstrated it seemed natural to apprentice a boy to a trade where they would be useful, such as

coach-painting or engraving. There existed few competing routes for the would-be artist; successful painters were scarce and rarely took on pupils. Apprenticeship, therefore, was not always the result of parental opposition to the art life, but the most reasonable decision possible. Indeed the most bitter discouragement came to young artists from those already established in the field. Colonel John Trumbull warned several generations of young painters against joining the profession. John Blake White, visiting Trumbull in England, was told to study law. Painting depended on fashion, "the caprice and whim of mankind," said Trumbull. "You have left the study of the Law for Painting, a certainty, for an uncertainty. . . . I would sooner make a son of mine a Butcher or a Shoemaker, than a Painter."[26] Several decades later Trumbull was giving the same advice to Sylvester Genin, another would-be artist. Make law your great pursuit, he urged, and historical painting the amusement of "hours of leisure."[27]

Parental opposition mattered little to the children of poor families already isolated in rural areas and lacking the means to move elsewhere. Such a young Virginian outlined the problems facing many like him in a pathetic letter to a Philadelphia engraver. He begged for instruction because of his love of art. But the boy admitted that he lived in an area where "a taste for the fine arts, if at all known, is only known to be despised, and where all efforts for the cultivation of them, are received with contempt or indifference, from fancied conviction of their inutility or *unprofitableness*." He had never seen a real painting or statue, he confessed, and engravings were the only art forms he knew. George Murray, the Philadelphian, granted free tuition, but the boy's career and life were ended by an overzealous sentry during the War of 1812.[28]

The peculiar conditions of American life, though they isolated and barbarized a number of young artists, also helped them in a less obvious way. When geographical and occupational mobility were the norm rather than the exception, the experience of moving from trade to trade before settling on one of the arts was not as dangerous or demoralizing as it might have seemed in Europe. Edward A. Brackett, a highly successful sculptor, tried six different occupations before he found his calling.[29] Because experimentation and movement characterized so

many Americans, it was less easy to label young artists as shiftless. The delays, of course, did have important professional effects.

In eighteenth-century America those who could aid the development of artistic talent were mostly impoverished immigrants who lived in the large seaboard towns. They jumped at the opportunity to make extra money by instructing young pupils. At first, the academies and drawing schools they organized were directed not at the future professional who would be better advised to seek a successful painter, few as they were, but at the amateur, young ladies desiring cultivation and young men cultivating desires. Thus M. Alexander Marie Quesnay announced in 1784 the opening of his New York City Academy to teach French, dancing and drawing, the "culture of the polite arts," as he advertised it.[30] Foreigners dominated this world—the Robertson brothers, who opened their Columbian Academy of Painting in 1797, were both born and trained in Europe. The names of other painters resident in New York and willing to give instruction, like Christian Gullagher and Auguste Demillière, betray their foreign origin.[31] Soon a few of them began to offer more specialized artistic training.

This small group of professionals had not merely some techniques to teach, perhaps a sketchy knowledge of perspective or color-grinding, but usually possessed as well a few examples of art from across the ocean. These faded masterpieces or copies served as models for their students. Occasionally art teachers tried to gain extra attention or income by showing them to a wider audience. Demillière, for example, announced he would hold daily exhibitions of his collection of Italian, French and Flemish paintings.

In the studios and workshops of local artists, rather than in the academies, aspirants discovered each other and found in their mutual ambitions moral support for the career they had chosen. Washington Allston, Thomas Sully and Edward Malbone met in places like John Rubens Smith's studio in Brooklyn, Samuel King's in Newport and Bass Otis' in Philadelphia. Student relationships were often amicable but not always lasting. Art was highly competitive, and one man's success threatened to spell many another's failure. Some painters discouraged pupils for this very reason, hoping to retain the secrets of technical skill, and

force the curious to commission portraits to gain knowledge. Thus Henry Dexter, although he had little enough money at the time, ordered his portrait from Francis Alexander in Boston, just to see how he went about doing it.[32] Chester Harding, as a traveling sign painter, had worse luck with a portraitist named Nelson who agreed to paint him, but refused to show the boy how.[33] And James H. Beard met an itinerant limner who would not let him observe the painting process, but agreed to teach for fifty cents a lesson. In four lessons Beard found out all he knew.[34]

Old-timers like John Wesley Jarvis were probably flattered when youngsters entered their studios. Henry Inman recalled his own appearance: he removed his hat and bowed to the master at first sight. "At that time I regarded an Artist with peculiar reverence."[35] Occasionally pupils were so apt that their teachers took them on as partners; Samuel Waldo, the miniaturist, invited William Jewett to join him in a firm which flourished for decades.[36]

But many students found only jealousy and backbiting. James De Veaux tried to avoid differences with fellow painters by not working in another's territory.[37] But even in Italy he discovered that American painters and sculptors were filled with venom and envy. "Except religious sects," De Veaux reported, "I think *we* are the warmest and best haters, and the most malignant devils the sun ever designed to shine upon. Except the French, I find artists the most disagreeable associates."[38] Later in the century travelers were shocked by professional jealousy among Americans abroad, particularly when they had hitherto seen "in the followers of Art only a noble band of brothers, dispensing beauty to mankind, and full of generous favors to each other."[39] The hardships which many artists suffered while young were partly responsible for this pervasive quarreling, though the habit remained even after they achieved prominence. Thomas Crawford, who accused competing sculptors of having "oyster supper'd and Brandy Punched the Editors of half the papers," treated every commission gained like a race won, and insisted he was merely "taking the Sword of Justice in my own hands" to end the reign of mediocrity which competitors had established.[40] Instead of aiding neophytes, prominent professionals allowed them to fight for positions without assistance.

Men of obvious generosity, like Washington Allston, were eulogized by colleagues for their disinterested helpfulness to struggling beginners; the tributes were fulsome more for the rarity than the utility of such aid.[41]

Material needs continued to intensify the social and pedagogic problems artists faced in America, though they led also to creative innovation. The scarcity of paints, brushes and canvases helped set a pattern of technical experimentation which would be handed down as a legacy to professionals of later eras. Interest in developing the tools of art became pervasive; everything from new paint bases formed of mustard to measuring machines and improved chisels emerged from the studios together with the busts and paintings.[42] The craft backgrounds of most artists accustomed them to the manipulation of mechanical devices; the fine arts seemed only further applications of the applied.

The need for improvisation was reflected by high prices. A Russian visitor observed in 1812 that American portraitists asked healthy fees because their expenses were steep; good brushes sold in Philadelphia for one dollar apiece, and canvases of bust size cost at least three dollars.[43] Rembrandt Peale noted that Philadelphia had no artist's color shop for years after Independence; the apothecary kept some colors in stock but this was all.[44] Not until 1793 did the city have even one gilder of frames. When at last, in the early nineteenth century, newly opened stores supplied paints, brushes, canvases and casts, they immediately assumed an important place in the artistic community. Decades later men remembered the great day in 1816 when L. P. Clover opened a looking-glass and picture-frame store on Fulton Street, New York.

Such store owners served as art dealers, exhibiting the work of favorite painters and acting as centers of artistic information. In the display windows the casual passer-by might find himself charmed by an attractive painting; inside the store he would be directed to the artist's studio. Students hung about, hoping to pick up information about colors, competitors or patrons. Auction houses grew up nearby, like the ones in New York conducted by John Gourley, and by Levy and Harrison; picture dealers, like "Old Paff," imported hundreds of spurious old masters. Sometimes the owner combined his gilding and selling

with an engraving business, and acted as an agent for interested painters. Clover sold the works of expatriates like Gilbert Stuart Newton and C. R. Leslie, framed John Trumbull's engravings, unpacked Joseph Bonaparte's gallery of pictures, and exhibited the canvases of Samuel Morse, John Quidor and Thomas Cole. These stores were the most effective art institutions of their era.[45]

The art merchants and their trading atmosphere emphasized artisanlike memories which some painters were trying to escape. The artist and storekeeper were tradesmen together, cooperating to find customers. Since artists and art stores remained few in number at the start of the century, they did not form picturesque neighborhoods, but were thrown into the city's natural mercantile district, where artists and businessmen lived and worked alongside each other, and met constantly. In some ways the situation benefited the artist; there was no need for him to advertise extensively if he could be met in the course of a normal week. Merchants could be slowly educated to the new craft springing up around them, and with their curiosity piqued, transformed into steady customers. Later in the century, when the appeals of the artist life became better articulated and more attractive to local businessmen, this is what happened.

But there were disadvantages in this arrangement also, for it delayed the development of artistic group consciousness. Few artists felt the interdependence which isolation in the artist districts of great European cities, or the large ateliers of successful artists, might have produced. There was little to differentiate the artist from other men; no particular dress or habit, no neighborhood, or institutions, or status attached itself to him. His studio was just like any other place of business, where the customer posed before buying. Artists adopted sound business techniques, issuing beforehand lists of prices scaled to meet a wide variety of needs and purses; they flattered their sitters, played on their vanity and acceded to their wishes.

A few artists grew bitterly hostile to business values and the materialism they found everywhere. Samuel Morse, trying to make some money in England, wrote home that the "avaricious devotees of mammon" had so filled his ears that he had begun lowering his art to a trade, "painting for money . . . degrading myself and the soul-enlarging art I possess," to mere financial

gain. "Fie on myself! . . . no, never will I degrade myself by making a trade of a profession. If I cannot live like a gentleman, I will starve a gentleman."[46] Horatio Greenough made frequent protests of this sort too. But such outbursts were rare among American artists before the 1830s. They appeared only after a lengthy exposure to Europe; Morse himself, later in his life, adopted these despised sales tactics on a massive scale, to persuade Congress to give him commissions.[47] Indeed, he turned to the telegraph to provide an income he could never attain as a painter.

Most American artists of this era neither noticed nor minded their absorption into the business world. Their objections were different, and focused on an exclusive slavery to portraiture. Henry Inman complained that his customers would not commission landscapes unless he stuck them on to portraits, perhaps an old tree or a bit of sky. If not for portraits he would have starved. But he consoled himself by acknowledging the universality of such a condition, for people inevitably preferred their own faces "in the infancy of the Fine Arts in all countries." Artists of his generation, Inman concluded, could prepare the way for a "higher and purer taste" in the future.[48]

The reign of portraiture seemed cheapening to the profession generally, making them servants of personal vanity and producers of mediocrity. "By-and-by," said Gilbert Stuart, "you will not by chance kick your foot against a dog kennel, but out will start a portrait painter."[49] Stuart's comment was hardly disinterested, but Mrs. Trollope also grumbled that boys knowing no more of anatomy than they did of heavenly bodies went brazenly and easily into the portrait business.[50] Patrons and parents, as they had in the eighteenth century, cautioned ambitious youngsters to moderate their dreams of history and scripture painting. The mother of Samuel Morse, knowing his temper, urged him to "be very obliging and condescending to those who are disposed to employ you."[51] Morse angrily replied that he had no thought of becoming a portrait painter. "My ambition is to be among those who shall revive the splendor of the fifteenth century; to rival the genius of a Raphael, a Michael Angelo, or a Titian."[52] A disgusted Alvan Fisher, complaining that he had "some skill in landscape, animals, compositions of

various kinds," requested a friend to know him only "as *Fisher the portrait painter*." That was his sole means of support anyway, and why should he conceal it?[53]

Portraitists, after all, had to be "obliging and condescending" to keep their clients well entertained during the long hours of sitting. John Neal pointed out that the portraitist had to make both a likeness and a pleasant picture, tell the truth and lie, paint by the clock in fair weather and foul, in a trade where cheap workmen and adventurers abounded.[54] Portraitists of sensitivity were worn out by the "disappointments, the delays, the pert criticisms, the tantalizing caprices of sitters and their friends."[55] The thousand little artifices which the successful portraitist had to develop were distasteful, though necessary. Men became artificial, pompous and opaque while posing, and as John Neagle pointed out, it was the artist's duty "to penetrate this disguise and discover the truth—the real manner and character of the sitter."

Experienced painters could establish a mood so that the subject would unconsciously "lay his character open as to day" for the artist's inspection.[56] A friend of Charles Loring Elliott recalled that this portraitist possessed enormous tact and a biting humor, and would draw his sitters "into conversation upon topics with which they were most familiar." With the greatest adroitness he would penetrate their defenses until he had recorded their actual "soul-life."[57] Gilbert Stuart was almost as famous for his salty wit and puns as for his artistic skill.

Some painters eased twinges of conscience about the servile aspects of the craft by viewing portraiture as a spiritual exercise; others believed in its inherent dignity. But in either case an attitude of hostility toward the sitter allowed the artist to take his revenge for such employment. Some saw their mission as "taking the conceit out of people," producing works more "amusing to others than flattering to the vanity of the poor victims."[58] Later in the century the spiritual insights supposedly the property of great painters helped to change attitudes toward portraiture and endowed the figure of the artist himself with an aura of mystery and romance. Gilbert Stuart's comment that a sitter's face showed madness shortly before his unexpected suicide, caused a sensation.[59] But in the early years a sense of drudgery and dependency overshadowed the mystery. Wit

counted for more than perception though an excess in either might be fatal. John Wesley Jarvis, who demanded a quart of wine for his composure when begged to make a merchant's ugly wife handsome, lost both the wine and the commission.[60]

The portraitist particularly valued the patronage of the famous, for it stamped him with fashionable approval and furnished anecdotes for less important clients. Details of dress or behavior became tidbits of gossip, expended economically in the studio. Henry Tuckerman counted contact with the great an incidental advantage for the portraitist, and added that deficiencies in early training were often compensated for by this means. Since the adventurous entered the army to see the world, painters might be forgiven for embracing portraiture "in order to reap the social harvest it enjoys."[61] Artists needed to be easy on many levels of society, to entertain the illustrious yet avoid insulting the prosperous neighborhood grocer.

Their lack of classical educations and established social backgrounds further clouded the uncertain status artists enjoyed in America. Though their calling theoretically demanded the highest respect, most practitioners, unlike many ministers, lawyers and physicians, were the products of low-income, poorly educated families. The entry of every college-trained or socially respectable gentleman represented a growth in status for all; in demanding deference for themselves alone, a socially conscious elite would receive it for the artistic profession as a whole. To those who felt that too many American artists entered upon their careers "unfurnished with the learning and culture which an early classical education alone can give," to those objecting to the "uncouth and brawny specimens of ignorance and impudence frequently to be met with in our profession," the examples of Allston, Trumbull and Morse offered pleasing exceptions.[62] A New York newspaperman commented in 1836 that for the past few years the artist was "known *by his profession* to be a gentleman," for his conduct usually coincided with the dignity of his art.[63] Horatio Greenough, who brought some social distinction to his field, denied that Allston and Morse were "exceptions of a high order," and insisted that a "man may be an *artist* without being ergo a blackguard and a mischievous member of society." Allston and Morse "have made the rule," he wrote James Fenimore Cooper.[64] Christopher Pearse Cranch, the

son of a distinguished judge, symbolized the highest artistic motives to Henry Tuckerman, along with Greenough, William Wetmore Story, and the scion of "an old Knickerbocker family," John W. Ehninger.[65] The condescension artists received from wealthier members of society maddened William Dunlap; he exploded on reading a description of Cosmo Alexander as "apparently above the mere trade of painter." "To paint for money would be degradation," Dunlap sneered, "not so to write—to plead—to physic—or to kill."[66] "Does the wretch who writhed in pain think he patronizes the physician who restores him to ease, because he pays his fee or his bill?"[67]

Nevertheless, painting remained, in the first quarter of the century, a precarious and sometimes humiliating occupation, its dependence upon a fickle public taste emphasized by the fact that many artists still found it impossible to settle permanently in any one place. Forced to travel from city to city, according to the season or more fortunately from year to year, they tried to benefit from short stays and novel appearances by concentrating their labor. Instead of spending weeks waiting idly in his studio, an artist could squeeze in dozens of orders during a brief visit. A little known painter named Thomson supposedly cleared thirty-seven hundred dollars in a five month stay at Norfolk, and John Wesley Jarvis made as much as six thousand dollars a trip.[68] William Dunlap, on a more modest scale, did thirty portraits for eight hundred dollars, all in twenty-seven weeks of work at Norfolk.[69] Dunlap had left Philadelphia in the autumn of 1819, after being advised to visit Virginia by Thomas Sully, a Philadelphia artist. Sully complained that he had not received an order for six months, but this was in a depression year and art was sensitive to economic fluctuations.

Sometimes itinerant artists were tempted to abandon their wanderings and settle permanently in a friendly city, but often they regretted such enthusiasm as public interest vanished along with their own novelty. At other times, after careful preparations —inquiries made about the wealth of a community and its pool of artistic talent, some commissions gathered in advance, glowing newspaper advertisements placed, the recommendations of local critics gained—disaster occurred, and traveling expenses would barely be met. Thomas Doughty regretted his decision to go to

Troy rather than Albany. He sold only two pictures there, while "in Albany I think I might have got the whole of them off by this time."[70] Samuel Morse, however, wandering into Albany in the summer of 1823 after having gotten to know the Patroon, could find no work at all. There seemed less money available for art than had been anticipated, and no one wanted portraits or miniatures.[71] Perhaps a rival had just come through town and capitalized on a long art famine. There was no way of knowing beforehand.

Occasionally a community which had faithfully produced a good number of clients for years, suddenly closed its doors coldly on its former favorite. Dunlap found that Norfolk had become "poorer and poorer from the time I first knew it," and his only reason for stopping there was to have a proper room (eighteen feet high) to finish a large composition.[72] Samuel Morse, after having done well in Charleston for three seasons, making as much as three thousand dollars a trip, discovered that his presence had become superfluous. "I receive no new commissions," he wrote sadly to his wife. "I give less satisfaction to those whom I have painted; I receive less attention . . . none at all from most."[73] Even painters like Thomas Sully, after years of residence in one city, discovered their sources of income totally dried up. Although he had made more than four thousand dollars a year for some time, Sully's patronage declined so drastically that he thought of going to Europe, but he could not even get enough subscriptions together to make the trip. Only after Philadelphia engravers, hoping to prevent his move to Boston, commissioned their own portraits, did things pick up once more.[74] Henry Inman was less fortunate in Philadelphia; invited down, he waited out several years, but eventually found it necessary to return to New York.

Baltimore, Charleston, Norfolk and New Orleans were favorite visiting places for Northern artists during the cold winter months, while Southerners often made northward migrations to Philadelphia, New York and Newport. Frequent travel involved advantages and disadvantages, though the latter proved to be stronger. Among other benefits, itineracy enabled artists to gain national reputations at a time when few men—outside of politics or the military—were well known beyond regional borders. The variety of experiences enriched artistic

perceptions and, in a circular fashion, they were made more interesting to their own circles of clients. Travel allowed the unskilled novice, crude and untaught, to find his true level gradually, working first in backwoods areas or small towns where, though he might get less money, criticism was less sophisticated and customers more tolerant than in the eastern cities. These he could reach after having made noticeable improvement. Moving around was one means of surmounting early discouragements and getting a series of second chances. On the road other traveling artists or local notables might be encountered, sometimes willing to offer technical suggestions and professional hints.[75]

Even artists fortunate enough to acquire permanent residences traveled extensively; often they made trips specifically to meet colleagues in other parts of the country or to view important collections. Two Philadelphia portraitists, James B. Longacre and John Neagle, made one such trip in 1825. Touring the Northeast for information and training rather than customers, they called on Morse, Durand, Rembrandt Peale and Colonel Trumbull in New York, and met Stuart, Washington Allston and Francis Alexander in Boston, painters all. Besides their conversations with these artists they were invited to view private collections and notable portraits, like Copley's "Samuel Adams."[76] Charles Willson Peale was another frequent traveler, conferring with other artists, attending special exhibitions, evaluating schemes of art encouragement. But most young artists had to combine travel with business; otherwise it was too expensive.

There was a certain adventure and glamour to the life of the road. A troubadour-like appeal brightened the outlines of an art career, a mobile trade in a mobile country. The free and easy artist life was even celebrated in literary works. "What a blessed life a painter's must be," cried Kitty Ellison in William Dean Howells' *A Chance Acquaintance*, "for it would give you a right to be a vagrant, and you could wander through the world seeing everything that was lovely and funny, and nobody could blame you."[77] This was written, of course, decades after the artist-itinerants had ceased their wanderings and the life of the road really belonged to the landscapists, sleeping under the stars in fields and forests.

Itineracy, however, required enormous expenditures of time and energy. Arrangements had to be made far in advance, long trips over primitive roads endured on horseback or in uncomfortable vehicles, with dirty inns and unsavory dinners the usual end of a hard day. Dunlap, among others, varied the routine a bit by painting huge exhibition pictures like his "Christ Rejected" and then arranging for them to be sent on tour in a series of paid exhibitions. He described the vicissitudes attending himself, his agent and his pictures in terms which represented the experiences of many other artists.

> At one place a picture would be put up in a church, and a sermon preached in recommendation of it; in another the people would be told from the pulpit to avoid it as blasphemous; and in another the agent is seized for violating the law taxing puppet shows . . . brought back by constables, like a criminal. . . . Here . . . encouraged by the first people of the place, and treated by the clergy as if he were a saint; and there received as a mountebank, and insulted by a mob.[78]

Several years of this life were enough to discourage most. John Trumbull, exhibiting his famous "Declaration of Independence," announced he was "heartily tired of a showman's life," despite the money it brought.[79] The constant physical and emotional readjustments, the risks and uncertainties, the heavily concentrated and wearying work periods alternating with weeks of idleness, the sudden illnesses caused by bad weather or poor food, the bouts of loneliness and depression unrelieved by familiar faces—these were closer to actuality than Kitty Ellison's description. George Durrie, a New Haven portraitist, was not unusual in writing home from Richmond: "This is Christmas eve and a gloomy one too. . . . Have thought much of home today. Have not enjoyed myself remarkably well."[80] Even artists who could count on spending several months in one place, like Durrie, found travel unpleasant. It meant family separations, or possibly a postponement of marriage. It meant also long hours of boredom and tedium, best relieved by stimulants like whiskey; a number of artists followed John Wesley Jarvis on the road to alcoholism, though not always solely as a result of travel.[81]

The traveling artist was prevented, moreover, from becoming a substantial member of any one community. The life of a sojourner clouded his status in the minds of his fellow citizens. Although Americans tolerated mobility better than Europeans, this movement from town to town, the lack of settled habits, the occasional eccentricities or alcoholism, and the financial insecurity and resultant extravagances seemed to mark the artist as a marginal member of society. Horatio Greenough could insist from Florence that the mass of American artists were "quite equal in knowledge, and light, and character, to the mass of the most refined classes, and are totally above the rabble," but he would have had a difficult time convincing many Americans that this was true.[82] Morse reported delightedly in 1825 that the younger artists of New York possessed a "refinement of manners, which will redeem the character of art from the degradation to which a few dissipated interlopers have, temporarily, reduced it,"[83] and Dunlap shortly thereafter insisted that artists knew their place in society, and, "instead of being looked down upon by those whose merits will only be recorded in their bank books," were looked up to by "the best in the land."[84] But their optimism, also, was a bit premature.

American artists were caught, in the early years of the century, between two roles, bearing the worst part of each; they still carried the marks of the manual worker, occasionally acting as salesmen and entrepreneurs, yet lacked the aura of steady respectability which was the most valuable property of honest tradesmen. They aspired to the free life of the great creator and the status of gentlemen, yet the artist image had not yet been hammered out in a society which continued to see frivolity or idleness in their dreams of glory. Romantic phraseology and grandiose dreams—"we could find ourselves in Italy amid the ruins of Ancient greatness, reveling amid statues and paintings" —alternated with more prosaic problems: "With the talent I consider you to possess with four week instruction in connection with me you would be able to earn $15 per month."[85]

False hopes and exaggerated ambitions ruined a number of young artists. One of them was discovered sketching horses in rural New York and invited by city gentlemen to come to New York. Only sixteen, he hoped to go to Europe for more study, but the promised funds never materialized. Meanwhile, the

Port Folio reported, city pleasures began to take hold; untutored as he was in the world's ways, "no place could be more dangerous to a young man of genius, than a city like New York." At last, dissipated and exhausted, Otis Hovey returned to his home and a permanent obscurity.[86]

Other would-be artists avoided Hovey's fate by postponing their creative work until they had achieved some sort of competence in more practical occupations. Frederick Fink studied medicine, then joined his brother in commerce and finally made it to New York, and Europe.[87] The Charleston artists, Charles Fraser, John Blake White and John Stevens Cogdell, all had active legal and political careers before they devoted themselves entirely to art interests.[88] In later years Francis Edmonds, a New York genre painter, held important banking positions before he began to exhibit.[89] Many American artists did not start to study or create until they were in their twenties or thirties, telescoping decades of learning into the space of a few years, economically making use of every opportunity at hand to improve themselves. This phenomenon of delayed achievement, paradoxically enough, intensified the earlier emphasis on technique and literalism as artists attempted to make up for the lost years which should have been spent in training. The deep commitment to art, the satisfactions it yielded to those devotees at last able to pursue their dreams, inspired a self-discipline pacified only by a greater accuracy and precision. Demonstrations of mastery became all the more necessary because they were so difficult. Occupational defensiveness must be added to consumer orientation as a reason for the strident realism which pervaded American portraiture of the era. The desire to show things "just as they are," stemmed as much from the need to demonstrate competence, as from the egalitarian commitments of bourgeois patrons.

Linear precision was further enhanced by the fact that many painters began as engravers. In the 1820s this was one of the few graphic arts which paid well. Alvan Fisher, a Boston painter, voiced a typical complaint in 1828 that he had but little cash, "as usual with the painters," but added that engravers "are usually in better condition."[90] With a bewildering variety of banks issuing notes, protection against counterfeiting required the employment of competent engravers. Artists like Trumbull

and John Vanderlyn, who tried to exploit their famous paintings by selling reproductions throughout the country, provided further openings, while periodicals, advertisements and calling cards also nourished a thriving engraving trade.

Generalization about the relationship between an artist's style and his craft training is difficult, however. John Neagle, who started out coach-painting, quickly displayed grander commitments. He insisted that a portraitist should not be literal, "especially if the subject is mean. I would scorn to copy a wart to make my likeness more formidable."[91] A picture was an "argument" and carried conviction only if well stated. "Secondary objects" must be sacrificed "to the leading points."[92] Neagle professed an allegiance to the principles of Sir Joshua Reynolds and to theories of art which had the ring of the academy about them. Whether he always acted upon such theories, however, is questionable, for his most famous portrait, "Pat Lyons at His Forge," was supposedly an apotheosis of the honest, unaffected mechanic, prosperous but unashamed of his origins.[93]

Years of professional identification (Neagle was president of the Artists' Fund Society of Philadelphia) often produced in former craftsmen a revulsion from mechanical, artisanlike traits, and a desire to emphasize mind and argument. Hence the attraction of allegory and scripture, even to painters who had never read any Reynolds. This was particularly true of sculptors, who expended their greatest efforts on gigantic ideal figures. In general, though, the revulsion from realism and literalism came in the second third of the nineteenth century, when more artists were in Europe, and when artistic societies and the artist image had attained stability enough to create professional identification. Craft backgrounds encouraged a stress on mechanical proficiency, until the artist was secure enough to proclaim his membership in a higher, more spiritual professional communion.

The status of artists was obviously not helped by the men who treated painting merely as one means of making extra money. Some, like Matthew Jouett of Kentucky who turned to painting after a wartime accident had put him into debt, eventually became full-time professionals, but enough part-timers remained to cause concern.[94] Their presence argued that no special calling or commitment was necessary for art creation,

for a man could pick it up or drop it as he wished. Part-timers, moreover, undersold more prominent painters, since art was not their sole source of income and quality differences did not always impress potential customers. Even established artists fixed their prices with an eye on their competitors. Returning home from Europe, Samuel Morse announced he would charge forty dollars less than Gilbert Stuart for portraits, in an obvious attempt to undersell him.[95] Price competition helped Americans even more to view art like any other commodity, encouraging the expectation that they could bargain and engage in comparative shopping, allowing them to treat canvas size or the number of figures as variables in their effort to get the most for their money.[96] These attitudes caused later generations of artists, particularly Americans resident in Europe, intense anxiety.

Some artists and more critics saw nothing wrong in this atmosphere of competition; it seemed to portend a humanization of art, bringing it to a level where ordinary citizens could comprehend and buy, freeing it from the rarefied constraints of private libraries and exhibition rooms. The artist, ran this argument, must be treated like any other worker, rewarded when he did well, criticized and ignored when he failed to meet expectations. "In the great game of human life," wrote a critic in *The Knickerbocker Magazine,* "few win and many lose, nor is the race always to the swift, or the battle to the strong."[97] A friend wrote Robert W. Weir that a "market was a good thing," and if painters did not please the public taste, they "may starve and be damned. So don't let me hear you complaining in future about the gloominess of your prospects. Your success depends upon the direction in which you apply your talents."[98]

Artists were told to accept national limitations; they could have no privileges in a democracy. William Dunlap, despite the fickle treatment his works often received and the hardships he had encountered, still felt that his countrymen had treated him reasonably well. Democracy, he wrote Washington Irving, was a system that sought "not the bringing down of the few but the exaltation of the many," and he was proud to call himself a democrat.[99] The ignorant, the afflicted or the weak may want help from the rich, "but the artist . . . will look to be honored and esteemed by his fellow-citizens; not seeking protection from them, or acknowledging superiority, except in superior worth." When the farmer, the mechanic or the sailor asked for protec-

tors, Dunlap concluded, then and only then should the artist
desire them.[100] In the early years of the century most American
artists did not consider their native political culture hostile to
the arts or painful for themselves. The vanity of sitters who
insisted on commissioning only portraits pained them, but this
was considered a necessary stage in the development of any
society, and they set about their work with a confidence that
better times would come. Most of these artists, emerging from
craft backgrounds, poorly educated and often itinerant, de-
pendent entirely on the community's favor, developed their
fusion of literalism, materialism and business ethics without
a sense of alienation from their own society.

But even at this early date another, more fortunate group
exploited opportunities to work and study in Europe, and de-
veloped a more critical stance toward American life. Some came
from wealthy or prominent families; their parents, while not
always sympathetic to art careers, nonetheless enabled their
children to spend several years of study in Europe. John Trum-
bull, Samuel F. B. Morse, Washington Allston, Horatio
Greenough, Henry Benbridge, Charles B. King and Henry
Sargent had educational backgrounds far superior to their pro-
fessional colleagues or even their future patrons. With letters of
introduction and meager allowances or inheritances, these young
men were usually sent off to London, attaching themselves to
the studio of a well-known artist like Benjamin West, attending
classes at the Royal Academy, drawing from casts and life,
copying masterpieces in private collections, meeting and com-
peting with other young artists and generally devoting all of
their time to improvement. Unlike their fellow artists who re-
mained at home, they usually put off painting for a living until
they gained mastery over the craft. Washington Allston wrote
Samuel Morse's parents in 1814 urging them to keep the boy
in Europe a bit longer, though he could probably earn his keep
at that very moment. If Morse returned immediately, said
Allston, his studies would probably prove abortive. "It is true
that he could . . . paint very good portraits, but I should grieve
to hear at any future period that, on the foundation now laid,
he shall have been able to raise no higher superstructure than
the fame of a portrait-painter."[101]
Meeting great European artists of the day, reading aesthet-

ics and scrutinizing the classical models, these young students absorbed traditional art principles. Cosmopolitanism, however, did not lessen national consciousness; on the contrary, exposure to foreign living for several years made many only more fully aware of how much they valued their own backgrounds. Despite their pleasure in sharing such a rich artistic environment, most American art students—after the Revolution had provided them with a nationality—returned home to settle, at least until the middle of the century. The increasing number of sculptors who journeyed to Europe after 1830 included more permanent expatriates, but technical considerations like the availability of marble and stonecutters were the primary reasons. And the sculptors continued to work for American patrons, often on national subjects.

Many such returning artists—Morse the most prominent— bore an acute sense of professional responsibility in the creation of national art forms which would rival Europe's; they felt a missionary zeal to enhance the role of art in American life. Flattered by the attention of peers and statesmen, accustomed to the company of professional colleagues, these artists made new demands on society, insisting that their countrymen prove their oft-mentioned delight in welcoming them home. If the blandishments of European court life were spurned for American poverty and simplicity, some rewards were appropriate, and they included, at a minimum, an enhanced social status. Europe had taught them that at least. "None but those who have visited Italy," wrote John G. Chapman excitedly to Thomas Sully, "can form any idea of the privileges any artist enjoys here."[102] Morse displayed the same reaction; he "was astonished to find such a difference in the encouragement of art between this country and America." At home it was "thought to be an employment suited to a lower class of people," but in England the most fashionable circles attended art exhibitions.[103] Although some of these painters returned "more ignorant than when they went away," they formed a socially prominent and professionally conscious group which supplied leadership for the American artist fraternity.[104]

Another category of artists who left for Europe before 1830 contained much wider social and economic variations and a different range of personality types. Not as well educated or as

well born as more independent colleagues, they made the trip through the kindness of an interested patron, often a successful merchant or lawyer from their home town. John Vanderlyn, who received a gold medal from Napoleon for his "Marius Amid the Ruins of Carthage," owed his lengthy stay abroad to the generosity of Aaron Burr.[105] Philadelphia and New York merchants made Benjamin West's odyssey possible,[106] and Robert Gilmor, a Baltimore patron, assisted Thomas Cole's return to the Old World.[107] Other artists, like Chester Harding, went to Europe after having earned or collected enough money to keep them independent for a short while.

The trip to Europe often represented the ambition (and sometimes the sole achievement) of a lifetime, the goal which kept young artists working night and day. Francis Alexander solved his financial problems by a successful marriage which enabled him to stay in Europe for years.[108] But many others, unable to find one patron wealthy or enthusiastic enough to supply their wants, toured the nation gathering orders for copies of European masterpieces to pay for the ocean voyage and living expenses. Thus Frederick Fink spent three years abroad, painting Titians, Murillos and Raphaels for his American friends.[109] Even Thomas Sully tried this method, making an unsuccessful application to the Pennsylvania Academy for several thousand dollars in 1819, offering in return copies of European art treasures.[110]

Sometimes, artists backed by family support for their first trip, found it necessary to tap other sources for a return. When Samuel Morse made another visit to Europe in 1829, New York patrons subscribed more than twenty-seven hundred dollars. Some of them, like Philip Hone and Stephen van Rensselaer, simply ordered any picture Morse chose for them; but others, like Moses H. Grinnell and William Russell, wanted particular canvases—a Carlo Dolce hanging in the Villa Borghese, and Alessandro Turcho's "The Fine Arts," located in Rome's Colonna Palace.[111] Orders of this specificity argued, on the part of the buyers, a knowledge of the fine arts and a taste which discriminated easily, if not always wisely.

Most of these artists had less leisure for study and were under greater pressure than their colleagues supported by parents or private incomes; their stay was dependent on the whims

of patrons or the receipt of more orders. Such commissions took up most of their time and sometimes inhibited their plans for study. Entry into the highest circles of European artistic and social life was less assured for them, although a few, relying on native charm and energy, did manage to break through class and craft barriers. Thomas Cole, though born in England, found British artistic circles quite cold,[112] but Chester Harding, a poor, uneducated backwoodsman, scored a triumph in the British Isles. He met C. R. Leslie, Sir Thomas Lawrence and Robert Owen, painted Coke of Norfolk, the Duke of Sussex (who took wine with him) and was urged to make his home in England by the Dukes of Hamilton and Norfolk. An honored guest at innumerable country houses, Harding shrewdly recognized the reason for his success. To Englishmen, his homespun background excited interest in itself. But on returning home, he would be judged "as one having had all the advantages of the best schools of art in Europe," and be asked to meet impossible expectations.[113]

Harding, like Benjamin West, benefited from the excitement with which Europeans viewed the return of the arts from West to East. American artists possessed a special appeal for Europeans fascinated by the new breed developing across the Atlantic. And American portraitists, trained in a competitive, consumer-oriented market, knew well how to please their sitters. The Duke of Sussex, Harding reported, "is as much pleased with the flattery in the last picture, as he is with my improvement. There is not a human being on earth who is not susceptible of flattery; and he who flatters most, in this great city, will do the most judicious thing."[114]

In choosing whether to remain in Europe or return home, the artists faced a painful decision. Although appreciative of the aid they received, their commitment to egalitarian values was generally too powerful to allow them to tolerate the condescension they found everywhere. Some feared that the plethora of fashionable amusements in Europe discouraged true artistic improvement.[115] Married artists chafed intolerably. Harding had three daughters, and though his profession entitled him to "move in the highest circles," his wife and children "would not be recognized. This is one of the cruelest customs of the aristocracy of Great Britain."[116] Twenty years later an American

novelist noted the same trait; English hosts never invited the wives and daughters of artists to their great parties or country-house weekends. "The liberty to rise, or the liberty to fall . . . to be judged . . . without class condescension, class servility, or class prejudice," seemed possible only in America.[117]

Still, it was wonderful to live in a culture where dentists treated artists free of charge, and where art dominated conversation more than politics.[118] American artists enjoyed in Europe all the benefits a hierarchical society presented to an occupational group with an almost unlimited social mobility; at home they suffered all the drawbacks a classless society imposed on men whose financial insecurity discouraged meteoric rises in status. National advantages were also professional disadvantages, and the price of liberty was high for many artists.

Those who scored great social successes in Europe found the return home particularly difficult. The contrast between Old and New World experiences could be enormous and often produced a permanent inability to readjust and a nagging sense of grievance and maltreatment, all the more painful because it could not be fully articulated. If it had been, these grievances would have involved an attack on the most fundamental aspects of American society: its mobility, its relative equality, its lack of deference, its economic aggressiveness. Artists like John Vanderlyn muttered half-strangled and impotent cries against American materialism, while Rembrandt Peale refused to "Worship the *God* of this country—Money." [119]

Critics did not lessen artistic resentment. John Vanderlyn expended enormous effort to make himself financially independent, even trying lascivious subjects "to attract a great crowd if exhibited publickly."[120] When this failed, he resorted to gigantic panoramas of European cities. With maddening condescension, a New York newspaper congratulated him for placing his view of Paris on exhibition for New Yorkers in a park rotunda.

> Although it was not to have been expected that Mr. Vanderlyn would have left the higher department of historical painting . . . to devote his time to the more humble, though more profitable, pursuit of painting cities and landscapes—yet, in a new country taste for the arts must be graduated according to the scale of intellect and education, and where only the scientific

connoisseur would admire his "Marius" and
"Ariadne," thousands will flock to his panoramas to
visit Paris, Rome and Naples. This is to "catch the
manners living as they rise."[121]

Vanderlyn's sense of rage and injury increased when his com-
promise with artistic ethics failed to bring in appropriate finan-
cial rewards.

While artists who remained at home knew only a business
orientation, the travelers had come in contact with another,
more thoughtful art life, relaxed yet intensive, in which the
artist could spend most of his time on his own conceptions,
supported by the bounty of wealthy aristocrats or generous gov-
ernments. The successful European artist did not seem obliged
to hunt up patrons or spend valuable hours copying hackneyed
and repetitive masterpieces for townspeople back home. This
was, to be sure, in the pre-1830 era, before the European artist
of revolt gained his hold on the popular imagination. But even
after struggling, poverty-stricken, rebellious artists became more
common, considerable evidence suggests that Americans had
little contact with them, devoting their time instead to the of-
ficial world of the academy and government pensioners.[122]
Sanford R. Gifford noted that Troyon's income for 1855
amounted to some two hundred thousand francs. "In America
they don't pay painters $400.00 a year. It is only Tom Thumb, or
the vendor of some quack medicine, that is entitled to such
substantial marks of appreciation." [123]

The returning artists, then, were often resentful. It was not
merely the loss of social status or the difficulty of finding pur-
chasers that irritated them. Rather it was the specific nature of
the art commissioned. Instead of being asked to do the historical
scenes, the scripture lessons or even the landscapes that formed
the traditional staples of European art, they had to apply them-
selves to the most trivial sector of their repertoire: portraiture.
Artists who had been abroad, who had absorbed the ideals of the
Grand Style and, more painfully and expensively, its techniques
as well, felt cheated when they were reduced to the same activi-
ties as artisan-artists who had never left America. Some, like
Stuart and Harding, were quite satisfied with the successful
business their portraiture created. But most would have agreed
with Morse who could not be happy "unless I am pursuing the

intellectual branch of the art. Portraits have none of it; landscape has some of it, but history has it wholly." [124]

What Morse felt about history, Thomas Cole felt about landscape. After an unsuccessful attempt to dispose of fifteen shares at twenty dollars each in a raffle of his pictures, Cole wrote Robert Gilmor that perhaps his paintings were not worthy of public attention; but when "not one landscape painter in New York has received from a gentleman of New York a single commission for the last two years," he was inclined to blame not himself but local apathy.[125] Artists who dared destiny by painting non-commissioned art were forced either to take a severe financial loss or else arrange for national tours. When great religious or historical paintings were created specifically for exhibitions, the trips took on all the aspects of a carnival. Newspaper advertisements and testimonials blared the painter's fame, and admission fees (ladies, children and clergymen free) bought exotic spectacles and grand moral lessons. William Dunlap and Rembrandt Peale exploited this technique most dramatically, though when Peale suggested to Benjamin West that one of the master's great historical works be sent on a tour of American cities, West grew so angry that he told Peale never to mention the subject again.[126]

Another alternative for the artist who wished to avoid private portraiture lay in government commissions. These were eagerly sought at first, not only because they involved large sums of money, but also because they conferred a distinction which the artist could never receive from private clients; his professional abilities were recognized by the larger community. Horatio Greenough insisted that artists did not want particularly great sums of money from the legislature; " 'tis the consideration and weight" that was most important.[127] Rembrandt Peale, offering a picture to Congress, acknowledged that "their adoption of it would be highly honourable to my reputation as an Artist." This consideration, he claimed, enabled him to lower his asking price.[128] And Thomas Crawford, after strenuous efforts to obtain a national commission, wrote home after his success, "The sun shines at last. . . . I have beat them all and the monument is mine! . . . I can scarcely credit . . . I should at one bold leap have reached the saddle they have been struggling for so long."[129] Government approval seemed to push him permanently ahead

in the competition with Horatio Greenough and Hiram Powers.

The 1825 visit of Lafayette was a magnet for such ambitions; the nostalgic return attracted a long series of portrait commissions which had the nation's leading painters scrambling. Charleston ordered an ivory miniature by Charles Fraser; the sculptor, John Frazee took a cast of the Frenchman's features and J. H. I. Browere was allowed to make a life mask. One artist painted Lafayette's Battery landing, while another, Thomas Sully, was commissioned to do a large portrait. The New York State Legislature chose Charles Ingham, an Irish-born painter to immortalize Lafayette for them, and the New York City Common Council, wanting a picture for itself, received petitions from John Wesley Jarvis, John Vanderlyn, Henry Inman, Charles Ingham, Samuel Waldo and Rembrandt Peale among others. Morse's victory in this contest was the major triumph of his artistic career.[130] Patriotism and profits made a happy union for the lucky artists, though for every commission there were many disappointments.

But occasions like Lafayette's return, with its obvious and appealing sentimental interest, were rare, and official art presented knotty problems. Although artists begged for government commissions in the early years of the century, the nature of American history produced restrictions on subject matter. For one thing, the national past was circumscribed by time. As Greenough wrote, America had no intellectual infancy; the "eye of mature reason has been on every action. We remember our first hour. We have had no age of barbarism; no dark remote antiquity. We began with experience. We laid our foundation in results." [131] The American history painter could deal only with a recent past; not for him were the mists and shadows of dimly remembered events, or the romance of ancient epics.

Within American history little seemed appropriate besides battle scenes, soon exhausted by the post-Revolutionary generation. Public events, Lieutenant Francis Hall observed during an American visit, no longer involved picturesque encounters but took place in quiet rooms and ministerial closets. Instead of reproducing events like the death of Brutus or Horatius at the bridge, modern painters had to concentrate on scenes of meditation and calculation—ministers partitioning kingdoms, revolutionaries plotting independence, statesmen governing under laws.

In battle scenes, Hall pointed out, the greatest interest attached itself to the leaders, whom the painter forced into repetitious groupings and clichéd patterns. America's very advantages turned against the arts, for the ideal world had not been included in the national domain. "It has, perhaps in mercy, been assigned to those nations which have learned to feel, by being compelled to suffer." [132]

The most painful episode in American history-painting concerned Washington Allston's refusal of a congressional commission. Battle pieces formed the only scenes American history suggested to him, and they were incapable of proper representation. When the "excessive movement, the dash of arms, the deadly roll of the drum, the blast of the trumpet," were taken away, "what is there left for the painter to do? It seems to me *caput mortum*." [133]

Although Allston's objection to war paintings was technical, it soon was transformed into a moral issue: the artist should not gild the horrors of battle with bright colors and excitement. Travelers to Europe abhorred paintings glorifying war, and when Charles Sumner eulogized Allston in a Phi Beta Kappa address, he praised the artist's morality. A true creator, said Sumner, "feels that no scene of human strife can find a place in the highest art." [134] He appealed to the profession to cease apotheosizing violence and so restore to art its essential purity.

If the artist followed Sumner's advice, excluded major American events like the Revolution and the War of 1812 and turned to dramatic scenes of exploration and discovery, he was forced to portray foreigners—Spaniards, Frenchmen and Englishmen—arrayed in alien armor, bearing flags and crucifixes. He would not be painting American history at all: such was the charge made against several of the rotunda panels commissioned for the Capitol. This was the dilemma of a land with "neither a legendary past nor a poetic present." [135] Civil events of importance like the signing of the Declaration of Independence were painted early and often; but because of their passive, contemplative nature, as Hall pointed out, they were not amenable to exciting artistic treatment. Trumbull's huge canvas was dubbed a "shin-piece" by Congressman John Randolph.

The peculiar character of the national past only increased the dilemma of trained artists then, even when the government

did grant occasional commissions. And the same artists were aware that "employment in our General Government is the only hope" for some of them.[136] Artists dissatisfied with portraiture and uninspired by history might have turned to landscape or the delineation of everyday events. But here also there were problems; the latter art required acute observation of ordinary life, a perception of scenes which would move and excite when placed on canvas. Some Americans argued, however, that genre— and landscape—were not artistic subjects because ordinary American life sustained no peculiar, exciting or moving scenes. Suppose our artists do turn to the native landscape and character, Walter Channing asked in 1816. Of the magnificent luxuriance of American scenery they could reproduce only an indistinct mental vision, or else sacrifice everything to a literal, artisanlike fidelity. And "have our peasantry individuality enough to ensure the artist, who may study and delineate their habits, a lasting fame? Is there enough that is peculiar in their costume, their manners, their customs and features?"[137] Americans would find such paintings neither novel nor instructive. The countryside needed associations to be truly beautiful; lacking them, even the finest native scenery was "inferior in interest to an Italian landscape," with its objects of emotional and intellectual pleasure.[138]

Though romantic naturalism helped legitimize the landscape, on the eve of the Civil War many critics still insisted that an American genre painter was an impossibility. No one had lived long enough in any one spot to develop the appropriate local habits; there was no American low life and no American high life.[139] Only older, more settled societies like Europe's, where the painter had the opportunity to combine nostalgia, humor, elegance and pathos, where class lines, picturesque costumes and storied cities supplied him with material, were suitable for genre. The freedom, the lack of constraint, the absence of definition in American life not only made it more difficult for the painter to assume a recognized niche, but robbed him of subject matter and the chance to break out of the confines of portraiture. Finally, the intellectual heritage from Reynolds made genre seem trivial and beneath contempt. J. G. Clonney's "Fourth of July" canvas brought forth the critical comment that while it was well executed, there was "something too much of the vulgar . . . in the subject," and the hope

that Clonney would soon be "employed upon details more in-
teresting to a pure and refined mind."[140] Even Rembrandt did
not escape criticism for his market women and grotesque boors.
"How much is it to be regretted, that he had not a refined taste,
as well as a natural genius."[141]

Primitive, amateur painters did unconsciously reproduce
features of their society in works which give pleasure today
because of their unconscious spontaneity and lack of sophistica-
tion. It was consciousness, however, that separated the art from
the craft, consciousness and intent. Professional artists were not
interested in the spontaneous or the unjustified. They had
spent years developing techniques to differentiate themselves
from mere visual craftsmen, and they did not even consider
surrendering their hard-won technical mastery and their intel-
lectual objectives to straightforward recording of the ordinary.[142]
Higher, more transcendental goals alone could justify their sacri-
fices and trials. Art was "divine," and divinity precluded com-
promises with vulgar needs. The painter's eye must still be
turned inward and not outward; his hand would seek to embody
not the outer forms of reality but the soul life which lay beneath.
Again and again, artists and critics alike sounded the call for
intellectuality. The "labours of genius are efforts of mind,"
and "he who seeks for representation in . . . mechanical skills,"
must be disappointed.[143] Painters were worthless who could
not "impress us with the moral sublimity of virtue," and the
"majesty of religion."[144] Americans desired "objects on which
to expend the mental energy we can create"; they wanted
men who would "devote themselves to the cultivation of the
mind."[145]

Behind these cries lay a genuine need for alternatives to
the materialism which, foreigners and alienated natives insisted,
formed so pervasive a part of the American consciousness. Per-
haps for a brief moment, with portraitists like Stuart and Peale,
there was no disharmony; their sitters were ideas embodied:
Adams, Washington, Jefferson and Franklin, men whose lives
included their apotheoses, and whose countenances took on the
glories of legends while they were still recordable. Their portraits
were not paintings but icons; Americans, wrote a Russian visitor,
keep a likeness of Washington in their homes, "just as we have
images of God's saints." Here was the man to whom all owed

their "independence, happiness and wealth!"[146] But when these noble subjects passed away, artists resumed a state of passive warfare with their clients, chafing at the necessity but needing the money.

What else could artists create? The conditions of egalitarian democracy and primitive simplicity did not favor the professionals or endow their art with specific themes. Cut off psychologically and sometimes, by virtue of their itineracy, physically, hampered by intellectual traditions extolling the values of high art, demanding constant proofs of the dignity of their calling and justifications for their personal sacrifices, American artists came to see their function as didactic rather than expressive, and sought to instruct rather than to please. With such self-consciousness, the grace of non-deliberation, the unconscious legitimacy which so enhanced the arts in Europe, remained a fugitive at home. Painting and sculpture could not serve their own purposes, but existed to fulfill other ones. Artists must never forget they have a duty to perform, advised William Tudor in 1816, and "should feel something of a *missionary* spirit," endeavoring "to excite the taste of the publick."[147] Their painful experiences and the compulsion to justify their value forced artists to seek ever grander visions to gain self-respect and public honor.

The post-1830 generation of artists evolved at least an interim solution. Lacking confidence in the dignity of painting human beings, lacking opportunities to paint history and scripture, bent on synthesizing the material and the ideal, they would turn from humanity to nature and, more particularly, to the American landscape. But before this became possible artists required a changed attitude toward the land, and a sense of physical place.[148] They and their customers had to be convinced that the natural face of the country deserved representation. The patrons of American art and the institutions they organized to foster it now presented artists with special challenges and limitations. The infant associations in the cities of the seaboard and the young but growing artist communities became the new determinants of this fragile discipline.

Professional Communities: Growing Pains

CHAPTER FOUR

With all its anxieties the quest for subjects caused American artists less pain than the quest for customers. Disinterested natives and critical foreigners agreed that growing American wealth could nourish the arts, but they considered artistic neglect pervasive. Patriots owned "with extreme reluctance" that arts and letters received little aid and blamed poverty of taste rather than poverty of purse.[1] Aware of the institutional solutions tried in Europe, artists and patrons were caught between the desire to imitate and the need to innovate by using the power of democracy to eliminate the influence of the wealthy few. The usual result was unconscious imitation disguised by bold rhetoric, an uneasy compromise between the artist's physical needs and the community's spiritual demands. Since neither imitation nor innovation wholly dominated their attempts before 1840, and since public interest remained low, early art institutions and their friends passed through difficult years.

Logic suggested that private aid support American artists. Let those with superfluous wealth distribute it to needy genius. But this seemed too much like the aristocratic system of Europe which the American experiment had ended forever. The very word "patronage" was spat out contemptuously by William Dunlap; it was undemocratic, it implied the client's superior knowledge.[2] The reason European patrons controlled their artists so rigidly, charged Samuel F. B. Morse, was to make them feel an "absolute dependence on wealth." The *native nobility of genius,*" he went on, must find this "repulsive," for it reduced artists to beggars and barterers of goods.[3] "A curse upon patronage," cried another; it was fit for upholsterers or barbers. Poets and painters wanted no "blind" or "egotistical" support but rather "expansive, keensighted" sympathy, respecting only true genius and granting it full freedom.[4] American critics retold with relish ancient tales of ingratitude: Andrea del Sarto, paid for his painting with a sack of corn; Correggio, forced to carry

home his fee in copper; popes and princes destroying artistic in-
dependence by trivial and selfish demands.[5] Rather than rely
on aristocrats, wrote the Reverend Orville Dewey, let the arts
find support "in the general spirit of a country," let a natural
refinement replace a nobility "who, if they have often fostered
genius, have sometimes cramped and enslaved it."[6] American
civic spirit would nourish great art.

Appropriately enough, artists organized the first institution
devoted to art. Charles Willson Peale, in 1795, grouped around
him a number of Philadelphia engravers, architects and wood
carvers, among them members of his own prolific family, to
establish the Columbianum. But that simple cooperative associ-
ation for instruction and professional communication proved
too modest for several British colleagues. Having imbibed their
ideas of association from the Royal Academy, they hoped to
set up a National College under the patronage of George Wash-
ington.[7] Political disputes further wracked the infant society,
and seven members seceded to Peale's angry charge that "America
is not the soil to foster seeds of such vanity and arrogance. . . .
We will leave conceptions so profound as a National College . . .
to those who started up from the hotbeds of monarchy."[8] Within
a year the Columbianum was defunct.

Peale and his fellow artists confronted a knotty problem.
Simple association would not meet their needs, but they feared
the implications of elaborate societies with their royal founda-
tions and noble connections; by 1800 these had become the
dominant artistic institutions in Europe.[9] The academies had
replaced ancient feudal guilds tainted by ties with handicrafts
and manual labor.[10] Although the first real art academy, or-
ganized by Vasari in the sixteenth century, operated as a social
mediator by associating artists with scholars and statesmen, the
institution soon became primarily educational. Colbert's Royal
Academy, with its hierarchy of academicians and elaborate
pedagogical rules, became the model for all of Europe. Such
organizations sponsored lectures by physicians on anatomy; they
invited mathematicians to speak on perspective and philosophers
to discuss aesthetics; and the curriculum included carefully
supervised classes in drawing and the study of the live model.
By the end of the eighteenth century, some academies were even
teaching industrial design.

Americans recognized the change in function. The rhetoric of those interested in native academies—positively or negatively —was primarily pedagogic. C. Edwards Lester and Gilbert Stuart opposed their establishment because they would preserve mannerism and artificiality; supporters claimed that "introducing correct and elegant copies from works of the first masters" and exhibiting them conveniently would stimulate American artists.[11] The *Monthly Anthology* called for such a repository in Boston to enable local artists to improve their work and connoisseurs to refine their taste.[12] Indeed, the American Academy of Fine Arts in New York owed its very existence to a set of art works. When Robert Livingston, ambassador to Paris, sought to send home some casts from the Louvre, his brother Edward helped form an academy to house them, convinced that "a constant view of the finest Models" would awaken American genius for the fine arts.[13]

But despite these hopes, little was actually done about providing schools. Although some young artists drew from the old-master collections in the Pennsylvania Academy—works which Philadelphians like Joseph Allen Smith and Benjamin Smith Barton presented to the organization—this permission was by no means automatic. John G. Chapman, later a prominent historical painter, was denied the privilege of copying in the building in 1828, for no apparent reason. That same year, twenty-seven Philadelphia artists, led by James B. Longacre, an engraver, and the portraitist John Neagle, in a petition complained that they were treated as menials. The Academy keeper was disrespectful, they maintained, and students were discriminated against. The Academy president, Judge Hopkinson, replied that few artists attended classes; plans for education must come from the artists themselves, he insisted.[14] In New York William Dunlap argued that the American Academy should have changed its title to "an association for the promotion of the fine arts," since its connection with education was wholly imaginary.[15]

The angry disputes which broke out in just about every academy surprised both the lay founders and professional members. Despite their high hopes and bold language, few of them— save perhaps for the much maligned conservative, John Trumbull—had great insight into the potentialities of American acade-

mies. One reason was their familiarity with the Royal Academy in London, which was quite different from its Continental counterparts. They were unlimited in membership, generously supported by government funds, and clearly emphasized the education and discipline of young artists. The Royal Academy, on the other hand, was primarily a social institution, closer to the early sixteenth-century academies than to their progeny. Through the early nineteenth century it remained the center of a small, exclusive circle of distinguished artists, entirely private except for the dignity of royal patronage. Self-governing and independent, it offered a theater for great artists to bask in the reflected glory of peers and princes.[16] But it was not primarily a school.

The glamour of this organization, with its international roster of honorary members and its splendid social festivities, blinded American admirers to the fact that its prestige rested on demonstrated achievements and associations; it was the product of artistic success rather than its cause. England's many private collections, its wealthy art lovers and its proximity to the Continent made absorption with the mechanics of education unnecessary. The Royal Academy was a legitimate, organic demand by artists for recognition and professional dignity, and was not intended to provide the rudiments of training or influence industrial art.[17]

American artists, with ambitions higher than Peale's, assumed that they could match the Royal Academy's triumphs merely by imitating its plan of self-government. They did not at first realize that their own institutions required much more enthusiastic, generous and constant lay support. They also needed a good deal of planning. Before the late 1820s these artists lacked the unity and self-consciousness to articulate demands for professional recognition, or construct educational rules. They were sensitive enough, however, to chafe instinctively at lay control. If either their hopes had been more modest or their early organizations better structured, these institutions might have prospered: by associating obscure artists with prominent amateurs they later yielded great social benefits. The problems were the belief of patrons that these informal, lay-dominated academies met all basic needs, and the hostility of artists to any form of lay control. Patrons felt their supervision

was justified by the intensity of artistic jealousies and quarrels.[18]
In the end, at least in New York—and to a lesser extent in
Philadelphia, where artists were strong enough to form their
own organization by 1810—the early academies were caught in a
cross fire and served no real purpose at all, except to institu-
tionalize the devotion which some lawyers, physicians and
merchants felt for the fine arts. Artists clamored for education
and self-government; patrons insisted on their own "wiser"
leadership, and no one was satisfied.

Academies failed to provide a base for the development of
American art, but they did provide a point for artistic concen-
tration and their exhibition programs yielded new customers.
The exhibition became the American Academy's most important
function, unlike Continental societies. The need for clients was
one cause, and it reinforced the other: the poverty of American
educational opportunities. Talented professionals crossed the
Atlantic quickly and obviated the need for immediate domestic
instruction.

With the best intentions in the world, American artists
seemed headed for just the sort of dependence on private benev-
olence that they had condemned in Europe. The development of
the art world thus differed strikingly from that of most American
institutions. They conformed not to abstract expectations but
to community needs. Religious toleration emerged not from
theoretical commitments but communal necessities; class lines
blurred not because of antipathy to the concept but from labor
scarcities and economic opportunities. Art ideals, however, post-
dated the American Revolution and bore its peculiar stamp: the
means to achieve greatness were intended to be unique. The
real lesson of the early academies was that such uniqueness was
impossible. They required the active support of the wealthy and
cultivated, and the same antagonisms which divided European
artists and patrons, reappeared in the New World.

From the start the academies revealed their dependence on
wealth. Their first and most urgent need was for capital to
transport casts and old masters. A building had to provide a
setting for the art objects, while lecturers, custodians, heat and
light created the other expenses. It was natural, therefore, that
most early patrons were at least well-to-do. Horace Binney,
one of the founders of the Pennsylvania Academy of the Fine

Arts, recalled that the Philadelphia Bar provided more than half of the seventy original members.[19] They included judges and congressmen, like William Tilghman, Joseph Hopkinson and Binney himself, besides other prominent residents like Richard Rush and Alexander J. Dallas. In New York the founders attracted the state chancellor, the mayor of New York City, Aaron Burr and Rufus King.[20]

Expenses loomed so large that the most appropriate organization was a commercial device: the joint-stock company, subscribers owning a share of all the property and receiving a few personal privileges like free admission to all exhibitions. Such was the organization of the American Academy of Fine Arts, the Athenaeum in Boston, the Pennsylvania Academy, and similar institutions in Baltimore and Charleston. Subscription fees varied; a short-lived museum at Richmond issued its shares in 1816 for two hundred dollars apiece, but the American Academy was more typical, authorizing the sale of one thousand shares at twenty-five dollars each.[21] Philadelphia tried the experiment of higher rates, but the Academy secretaries spent much of their time and energy begging members to pay their arrears.[22]

The proprietary attitude the joint-stock company device fostered alienated many artists, and made them feel locked out of associations supposedly formed for their professional benefit. When the Society of Artists in Philadelphia sought to join the Pennsylvania Academy they were forced to put up two thousand dollars for shares. At the same time they were allowed to elect several of their number to the board of directors. And the final break between New York's rebellious artists and the American Academy occurred in 1825 when its president, John Trumbull, took one hundred dollars from the artists and then refused to allow more than two of them to sit on the board.[23]

The academies were in constant financial trouble anyway. The money gathered so painfully disappeared quickly. In New York it went to pay for the casts, and after 1816, for the paintings bought from Trumbull. In Philadelphia much of the cash was spent on the building, which Charles Willson Peale condemned as elaborate and expensive.[24] Artists based part of their right to conduct their own academies on the financial mismanagement of lawyers and businessmen. When exhibitions ceased yielding good profits, running expenses became unbearable.

Despite New York City's benevolence, the American Academy had rolled up debts of several thousand dollars by the late 1820s and went bankrupt some years later, degenerating into a rarely visited depository of old paintings and dust-covered statuary.

So oddly were the institutions constructed, that they even lacked academicians at the start. The category was introduced to Philadelphia in 1810, some years after the Academy had been founded. Significantly enough, at the ceremony of presentation the artists' orders of fellowship turned out to be but blank paper. The New York association, completely reorganized under De Witt Clinton in 1816, adopted an elaborate academician system, but artists were angered by the limitation to twenty places and by the fact that only shareholders could vote. The very language of the new rules was infuriating. While gentlemen amateurs were "invited" to hang pictures for exhibition, only the "most distinguished" artists would be "permitted" to do the same.[25] Whatever its cause this was a shortsighted policy; the Pennsylvania Academy and the National Academy of Design (organized by rebellious New York artists in 1826) demonstrated that financial security depended upon the size and novelty of the annual art displays. If large crowds appeared, even at twenty-five cents a head, enough money could be gathered to keep things going and even lay a bit aside for a building fund. Well-attended academy schools would have helped maintain a fresh supply of new paintings, but the yearly output did not allow much room for choice. The American Academy could have survived only by generating enthusiasm, rather than exercising discrimination.

The success of the Pennsylvania Academy may seem paradoxical, for it was governed by a group of lay patrons; the American Academy, on the other hand, though headed by an artist, collapsed. Part of the problem lay in Colonel Trumbull's personality; sensitive, proud, sarcastic, his experiences with many of the quarreling, semi-literate and barely competent draftsmen who filled the ranks of New York artists about 1820, made him identify with the amateurs. The epithet "ungrateful" leapt to his mind when artists complained; their privileges were unavailable forty years earlier, when he himself was forced to go to England to acquire a professional education. This was the spirit of his oft-quoted set of remarks, which, according to

William Dunlap, were insulting and spelled the doom of the institution. "When I commenced my study of painting," Trumbull said, "there were no casts to be found in the country. . . . These young men should remember that *the gentlemen* have gone to a great expense in importing casts, and that they [the students] have no property in them. . . . They must remember that beggars are not to be choosers."[26]

Trumbull was stating a view of the artist's position realistic in the earliest years of the century when he was trying to educate a connoisseur elite to support the divided and impoverished artist community.[27] But by the late 1820s New York's artists had increased in number and competence sufficiently to exert a force of their own. This Trumbull refused to recognize.

The Pennsylvania Academy's success, on the other hand, rested on the strength of the Philadelphia artist community which was able to arrive at a working arrangement with the laymen.[28] In later years, when it might have been better for Philadelphia artists to create their own permanent institutions, they instinctively agreed with the aesthetic commitments of their lay patrons; the Society of Artists in Philadelphia, which grew to one hundred members within six months, actually condemned the Academy's exhibition of nude antique casts as "indecorous and altogether inconsistent with the purity of republican morals." Exhibits were to be places of "fashionable resort," and liberalism must be sacrificed if it irritated the mores of the community.[29] Such reasoning reflected a state of mind that made life classes rare for decades to come. The intellectual and moral autonomy of American artists did not disappear under civic attack; it never existed. Artists were eager to rely upon majoritarian sentiments in everything except technical expertise.

The split between the lay stockholders who owned the academies and the artists who seemed to work for them contrasted sharply with the owner-artists of the Royal Academy. But it resembled a break in another American institution organized before professional strength could support it: the university. The divorce of owning corporation and faculty fellows resulted from a similar professional instability and impermanency.[30] For legal and financial reasons, scholars could not break the pattern or found their own degree-granting institutions. But in the free-wheeling legal atmosphere of Jacksonian

America, artists could and did incorporate any number of professional societies.

The first generation of native artists, grateful for whatever attention the mercantile and professional aristocracies bestowed, gave way in the 1820s to a more demanding and self-conscious group. Often trained in Europe and better educated than their predecessors, they longed for organizations which would uphold their status and allow them to control their own professional destinies. One aspect of this quest for dignity lay in the use of initials. In 1823 Washington Allston berated an engraver who omitted the A. R. A. after his name, the symbol of his election to the Royal Academy.[31] Soon other artists began to use P. A. or N. A. after their names also, in reference to the nation's two major artistic organizations.

Another indication of this search for status lay in financial management: artists now wished to administer their own funds and operated a number of institutions with great success. The Artists' Fund Society, incorporated in Philadelphia in 1835, reflected the growing sense of professional community in its constitution. Philadelphia artists, "anxious to promote the welfare and happiness of themselves and their professional brethren," combined to create a fund for mutual advancement and relief, money which would aid indigent and disabled artists, or relieve the families they left behind.[32] An American artist, wrote Joshua Shaw, must "think better of the profession as a body than of his own individual self." Such selflessness, he assured Asher B. Durand, would eventually reward even the most ambitious.[33]

Insistence that only professional artists should decide questions of taste and arrange all exhibitions themselves marked another advance in professional self-confidence. This was the way the National Academy operated. The best-educated connoisseur, agreed a New York newspaper, could not know as much as even the most indifferent painter. As for committees of "lawyers, or grocers, physicians or merchants, or any other trades or professions who may fill the seats of Congress," their competence to judge art works was highly questionable.[34]

Growing strength, in fact, brought artists into conflict with native connoisseurs who fancied their own opinions and were not eager to have young painters check their preferences.

The same disputes which had caused European artists agonies—
and which Morse and Dunlap had hoped might be spared the
Americans—reappeared in the New World. The earliest group
of patrons, the men active in the formation of academies and
athenaeums, desired artistic activity not as a demonstration of
national greatness, but as a means of counteracting materialism.
The absence of standards threatened a national plunge into
barbarism and ignorance. Theodore Dehon feared that "through
the innovating spirit of the times," the Republic of Letters
might turn into a Democracy, while others spoke darkly of
degeneracy and corruption.[35] Not all of them were pessimists;
temperament as well as tradition determined their attitudes.
They shared a desire, however, to strengthen humanistic values
in America, and sought at least a minimum of respect for tradi-
tionally honored fields of learning and creative achievement.
Their efforts to reflect honor on "the vocation of intellect" bene-
fited writers principally, but painting was also among the agen-
cies of refinement.[36]

Such patrons were not easily argued out of their opinions;
they denied that artists were more competent judges than con-
noisseurs. Franklin Dexter, attacking the views of Samuel F. B.
Morse in 1827, contended that artist-run academies would
lead to mannerism, while lay critics could be more objective.
"The real want in America," he concluded, "is not so much of
good patrons, as of good painters. . . . We know of no good
paintings left unsold."[37] Professors of art, said C. Edwards
Lester, do more harm than good. "I can conceive of nothing so
directly calculated to degrade genius to the level of mediocrity,"
he wrote in the 1840s, "as the system of academies that has been
the rage in Europe for two centuries." [38] Sometimes these com-
ments were coupled with attacks on American art practices and
hints that it was better to purchase fine foreign art than to en-
courage mediocre natives.

Artists reacted angrily to such attacks on their rights and
joined the cause of artistic nationalism to that of self-govern-
ment. A defender of Morse's artist-run National Academy casti-
gated those delighting in foreign art and advocated an American
System to "drive out of the market these foreign importations."[39]
Every profession, Morse had said, "knows what measures are
necessary for its own improvement."[40]

The pretensions of artists were also subject to attack by believers in popular taste who insisted that "the basis of taste and criticism is *common sense.*" Sound judgment would emerge only from the "free exercise" of the popular understanding. If given the opportunity of seeing more works of art, most citizens could be trusted and would never be "corrupted by affected connoisseurs."[41] Such criticism actually helped bring artists and patrons together, since populistic assumptions of expertise threatened both groups.

James Fenimore Cooper, who embraced both artistic nationalism and a belief in the value of professional opinion, indicated how conservatives could rally against such populism. A loyal supporter of Horatio Greenough, Cooper warned the sculptor that America was a country where "every man swaggers and talks, knowledge or no knowledge; brains or no brains; taste or no taste." Americans considered themselves all "*ex nato* connoisseurs," and would judge sculpture the way they evaluated "pork, and rum, and cotton." "Sell them your wares," he advised, "and shut your ears."[42] Academies were needed not merely to improve art, but to raise popular standards and create a mass clientele capable of accepting the good and the true.

The shameless audacity of American critics irritated artists and their conservative friends. Art questions in Europe, wrote C. Edwards Lester, were left to "the ripe judgment of men who have devoted themselves to congenial studies." In England only journals devoted to the fine arts reviewed statuary. But any American newspaper deemed itself competent to evaluate "The Greek Slave" or Michelangelo's "Last Judgment." A single paragraph sufficed after a five-minute glance.[43] "I am tired of patting the dogs," wrote the poet, James Gates Percival. "I will now turn to kicking them."[44]

Fear of the mob extended even to government patronage. Foreigners complained that American governments were niggardly in rewarding painters and urged legislatures to commission heroic portraits or celebrations of great events.[45] American newspapers picked up the theme, and several of the older artists were enthusiastic. Colonel Trumbull suggested to President John Quincy Adams that any event important to the cause of freedom should be celebrated immediately by commissioning "the most eminent painter of the time" to immortalize it on canvas.

Placed in a national building, the masterwork could then be copied by an artist of "secondary talent" and presented to the hero directly involved. With engravers making plates and impressions reserved for the diplomatic corps, the triumph of art and patriotism would be complete.[46]

However, those who judged the character and quality of government work were politicians, considered ignorant and crude by most artists. Every commission, from Trumbull's giant rotunda scenes to Horatio Greenough's nude, Washington, and Clark Mills's equestrian statue of Andrew Jackson, endured colorful criticism in the press and in the legislative halls. Even while the artist labored, journalists issued progress reports to an expectant nation. Washington Allston listed as one of the many reasons he wished to avoid a government contract, a desire to escape public criticism. If people reproached him for dallying on a private affair like "Belshazzar's Feast," he wrote Congressman Leonard Jarvis, what would they say if he were employed with public funds. " 'Will he never finish that picture for the Government?' might be asked from Castine to St. Louis. No money would buy off the fiends that such words would conjure up."[47] Bitter artists turned away from the public, erecting some personal and internal standard of judgment to replace popular approval. Horatio Greenough, preparing for the criticism about to erupt around his "Washington," wrote Allston that he rested his hopes "upon ground which has little relation with the success of my work with the world. Was it not always so?"[48] The public criticism Greenough feared soon exploded, and he was forced to argue that his statue merited its thirty-thousand-dollar cost as a monument to the first struggles of national art.

Since the academies did not solve their problems, since government commissions were too few and too upsetting, American artists could turn only to the private patronage of the wealthy, a repetition of the ancient pattern they had attempted to foreswear. Such patronage was legitimized in a manner resembling the attack on the luxury concept. After repeatedly denying its need, art publicists discovered patronage as a form of social control: it would prevent the excesses of great wealth from becoming dangerous and ventilate the cells of corruption. Better by far, said Joseph Hopkinson of the Pennsylvania Academy, that the wealthy patronize art academies than spend

money on gargantuan feasts. Noble usages of wealth gained credit with posterity, for patronizing art was not merely healthy but the key to immortality.[49] Young men of leisure must have excitement. It was better "that their leisure and wealth should be employed in fostering the arts which embellish life, than squandered in gross sensuality."[50] New York Congressman Gulian Verplanck emphasized the benefits to society, for the time and money spent on artists was rescued from "the calumnies and slanders of malicious indolence, from ostentatious luxury."[51] Art would grant the rich relief from their ceaseless quest for wealth and soften inevitable coarsening processes.

Artists eagerly embraced the new doctrine. "It is a good thing for rich men to have any kind of intellectual occupation," wrote Allston.[52] They could find redemption in the atmosphere of the artist life, and the rest of the country would be more secure knowing that its men of power were being constantly exposed to the refining and elevating influences of the arts. If wealth was "the power to constrain—the power to elevate—the power to depress," artists could ensure that its uses were benevolent and its effects favorable.[53]

The problem of justifying great private patronage was more easily solved than the task of creating it. In the early years of the century, individual fortunes, no matter how respectable by American standards, appeared woefully inadequate for the task. The *Port Folio* advised the wealthy to purchase one picture of great merit, perhaps a copy of a European masterpiece, instead of dissipating their money on a variety of baubles.[54] European visitors blamed the abolition of primogeniture and entail for the weakness of private fortunes. No one would spend years gathering treasures which he knew would be scattered on the day of his death. Who would build stately homes, asked Godfrey Vigne, doomed to become ruins within a generation? "The powerless genius of embellishment wanders disconsolate along the beautiful banks of the Susquehanna," he mourned, a victim to republican prejudices.[55] And Americans like William Tudor agreed. "The fame of a family is entailed with its estate," an effective discouragement to massive patronage.[56]

In parts of America the lack of primogeniture had little to do with the failure to sustain art. Collecting the works of others

was a rather sophisticated innovation in human history, and some Americans saw no sense in it. Mrs. Trollope, analyzing the collapse of a fine-arts academy in Cincinnati, reported an anecdote about an American who showed some Cincinnati gentlemen his engraving collection. There was considerable admiration until one of them cried, "Have you really done all these since you came here? How hard you must have worked!"[57] The logic of collecting was not inescapable.

Still, a good many Americans purchased art in the early years of the century, though many of them were entirely indifferent to the fate of native painters and sculptors and expended their funds and attentions on European art. Many were performing a ritual activity or engaging in speculative exercises entirely unconnected with more general art interests. Wealthy Virginians and Carolinians making the Grand Tour picked up art works on the Continent as furnishings, much as they purchased carpeting and silver.[58] Not interested in building up galleries or improving contemporary design, they sought merely to enhance their personal surroundings and imitate the appearance of great European homes.

Others purchased art because they discovered themselves in situations which offered special opportunities. Richard Worsam Meade, a United States naval agent in Spain, formed a fine collection of pictures and statuary much as he shipped merino sheep home; they were uniquely available to him, and relatively inexpensive.[59] Other Americans, traveling in Europe during the Napoleonic Wars, were importuned by frightened art owners and purchased paintings as a speculative enterprise, intending to sell at much higher prices when the market returned to a normal level. John Trumbull was one of many who took advantage of the situation to load up with bargains.[60] Some of these purchasers were gulled by the little factories in Rome and Florence which regularly turned out darkened daubs claiming the paternity of famous Renaissance masters. American artists angrily denounced the purchasers as gullible, greedy and crude and accused them of injuring national aesthetic standards by their importation of trash. "It is a notorious truth," the *Port Folio* reported in 1814, that the manufacture of old pictures, baked (until they cracked), smoked, and placed in old frames was tak-

ing place in London. American connoisseurs "who consider nothing excellent unless it be old and come from abroad," were abetting such forgeries.[61]

By 1830 America contained some fine old paintings, even by the best European standards. James Bowdoin, who had improved his taste while a student at Christ Church and during an embassy in Spain, left a sizable group of old masters to the college he founded in Maine, and Thomas Jefferson had several dozen canvases, most of which were modern copies.[62] Gulian Verplanck, describing the American Academy's exhibition in 1819, said it was much better than had been expected; a little inquiry in a city the size of New York, he concluded, always turned up some fine works. "It is, to be sure, our 'day of small things,' but nevertheless not to be despised."[63] Verplanck himself built up a fair collection, as did Bostonians Isaac P. Davis, Harrison Gray Otis and Charles Russell Codman.[64] For the third annual Boston Athenaeum Exhibition in 1829 some fifty collectors, including half a dozen New Yorkers and residents of Philadelphia, Baltimore and Washington, allowed more than two hundred and fifty of their pictures to be shown.[65] These art lovers could console themselves, moreover, that they were not only educating the public but also aiding American artists, for the Athenaeum used the profits from the exhibition to purchase native works. The 1828 exhibition led directly to the acquisition of paintings by Samuel Waldo, Thomas Doughty and Washington Allston. But this boon, while valuable, was incidental, for most of these donors were indifferent to the status of American artists.[66]

During the 1820s, however, a different type of art patron emerged, to become much more prominent in the decades to come. Men like Philip Hone, Gouverneur Kemble and Luman Reed of New York, Robert Gilmor of Baltimore, Nicholas Longworth of Cincinnati and Edward L. Carey of Philadelphia would exert enormous influence on the development of American art. They were more often merchants than professionals, less educated than the sorts who founded the Athenaeum or the academies, and they were enthusiastically interested in the careers of young artists. With the time and energy made available by successful mercantile careers and early retirements, they were sometimes active in art unions and academies, but most of

them preferred personal contacts. As the American artist life grew more articulated and defined, and as American business grew more frenzied and competitive, participation in the activities of the studios, and friendships with painters and sculptors, became more attractive. A whole group of wealthy but nostalgic businessmen were pulled toward the art world in the decades before the Civil War.

Before 1830 these figures were still exceptional, though generous and often quite shrewd. Philip Hone, a Whig mayor of New York who retired from business at forty-one with half a million dollars, spent the next thirty years of his life busying himself in political, cultural and philanthropic affairs, while building his link with immortality in his memorable *Diary*.[67] Hone owned portraits, sketches, landscapes and allegories, buying almost anything friends like Thomas Cole, Robert M. Weir and Samuel Morse produced. Not a uniform enthusiast, Hone thought Cole's landscapes "too massy and umbrageous," but insisted that "every American is bound to prove his love of country by admiring Cole."[68]

Patriotic motives, while producing customers, did not always please artists. Morse was infuriated by too much talk of encouragement; he felt like a beggar living on charity. Who purchased pictures simply because they loved them? Do not most he asked, "give as the reason *their wish to encourage the artist*? How few to gratify their feelings of love for the art or the production. Who purchases a coat or a table, or a book, to encourage the tailor, the cabinetmaker or the bookseller?"[69] Morse was still seeking to reap the benefits and avoid the condescension which private patronage seemed to bring in its train.

The criticism which even the most generous patrons offered to painters intensified the desire for more visceral approval. Robert Gilmor, kind and good-natured, consistently extended advice to the artists. Some of them, like Alexander Robertson, took it in good part.[70] But Thomas Cole was less yielding. He complained to his patron that a commissioned landscape view was barely satisfactory, "the most unpromising subject I ever attempted."[71] Cole, in fact, kept up a running battle with Gilmor, though he was grateful for his generous aid. The two debated artistic style incessantly, Gilmor favoring an absolute literalism, a painting "without manner" as he put it, while Cole

defended idealization and the dignity of the creative intellect.[72] "If the imagination is shackled, and nothing is described but what we see," he wrote, "seldom will anything truly great be produced in Painting or Poetry."[73] This basic disagreement became a major theme of American art debates in the years before the Civil War; its early discussion between artist and patron reveals the intense enthusiasm which they brought to their task.

Cole's greatest patron, and the most influential sponsor of the New York art world for some years, was Luman Reed, a self-made man who began by sending farm goods to New York City in exchange for items to stock his small grocery upstate and ended by owning a great metropolitan grocery establishment.[74] Reed encouraged Asher B. Durand and helped him switch from engraving to oil painting; he aided William Sidney Mount and George W. Flagg, and sent whole groups of artists to Europe at his own expense. His home on Greenwich Street was equipped with a gallery which he opened to the public one day each week. From Cole, Reed commissioned a gigantic set of allegorical pictures, "The Course of Empire," which he purchased for five thousand dollars, after continually raising his original offer.[75] Reed's death in 1836 shook the American artist community, and a grief-stricken Cole composed a sonnet, comparing him with the Medici:

> *Who lov'd like them, to nurse the growing arts,*
> *But with a purer love and more exalted end:*
> *Who plotted not to tyrannise and rule;*
> *But trod the nobler though less dazzling path.*[76]

Despite the rhetoric of new beginnings, then, American artists depended for success on the personal attention of men of wealth, toward whom they often maintained a traditionally deferential deportment. A young painter like John Vanderlyn addressed his benefactor, Aaron Burr, as "My dear Patron."[77] Art education, such as there was, shared this traditionalist bias.

A few youngsters, often from the West, did entertain suspicions about these conservatively organized art communities emerging in the East. Sylvester Genin complained that New York painters "seem to think that copying old pictures, busts, etc., is the only way to become a painter," instead of realizing they should copy nature "as the authors of these old masterpieces"

had done in their own day.[78] And foreigners warned Americans that they were encouraging mechanical reproduction.[79]

But most young painters and their sponsors agreed with the critics who explained that "the great school of nature . . . is a good school, but difficult to get into without an introduction," which only the masterworks could provide.[80] Rules were not the "fetters of genius"; an artist who "begins by presuming on his own sense, has ended his studies as soon as he has commenced them."[81] With some exceptions, like Gilmor, the genre painter William Sidney Mount and the sculptor Erastus Dow Palmer, the American art world emphasized the need for knowledge of the old masters, the careful study of drawing and the continual application to traditional courses of study. "Ah, the old masters, after all, are the only masters to make a great artist," Washington Allston cried, and Luman Reed agreed so emphatically that he tried to get Americans to spend more of their time (and his money) studying in Rome.[82]

Traditional art training had a great deal to do with one of the major choices artists faced in the first third of the century: where to take up residence. By the 1820s artists seeking advancement, or competent enough to preserve a permanent clientele, began to move to the cities of the Northeast in large numbers. Cities, after all, contained academies and collections, and only there could artists compete before a sophisticated audience. Patrons were not always happy at the move, though they encouraged training. When young Thomas Buchanan Read decided to try his fortune in the East, Nicholas Longworth, a Cincinnati collector, exasperatedly told him he was "on a visionary Experiment," and had let "ignorant friends" induce him to practice before he was competent. Pursue the art in Western towns, Longworth urged; until he improved, it was silly to compete with cosmopolitan artists.[83] Read himself understood the problem, but dissented from Longworth's diagnosis. How could he stay in Western towns where good paintings were unknown, he asked, and yet improve to the point where he could stand with Henry Inman and Thomas Sully? Longworth's suggestion was "one of the most absurd ideas" he had ever encountered, and put him in mind "of the old woman that would not let her son go to the *River* until he had Learn'd to swim."[84] Many other young artists faced the same problem, yearning

"for the northern cities" "to breathe an atmosphere of art," but still unable to support themselves meanwhile.[85]

But once a young artist decided to move to a city, a further problem arose: which city to choose. By 1825 Boston, Philadelphia, New York and Baltimore were all competing in the race for cultural hegemony. They had begun to develop distinct corporate personalities as their guidebooks, travel accounts and newspapers reveal. Travelers commented on the romantic designations American cities adopted: New York was the Empire City; Philadelphia, the Quaker City; Boston, not yet the Hub, was the Pilgrim City; and Baltimore, the Monumental City.[86]

Their very appearances differed characteristically, stimulating visitors to account for the reasons. "A sort of civic idiosyncrasy," said Thomas Hamilton, distinguishes each city "even to the eye of an unpractised observer."[87] To men whose professional success depended on their perceptions, physical appearance was one consideration in the choice of residence. Here was a contributing element in the mysterious transfer of urban cultural power which occurred between 1815 and 1835, and which led to the decline of Philadelphia as a center of American creative life.

At the start of the century, Philadelphia was the strongest contender for the proud title of "The Athens of America." It led all other cities in reputation, size and magnificence. Profiting from its years as national capital, it contained a brilliant cosmopolitan society and a flourishing port; it was home for many famous writers, artists, attorneys and physicians. An innovator in the development of modern municipal institutions, Philadelphia was known for its university, its free library and its art academy. Federalist America's most important literary periodical, the *Port Folio,* was published there, and its artist colony was the most prominent in the nation.[88] Charles Willson Peale and Matthew Pratt, former students of Benjamin West, painted for Philadelphians, as did other Peales like James and Rembrandt; immigrant artists such as Robert Edge Pine and Joseph Wright headed straight for the city on arriving in America.[89] Trumbull and Gilbert Stuart were frequent visitors, Stuart even taking up residence for a time, and Edward Savage and Benjamin Trott were among its artistic lions. Benjamin West

threw his support behind the city's ambitions; Benjamin Latrobe designed its great buildings; and William Rush, the first American sculptor of distinction, was born there. The foreigners who flocked to describe its sights helped make it America's most impressive community.

But after the War of 1812, Philadelphia fell behind New York—and even much smaller Boston—as a center of national culture. Her artist community diminished in distinction as those of New York and Boston attracted a growing set of landscapists and genre painters. By the 1830s and 1840s Philadelphia's most famous artists—Thomas Sully, John Neagle and John Sartain—were more conservative than New Yorkers like Henry Inman, Asher B. Durand, John G. Chapman and Thomas Cole. Skillful artists—Thomas Doughty was one—tended to leave the city, as writers would do in later years.[90] Of the great group of American sculptors born in the first quarter of the century—Greenough, Powers, Palmer, Dexter, Mills, Crawford and Clevenger—Philadelphia produced not one.

Philadelphia's appearance seemed to mirror (and perhaps to influence) this decline. As romantic values of picturesqueness, irregularity, energy and movement began to permeate the visual world, just as they had the literary, travelers reported less and less favorably on angular, linear, carefully planned Philadelphia. In the late eighteenth century and for a few years in the nineteenth, the city's splendor and novelty still captivated many, but by the 1830s Thomas Hamilton termed it "mediocrity personified in brick and mortar."[91] Sir Augustus Foster had pronounced his contempt decades earlier with the image of a chessboard; "New York has greatly the advantage over it for striking views," he noted. Long lines of broad streets which met at right angles were fine for sanitation but less appropriate for architectural ornament; Foster assumed the city's regularity was the work of mason-architects "who had emigrated to seek their fortunes in the colonies . . . fond of what is easiest to do."[92] Mrs. Basil Hall felt the city to be inferior to much smaller Boston, and others bewailed the stillness in the streets, so "difficult to reconcile with the idea of a large city."[93]

Cities which had copied Philadelphia's plan, like Baltimore and Richmond, came in for much of the same criticism, though their hilly sites relieved the monotony.[94] But New York,

however much it irritated or annoyed, was rarely described as either quiet or monotonous. Even from a distance the city's spires and turrets, its long lines of shipping and its busy harbor gave it the air of a metropolis.[95] Thomas Hamilton saw it as a frisky young giantess, bustling with energy.[96] Its streets were dirty and narrow at first, its wooden buildings lacked distinction and its parks were undoubtedly small and scarce, but the city exuded wealth and power, and its great stores were royal palaces magnificently decorated by the "influx of German and French artists."[97] Its cosmopolitanism so impressed Theodore Dwight that he concluded it was no longer necessary "to go abroad to see the habits of Europeans."[98] Even loyal Philadelphians paid their tribute. Charles Willson Peale conceded that New York had sights "as pleasing to a painter's eye as can be found in any city of America," and Sidney George Fisher admitted sadly that after a visit there "Philadelphia seems village-like. Everything is on a grander scale and the aspect of the streets, the buildings, shops, & people indicate a metropolis."[99]

Aside from visual appearance, artists had special reasons for being careful in choosing a home. Other men also took an interest in such selections but not usually for professional reasons. A physician expected to find the same general need for his services in Baltimore as in Boston, and an attorney or blacksmith could anticipate approximately equal prospects in Philadelphia or New York. Sometimes newer communities provided special opportunities, and young lawyers and merchants found it advantageous to tap new markets. But for most men one community presented the same level of demand as another.

By contrast, the artist's livelihood depended on the wisdom of his choice, for communities differed markedly in their patronage of local talent and in the value they placed on art objects. Why one city rewarded its artists more than another no one really knew, and which city was the most hospitable no one was quite sure, but that real differences existed, few doubted.[100] Artists' letters were filled with comparisons and assessments, arguing out just where the most promise lay. Richard Greenough of Boston asked his fellow sculptor, Henry Kirke Brown, how things stood in Albany and whether he would make money by the move.[101] Young Sylvester Genin was advised by a sculptor to

go to Boston, "as it is the emporium of the arts."[102] On the other hand, Cephas G. Thompson, "almost frozen by the lack of interest in our work and studies that is so necessary to the life and progress of the Artist," wrote a friend that "Boston is not so warm a place for an artist."[103] Thomas Doughty also found Boston patronage "villainously bad" and the city expensive to live in, cursed additionally by a fickle climate.[104] Similar disagreements marred other descriptions. Philadelphia, praised by the architect Alexander Jackson Davis for "the noble spirit" of its Artists' Fund Society, was characterized by Thomas Sully as "a sad place for an artist."[105]

Samuel Morse exemplified, by constant movements and a series of false starts, the sorts of choices and the agonizing decisions artists faced in choosing a home. Morse had always been suspicious of Boston; in 1812 he announced that Philadelphia was destined to be the American Athens, and he intended to make his home there or in New York.[106] Two years later he was still high on that city, urging Americans to "throw aside local prejudices and give their support to one institution. Let it be in Philadelphia," he begged, and make it "a national, not a city institution."[107] In 1815 his thoughts turned back to Boston, but this was only a brief return, for he predicted to Washington Allston that it would be "the last in the arts."[108] By 1832 Morse was convinced that New York should be his home and outlined the reasons which must have convinced many others who began moving there in that same decade.

> The more I think of making a push at New York
> as a permanent place of residence in my profession,
> the more proper it seems that it should be pretty
> soon. There is now no rival that I should fear; a few
> more years may produce one. . . . New York does not
> yet feel the influx of wealth from the Western canal
> but in a year or two she will feel it, and it will be
> advantageous to me to be previously identified among
> her citizens as a painter.[109]

Colonel Trumbull was growing old, and Morse thought he might take his place as president of the American Academy. But as disillusionment closed in about this, disenchantment enshrouded New York itself. Everyone agrees, he wrote, that the city is "wholly given to commerce. Every man is driving at one

object—the making of money—not the spending of it."[110] Though Morse's odyssey threatened to end in Mexico, he remained permanently disgruntled in New York, until science came to his aid.

Many variables made a city attractive to artists. The number and strength of its art organizations were obviously important. Before 1840 only Philadelphia and New York had institutions of any size or permanency, though the Boston Athenaeum held yearly exhibitions and other cities made sporadic attempts at imitation. Several communities boasted stores handling art supplies by the 1830s, professional artists willing to take on pupils and rudimentary collections of casts and engravings, though only the Northeast had these in quantity.[111] Because they were also publishing centers, the largest cities gave artists opportunities to increase their incomes by illustrating books, newspapers and magazines, engraving bank notes and designing lithographic advertisements. Francis Alexander went to New York mainly because an old peddler showed him some book illustrations, and the volumes published by a New York house, Samuel Ward & Sons, seemed to have the best pictures. The peddler confided that they "do these things better in New York than in any city in the country."[112]

The vogue for gift books like Boston's *Token*, Philadelphia's *Atlantic Souvenir* and New York's *Talisman* further aided city appeals, though the rewards were greatest for engravers.[113] Inman, Morse, Cole and John G. Chapman drew for *The Talisman*, whose editors, William Cullen Bryant and Gulian Verplanck, were particularly friendly to the artist community. New York, Philadelphia and Boston dominated book publishing as they did periodicals; Carey & Hart of Philadelphia, Appleton & Company of New York and Samuel G. Griswold of Boston aided artistic centralization. The house of Harper alone employed J. G. Chapman, John Inman and Robert W. Weir; and Joseph A. Adams, an engraver, made sixty thousand dollars from his designs for their elaborate Bible.[114] Edward L. Carey, Daniel Appleton and other publishers became noted art collectors themselves, often using their purchases as subjects for engraving. Philadelphia lithography was particularly hospitable to painters, and owners like P. S. Duval, Cephas Childs and J. T. Bowen took artists into partnership.[115] The strength of this

industry accounted for continued artist immigration to the city, long after New York had become the nation's art capital; the days were gone, however, when foreign painters and returning Americans headed straight for Philadelphia.[116]

There were other inducements besides publishing. The development of New York's steamship connections and its comfortable facilities for transatlantic travel enticed artists, who went to Europe more frequently than most countrymen. A less tangible but more significant asset lay in the generosity of a city's professional and mercantile classes. Sometimes New York's overexuberant commercial atmosphere made artists long for quieter communities, but it gradually became apparent that business competitors fought fiercely over their art collections also. The quiet halls of the academy and the exciting life of the studios attracted other merchants who wanted relief from business. Men in many cities—Gilmor of Baltimore, Daniel Wadsworth of Hartford, Edward L. Carey of Philadelphia—took such an interest, but New York simply had more of them: Philip Hone, Samuel Ward, Luman Reed, Jonathan Sturges, Gulian Verplanck, William Appleton and Charles M. Leupp were just a few New Yorkers of this type.

New York's literary community proved attractive as well. Friendships bound Knickerbocker artists and writers together; Cooper and Morse, Bryant and Cole, Washington Irving, Henry Inman, Fitz-Greene Halleck, Asher B. Durand, George P. Morris and William Dunlap were all part of a close-knit group.[117] The artists were dependent on the literary community. It was comforting to be able to introduce youngsters into established circles. E. A. Brackett, a Boston sculptor, told William Cullen Bryant that he knew "from experience" how much young artists benefited by associating with writers.[118] Certainly literature occupied a higher status than the visual arts in early nineteenth-century America, and in the constant debates which fashionable journals ran about the relative merits of poetry and painting, poetry usually came out ahead.[119] Poets were not tarred with the craft legacy of the visual artists. Theirs was the realm of the ideal, and their spiritual abstractions supposedly produced more intense emotional reactions; Shakespeare, Milton, Pope and Byron were greater names in Jacksonian America than Hogarth or Rembrandt, Reynolds or Raphael.

Writers, moreover, were able to give their artist friends publicity, in newspaper reviews, biographical sketches and poems of appreciation.[120] By providing them with characters to illustrate and scenes to reproduce, poets and novelists aided in the legitimization of foreign subjects. In another part of his massive correspondence about government commissions, Washington Allston suggested that Columbus' interview with Ferdinand and Isabella was a possible theme because Washington Irving, in an American book, had made the scene famous.[121] Cole and John Quidor utilized the characterizations of Cooper; and Emanuel Leutze, who sanctified in paint Washington's Delaware crossing, illustrated the poetry of Bryant and Longfellow.[122] Friendly authors volunteered pieces to needy artist friends, who would then attempt to sell them with a drawing attached.

The very existence of the writers demonstrated that America could support men dedicated to *belles lettres,* and occasionally reward them handsomely; and this extended moral support to the artistic career. Sometimes, also, writers had set up semiprofessional and social institutions, informal clubs or dining societies like Cooper's "Lunch," amorphous circles which artists entered at a time when they were not welcomed by the favored portions of society. Cooper encouraged Morse, Greenough, Robert W. Weir and Dunlap; he was a symbol of the growing confidence conservative Americans placed in the arts. What had once been feared as corruption, extravagance and luxury could be praised as an improving instrument for both the national spirit and the national economy. "There is an intimate connection between all the means of national prosperity," Cooper lectured his economical countrymen.[123]

Writers eagerly welcomed the arrival of painters and sculptors, whose presence denoted a growth of national taste, a touch of the picturesque added to the drabness of daily life. Artistic refinements would produce a more sensitive, receptive public and a more varied and numerous set of colleagues. So James Russell Lowell and C. F. Briggs wrestled for the presence of the painter, William Page. One told him that New York's atmosphere would threaten his "spiritual advancement" while the other pitied him his New England "drizzle, and sleet, and mists," the "evil woods of Boston, the cold sky, the northern

darkness," and begged him to leave that "absurd corner of the universe," and return to New York.[124] Page was too peripatetic to stay in one place long, but a fine artist was a splendid catch for any literary community.

As a group writers had more self-confidence than visual artists; it was easier for them to prick the balloons of fashion and pomposity. Artists were compelled by their clients and their ideals to be more affirmative in their work, but their life style, their poverty, their lack of recognition and their personal eccentricities permitted them to live out the protest writers could make only with fictional characters. Lacking formal educations, artists felt most at home with writers of fiction and poetry, creators of romances, novels and comic histories. Essayists, philosophers and theologians made less amiable companions. Sharing an attachment to majoritarian values—even if they were alienated in practical areas—artists were more comfortable with the Knickerbocker group of Irving, Bryant, T. B. Fay, Halleck, Paulding and Willis, than with Emerson, Channing or Thoreau. *Paul Fane* and "Thanatopsis" were more comprehensible than distilled German philosophy and New England's neo-platonism, though Lowell and Longfellow were friendly with some Boston artists.[125] Only when the Northern mysticism became less clearly articulated and more emotionally sharable could most of the New Englanders join their artists. Boston's literary values were too university-oriented and all-absorbing in their own right to allow painters the role in the city's culture they played in New York. To perceive the difference, one has only to compare the membership lists of Boston's Athenaeum or its Saturday Club with New York's Sketch Club or its successor, The Century. By the 1830s Philadelphia writers had so dwindled in number that the town could hardly compete with either New York or Boston. When artists and writers could live symbiotically, a city became more interesting to both groups.

That creative genius needed some sort of urban culture for nourishment was an assumption most art patrons made easily enough. Because all American cities were small and institutionally underdeveloped, the absence of a great metropolis seemed a serious handicap to American intellectual life. A metropolis provided the arts with competitors as well as patrons, men who could exchange ideas, criticize and encourage each

other's work. Joseph Buckminster bemoaned the wide separation of writers. "There has been little to excite emulation, nothing to generate an *esprit de corps*."[126] Good taste could not exist without a metropolis, "where individual prejudice and conceit will be confounded and put down by the collision of equal or superior minds."[127]

The same comments were applied to artists. *The Southern Review* grieved that there was no "common theatre, upon which the talents of our painters can be brought into immediate and direct competition . . . Without a Paris or a London . . . we can never have a Louvre or a Somerset-House."[128] C. F. Briggs quoted Hazlitt approvingly, that England's two greatest artists lived out obscure lives because they "sat down contentedly and quietly in different country towns, and painted country squires and their families."[129] And Rembrandt Peale bemoaned the dispersion of paintings and sculpture, "scattered over the face of our extensive Country for the want of One Capital of our Empire, where they might be concentrated."[130]

Large cities preserved a creator's originality; neglect was dangerous because it induced self-doubt and frustration. Cut off from the public, artists would end up talking to themselves and working for the few. So Matthew Jouett discovered, writing from Kentucky to Thomas Sully. "I am getting on but indifferently," he complained. "I share no competition of any sort here. I see no good pictures to compare my daubs with, consequently am getting deeper and deeper into the mire of mannerism and that of the worst sort." A day's work with Sully and the benefits of a metropolis might "revive the once spirit of enthusiasm," and help him forget the tedium of working in isolation.[131]

A few artists, bitter under criticism, claimed that neither contemporary communication nor general comprehension was their goal; cities, therefore, were not vital to success. Greenough described Philadelphia and New York as "great marts," which were death to art. "It is comical to see the Academy, and compare the temple of art with the shop of a milliner or office of a broker. These last are substantial and handsome."[132] Cities symbolized the commercial spirit, the materialism and philistinism which Greenough found so despicable in his countrymen, and from which he appealed to an enlightened posterity. But for most other artists the rhetoric of withdrawal and an insist-

ence on awaiting the verdict of the future was a cry of pain and anguish. Popular approval meant a great deal; it legitimized and justified their profession, pointed up their social value, enhanced their incomes and brought them the status given only the successful. Residence in a Northern city became a practical necessity for such popularity.

Just as some artists were caught in the dilemma of idealizing popular taste and condemning its particular judgments, others were torn by the need to live in large cities and a growing revulsion from them. The same periodicals which urged the support of burgeoning cultural institutions and bemoaned the absence of an American metropolis also damned large cities. Joseph Dennie, editor of the *Port Folio,* used Biblical texts to prove that tranquillity was attainable only in the country. Ambition, greed and passion stalked the city streets, and those who wished to "respire with freedom, to enjoy the pleasures of reading and reflection, and to sleep sweetly," must avoid the great towns where "every tenth house is a hospital."[133] Benjamin Welles, in the *Monthly Anthology,* described city dwellers as prisoners who sickened and rotted until "at death their eye shuts blankly on the walls of their prison."[134] And New Yorkers as urbane as George Templeton Strong looked at city improvements with a critical eye; they were dangerous to happiness and morality. "Cities are bad enough at the best, but a rich commercial city (like this) I regard as a *hell*—a sink of vice and corruption and misery—lightened on the surface by the false glare of unhealthy exhalations."[135]

This was not populistic paranoia or fundamentalist moralism, but the educated and cosmopolitan portion of the community, restating ancient views in the language of gentility. Suspicion of cities was pervasive in the middle of the century, and noted by foreign visitors. The absurdity of placing state capitals in small towns like Albany or Montpelier owed something to geography but more to prejudice.[136] Several thought the cause might be jealousy; they supposed that agricultural districts moved the capital when wealth and talent began accumulating in one place.[137] "This is a land of equal rights," Cooper's Steadfast Dodge observed, "and I confess that I see no claim that New York possesses, which does not equally belong to Templeton."[138] But much more than jealousy was involved.

Timothy Dwight showed the intensity of ideological distrust
of the city when he described the condition of Harvard Uni-
versity. The college's greatest disadvantage, Dwight wrote, lay
in its proximity to Boston, for the city's allurements were too
great to be resisted by college youths. "The bustle and splendour
of a large commercial town are necessarily hostile to study.
Theatres, particularly, can hardly fail of fascinating the mind
at so early a period of life."[139] This, despite his own admission
that the city's opulence had provided Harvard with crucial
financial support and that its cultural contacts with Great
Britain had yielded even greater advantages.

Threats to health, morals and tranquillity, cities seemed to
endanger the simplicity and equality which was the unique
property of rural areas. Slighted farmers and mechanics resented
"the offensive display of wealth, the unkind port and bear, the
swell and strut," of urban merchants who measured everything
by the standards of their own community. They warned that if
cosmopolites persisted in aping the manners of foreigners, "they
must expect to be excluded from all participation in political
influence."[140]

When artists rebelled against their urban environments,
then, they were not being idiosyncratic but expressing the
sentiments of many of their countrymen. Beginning in the
1820s and continuing through the next decades, artists and
writers began to proclaim their need to be out in the fields or
on the rivers, sketching trees and flowers in God's quiet land-
scape, far from the evil haunts of man. They stressed not the
threat to morals that the city presented, but the routine, the
slavery and the monotony of most forms of urban life. Henry
Inman "panted to live in the country, where I can be sur-
rounded with something pleasanter to look upon than the
everlasting brick walls of a city." The natural result of such
an exodus was a decline in portraiture, a social art, and an
increase in the solitary act of landscape painting. The painter's
eye continued its turn from man. Inman added appropriately
that in his rural isolation he would be "better enabled to with-
draw myself gradually from mere face-making, to practice in
the more congenial departments of art—namely, landscape
and historical painting."[141]

Charles Lanman provided the literary counterpoint to
Inman's views. Landscape painter, poet and essayist, the friend

of Thomas Cole, Asher B. Durand and William Sidney Mount, Lanman tried to dispute the view that great mental achievements were impossible in the country. Stratford, not London, produced Shakespeare, he observed, and Homer and Wordsworth were rural bards. "The country is the place to study, to think and to write; but the city is the place to sell the products of your mind."[142]

Thomas Cole best expressed the revulsion from human personality which swayed American artists in the 1830s and 1840s. Cole found the human landscape much more threatening than the natural. When Durand complained of feeling penned up, Cole urged him to leave the metropolis. "In the city we are surrounded by our fellow-men and we feel their presence; we labour for their approbation and require that sentiment frequently."[143] But in the country, the artist's sole motivation was the desire for excellence. Cole was more than merely attracted by rural society; the city actively repelled him. He wrote in his journal that he always went to New York "with a presentiment of evil." He enjoyed seeing other artists, but was irritated by bad criticism and had no small talk.[144]

His fellow men also caused Cole anxiety. "An excessive bashfulness," wrote William Dunlap of Cole's youth, "caused him to avoid the society not only of adults, but children his own age."[145] Cole told a friend that "nothing delighted him so much as that his sitters should fall asleep. . . . he then felt that he had them in his power."[146] Coming to the city of Philadelphia for the first time, he was awed by the great buildings and wide streets. "Accustomed to the lowly structures of the West and the solitude of the wilderness, he felt oppressed, and in the midst of a crowd of strangers his spirits sunk."[147]

Cole's brooding and preoccupation with death and decay, his aversion to large groups and the intensity of his reflections all indicate a depth of anguish probably not experienced by most artists of his generation, though the number who exhibited obviously neurotic characteristics, like Allston, Horatio Greenough and William Page was fairly high. But Cole's aversions were shared by others in a milder form. Even the great American statesmen lived self-consciously on their estates or country houses—Mount Vernon, Montpelier, The Hermitage or Ash Lawn—cut off from the contamination of mobs and cities. Alexis de Tocqueville, although convinced that democracy eventually

diverted the imagination "from all that is external to man" to humanity itself, admitted the possibility of an alternative. When equality depopulated heaven of its heroes and gods, poets turned to describing streams and mountains, and "this embellished delineation of all the physical and inanimate objects which cover the earth" was thought by some to be true democratic poetry.[148]

The turn toward nature, moreover, was hastened by a growing infidelity and fear of death. An increasing confusion about immortality and the truths of revealed religion and a growth of sentimentality and tenderness pervaded Jacksonian America.[149] "We twine our affection about the heart of a young and delicate child," mourned Lanman, "but in one short hour it is cut down, by the rude hand of Death. . . . Everything that we love must die."[150] Everything, that is, save nature, which eternally renewed itself. The city threatened happiness by its suggestion of decay as much as by its materialistic arrogance; Cole's "Course of Empire" gave him the chance to destroy—on canvas —a huge flourishing city, but his exultation in the destruction was tempered by a sorrow for the ruins it left behind. Nothing human could survive.

Yet artists realized they could not exist apart from the city either. There they sold their paintings and held their exhibitions, gathered money for European visits, studied under masters and faced critics. But they did not spend much time on the city in their art. As the cities grew larger and more numerous, the public valued the painted landscape more and more. As it became clear that the nation's history would be composed not of the woods and meadows of rural America, but of iron and stone and steam, of cities and factories, the painter's ability to make the dream transcend reality became all the more valued. Landscape painters had ceased to be observers and were transformed into history painters; their Edens of the imagination, however, substituted inspiration for memory and the ideal for the event.

It was appropriate, therefore, that few paintings of American cities were created before the Civil War. Most illustrations were prints meant for newspapers, guidebooks or magazines, lithographs used in advertisements, and occasional engravings for books devoted to the American landscape. The artists who did illustrate American city life were usually foreigners. John

Lewis Krimmel, famous for his views of Philadelphia, was a Württemberger who came to the United States when he was twenty-one; Francis Guy, known for his charming Brooklyn scenes, was an Englishman who arrived in New York while in his thirties; William James Bennett, another painter of New York scenes, was an Englishman who came to New York at the age of forty; and other city painters born abroad included J. C. Wild, William Birch, August Köllner, and William L. Breton.[151] Perhaps only foreign artists, comfortable with urban experiences, could recognize the pattern of American city life and indulge their curiosity in the dress and habits of urbanites.

Many of their scenes, moreover, at least until the 1830s, were views made across the water, silhouettes in which the viewer stood consciously outside the complex of people and buildings. Only gradually did the artist stand in the heart of a city or directly above it, looking out and absorbing the urban landscape as he had already assimilated the natural.[152] J. C. Wild's Independence Hall steeple views of 1838 were among the first truly "urban" views, and were soon followed by a series of others.[153]

For most artists the urban community was a place to eat and work in, and then ignore aesthetically as much as possible. This was true despite the fact that many communities sought painters avidly. The spirit of cultural competition stimulated communal soul-searching. "Are our rich men *forever to* be stigmatized with the reproach of our Sister States," cried one Bostonian, pointing out the artistic achievements of Philadelphia.[154] Philadelphians, at the same time, used Boston as a specter with which to frighten their fellow citizens. "With such rivalry Philadelphia must yield the proud title which she has borne, or rouse from the withering lethargy in which she slumbers."[155]

Art activity shed benefits on commerce and manufactures, and even aided tourism. Though artistic bohemias did not fully develop until the second half of the century, guidebooks boasted of resident artists and art clubs, and of the modest treasures contained in libraries and academies. Private patronage took on civic importance, and when Americans purchased art at studios in Italy, they sought out townsfolk carefully to emphasize their pride in local achievement.

Artists themselves did not develop a sense of municipal

identification strong enough to breed antagonism. While there were occasional mutterings when a municipal commission went to an outsider, the frequency of such awards showed the lack of regional jealousies. At exhibitions, out-of-town artists were usually well represented, and critics very often complained there were not enough of them; they blew up the virtues of these strangers to deflate the egos of local talent. Collections all over the country were tapped as sources, and Baltimoreans and Philadelphians like Gilmor or James McMurtrie did not hesitate to commission works from artists in other cities. Harking back to the glorious days of Renaissance Italy, a speaker at New York's National Academy in 1826 insisted that there was no reason why "the artists of Philadelphia, and Charleston, and Boston, and New York, should not feel an honourable rivalship," for it might lead to the same glorious results which the competition among Florence, Rome and Venice had yielded.[156]

Though the choice of city was important, this did not create permanent regional antagonisms; artists were willing to transfer their allegiances with their customers. Before 1840 choice of a place to live was simply one more of a series of problems the American artist faced; committed intellectually and emotionally to the pastoral life, his forced residence was a link in the chain which bound him to clients and customers, while the decision of where to settle used up precious time.

New York's dominance became more pronounced in the two decades before the Civil War as the habit of annual visits there became established among out-of-town merchants and professionals. Residential flexibility decreased for artists, but their strength and self-confidence grew rapidly. These years witnessed the first full definition of the American art world, the birth of a class of patrons, the development of artist-run academies and powerful professional associations. All this activity was built upon an increasing public interest in art and a more favorable impression of the artist's function. The growth of enthusiasm and sophistication began, however, not in America but in Europe. The accounts of a generation of travelers, on pilgrimages as sacred in their way as those of Crusaders, played a crucial role in this nineteenth-century transit of culture.

European Travel:

The Immediate Experience

∿

CHAPTER FIVE

From the signing of the Treaty of Ghent in 1814 to the outbreak of the Civil War, increasing numbers of Americans poured across the Atlantic on journeys of exploration and nostalgia.[1] For the first time many of them confronted powerful masterpieces, and their awe, fear, delight or anger forced some consideration of the value of art. Previous indifference or unconcern disappeared forever as these experiences produced grandiose conceptions of art as a moral and political instrument, and a panacea for human ills. Travelers recorded their reactions of excitement and exaltation; the commitments and insights which resulted had a momentous impact on the future of the American artist and the status of his profession. Even the frustrations of a disappointed minority produced a lasting effect at home.

Travel between the New World and the Old had never been extinguished, of course, but the trip was so dangerous, arduous and expensive during the seventeenth and eighteenth centuries that only the wealthy or desperate undertook it. But the growth and dispersal of American fortunes, a renewed interest in European society, the establishment of transatlantic social connections and the greater safety, speed and conveniences of sailing packets and steamship lines combined to increase the tourists dramatically. In 1828 Philip Hone noted that every member of a New York dinner party had been to Europe. When he had first begun dining out several decades before, the number of "learned pundits" who had been abroad was so small that everyone else looked up to them with the greatest deference and respect. "Now the streams of accumulated knowledge may be obtained at innumerable fountains; the Abraham Schermerhorns, the James J. Joneses, the Gibbses, the Primes do pour forth streams of intellectuality,"[2] The president of Wesleyan University, abroad himself shortly thereafter, counted at least

124

three hundred Americans in Rome during Passion Week.[3] Twenty years later that many American artists resided in the Eternal City, bolstered by art colonies in Düsseldorf, Florence, London and Paris; alongside of them were thousands of students and travelers constantly on the move.

For many visitors, the purpose of the trip was simply to relax after years of hard work, or take a temporary break in an active business or professional career. For others the voyage was an attempt, often a vain one, to regain health lost in the rigors of New England's climate or in the service of a demanding congregation. Some traveled for business reasons; thus agricultural and landscape experts like Henry Colman or Frederick Law Olmsted observed European methods and exchanged information with foreign experts. Clergymen by the hundreds attended world-peace conventions in Paris and Frankfort, and physicians, medical students, lawyers, engineers, merchants and artists helped fill out other categories.

While most of these men were intent on getting to a particular destination, the opportunity to see other parts of Europe was too alluring to be passed up; many visitors made extensive trips through England or the Continent. European travel was slow, and with so many frontiers to cross, cumbersome as well; where today's conscientious tourists might spend a week, Americans stayed a month or even a season. Europe was cheaper to live in than home, and an Atlantic society fulfilled its obligations with mutual acts of hospitality. Many Americans spent weekends as the guests of friendly Englishmen, just as they entertained their hosts in Boston or New York. The triumphal circuits of Charles Sumner in England and Dickens and Thackeray in America are well known, but such enthusiastic hospitality extended to many less illustrious figures. Henry Colman spent his weekends on the greatest estates in England, the guest of dukes, earls and baronets.[4] Private collections opened like magic at the behest of Americans, who also managed to get hold of ball invitations and places at coronations and royal levees. On the Continent the small groups of Americans spending the season abroad grew tight-knit, though they often joined the larger, more illustrious English contingents. Thus Americans permeated the circle of the Anglo-Florentines, whose ranks embraced the Brownings.

A touch of the pedagogical tradition of the Grand Tour hung about these nineteenth-century travelers; they devoured guidebooks, travel accounts and novels of place with a savage conscientiousness. Familiarity with classical history could often be assumed, but some brushed up and studied modern history as well. Charles Eliot Norton wrote angrily in 1860 that most American travelers were abysmally ignorant and judged art before they had any acquaintance with previous authorities.[5] But this was the reaction of a scholar, made when larger numbers of less cultivated Americans were flocking to Europe; earlier tourists were remarkably well informed about art and expressed only the most conservative opinions, absorbed from well-known authorities.

To justify their pleasures, many travelers insisted that their goals were educational, whether direct and immediate, or a vaguer, more generalized spiritual improvement. Information was therefore treasured and recorded, the American love of figures, dimensions and costs even then asserting itself. Reactions were carefully self-observed to provide subject matter for the letters home, and also for the inevitable travel books which appeared shortly after the journey's completion. By 1860 hundreds of them had been published, and if the serialized reporting of trips in periodicals is included, the total runs into the thousands. There were so many that by the 1840s many a volume began with an apology acknowledging the plethora, but promising at least a few new insights and some personal experiences.

The travel-book genre contained some easily recognizable features, similar plot lines and a set of predictable conclusions. The crossing by sea, the difficulties of handling a foreign language, the dishonesty of porters, the atrocities of bandits, the bustle of some cities and the decay of others, the pride of being an American and the joy of a safe arrival home, the ache of homesickness and the depression which beset the traveler—all were duly noted by almost every writer. The ritualistic similarity of the observations may suggest that they were copied one from another as expressions of the appropriate. But while many travelers tried to work themselves into expected reactions based on the reputation of specific cities and masterpieces, this uniformity was also the product of an experience so basic to Americans that personal background, status or occupation was of less

importance than the common heritage of nationality and the problems of coping with a strange physical world. And although common themes are detectable, an individual, idiosyncratic quality pervades so many of these observations that the conventional rings true, the honest result of actual experiences.

The effects of galleries, palaces and churches were often so intense and dramatic that it is easy to dismiss them as self-inflicted hyperbole. This can be done only if the whole era is accused of laboring under emotional delusions which must be diluted by the historian. It is impossible to determine just when these self-described emotions were felt to the degree indicated and when they were merely delusions. Nor is it really necessary to do so, for all historical evidence depends ultimately upon description. Unless fundamental semantic distinctions are unearthed which threaten to revise the meaning of the original statement, it must be accepted as meaningful, even if imitative, self-induced or exaggerated. Experiences cultivated for the sake of a social or religious code—as, for example, the Puritan conversion experience in the seventeenth century—do not require evaluation as objective occurrences in order to point up specific attitudes and assumptions.

This point is emphasized because it is impossible to accept the continual emphasis on the moral efficacy of art objects, as threats or bulwarks to the established order, unless it is understood that the art experience of many travelers was so traumatic that they believed vision could exert permanent and radical influences on health, morals and politics. This visual sensitivity, partly the result of sensory deprivation and training in verbal description, did deteriorate as facilities for visual reproduction improved; verbal precision lessened as the century progressed, but it remained acute before the Civil War. Though this era was characterized by the deliberate cultivation of emotions, it was just this mixture of sentimentality with fresh visual discoveries that helped reinforce and perpetuate the American emphasis on art's moral and pedagogical values. Enshrined by the travel books, new attitudes toward art and its creators added to the intellectual baggage these tourists brought home, and helped lay the basis for new popular interest in visual design.

Although for many Americans the European trip was primarily an intellectual or a spiritual journey, its first and most

immediate impressions were unforgettably physical. The long, sickness-ridden ocean trips, particularly in the first half of the century, were uniformly described with such intense pain and repugnance that they must have acted like seals on either end of the European experience, bottling it up, allowing it to retain a freshness and discreteness by surrounding it with sterile, if hateful, obstacles. Washington Irving called the ocean a *"blank page,"* while Sanford R. Gifford exclaimed his delight "after the cold, stormy Atlantic," in feasting his eyes on "the rich green" of the English countryside.[6] The weeks of illness, fatigue, lack of food and sunlight, the seasickness which made death itself seem like a relief, and the ill-tempered and sometimes criminal behavior of captains and crews only made the sensory pleasures they suspended the more delicious when dry land, security and good food were finally reached. More rapid forms of transport had not yet allowed foreign travel to blend casually into ordinary experiences.[7]

Certainly, a sense of awe at the power of artistic Europe emerges from the pages of the travel books. Prepared for what they saw only by written descriptions, or through casts and reproductions, tourists described the actual experience as totally different from anything anticipated. A New Yorker spoke for a generation when he wrote in 1845 that Americans

> know nothing of what the brush can effect. We do not dream of the new sense which is developed by the sight of a masterpiece. It is as if we had always lived in a world where our eyes, though open, saw but a blank, and were then brought into another, where they were saluted by . . . grace and beauty.[8]

A visit to a great gallery revealed a whole "new universe." Europeans, familiar with art all their lives, could never understand the "astonishment of delight" the "tumultuous reaction of enjoyment" with which Americans greeted great works of art.[9] A clergyman viewing a Raphael Madonna felt in the presence of a miracle; it seemed like "the supernatural put into color and form."[10] Henry Tappan, standing in Antwerp's Cathedral at the foot of Rubens' "Crucifixion," perceived the power of art for the first time. We can read books, wrote Tappan, we can understand aesthetics, but "until we see with our

own eyes what art has done by the hand of the great masters,"
we can never know what art was like.[11] Henry Ward Beecher
discovered himself "absolutely intoxicated" in the Luxembourg
Gallery; he could not control his nerves, found himself "trembling and laughing and weeping, and almost hysterical. . . . I have
lived for two days in fairyland."[12]

The delights were so great that a few feared they would
become addicting. John Corson warned his readers that a trip
to Florentine galleries might produce a "mania after ideal
beauty." Love for art was a passion, an infatuation which grew
ever stronger. "Step by step you bring yourself to linger among
lifeless images for hours . . . You come to understand the secret
charm that led, perhaps, some cherished companion of your
boyhood to reject a more lucrative profession and grow solitary
and haggard in the confinement of a studio."[13] Plunged into this
new sensory world, many echoed Harvard President Felton's cry
that the "sight of these glorious works" formed an "epoch" in
their lives, never to be forgotten.[14]

Sculpture, buildings, vistas, and gardens caused rapturous
wonder also. The Riccardi Palace in Florence made one American feel "for the first time the power of architecture."[15] Henry
Ward Beecher, again, caught himself weeping at the sight of
Kenilworth Castle. "I had never in my life seen an *old* building.
I had never seen a ruin."[16]

Immersed in their raptures, many still took the time to
analyze the amazing effect of art; they were unexpectedly
puzzled. After all, it was not the first time they had ever seen
paintings or statues, and engravings had made some masterpieces quite familiar. The Reverend Orville Dewey, in later
years an active art publicist, was bewildered by the power of
the "Laocoön" and the "Apollo Belvedere." He had seen a cast
of the "Apollo" in the Boston Athenaeum, but the original
"arrested and thrilled" him "as if pierced with one of the arrows
of the god of light." Dewey found this reaction upsetting. "I
did not see why the cast would not give the general, the main
expression, intended to be conveyed by the original."[17] The
answer lay in the character of artistic achievement. The sculptor's marble was inimitable and the strength of the original
was therefore unique. Such experiences increased American
reverence for the gift of original creation and led to a growing

contempt for reproductions. "A copy must be a failure," wrote
Walter Channing. "Who can copy a mind? Nobody."[18]

The decades of distance and isolation which caused such
astonishment led also to a rediscovery of earlier, undefiled
techniques, the models for what suddenly appeared to be in-
ferior American copies. Henry Ward Beecher, visiting Oxford
in 1850, was struck with the embellishments carved of stone. The
cornices of old buildings were "not wood painted *like* stone, but
stone curled and carved," as if it were the easiest thing in the
world. Americans knew only decorations in wood, wax or plas-
ter.[19] Thus by the mid-nineteenth century, the adaptive tech-
nique, the convenient fraud of carving wood to look like stone
had actually become the norm; Beecher had never even realized
the nature of the imitated object; copies had blotted out the
model. Perhaps this was an aspect of the artistic barbarism
Jefferson had sought frantically but unsuccessfully to avoid.

Although it seemed logical to expect that copies could
transmit at least an object's shape, size and color, sometimes even
these qualities could not be conveyed. Scale, for example, re-
sisted transmission, and many tourists were surprised to learn
the effect of size in paintings. Large canvases conveyed some-
thing special; there was "a sense of reality in things of life-size,
or even greater than natural, which does not belong to and can
not be conveyed by under-sizes."[20] Emma Willard reached the
same truth about buildings, discovering that prized engravings
could distort dimensions. "When we meet in books the drawings
of different buildings," she wrote back to her seminary pupils
in Troy, New York, "each one is made to fill about the same
space on the paper, let it be great or small;—and we thus fail
to acquire these ideas of their comparative size," attainable only
by actual experience.[21] Students saw pictures of facades and
thought them like American colleges, long and narrow, whereas
actually they were often only the sides of vast piles.[22]

Engravings of buildings distorted further by leaving out
surroundings and the peculiar details which added to architec-
tural effect. George Hillard, author of one of the most popular
travel books, suggested that "to lie like an engraving would
be as good a proverbial expression as to lie like a bulletin." It
was not that dimensions or shapes were deliberately falsified, but
in removing minor details and seeming irrelevancies the total

effect became idealizing and untrue. "Every thing is smoothed, rounded, and polished. Holes are filled up, inequalities are removed," and a totally strange environment created.[23]

Discovery of these discrepancies increased respect for mind and artistic creativity. Uncontaminated nature, the standard of perfection for Americans at home, developed a competitor. God revealed His true greatness not through His own works, but through the man-made objects which He inspired. Cyrus Bartol entitled one of the chapters in his travel book "The Superiority of Art to Nature," while William Preston considered the "Apollo Belvedere" more stunning and overwhelming than the Alps or Niagara Falls, nature's most sublime achievements.[24] Bartol explained that art's triumphs were also nature's, but nature ripened and extended. "God has made the crude world first with his hands; but this secondary world of art—the flower of the first . . . he has made with his spirit, by the inspirations of genius."[25] True masterpieces were distinguished not by manual tricks or sleight of hand, but by a grandeur of mind. "A statue which is a genuine work of Art," wrote George Calvert, "cannot be appreciated, nay, cannot be seen, without thought."[26] When mind deteriorated, so did art. The reason Italian artists had produced so many paintings, Mrs. Caroline Kirkland suggested, was their belief that an "artist should be a man of learning." The test of immortality lay not in technical beauty but in the quality of reflection expressed.[27] "Neither in Art or literature more than in life, can an ordinary thought be made interesting because well dressed."[28]

The purpose of painting, therefore, was not to imitate nature's beauties but to present a great and original concept. "The great artists do not give us nature, but give us *themselves,*" wrote James Freeman Clarke.[29] If imitation had been the supreme goal, great paintings would have resembled each other; instead, each master developed his own characteristic style.

Here were the echoes of the position which Thomas Cole had defended against his patron, Robert Gilmor. The artist's primary function was to be true to his own conceptualizations, enriching natural views with personal insights. The American patron's insistence on literalism and verisimilitude would soon be condemned as the unhappy result of a limited experience with European art. These first, astonishing initiations into the

supreme achievements of great artists not only expanded the senses but forced new respect for the minds of the creators. Using the same materials as painters anywhere, surrounded by the same nature, a few men had produced works of special beauty. By increasing respect for the artist's creativity, European travel led Americans to place more importance on the ideal element in a work of art. This may account for the tremendous enthusiasm with which visiting Americans greeted their native sculptors at work in Italy, hailing efforts now considered banal abstractions as mighty evidences of genius. George Hillard saw Greenough's "Angel and Child" as an "Idea, embodied in a material form."[30] Calvert praised the same sculptor's "Washington" because it lacked the "insignia of temporary office." Washington was shown "not as he came from the hand of the tailor, but as he came from the hand of God."[31] The most popular sculpture piece of the era, Hiram Powers' "Greek Slave," was valued particularly for its ideality which shielded the onlooker from the sensual thoughts which the sight of a naked woman ordinarily provoked. Belief in the ideal was a defense against the appeals of realism, and to some extent a continuation of the old arguments Sir Joshua Reynolds had used when he spoke out against clothing heroes in modern dress.[32] Since it was easier to adopt this orthodox opinion in marble than on canvas, sculpture enjoyed great popularity among Americans, and they dominated that field more than painting; American artists had grown less innovative since the days of West and "The Death of Wolfe."

Although emphasis on the ideal sometimes allowed Americans to view nude figures with respectful attention, it did not legitimize most representations of the naked body. While travel forced some tolerance as visitors toured mixed groups of artists drawing from nude casts, and heard about the life classes at foreign academies, resistance remained surprisingly strong. A Puritan heritage was partly responsible for these strait-laced opinions, but fear of nudity was also the product of scarcity of representation. Appeals which seem slight today after the improvement of visual reproduction and the abandonment of several layers of clothing, were sharp and pointed in the early nineteenth century. Moralists demanding that sculpture galleries admit only sexually segregated groups were probably aware that

exhibitions of nudity at home often led visitors to deface naked statues. Tourists who praised the deportment of Europeans in art galleries were concerned not merely with the manners of their compatriots, but with the outrages art works suffered in America.[33]

As a result, nudity had few defenders. In the early part of the century some travelers made connections between Italian immorality and artistic taste, and one American suggested that exhibitions in the Louvre led directly to the high percentage of illegitimate births in Paris.[34] Young travelers to Italy were cautioned to protect their moral feelings, lest art displays shatter them forever. The purity of American youth seemed threatened by artists and collectors. Wilbur Fisk feared the day when naked Venuses would decorate American gardens and galleries, but he sadly admitted that many contemporaries would "sneer at the *squeamishness,* and *superstition,* and *vulgar destitution of taste,* which could object to these exhibitions. It is becoming fashionable with us to affect the European taste. . . . Be it so. I must do my duty."[35] A Virginian in Florence was willing to accept the nudity of the male figure, because of its natural "majesty," but he found that "a naked woman is positively unpleasant. . . . Modesty is an essential element of female beauty."[36]

The female visitor reacted most vigorously. Separated by a generation, Emma Willard and Jane Anthony Eames exhibited much the same fear and loathing of European tolerance. Horrified by the statuary in the Tuileries, Mrs. Willard told her students that only in America, "where the eye of modesty is not publicly affronted," can "virgin delicacy walk abroad without a blush."[37] Her sister traveler was not opposed to nudity as such, but raised her voice, "against having pictures exhibited that a daughter would blush to look at in the presence of her father."[38] It might be noted that some of the French and German art which aroused her distaste was close to pornography and still seems deliberately sensual. And in one area, ancient statuary, more mature judgments began to appear. The Reverend Henry Bellows pointed out the different significance the human form possessed in Periclean Athens. No distinction was recognized in the classical era between the soul and the body, he explained; thus the body itself represented the height of beauty and

meaningfulness. Marble sculpture, moreover, cooled the passions instead of exciting them, "for it took away the color and the warmth with which the nude was familiarly seen."[39] Other Americans agreed the appeal of color was so strong that the plain, white marble of the sculptor was much less threatening than the painted nude.[40]

While resistance grew more qualified, it hung on, and even free-wheeling millionaire collectors at the end of the nineteenth century stowed their respectable nudes out of sight. Americans did prepare to allow the artist greater latitude in his work, and life classes were gradually admitted as a necessary, if unpleasant, part of his professional preparations. But European experiences undoubtedly induced more tolerance than could survive permanently, and it is instructive to compare the approving comments of studio visitors on Horatio Greenough's half-nude, Washington, with the shocked reactions which greeted its arrival in America. Those who had just come from the Academy or another Florentine gallery were hardly even aware that the statue represented the first President in an immodest way; at home the visual shock was much greater, and the voices of disapproval much louder.

The growing respect for mind and creativity, and the grudging acceptance of artistic license, were less significant results of the pilgrimages than the knowledge that art objects were powerful means of bringing men to God. Described reactions bore amazing resemblances to the accounts of religious conversions which had filled the pages of American diaries and letter books for centuries. The religious tone of these art experiences was emphasized by the many clergymen making the trip abroad. Ministers like Henry Ward Beecher, Wilbur Fisk, James Freeman Clarke and C. A. Bartol fell back naturally on their trained vocabulary to record their inmost thoughts. They found in the masterpieces of European art a new proof for the existence of God, and slowly began to move toward an alliance with the artistic enterprise.

Henry Ward Beecher's comments were representative. He reported that he left the Louvre uplifted, but with a greater sense of personal sin than when he entered. This corresponded neatly with the period of doubt, frustration and personal contempt that generations of New Englanders had evolved as a

conversion formula. "O, with what an outburst of soul did I implore Christ to wash me and all whom I loved in His precious blood," he wrote. Surrounded by man-made beauty, "all my sins seemed not only *sins,* but great deformities. . . . insults to my own nature."[41] Ugliness and immorality could be synonymous, and the presence of the one invited the other. Great paintings of sublime beauty were enough to convince honest men of religious truths; faced with such sublimity, who could doubt "of there being a God, a Heaven," or even "an immortal life," exclaimed C. A. Bartol. The "argument for religion . . . which was offered to my mind in the great Madonna of Raphael, cannot fail."[42] Experiencing art produced not only a sense of exultation, an "all in a glow" as Horace Bushnell put it, but invited refined judgments and stimulated renewed energies. An hour in the Pitti Palace led to invigoration: "I know that it must be a benefit to me, as regards writing and the conduct of life, to have dwelt in such an atmosphere."[43] Art could propagandize, but this was only to the good, for it could produce arguments as amenable to Protestantism as to Catholicism.

Ministers had no monopoly on conversion experiences or the rediscovery of religious truths. The argument from design also affected laymen. "In surveying the works of these great painters, architects and sculptors," wrote William Gould, "I have a thousand times been impressed with the most overwhelming convictions of the immortality of the soul."[44] Had there never been a Bible, had there never been a series of direct revelations demonstrating God's existence, this would have been sufficient. It was no wonder that Henry Ward Beecher vigorously defended the role of art objects. God has "ordained a usefulness of the beautiful," Beecher explained to the doubters; beauty meant education. Christians had "not only a right of enjoyment in the beautiful, but a duty . . . of producing it, or propagating it, or diffusing it abroad through the community."[45] He who made the world, agreed Harriet Beecher Stowe, was "no utilitarian, no despiser of the fine arts, and no condemner of ornament."[46] Every instinct was God-given, including the desire to adorn; in a higher religion men would refuse to shun beauty "as a temptation, but rather offer it up as a sacrifice to Him who has set us the example, by making everything beautiful in its season."[47] The fine arts, concluded the Reverend Orville Dewey

in phrases which would have startled eighteenth-century clergy-men, "have been the handmaids of virtue and religion. More than half of the great paintings in the world are illustrative of religious subjects."[48]

The conversion of the clergy to the cause of the visual arts was one of the most important results of the European pilgrimage, and many ministers would eagerly support native artists when they returned home. For them, as for laymen, art's greatness lay in its capacity to produce gigantic emotional reactions, to bathe the spirit in moods of exultation, belief and love. It was natural, therefore, for many Americans to be unimpressed by the picture galleries of Holland, dominated by paintings uninspired by religious visions and incapable of producing them. Tourists praised Potter, Ruysdael, Cuyp and Snyders for their accuracy, but accuracy was irrelevant if exercised only on peasants, cows, fruit and flowers. Dutch galleries produced pleasure but not wonder. "The imagination remains unexcited, the sensibilities dormant; and Art that but confers a momentary pleasure . . . has fulfilled but half its office."[49]

Absorbed in their own emotions, travelers began to place a new value on incompleteness, reflecting unconsciously contemporary romantic ideals. High, religious-like ecstasy depended on mystery and subtlety. A picture needed to suggest "something more than it tells," James Freeman Clarke explained.[50] The gothic seemed appropriate for religious architecture precisely because it had less finish and definition than classical forms; its fragmentary, tentative qualities suggested the infinite, as religious buildings were expected to. Harriet Beecher Stowe liked its rudeness, a "something inchoate and unfinished" which symbolized "matter struggling witth religious ideas too vast to be fully expressed."[51] The gothic could never be mastered all at once, for it was "as deep and rich as human nature itself," wrote Hawthorne. Greek temples he found less interesting, "being so cold and crystalline."[52] Even the Düsseldorf painters, so long popular among American artists for their superb technical abilities, drew the fire of visitors who felt this very mastery blotted out ideas. "The Düsseldorf school always strikes *twelve*," complained Walter Channing. "You see the brush and the palette. You see not the mind, the soul of the painter."[53]

Fears of sensual appeals made American travelers empha-

size the ideal; boredom with the monotony of clear outlines and symmetrical facades made them prefer the indistinct gothic; and contempt for the flimsy buildings they found at home molded a desire for age and durability. Great forts, cathedrals, palaces and walls gave a sense of strength and security. Again and again reports of awe filtered through as the tourists gaped at monuments which seemed to possess immortality. Henry Blake McLellan was awe-struck by the dark strength of the Collegiate Church of St. Gudule in Brussels; even with the scars it bore, "its giant frame will yet endure the ravages of many ages, standing firm, while all that now surrounds it, may lie prostrate, a wreck of ruins."[54] Americans who had seen "nothing more venerable than perhaps some moss-covered shingle fabric of fifty or a hundred years' standing," were deeply moved by the remains of older eras, and their testimonies to departed greatness.[55]

In the end, however, despite the competing attractions of size, age and ideality, it was the primitive appeal of color which most aroused American visitors. Their lack of flesh tints allowed Greek nudes a minimum of toleration, and American visitors hurled their choicest abuse at an English sculptor, John Gibson, who followed tradition in painting his figures.[56] Some travelers were kept in a continual state of irritation by the faded glories of old paintings; Hawthorne could hardly bear to look at them if the original colors were gone.[57] Painters' studios were more inviting than sculptors' precisely because they had "color, warmth, and cheerfulness," from the "glow of some picture resting against the wall."[58] The unspoiled colors of stained glass provoked astonished raptures. "What a flood of glory here burst on the sight," exclaimed a Connecticut minister; "it seemed like a scene of Arabian enchantment."[59]

The conscientious manner in which the visitors toured as many public and private galleries as possible sharpened the development of artistic preferences and increased sensory tolerance. Americans realized that trips to Europe occurred only once in a lifetime, and in the prephotographic era this formed their only opportunity to confront art literally. Many acted from a sense of duty to their self-education, or from a desire to duplicate or outdo the touring achievements of famous compatriots; as a last resort, such conscientiousness allowed them to

fill the pages of their travel books. Jonathan Russell, President
Monroe's ambassador to Sweden, was more energetic than most,
but his energy was representative; in six months he saw collec-
tions in Stockholm, Berlin, Dresden and Vienna, before tour-
ing churches and palaces in dozens of Italian cities. He cele-
brated his reception by the Pope in March, 1819, by visiting
the palaces and villas of Borghese, Rospigliosi, Mattei, Simonetti,
Doria, Albani and Ludovosi.[60]

Russell's accomplishments were contagious, and some
travelers saw so much that they claimed not to care whether they
ever again looked at another painting or cathedral. Wilbur
Fisk, bubbling with enthusiasm at the start of his trip, com-
plained eventually that palaces with their huge, empty rooms
were not worth visiting except for their galleries, and even
these paled after a time. "There is an endless repetition of the
same subjects, some of them disgusting enough, and others lose
their interest . . . by comparison," Fisk admitted sadly.[61] An-
other traveler got so tired of old masters that she promised if
"a general conflagration of all the Holy Families were proposed,"
she would save from the flames only those of Raphael, Guido,
Carlo Dolce and Andrea del Sarto.[62] "Pictures by the mile" were
difficult to enjoy.[63] This fatigue, which is readily comprehensible
after so many months of concentration, did not occur too often
in travel literature, and was generally accepted with resignation
or feigned optimism. Boredom was a necessary evil which
would eventually disappear.

Much more disturbing than fatigue was the failure of some
travelers to experience the expected emotions of reverence, love
and self-elevation on confronting masterpieces. There were many
whose experiences matched their hopes, or whose hopes were
matched by their experiences. But others learned that art en-
counters might be more complex and less satisfactory than they
had imagined. Their puzzlement led to a number of interesting
speculations about the nature of art, and sometimes to funda-
mental reassessments. After the Civil War these disappointments
were codified in an I-know-what-I-like creed, which often
enthroned ignorance and insensitivity and helped strengthen a
condescending attitude toward creative efforts. Its most endur-
ing monument was Mark Twain's *Innocents Abroad*.

But Twain's self-assurance and even arrogance would have

met little response in the first half of the eighteenth century. Disappointed hopes led to disgruntlement and discouragement, and occasionally to loudly voiced suspicions about the truths of *any* of the rapturous experiences other travelers encountered. But the tone of these critiques was muted; this generation of tourists, brought up on the classics of art history, could not turn its back entirely on traditional reverence. Their comments reveal painful self-examinations, as they sought to discover reasons for what seemed to be personal failures.

A variety of explanations was offered. Some who came eventually to worship European art, warned readers that the "visitor who expects that the beauties of great painting will strike him vividly like a flash of lightning" would inevitably suffer keen disappointment.[64] Only a few gigantic works, confessed W. M. Gillespie, could yield immediate rewards, and most art required deep study and a special education for true pleasure. Painting was, after all, a new language which the traveler had to learn letter by letter.

Other tourists offered encouragement to those who met obstacles. A traveling physician, Andrew McFarland, exulted that he was "reaping and harvesting the highest reward that ever repays the traveller," but he admitted that the early days had been discouraging. He was extremely disappointed on first seeing the "Venus di Medici" and thought it far inferior to Hiram Powers' "Greek Slave." But he returned the next day and discovered that he liked the Venus; by his final visit he adored it. "I should now be ashamed of my first inappreciation of this embodiment of beauty, if I did not know that in real, as in still life, *true* beauty never carries the heart by storm."[65] Such comments revealed a natural American conservatism, a conviction that the subtleties of great art required gradual savoring and a wider education in the principles of art. They even implied that painters who attracted immediate admiration were actually resorting to technical tricks, unworthy of true genius.

But increasingly, Americans who had problems in appreciating art blamed their troubles on the overblown reputations and the counterfeited emotional reactions of others, rather than on their own personal ignorance or impatience. When Harriet Beecher Stowe arrived at the Louvre, she ascended to the picture gallery in a flutter of "excitement and expectations," glancing

around quickly to see if any picture could "seize and control my whole being, and answer, at once, the cravings of the poetic and artistic element. For any such I looked in vain. . . . Most of the men there had painted with dry eyes and cool hearts . . . thinking little of heroism, faith, love, or immortality."[66] Only after moderating her hopes did she discover painters like Claude, who satisfied her needs. But she remained uncertain about the spontaneity of her admiration. Most people, after all, admired "what has prestige and sanction"; her own pleasure may have been based on a need to feel the appropriate.[67] Mrs. Stowe felt it vital to be sure that her response was genuine and not imitative, but such validation seemed impossible. If not prestige, perhaps familiarity led her to enjoy the old masters. We "can bring our taste to any thing, if only we know we must, and try long enough. People never like olives the first time they eat them."[68] Mrs. Stowe did not carry the logic of her argument further, however, and invalidate a preference for olives simply because it was an acquired taste. Somehow, the same acquisition seemed spurious when it involved works of art.

Armed aggressively to discover their true preferences, suspicious of "old, black, smoky Poussins," insisting that artists must display great thoughts and not merely superb techniques, many travelers were doomed to disappointment and returned home viewing all the visual arts with suspicion and hostility, as sources of fraudulent exaggeration.[69] Mrs. Stowe did not go this far; she was able to build up the moderns at the expense of the old masters, and to console herself that despite the dour criticism of experts art was advancing; the art lover could hope for grander ideals and conceptions from American artists, if they would turn back to God's Nature.[70]

Others, like Nathaniel Hawthorne, were unable to maintain her compromises. His notebooks poignantly illustrated the problems of a well-read and conscientious would-be art lover in communing with the objects of his affections. In them lie revealed the torments of a man whose expectations had risen so high that they could never be fully satisfied, and whose resulting bitterness led him to view art and artists with suspicion and occasional hostility.

The first thing that bothered Hawthorne in his European visit, was the spectacle of many works of art gathered together

in one gallery. Asserting that a room should never contain more than one picture, he termed painting galleries "the greatest absurdities that ever were contrived."[71] He feared the expenditure of energy involved in choosing just which picture deserved his attention; it was so easy to make a mistake.[72] High hopes would then come crashing to earth. Like Mrs. Stowe, Hawthorne feared the layman could never be certain just which attitudes were his own. Paintings made great symbols, but if they meant one thing, they also meant "a thousand, and, often opposite things." Good pictures left the spectator nothing to do, but a bad one "stupifies, disenchants and disheartens him."[73] For this reason Hawthorne, like others in his generation, preferred the drawing, the first sketch, the forecast whose greater suggestiveness gave the viewer freedom to maneuver the artist's intent; the finality of a finished idea repelled by its very completeness. It seemed to demand one special type of reaction, and Hawthorne never knew just which it was.[74] This formed one of the reasons why so many enjoyed the mobile mysteries of the gothic.

Torn by such anxieties, Hawthorne often found connoisseurs and artists fraudulent. Meeting George Loring Brown, a New England landscapist who lived in Florence, Hawthorne noted approvingly that "it is not often that we see an artist so entirely free from affectation in his aspect and deportment."[75] Glancing about a British gallery, he reflected that not half a dozen viewers got the enjoyment art was intended to produce. "Very respectable people they seemed to be, and very well behaved, but all skimming the surface, as I did. . . . It seemed like throwing away time to look twice even at whatever was most precious."[76] It was all or nothing; either a work of art exalted the spectator to heights of feeling or it was valueless. There lay no point in between at which viewer and object might compromise.

Certain that most connoisseurs lacked "deep, poetic feeling," Hawthorne was happy to accept the observation of Hiram Powers that a taste for painting and sculpture was often the property of the unprincipled.[77] A genuine love of art, Hawthorne reflected, "distinguished men capable of every social crime," perhaps because such tastes were "artificial, the product of civilization, and, when highly developed, imply a great remove from natural simplicity."[78]

Attacking modern sculpture and the value of portraits, Hawthorne paid scant respect to another quality which appealed to many Americans: venerability.[79] Artists may say what they like, he wrote, but "I know no drearer feeling than that inspired by a ruined picture, —ruined . . . by time, damp or rough treatment,—and I would a thousand times rather an artist should do his best toward reviving it, than have it left in such a condition." Landscapes which were "lustreless" were particularly repugnant, for when the colors dulled there was nothing left but a shell. As a result, Hawthorne found himself attracted by bright, modern pictures more than by the old masters, and he attempted to relieve in aggressions his feelings of guilt and hostility: Cimabue's "Virgin" should be "reverently burnt," for it had served its purpose, and pious preservation did more harm than good.[80]

But despite his suspicions of nudity, his jealousy of the immortality given painters and sculptors, his insistence upon perfection and his disparagement of the old masters, despite all such conflicts—and perhaps because of them—Hawthorne still feverishly sought the pleasures of pictorial art, and grasped at any straw to convince himself that he might yet become a true connoisseur. His ability to distinguish between Rubens and Rembrandt he found heartening. "It is a hopeful symptom, moreover, of improving taste, that I see more of merit in the crowd of painters than I was at first competent to acknowledge," he wrote excitedly. Perceiving defects was "the earliest stage of connoisseurship," and he had now climbed a few steps higher.[81] But he brooded about the time and energy which improvement required, and wondered whether others were more fortunate in finding beauty. Change was fine, but "I am still . . . a very sturdy Goth," he concluded. Possessed by a need to love art, guilt-ridden by fears that he admired it insufficiently, searching for improvement while disclaiming the need, scribbling dozens of contradictory sentences strung together, Hawthorne seemed like a saint doubting his own canonization.[82] He tried to invite the muses to take by storm what kinder invitations had failed to achieve.

Hawthorne's creative resolution of his art problems is the task of his literary biographer to relate.[83] But these experiences —intensified as they were by a sensitive temperament, and

articulated because of literary skill—symbolized the anxieties which beset other travelers. The tourist's encounter with art was not monolithic, and yielded both hells and benefits. Some Americans reluctantly admitted that famous art works exerted no pull on their emotions, and labeled the raptures of others humbuggery. The alternative to self-analysis lay in feigning the appropriate reactions. Some probably hid their indifference behind phrases of enthusiasm, but many others, like Hawthorne and Mrs. Stowe, were more honest if less compromising. Frequent veiled warnings hid unresolved doubts. James Freeman Clarke, an apparent enthusiast, revealed some of the dangers in the rules he outlined for future travelers. The secret formula was faith. Take galleries slowly, he advised compatriots, and place confidence in the judgments of generations. This was the only means of countering the quick despair that so often set in with the first disappointments.[84] Clarke's enthusiasm disguised a situation filled with frustrations for the unwary or the independent.

European travel, then, produced two opposing traditions which influenced the nature of artistic support in the United States. Disappointed art seekers returned from Europe convinced that the romance and grandeur surrounding the arts was the product of overenergetic and disordered imaginations. The discrepancy between reality and expectation led them to evaluate all art—native and foreign—by the immediate response. Many dismissed as irrelevant the need for informed criticism, because it seemed to have little to do with their own reactions. As the habit of travel spread and respect for traditional authorities diminished, this lack of communion became more common. The growth of travel, ironically enough, probably produced more intensive dissatisfaction with artistic expression than earlier, less-traveled, though more erudite, generations felt.

But the larger number of tourists who returned home after exciting involvements with painting, architecture and sculpture were natural publicists for the cause of the the visual arts. With their fondest dreams realized, they sought to convert the wary or unenthusiastic. Like their disappointed countrymen, they insisted that art justify itself by producing some vibrantly significant personal encounter, but unlike the frustrated travelers, they claimed actually to have experienced such reactions.

Sensory education acquired in European travel produced staunch friends and bitter enemies for the American art world; it did not allow for benevolent neutrality or indifference. But although the single requisite of any art philosophy may have been the emotional experience, Europe's art achievements led many Americans to a new consideration of the institutional power of art, used in appropriate settings and for social and political purposes. Emotional excitement produced intellectual commitments, as many Americans abroad probed still more deeply into the uses of art.

European Travel: From
Perceptions to Conceptions

❦

CHAPTER SIX

FOREIGN TRAVEL, BESIDES GALVANIZING interest in works of art and stimulating excitement about individual masterpieces, also allowed Americans to analyze the relationships between art and society. European experiences dissolved certain assumptions about the dangers of high art and prepared support for schemes of cultural regeneration at home. Many Americans learned abroad to look at their own country for the first time, and many were unhappy with what they saw. Out of their sense of native deficiencies grew a new respect for European institutions and commitments to the artistic enterprise in America. Americans once had idealized individualism and pluralism, attempting in their polity to control the effects rather than the causes of faction; they now sought new means of engineering consent and molding the opinions, as well as the actions, of their fellow citizens.

One of the major bars to American Protestant enthusiasm about art lay in its uses by alien faiths. The greatest of all European patrons—the Roman Catholic Church—tainted all religious art. Travelers early in the century echoed ancient fears about the power of crafty priests and cardinals cunningly exploiting the greatest talents in history for their own purposes. Matthias Bruen warned Protestant visitors in the 1820s that they could keep their religion undefiled only by "a continual watchfulness" on their senses.[1] The splendor of papal ceremonies demonstrated that "the perversion of divine religion in the Romish church" had originated "in the substitution of appeals to the senses, in the place of the simple forms which belong to genuine Christianity."[2] Samuel F. B. Morse, who spent much of his life fighting an imaginary Catholic conspiracy to take over the United States, warmed to the problem of religious art while visiting Milan Cathedral in 1851. He compared the Church with the theater and reflected sadly on the grief and falsehood dis-

146

seminated by his professional colleagues. Sometimes he even doubted the "lawfulness" of his own art when he perceived its religious prostitution. When "used for its legitimate purposes," painting "was one of the greatest correctors of grossness," and deserved cultivation. Nevertheless, since "man is led astray by his imagination more than by any of his other interests," Morse condemned the custom of introducing pictures into churches. He would "rather sacrifice the interests of the arts," than risk endangering the souls of millions.[3] The very subjects of religious painters were offensive and impious. The Bible's images, wrote Benjamin Silliman indignantly, "are sufficiently distinct, without the aid of the pencil. . . . There seems to be a *licentia pictoria,* as well as a *licentia poetae.*"[4]

While some anti-Catholicism persisted, the flavor of admiration increasingly mingled with the traces of suspicion in comments on Roman ceremonies and services. Fanny Hall, making her tour in the 1830s, visited a Catholic church in Lyons bedecked with flowers, sculpture and paintings. Everything in the building, its music, images and incense, was designed to lead "the senses captive." But, Fanny Hall qualified, "let me not be understood to condemn the religion of another."[5] By the time she reached Rome and stood before Raphael's "Transfiguration," tolerance had become admiration. "I involuntarily caught myself saying, 'Are the Catholics wrong in placing pictures in their houses of worship as a means of increasing their reverence and veneration for the Deity?' "[6] The question needed no answer; its presence alone indicated a profound change of mind.

Other Americans who felt a growing respect for Catholicism included Charles Godfrey Leland and Francis Parkman. Leland wrote from Munich that he liked to go into Catholic churches. "You can have no idea of the sublime magnificence of a Catholic Cathedral. . . . The Catholics in *my* humble opinion are much abused. . . . It may be that in my passionate admiration of the Arts I see the Catholic Church a protector of the Fine Arts."[7] Francis Parkman reflected in Italy that Catholic churches had instilled in him new ideas of their religion. He had always reverenced it as the belief of "generations of brave and great men—but now I honor it for itself. They are mistaken who sneer at its ceremonies as a mere mechanical farce; they have a powerful and salutary effect on the mind."[8] And the violated

beauties of English cathedrals, stripped of their incense, paintings and sculpture, allowed Grace Greenwood to sympathize with the Puseyite reaction. "If we are to have a religion of form," she wrote, "let it be the perfection of form. . . . if we are to worship through the outward and visible, let at least our types and symbols be beautiful and harmonious."[9]

Travelers insisted that Americans who had not visited Europe could never evaluate Catholic pomp. "I am no Catholic," said Henry Colman, "but, from any thing which we have seen in our country, we can form no just conceptions of the splendor and beauty of their ritual here."[10] Happy were they whose faith needed no physical support, wrote others, but most people did require relief from worldly sorrows and disappointments. "Surely, if we could bring home but one thing from Europe, that one thing should be a cathedral."[11] "Oh that we had cathedrals in America," echoed Hawthorne, "were it only for the sensuous luxury."[12] It seemed a pity that Protestants had ignored the possibilities of paintings as appeals to religious sentiments. "What an influence pictures might have upon the devotional part of our nature," Hawthorne mused, contemplating a Domenichino "St. Sebastian" in a Roman Church.[13] "Whose mind would not be touched," asked the Reverend Orville Dewey in a similar situation.[14] The Protestant reaction to Romish idolatry now seemed exaggerated and harmful. It was time, concluded Harriet Beecher Stowe, for the "forming of a new school of art, based upon Protestant principles."[15]

Not every traveler gained insight into the power of visual appeals, or respected their American potentialities. Morse remained hostile through the 1850s. Daniel Eddy wrote scornfully of the Madeleine in Paris, with its gold and glitter, "its richly wrought robes and its decorated priests, which utter its appeals to the passions and the imagination."[16] Others condemned even Anglican St. Paul's as a monument to pride and material splendor, "a vast heathen temple" unfit to be the center of a religion founded by a poor carpenter.[17] But a growing majority took the position of Bayard Taylor, that those who "oppose everything which can refine and spiritualize the nature of man, by binding him down to the cares of the work-day world alone, cheat life of half its glory."[18] Occasional excesses and

perversities were the result, not of artistic deceit, but of bad taste.

In an age of utility and moral declension, Protestantism could not afford to sacrifice *any* means of communication, even those prostituted by others. Temptation was so powerful that "nothing is so small as to be rejected."[19] Art and religion were not merely compatible, but interdependent. While religion needed art to grasp the worshiper's senses, to encourage his approach to the throne of God with the appropriate awful respect, artists required religion to reach their full potentialities; great art was impossible without a supporting consensus of belief. An age without faith and love, George Hillard wrote, could produce nothing great. When the Sistine frescoes were painted, religious values were strong. This faith was the secret of the frescoes' power, forgotten in the intervening centuries when "religious adherence has been lowered into artistic admiration, and the homage has been diverted from that which inspired the genius of the artist to the genius itself."[20]

Travel experiences emphasized the teachings of Ruskin and the Pre-Raphaelite Brotherhood, which had already struck responses among American art lovers. Charles Eliot Norton decided in Europe that the decline of art dated from the time when "artists began to work for purely worldly ends."[21] Accuracy and effectiveness increased, but they contained the seeds of decay. This new emphasis led Americans to approach Pre-Raphaelite artists with a fresh interest, though few actually collected any before the Civil War.[22]

Surrounded as they were by civilizations which had produced centuries of masterpieces and yet could create only the most vapid and inferior imitations in modern times, American travelers inquired into the causes of decay. The major determinants seemed a decline of simple religious faith and the loss of political freedom. But the Roman Church, although a conspicuous villain, was not totally blamed. The mercurial temperament of the Italians, for example, suggested that they needed gorgeous ceremonies and sensual appeals as stimulants to worship, and these needs the Church had attempted to fill. With all its defects Catholicism had managed—through its pageantry—to keep the masses practicing Christianity. Americans

who "never before realized the effect of church architecture upon the mind," now insisted that "every allowance is to be made for the effect of habit and for the established customs of a country."[23] Institutions could not be praised or condemned without some understanding of the part they played in the life of the community, and what seemed like excess and degradation from a distance often turned out to mean restraint and elevation in actual practice.

The new sympathy for sensory appeals induced American travelers to redefine their notion of art as a form of egotistical, wasteful self-display. A Boston merchant visiting Europe in 1815 still shared the sentiments of John Adams in reflecting that the Royal Mews in London cost more than did President Madison's salary. Americans should appreciate "the simplicity of the establishment of their own government," he concluded, "which has excluded this useless waste of money."[24] Versailles and St. Cloud stimulated comments of pity for the French populace, "roused to revolt at the extravagance and wasteful expenditure of money so lavishly thrown away in decorations. . . . This Palace, with its immense gardens, walks, fountains of bronze, statuary of marble," cost France more than two hundred million dollars, some calculated.[25] Wilbur Fisk charged that the government of Tuscany cultivated the fine arts at the expense of the comfort, education and diet of the poor.[26] Even in the 1850s, a minister visiting Westminster Abbey conceded the monuments their splendor but damned them as unnecessary and extravagant. Far better to spend money on schools or public improvements. This was not "national glory! rather national disgrace. I cannot look upon these things with pleasure. Am I really without taste or patriotism?"[27] Nevertheless, the Reverend Mr. Trafton proclaimed his delight with the public gardens and sculptured retreats of European cities, hoping for the day when "the fever for money-making abates," and Americans would turn some of their energies to the cultivation of art.[28] Something was happening when conservative clerics could couple economy and pleasure as basic human needs.

This shift of opinion is summed up neatly by two American descriptions of the Medici Chapel, made just ten years apart. Covered with marbles, mosaics and precious stones, the Chapel was a symbol of wasteful tyranny to Wilbur Fisk in 1838. "It

is thus that for mere purposes of pride and show princes impoverish their subjects, and . . . exhaust the resources of the country," he charged angrily.[29] But by 1848 another visitor, Mary Jane Eames, saw the tomb as a different sort of symbol; it marked a devotion to spiritual and aesthetic values which rose far above vulgar materialism. The Medici Chapel, she reported, would cost more than ten million dollars when completed. "What should we think of a church like that in our country? Our fellow-countrymen are too much engaged in speculation and trading, to think of investing their money in any other way than will be for their immediate profit."[30] Objections to such magnificent extravagance were now merely mean and penny-pinching; superfluous expenditure, once condemned as wasteful, was now the proof of a desire to adorn, the emblem of an anti-utilitarianism badly needed in America. What American, asked Horace Greeley, "ever thought of spending half an immense fortune in the collection of magnificent galleries," and then quietly opening them all to the public, "without expecting a word of compliment or acknowledgement in return?"[31]

Even great private establishments like Chatsworth House excited admiration and respect. Henry Colman discovered that one wing alone cost seventy-eight thousand pounds, but the pleasure it would supply for centuries was worth much more; indeed "hardly any expenditure could be deemed excessive."[32] Colman made his visit with a New Englander who, for all his traits, might have been a relative of John Adams; but he found repellent the Yankee's constant questions, his desire to know "how much it cost, and whether it could have been made cheaper, and whether it could not be sold for more than it cost . . . as though every good in life was to be estimated by a mere pecuniary standard." Men should regulate their expenses, Colman allowed, this was only common sense; but if a man possessed ample means, what did it matter whether he spent little or much.

> Wealth, with us in New England, seems an exclusive matter of pursuit and acquisition. I hope those who get it will presently understand, that there are, besides . . . two other very good purposes . . . use and enjoyment.[33]

The shift in favor of conspicuous expenditure within

America was aided by travelers who understood, perhaps for the first time, that large sums of money could be expended gracefully and pleasurably, without guilt or apology. Gentlemen of wealth showed off their beautiful homes, their collections of masterpieces, their parks and gardens as badges of honor, tributes to their willingness to give up hard-earned gold for beauty. Under such impulses the most sacred American traditions came under suspicion. "I am no advocate for entail or the preference of the eldest son," Elias Hasket Derby asserted, "but yet would ask is not accumulation viewed in America with too much jealousy?"[34] European wealth accomplished so much good, it seemed trivial and selfish to complain about great fortunes. Travelers moaned that America would have no great art until she had more men of wealth, and until they allowed themselves more leisure for the cultivation of beauty.[35]

Further evidence of this changing attitude toward wealth and consumption lies in the ridicule heaped on the American art buyer, criticized because of his shrewdness in driving artistic bargains (particularly with young countrymen studying in Rome or Florence), unwilling to part with an extra dime though he could easily spare it. At one time this watchfulness would have been praised as virtuous thrift, but by mid-century it had been transformed into greedy and self-assertive stinginess. Travelers enjoyed popularizing the anecdote about a wealthy but ignorant American tourist who visited the studio of Hiram Powers and saw a copy of "The Greek Slave." Inquiring immediately about its price, he was informed that it cost three thousand dollars. His startled response, "Why statiary is riz, ain't it?" provoked gales of raucous laughter.[36] Artists and sophisticated travelers portrayed such consumers as crude, bumptious, arrogant fools who would stop at nothing to get what they wanted. They sought "landskips, internals, insides" for their mantels back home.[37] Henry P. Leland created for his travel memoirs a character named Cyrus Shodd, who, with his wife and daughter abetting him, tried to get a portrait which an American painter refused to sell. Self-educated, mercenary, his conversation was rambling and self-contradictory. At one moment admitting his artistic ignorance, at another moment touting his townsman, Hoskins, who "knows more than any of your 'old masters,'" Shodd coupled his regrets at poor schooling with observations

that scholarship was folly. "Unfortunately," Leland concluded, pricking an old American balloon, "self-education is too often only education of self!"[38]

Other travelers pitied their provincial countrymen who came abroad with their hearts left in the counting house, many of them "what the Methodists call 'anxious inquirers' in regard to art, and . . . too often the victims of dealers in oil paintings . . . they are generally better judges of canvas-back ducks than of canvas."[39] A typical example was Lycurgus Sempronius Josiah Clapp, who promised Thomas Crawford that he would describe the "elegant effigies I have seen . . . and I'll get somethin' put into the newspaper of our destract tew." But, he told the sculptor, "I hope you ain't goin' to stay long in this benighted country!"[40]

The virtues of shrewdness, thrift, self-education, curiosity, lack of deference, badinage—traditional attributes of American individualism—suddenly appeared contemptible and inappropriate in the genteel atmosphere of the European art world. Purse strings, like emotions, were meant to be looser than in America, and men who never purchased art before found themselves ordering paintings and statuary in Florence. Nevertheless, complained one painter, they returned home only "to plunge again as soon as possible into business, politics, or speculations." When the artists to whom they had gushed sympathetically took them at their word and came home, they found only neglect and indifference instead of counsel and support. Such travelers had no love of the beautiful, only a "love of ostentation. . . . They purchase a picture by a popular painter of the day, as they go to a fashionable tailor for their coats."[41] Indulgence in portraiture, under such criticism, seemed like an assertion of egotism and materialsm. One of the glories of art, said one traveler, was transcendence of individuality: "It is the very antagonist of petty egotism. How absurd then for private persons to order their own busts, and expect immortality as a reward."[42] Laymen could begin to share artists' disdain for the portrait, and understand their longing for higher things.

Transformed attitudes toward Catholicism and extravagance were part of a larger concern with the connections between national life and its physical symbols. Visitors refused to consider art objects in isolation; everything had necessary ties with

the nation's temper and political history; they reflected or
diffused ideals.[43] The indifference to the political and social
value of visual stimuli of the Revolutionary era vanished for-
ever, and familiar American landmarks were reassessed according
to the new scale of values.[44] Even descriptions of European
cities reflected the new concerns, as travelers sought to explain
how and why they differed—as physical entities—from their
American counterparts. Henry Tuckerman spoke of "a kind of
natural language in cities as well as in individuals," which
"produces a spontaneous impression upon our minds."[45] For one
thing, European cities seemed smaller than they were; Augustus
Gardner laid this down to a uniformity of structure, material and
color. "In our cities, the red brick, white spires, and wooden
buildings variously painted, not only render the *coup d'oeil*
bright and lively, but by their diversity communicate an impres-
sion of extent which does not belong to them."[46] Benjamin
Silliman, who had sharpened his perceptions by studying
American city design, accounted for misleading impressions by
the higher and more compact European houses, which contained
many residents. Thus Greenock, in Scotland, with four times as
many people as New Haven, looked much smaller, and Edin-
burgh paled alongside Philadelphia.[47] Sensitive to color, Ameri-
cans reacted quickly to the duskier, dustier and duller hues
predominating in European towns. The coal dust which dark-
ened buildings in London and Liverpool elicited universal
comment; American cities were brighter and gayer, travelers
agreed, but also less substantial.[48]

 The irregularity and picturesqueness of European cities
was a pleasing relief after the more monotonous geometry of
those at home. John Durbin, visiting Amsterdam, noted that
the roof line was not, as in America, a long range of unbroken
eaves, but consisted of a series of independent fronts punctuated
with turrets and ornamental gables.[49] Another American, this
time in Rome, was delighted by the variety of silhouettes;
nowhere was there the "formal horizontal monotony of our
blocks of buildings." To the irregularity of the city's surface,
towers, domes, obelisks and columns had been added as "Rome
shoots out into the gulf of the sky a great number of capes and
promontories." The city possessed an infinite variety of pictur-

esque vistas, which, said George Hillard, accounted for its magic attraction to artists.[50]

Hillard's sensitive accounting of the Eternal City's physical personality not only revealed a sharper American concern with urban personality, but also assumed the values of variety and irregularity which contemporary Europeans shared but which were threatened in the United States by excessive formalism.[51] Abroad for the first time, Americans like Hillard embraced these values also, as change, drama, novelty and excitement formed the ingredients of a satisfying visual experience. Standing atop a crag in Edinburgh, Emma Willard exclaimed about the city's witchery; as the viewer changed his position all its buildings were transformed. Thus "the charm of perpetual novelty is kept up. The wild and singular hills offered a further interesting contrast with this 'city of palaces and gardens.' "[52] Even American gardening seemed, in retrospect, too formal and unnatural. "The walks and beds must be just so straight, uniform and precise; the trees and shrubbery must be planted in exact circles or squares."[53] Europeans managed much better; their gardens were just as contrived but looked more natural and spontaneous. Even their shops were arranged in better taste than American stores, though ordinarily much smaller.

The clearest evidence for the decline of visual formalism came when American travelers reached Europe's Philadelphia, the Bavarian capital of Munich. Erected and adorned with deliberation by the royal government, it was costly and magnificent, but much too cold, cheerless and orderly for real pleasure. "Munich is the most artificial of all cities of the world," said one American, "its customs the quaintest, its realities the most unreal."[54] The Pinacothek and Glypothek, the miles of newly painted frescoes and the colossal statue of Bavaria were all impressive, but in George Calvert's words, the city bore a "made-up" look. "It seems the work of Dilettantism; it is not a warm growth out of the wants and aspirations of the time. It is as if it had been said: architecture and painting are fine things; therefore we will have them."[55] This had once been American rhetoric but now it no longer seemed appropriate. Travelers began looking for mellowness, patina, spontaneity, all missing in their homeland.[56]

The beauty of European cities was also the result of a
rationalized and collective approach to visual problems; plan-
ning did not have to produce monotony or dull formalism, and
its very success suggested basic social and political differences
between the two civilizations, not always to the benefit of
America. Henry McLellan, admiring the western portion of
Edinburgh with its planned variety of crescents, squares and
hexagonal parterres, reflected that such a scheme would be
impossible in America. For these stately buildings, which seemed
like noble palaces from a distance, turned out to be the homes
of separate families. Americans set too high a price on individu-
alism to build like this. "Every one feels at liberty to build
according to his own taste." If several united to construct a
group of buildings, so many disagreements ensued that the least
possible distinction inevitably resulted. England was different
because "the distinction of condition which would repel all
inferior and opposite elements naturally brings the kindred
ones into a closer union."[57] Corporate union within society
seemed preferable to the legalized anarchy and straining anxie-
ties which characterized American social life. The concern with
status, in part the product of a pervasive mobility, led to anxious
competition. The sensitivity of American builders to public
opinion made them proclaim their independence even louder.
If they feared eccentricity, they were equally determined to
preserve their formal freedom to build as they pleased. One
traveler complained that New Yorkers ran "democracy into the
ground; this whim of every vulgar fellow who owns a front of
twenty feet, that he must illustrate his independence by building
on it in his own peculiar way."[58] Egotism and selfishness, not
sturdy independence, lay at the root of such variety.

Some travelers recognized the aesthetic triumphs cooperation
might produce, but stoutly defended a society like their own
which, if it had less sublime beauty, had less severe misery. In
London, said Henry Tappan, long streets could be uniformly
built because there were only a few proprietors; in New York,
diversity dominated because there existed "multitudes who can
build their own houses," tasteful or otherwise.[59] And John
Durbin reflected that the contrast between French and American
towns illustrated the "difference in the sentiments and feelings
of the people," the great complexes of public edifices in France

showing how each man consulted first the glory of the nation, while the chaos of American private houses indicated its more independent and prosperous citizenry. But Durbin, more representative of his fellow tourists than Tappan, was not prepared to condemn the European style totally. "Neither system is perfect. If in Europe the individual is merged in the state, in America the state has hardly a substantial existence."[60] Individualism was no longer an absolute; its defects were substantial, discovered by encountering the physical achievements of a competing political system.[61]

This surprising tolerance and even admiration for centralized political control, often expressed in moments of visual observation, was further emphasized by American estimates of Napoleon in the decades following his death. To American travelers, his name conjured up no images of a conqueror, a legislator, or even a great general; he became rather a great urban planner, a builder of roads and monuments whose physical legacy to Europe had been a good one. Charlotte Cushing, seeing the Arch of Triumph and the Madeleine in Paris, beauties already achieved, wondered what might have happened if Napoleon had lived long enough to execute all of his designs. "To say that a column, a street, or an edifice . . . was built by Bonaparte, is to say that it is all, which the imagination can depict, of rich, sumptuous, beautiful" effects.[62] Her disappointment with the city of Madrid was tempered by the thought of how beautiful it could have been if Napoleon had managed to carry out his plans for Spain.[63] Mary Jane Eames, seeing the sites in Milan upon which Napoleon had planned to build, observed that no one could pass through Italy without admiring his genius. "Had he lived twenty years longer, almost every city in France and Italy would have been able to have boasted of much greater beauty."[64] William C. Preston, impressed with his road-building, called him "That wonderful man."[65] And even Horace Bushnell felt the power of Napoleon's career as he expressed his gratitude for the Frenchman's efforts to complete Milan Cathedral. "What is not, where is not, the monument of Napoleon?"[66]

Such statements carried an implied criticism of free, mobile societies. They may have been happier, even more energetic than despotisms, but nevertheless they accomplished far less in

the advancement of physical beauty and the erection of monuments to their own greatness. The inescapable inference seemed to be, as George Hillard put it, that republics rarely managed to identify aspiration and performance. "To bring a vast design to its ripe completion, requires perhaps the steady uniformity of monarchical institutions, and a political atmosphere undisturbed by the warring breath of popular faction."[67] Faction had once presented a threat, not to the completion of palaces or cathedrals, but to political virtue. Now political virtue was itself irrelevant, in the face of physical beauty.

The very sight of the wonders which monarchy and despotism could produce acted to brake the crusading, proselytizing Americanism which at one time sought to extend the benefits of democracy to all creation. Republicanism now revealed both its defects and its relativism. Travel was a broad and catholic teacher, George William Curtis wrote from Naples to his friend John Dwight. Americans prophesy that Europe shall not see happiness until it deposes its kings, but this is

> like taunting the bay of Naples with the bay of New York, or apples with oranges. . . . Why should all men be governed alike rather than all look alike. . . . These monarchies which are decried here have been the fostering arms of genius and art; and in Italy and the rest of the countries here lie the grandest achievements of all time, which draw the noblest and best from America to contemplate them.[68]

Cosmopolitanism was indeed a threat to patriotism; belief in a peculiar national virtue stretched thin when it encountered the tempting philosophy of cultural pluralism.

The attitudes travelers took toward the future demonstrated in still another way this lessening of national self-confidence, or at least of native arrogance. The fears of Jefferson had now become representative as the archaeologist suddenly occupied as important a position as the historian. Americans now assumed that historical evaluations were necessarily archaeological by nature, and if America wished to dominate the memory of future ages, she must begin to plan her monuments.[69] Italian experiences particularly reinforced this belief; when past grandeur and present degradation were so graphically contrasted, only the physical remains of Roman dominion and Renaissance splendor,

the crumbling Colosseum and the giant aqueducts served to remind the onlooker of the power and brilliance that had once held sway there.

Many travelers quickly learned also the uses of art as an instrument of social control; their enthusiastic support of this device revealed frightened and pessimistic attitudes toward America. All the abstractions about the power of art to soften brutish feelings and refine the swinish multitudes suddenly drew life. One early and surprising discovery was the behavior of European crowds. In contrast to Americans, who seemed dangerous and unruly when gathered together in large numbers, Europeans were orderly and restrained. The public galleries and gardens exhibited their treasures to workers and peasants in an atmosphere of peaceful security. Mary Jane Eames noticed the perfect order during a concert in the Tuileries. Not a flower or a blade of grass had been injured. If the same event had taken place in America, the result would have been far different; every man with a jack-knife "would have left the initials of his name upon the nearest tree. Reverence for public buildings and public property" was not characteristic of "our republicans at home. We can never have parks and fine promenades," simply because Americans did not know how to value them.[70]

Similar thoughts occurred to Charlotte Cushing, witnessing a three-day fiesta in Madrid without the slightest disorder or riot. "Could such a thing take place in America, how different would be the result? How many hundreds of persons we should see extended upon the earth," completely intoxicated.[71] In Florence, William Cullen Bryant praised Italian respect for works of art; they never touched, defiled or injured any, and even the lowest workman had proper reverence. It was quite different in New York.[72]

The riddle of order was easily solved. European governments, despotic as they were, nonetheless interested themselves in the sensory welfare of their populations, supplying them with parks, galleries and museums. The French were governable, said John Durbin, precisely because their senses were gratified with shows, gardens, theaters and music.[73] Americans were rediscovering the fact that education, to be effective, could not be confined to classrooms or formal pedagogy but required a concern with all the hours of every day. Palaces and museums

were open free on Sundays in Europe, and even the lowest classes
had beautiful things before their eyes constantly. The French
government surrounded Parisians with instruments of refine-
ment, wrote Walter Channing, and the citizens treasured them.
Thus during the Revolution, they "killed a king, but spared
the Louvre."[74] Within the Louvre itself, mobs of people moved
with particular reverence. "Do you wonder at the silence which
is here? Crowds are daily and hourly treading its vast halls and
everywhere is silence. I recollect few things which more deeply
impressed me than this form of homage to art. The people had
put the shoes from off their feet, for they were on holy ground.
Now is it not well . . . such a means of culture for a whole
people?"[75]

Sensory pleasures led not only to reverence for masterpieces,
but to public order. They controlled as well as refined and
inspired. Police were not enough, Henry Tappan went on, to
maintain discipline. Men in large cities "are exposed to more
corrupting influences" than when scattered in rural areas; more
tempted by crime, they can become ferocious. The terror of mob
power was always a possibility. "Hence we need more powerful
influences of civilization and refinement: we need art and culture
. . . breathing into the air." Even more than Paris it was New
York which required the "humanizing, softening, genial and
subduing power" found only in institutions of art and learning.[76]

A full circle had been completed. Once frightened of the
arts because they had so often been the tools of Church and
State, enemies to freedom and equality, Americans now valued
them precisely for their political uses. The arts were tools to
maintain a minimum level of public security and contentment,
opiates which would quiet and eventually tame the savage
beasts who prowled in American cities. The teacher of Europe,
America had now become her pupil, eager to learn just how art
could be made instrumental to the public welfare. Friends of
security, aids to peace, this was the argument repeated again
and again later in the century, by businessmen-patrons drum-
ming up support for their museums, orchestras and library
associations. By ministering to public order and decency, the
arts would repay with interest any financial contributions. It was
appropriate that travelers like W. C. Dana quoted Edmund
Burke approvingly. " 'Manners,' says Burke, 'are of more

importance than laws. Upon them . . . the laws depend. . . .
Manners are whatever soothe, corrupt or purify, exalt or debase,
barbarize or refine us, by a constant, steady, uniform, insensible
operation.' "[77] Courtesy, gentility, honesty and patriotism would
inevitably result once the arts were cultivated; at a minimum,
they would encourage the lower voices, better table manners
and smarter dress that many travelers felt were so lacking in
America.

Europeans were surrounded by thousands of informal artis-
tic devices. No opportunity was lost to make use of some princi-
ple of art. Mrs. Kirkland, visiting a silk factory in Italy, was
delighted to find the walls decorated with fine oil paintings;
this intermingling of art and industry seemed characteristic of
Italy. "Imagine even a Lowell factory, which edits a magazine,
hung with oil paintings!"[78] Nathaniel Wheaton found evidence
of cultivation in the ornaments which shops offered for sale;
stores were magazines of classical antiquities. "The cup from
which you sip your coffee is modelled after the most admired
proportions of the Grecian vase. . . . a refined taste is discoverable
in almost every article, whether for use or ornament."[79] In
Holland, for example, public buildings discharged water from
their roof gutters through the sculpted mouths of animals. In
America—and even in England—wrote John Durbin, they would
have been plain, simple spouts, but on the Continent every idea
is made to

> speak to the senses; and there is scarcely a beautiful
> or magnificent conception published in Europe that
> has not been painted, engraved, sculptured, carved,
> or molded in plaster, and placed in galleries or offer-
> ed for sale in the shops. Thus the mass of the
> people can look upon the visible embodiment.[80]

Ralph Waldo Emerson noted the same characteristics in his
Italian tour of 1833. "Every thing is ornamented," he com-
mented, coats, jackets, cloaks and garters; the very crutches
cripples leaned on were carved. "Every fountain, every pump,
every post is sculptured, and not the commonest tavern room
but its ceiling is painted."[81]

Filled with beauties, natural and artificial, such nations
naturally made progress in creating art; artists would always
prefer a society maintaining elegancies; the public in turn,

surrounded by articles of taste, honored their creators and learned how to appreciate their achievements. Travelers were struck by the pride which Europeans took in the genius and society of their artists. In Rome even artisans and valets displayed "some knowledge of antiquities" and criticized statuary and paintings with informed sensibilities. The very conversation of the streets afforded a powerful "stimulus to experience." Genius would languish without this interest, for it "must be animated by the plaudits of the crowd."[82] Only when art was brought close to the people could the popular mind be "elevated, softened, and enlarged." Streets, squares, churches and homes had to be decorated if art was to reach the uncultivated, to "substitute the statue, the picture, and the song," for "prisons, laws and preaching."[83]

With so much at stake, many Americans were convinced by their European experiences that it was the government's obligation to promote art, if only for its own safety. The voluntary associations which represented the traditional American approach to such problems no longer seemed adequate, and the democratic ideals of early patrons and artists, with their hostility to official patronage, came to seem naïve and ineffective. The state, said Horace Binney Wallace, was really the most valuable patron of art, for it could not humiliate or enslave what it fostered. Versailles, St. Paul's Cathedral, the Rumeshall near Munich, all were examples of what could be done.[84] Visitors did not hesitate to attack even the English government for its comparative neglect of the arts. In all the Island, said Isaac A. Jewett, there was no Louvre or art center, although England was rich in private collections. But paintings and statues had to be ferreted out from their widely separated owners to be made available to the public. If the collectors were friendly or their servants corruptible, masterpieces could be seen; but if not, art lovers were doomed to disappointment.[85] The National Gallery in London helped, but was inadequate.

> Let the fine pictures . . . be brought out and presented to the public gaze. There is something preposterous to our American eyes in furnishing palaces with such treasures of art to be seen by the Queen or King exclusively. Why should not these glorious works be brought out for the use of the people who own them?[86]

Art was now public property and masterpieces could not be secluded because of the accident of private fortune or royal birth.

If English deficiencies were so roundly condemned, American arrangements attracted still more abuse. Any comparison between the British Museum and similar institutions in America was laughable, said Henry Tappan; in New York a museum was a home for some "stuffed birds and animals, for the exhibition of monsters, and for vulgar dramatic performances—a mere place of popular amusement."[87] While Versailles housed a great gallery of specially commissioned historical art, constantly filled with students and painters, the United States government "can boast of owning some half a dozen paintings, which have been thriftily hawked about the country for exhibition at twenty-five cents a head."[88] European governments ran free art schools; they gave artists pensions and scholarships; they established factories and supervised the production of china, carpets and tapestries.[89] None of these commitments had yet penetrated America.

The outstanding symbols of this integration of beauty with daily life which Americans found so appealing in Europe were the superb municipal and royal park systems which dominated many European cities. These landscaped complexes presented greenery and spaciousness on a scale which Americans, familiar only with the tiny, gravel-crossed City Hall Park or the somewhat more ambitious Boston Common, never dreamed possible. One traveler after another expressed his joy and surprise on encountering Hyde Park, the Boboli Gardens, or the grounds of the Tuileries. Oh, "how these green and shady walks make us long for similar places of recreation and refreshment in our own dear country! When shall we, too, have parks, beautiful with all that Nature brings in spring time, and with such glorious things as Art furnishes for all time?"[90] In the midst of bustling streets the country burst upon the eyes. Existence in a great city was, after all, "at best, a war with nature; and ought never to be tolerated" unless pure air, pure water and cleanliness were secured. No matter the expense, these commodities were worth it.[91] "Life would be an uneasy and desperate thralldom," wrote Samuel Cox, "unless Beauty enfranchised its activities."[92]

The absence of American parks symbolized the speculative, mercenary, selfishly individualistic spirits which, travelers feared, were conspiring to destroy art and beauty. Parks, squares, cres-

cents, courts were the needed expressions of communal responsibility and interdependence. Tappan once more, describing the modern portion of Newcastle, related how ugly buildings and narrow streets had been destroyed and fine squares, parks and structures put in their places; all had been marked by foresight and wisdom. But in New York improvement meant individual investors "intent on speculation merely, and desirious of reaping the largest gain on the smallest possible outlay," narrowing lots to increase the number of houses, covering up "the imperfection of the woodwork with painting and gilding."[93] Fenimore Cooper also condemned the "miserable and minute subdivisions" of American towns which prevented the establishment of parks and gardens. If by chance a man built a garden, business speculations would inevitably "compel him to admit an avenue through his laurels and roses, in order to fill the pockets of a club of projectors. In America, every body sympathizes with him who makes money . . . but few, indeed, are they who can enter into the pleasures of him who would spend it elegantly, rationally, and with good taste."[94]

The very shape of the few American parks in existence before 1860, seemed a compromise with rigid utilitarianism, condemned to "geometrical lines of elms and maples, as if there were in nature neither such things as shrubs, flowers or curved lines." American parks were merely rows of trees with paths between, designed to allow the businessman to reach his shop by the shortest possible route, with "never the sacrifice of a foot or inch to taste, the love of beauty, or the enjoyment of a walk."[95]

When Americans considered the irony that their cities had recently possessed a great deal of empty land, they grew still more irritated at the lack of parks. John Griscom "blushed" when he compared the plenty of land in New York and Pennsylvania with the tiny portion appropriated for parks; even Western cities like Cincinnati and St. Louis had not considered the recreation of their citizens.[96] Hiram Powers, delighting in the walks around Florence, beautiful groves for citizens to enjoy, found it shameful that Cincinnati, the *most beautiful city in the world,* provided no such retreats for "our population to breathe in and pass away a quiet evening hour."[97] Warnings were given that "the time to secure the advantage of these de-

lightful promenades" was quickly disappearing and would be gone forever if something were not done immediately.[98]

Parks were perfect examples of how man could work *with* nature to achieve greater beauties than either was capable of working alone. They were institutions "in which nature and art seem to be in perfect harmony," a means of defeating both artificial heartlessness and untamed savagery.[99] Like other artistic institutions, parks would unite the community, destroy class boundaries and bring rich and poor into a situation where they could feel their oneness. Workingmen needed parks for rest, just as harried businessmen required paintings and sculpture. "I plead earnestly for wide, generous fields, clean walks, and soft-flowing water, for the use of such as own nothing but hands and hearts. Who can estimate the benign influences of passing through delicious shades . . . in returning from hard and depressing toil?"[100] Parks seemed as much a part of community hygiene as public baths. There children would play, the rich would exercise, the poor retain their health and inspiration, all coming closer together, nurtured in nature, perceiving the solidarity of the social fabric.

This image of art and nature joined together, a manipulated environment to unify, reconcile and heal, an instrument of nationality to transcend social barriers, was the most important perceptual lesson Americans carried home with them from Europe. Many were surprised that their most striking memories were not of art alone, but of "that happy intermingling of art and nature so essential to form an attractive landscape."[101] Europe's natural wonders, developed and protected by the state, astounded Americans like Horace Binney Wallace. The American "supposes his own land to be the one where all natural beauties and glories are in the highest condition, and he is astonished to discover that that in which the Europeans most excel us is a matter in which we might compete with them on equal advantage, if we only had the knowledge, the taste, and the determination."[102] For many it took a trip to Europe to create an interest in their own natural scenery. It was from Europe that Horace Greeley wrote back: "Friends at home! I charge you to spare, preserve and cherish some portion of your primitive forests; for when these are cut away I apprehend they will not easily be replaced."[103]

Always pervading the cry for more parks, more galleries, more art, more conservation, was a sense of crisis and faction; it was prudent for government and the socially established to aid in such patronage. "How much has been done in Europe, even in the despotic states," wrote a friend to Fenimore Cooper, "for the comfort and convenience of the mass of the population . . . in the abundance of public fountains, and . . . public gardens." Democratic states, like aristocratic ones, must concern themselves with "the comfort of the lower orders."[104] Again the implication was inescapable that Americans should learn their lessons from Europe's aristocratic leadership, and ensure domestic tranquillity through the cultivation of the beautiful.

The interest travelers took in improving the customs of their less fortunate compatriots was often so aggressive and vehement, that many were treated with scorn and contempt by Americans who stayed home; they considered such critics spoiled and over-ripened by the delicate atmosphere of the Old World. James Fenimore Cooper was merely the most prominent target of this resentment. Mrs. Basil Hall observed that the returned travelers acquired so "great a taste for the superior elegancies of life . . . that they either aim at too high a standard without keeping in mind the number of intermediate steps necessary, or feel so disgusted when they get home that they sit still and do nothing."[105] Such discouragements only further emphasized the class bias of their observations and helped prepare the way for the alienation of many Americans from the cause of high art. The proprietary attitudes of the more refined travelers and their increasing association of art with a particular brand of gentility made the task of redoing physical America much more difficult. On the lips of self-interested and vain connoisseurs, talk about the social value of art patronage seemed so fraudulent that the language of sincerity appeared to turn into the language of propaganda; in the decades following the Civil War popular contempt and disbelief often greeted the opening of great cultural institutions. Once again European experiences exerted ambivalent influences on the institutional development of American art.

The opinions of these travelers in the thirty years preceding the Civil War exhibited a strange sort of alienation, not easily apparent in comments upon social and political institu-

tions. Here embarrassment and anxiety about stating things so hostile to American hopes usually curbed their tongues. But the world of art they admired in Europe and sought for in America acted as a loadstone for their fears and concerns and allowed them to articulate beliefs in hierarchy, order and deference. Art was meant to control passions and support government, re-emphasize nationality and illustrate morality. They did not wish American art to imitate American life; there was so much that was sordid, vulgar and mean about ordinary existence that an art reflecting it could only deny itself. Instead, American life was meant to imitate American art, and this became the goal of a whole group of post-Jacksonian patrons, architects, painters and gardeners. The cult of nature provided them with per-manency, harmony and elegance, and the European trip was often an essential bridge to this ideology. They found in Europe not only a physically objectified past which testified to the con-tinuity of its civilization, but also an unconscious, unthinking integration of the useful and the ideal, of nature and art, whose very unconsciousness transcended American efforts. These were "things which money cannot command, and which mere industry cannot produce," and as such were invaluable.[106] Social and political forms now seemed dependent on physical objects; in the eighteenth century it was the polity itself which produced intellect and virtue. Much of the force behind American art patronage gained strength out of a feeling of difference with American society, since professional artists, not necessarily alienated but weak and dependent upon private aid, were only too happy to aid in campaigns of moralism. Art appreciation would become the agent and product of future refinement as the cause of art was captured by energetic conservatives, eager to bolster their harmonious ideology.

There were, of course, Americans who saw the nation's youth, energy and rawness as virtues and not defects, who longed for painting and sculpture to assume the virility that supported national greatness and to symbolize, rather than refine, Ameri-can vitality. They justified artistic activity on Benthamite grounds. To the businessman they explained that art would im-prove industrial design, increase exports and attract tourists. To the politician they promised that art would intensify patriotism. And to the clergyman they demonstrated how art affected moral-

ity. They expected no radical social changes to result from artistic growth; dynamic democracy was not the goal of art but the condition wherein it flourished best. This was the view of New York patrons like A. T. Stewart, Jonathan Sturges, and A. M. Cozzens. But such attitudes, crude though energetic, became steadily scarcer as the decades went on and were never as dominant among those traveling to Europe as in domestic newspapers and magazines. Artistic culture took on European overtones as American artists sought for their friends abroad the most conservative colleagues; Turner, Delacroix, rebels or dissenters, all were ignored or condemned until posterity established their reputations.[107] Europe's prosaic and conventional remained exciting to the visiting American.

In Europe the possibilities of art as an instrument of social control were first realized, and there characteristic American conceptions of the relationship between art and society were firmly set. Not all who went to Europe returned feeling the same way, nor did all those interested in art go to Europe. The travel literature served, nonetheless, to crystallize dominant doctrines and objectives. These positive goals placed still more pressure on artists as agents of moral, social and political welfare. As travelers returned to forge a vast benevolent alliance with artists and patrons who had remained at home, the message learned abroad would soon find eager followers and imaginative craftsmen. A campaign of conservative culture was readied for release on a complacent and complaisant populace.

Art and Transcendentalism: Beauty and Self-Fulfillment

CHAPTER SEVEN

TRAVELERS WHO RETURNED FROM Europe intent on remaking the American environment found an increasingly favorable reception for their opinions after 1830. Thousands of Americans began to express intense interest in the shape of their landscape and in the achievements of native painters, sculptors, architects and gardeners. Proponents of the sprawling beautification campaign that ensued were moved by a general attachment to the value of sensory pleasure and by a belief that correspondences must exist between internal and external beauty.

Ironically enough, conservative moralizers discovered support for their art interests among the members of America's most radical, anti-institutional circle. New England Transcendentalists also tried to excite their countrymen to the delights of nature and art. Although many Americans were indifferent to, or ignorant of, the most abstract Transcendentalist speculations, they could share in their assumptions. Supported by the idealization of nature which Wordsworth and other romantic poets helped diffuse, and by the writings of European idealists like Ruskin, Hegel, Victor Cousin and Coleridge, the American philosophers gained an attentive audience, though they never fully solved all their logical inconsistencies.

Their abhorrence of formal institutions and their stress on individual self-fulfillment also differentiated them from many of the most popular architects of daily life. But the justification men like Emerson and Thoreau provided for beauty crusades was an indispensable element in the alliance of statesmen, poets, clergymen and artists who applied their talents to make America over. The expansion of artistic and engineering competence and the interest of community leaders further emphasized the commitment to beautification which the Transcendentalists expressed in a variety of ways.[1] The massive popular campaigns to improve physical America and to demonstrate a national recon-

ciliation with the forces of nature, rested ultimately on the rationale which America's most exalted intellectual circle provided.

Believers in artistic improvement were able to arouse interest partly because the relationship between objective reality and the life of the spirit had long been an American concern. From the time of the first settlements natural objects suggested more than the ordinary associations they bore for those living in safer, more settled areas. Danger and need made human dependence on natural phenomena more immediate and obvious than in Europe. Trained, particularly in New England, by their religious commitments, to look behind the facade of reality for the hand of Spirit, Americans saw evidence of divine planning in natural disasters and windfalls. Comets and hail storms were portents of God's displeasure; wars and pestilence instances of Providential punishments.[2] The Puritan vision often veered dangerously close to the heresy of pantheism; ministers like Jonathan Edwards took care lest their glorification of the natural world degenerate into its worship. Edwards himself was the spiritual father of many nineteenth-century art enthusiasts. Although there is no direct line of intellectual descent, like the later theorists, he was interested in the potentialities of sensation and in the manipulation of the sensory environment. He "committed himself as a preacher to a rhetoric in which words were obliged to stand in the place of engendering objects" as the source of ideas.[3] Edwards' devices aimed to provoke his listeners to search out God, while most later manipulators sought more secular goals; but the instruments used were similar. Emerson bears an interesting relationship to this Edwardsean effort to relate thought and environment, and so do Andrew Jackson Downing, Frederick Law Olmsted and others of the multitude who sought to create an external world that would resolve the discrepancies between the ideal and the actual.[4]

Vision and the physical environment received special attention on all levels of thought. Americans had begun to notice their own country. The guidebooks of the 1820s often contained lavish engravings and descriptions of beauty spots. Theodore Dwight, William Tudor and Benjamin Silliman ministered to the new taste.[5] Dwight's description of New Haven subjected the elements of visual delight to minute examination.[6] The psychol-

ogy of vision received great popular attention also; speaking of
the pleasures of travel, Dwight exclaimed on the enjoyment
that came "through the eye—the narrow window of the eye's
pupil! Creation! . . . How diminutive a watchtower is the human
frame; how minute is that telescope, yet how wonderful its
power." [7] "Beautiful are the workings of the mystic and micro-
scopic machine," cried Henry Tuckerman, who called on Ameri-
cans to use their eyes to communicate emotions.[8]

On the most rarefied level of American thought, New Eng-
land's Transcendentalist and Unitarian mystics paid the same
tributes of thanksgiving to the organ of vision and created a
justification for visual beauty that filtered down to activist re-
formers. "Our age is ocular," wrote Emerson in his journal; and
this absorption with sight culminated in his great image of a
transparent eyeball, wherein, seeing all, man became a part
of God.[9] Hawthorne's preoccupation with vision has already been
charted; "I have often felt that I could be a painter," he wrote
his wife, "only I am sure I can never handle a brush."[10] The
most rhapsodic paean of all was paid to eyesight by the Reverend
Frederick Hedge, who brought to the Transcendentalist circle
his enormous knowledge of German philosophy. Appropriately
reviewing a travel book, Hedge mused that the eye was "the
most *exigeant* of the senses. A great part of our living consists
in seeing. The better part of all our enjoyment . . . knowledge
. . . education . . . is derived from that source. The eye is the
instrument by which we chiefly lay hold of the world." "It is,"
he concluded, "lord of all things."[11]

Transcendentalist views rarely passed intact into general
circulation, but underwent simplification and distortion in the
market place. They were significant as evidence of the breadth of
American concerns with art and vision. Like many in the press,
politics and the ministry, Emerson, Hedge, Thoreau, Margaret
Fuller and George Ripley were dissatisfied with contemporary
art; despite some exceptions it seemed artificial, external and
meaningless. Not that the New Englanders and their friends
saw much art before they made their European trips. All they
knew were the casts and canvases in the Athenaeum. But it was
almost impossible for any art form to meet the conditions set
up by their idealization of nature. Transcendentalists held that
material objects were significant only as emanations of Spirit,

the world being, in Emerson's phrase, "a divine dream," and matter a phenomenon rather than a substance. "Every Natural Fact is a symbol of some spiritual fact"—this Swedenborgian utterance lay at the heart of their philosophy of nature.[12] It was vital for man to understand his proper relationship with the external world, for strangers to nature were alienated from God. The energy of the Supreme Being, what Transcendentalists called "Spirit," lay behind and throughout all material objects. All matter was therefore good in the sight of God, and all of nature deserved reverence. The henhawk, wrote Thoreau, hid its nest and laid no eggs for man, but its wildness was not willful or sinful. "What we call wildness is a civilization other than our own."[13] Enthusiasm about art presupposed interest in the glories of nature. "It is monstrous when one cares but little about trees but much about Corinthian columns, and yet this is extremely common."[14]

Nature worship opened the door to art appreciation, but also constrained it. The visual arts had to limit the infinite, for they placed bounds on the world of the Over-Soul. Art's only importance lay in its representation of nature; its own objectiveness and its technical craftsmanship were doomed to perpetual inadequacy. "The feeling expressed is of far greater importance than the vehicle in which it is conveyed," wrote Elizabeth Peabody. "An expression of the infinite by means of the beautiful, is inadequate indeed as expression, but deeply interesting . . . to those who can read the intention through the uncertain and vague embodiment."[15] Appearance, achievement, external reality were all meaningless in themselves. "Thus always we are daunted by the appearances," Emerson announced in his lecture on war, "not seeing that their whole value lies at bottom in the state of mind."[16]

In a strict sense creative activity could never be as important as nature's thought, and artistic objects achieved interest only by embracing necessity. Artists were strong when they worked within the limits of nature, and failed when they attempted to resist by asserting their own individuality. "The universal soul is *the* alone creator of the useful and the beautiful; therefore to make anything useful or beautiful, the individual must be submitted to the universal mind."[17] The artist was never the true author of his own work. Emerson suggested that this explained why

men were unwilling to attribute to an author the intense re-
actions a work of art produced. The power of nature "pre-
dominates over the human will in all works of even the fine
arts. . . . Nature paints the best part of the picture; carves the
best part of the statue; builds the best part of the house."[18]
The artist who would be great must "disindividualize himself,
and be a man of no party, and no manner, and no age. . . . an
organ through which the universal mind acts."[19]

At its happiest, art was one with nature, necessary not ac-
cidental, its value pedagogic and not inherent. If we searched
deeply enough, wrote George William Curtis, a frequent visitor
to Brook Farm, we would find "all matter to be one substance."
The best critic of art was "the man whose life has been hid
with God in nature; and therefore the triumph of art is com-
plete when birds peck at the grapes."[20] Art was valuable if it
detached specific natural objects from their normal diversity;
this allowed more careful study, and isolation would lead even-
tually to appreciation. Painters and sculptors served but an in-
itial office in this view. "The best pictures can easily tell us
their last secret," said Emerson, for they were only rude copies
of the miracle of the real universe.[21] Painting and sculpture were
"gymnastics of the eye. . . . There is no statue like this living
man."[22]

The comments of Curtis and Emerson revealed a basic
Transcendentalist dilemma. They called for artists of sensitivity
and intelligence rather than technical experts, but in doing so
seemed to reduce art to imitation. Despite Emerson's insistence
that art was an important act of the intellect, his prescription
seemed best suited for photography. An interim solution, which
Emerson adopted, was to allow genius in the selection and
idealization of details, giving scope only to the ordering of
imitation. Slight as this gesture was, it went too far for others
of his circle who insisted, with Thoreau, that naturalism and
realism were themselves the highest values, because of nature's
inherent goodness.

Just as nature was moral and religious, so the highest art
would have to be moral and religious, though its material ex-
pression might circumscribe the thought it attempted to express.
A great work of art, since it encased a universal thought, was
comprehensible to all men. Before going to Italy, Emerson

wrote, he had imagined that Italian paintings—with their glory
of color and refined composition—would completely astound him
as expressions of another being. Instead, he encountered no
strangers at all, but plain, old friends. "I now require this of
all pictures, that they domesticate me, not that they dazzle
me. . . . All great actions have been simple, and all great pic-
tures are."[23] His supreme example was Raphael's "Transfigura-
tion."

The objective of art lay far beyond its own existence or the
production of pleasurable emotions. Its purpose was individual
fulfillment, attained by uniting the spectator's mind with some
great universal expression and reproducing within him the
thought which animated the artist. The glory of portraiture lay
not in its transmission of particular features, or in its virtuoso-
like handling of silks and satins, but in the character expressed.
As James Freeman Clarke wrote, for *The Dial:*

> *Blame not the Artist, then, who leaves*
> *The circumstances of the hour,*
> *Within the husk the fruit perceives,*
> *Within the bud, the future flower.*
> *He took the one pervading grace*
> *Which charms in all and placed it here,*
> *The inmost secret of her face*
> *The key to her locked character.*[24]

The artist who educated men to the possibilities of Spirit
exerted both a practical and moral influence. It was imperative
that he be sensitive to nature and deeply religious. Christopher
Pearse Cranch, who, with his brother John and the painters
William Page and Washington Allston, was one of the artists
most involved with the Transcendentalists, met this require-
ment easily. He felt surrounded by Spirit everywhere, all the
time. "And yet, fools that we are, we disbelieve, we doubt, we
forget. . . . God is in us, but we so quench the spirit."[25] Art was
invaluable because its contemplation drew men into a religious
state of mind. "Would you read the Bible aright," cried Margaret
Fuller. "Look at Michel[angelo]."[26]

Though art required both material expression and sensory
response, the less of these it had the better. Margaret Fuller con-
sidered music superior to all other arts; it took what was "most
interior," what was "too fine to be put into any material grosser

than air," and conveyed it from soul to soul.[27] Painting she ranked lower than sculpture, since by using color it created more illusion. And according to Sophia Ripley, architecture was inferior to both painting and sculpture because the useful arts resisted nature while the fine arts worked with it. "Architecture, as it arises protectingly aganst the unfriendly external powers, takes a lower place than the other fine arts."[28] On the other hand, some denied that sensuousness unrelieved by intellect was satisfactory. Horace Binney Wallace, not a member of the Transcendentalist circle but concerned with many of the same issues, would not agree that music was the superior art. It does "refine the passions into sentiments," he admitted, but unlike painting it does not "raise the sentiments into ideas. It opens the sources of feeling, but the feelings are motive, rather than guiding powers." "The moral influences of the pencil," he concluded, "are as healthy as those of music are morbid and extreme."[29] Most Transcendentalists, however, would probably have taken Margaret Fuller's position.

Despite their depreciation of creative power, Transcendentalists responded movingly to works of art. In Italy, Emerson underwent most of the reactions other American travelers experienced. He went round the galleries in Florence until he "was well nigh 'dazzled and drunk with beauty'!"[30] The art he claimed was familiar and universal—those "plain friends," hampered by their physical expression—drew continual exclamations of startled delight. The churches of Sicily led him, like Francis Parkman, to ask whether Americans "never entered these European churches that they build such mean edifices at home? . . . O the marbles! And oh the Pictures and oh the noble proportions!"[31] Some of his opinions obviously needed major revision. But Emerson, his tolerance for inconsistency raised to a doctrine, went on setting impossible tasks for the artist. At one point he wrote that art was universal and the artist had to disengage himself from his era and nation; at another he declared that the artist must employ the symbols of the day, since no one could "quite emancipate himself from his age and country."[32] Advocating that the artist portray nature as it flooded him, he also insisted that art's aim was not imitation but inspiration. "In the landscapes the painter should give the suggestion of a fairer creation than we know. The details, the prose of nature he should not admit."[33]

Margaret Fuller agreed that painting and sculpture compensated "for the necessary prose of life."[34] Other Transcendentalists, however, had denied that nature contained any prose and had written of the poetry of necessity. "The true art," said Thoreau, "is not merely a sublime consolation and holiday labor which the gods have given to sickly mortals to be wrought at in parlors, and not in stithies amid soot and smoke."[35]

If Emerson claimed that he valued intellect over imitation, even intellect revealed in allegories, and yet insisted that he sought only nature's expression, the solution to this paradox had to lie outside of art. Pedagogy, technique and learning were not enough; the society that produced great art produced it naturally and necessarily, simply because great thoughts had to find an expression. "It never was in the power of any man, or any community, to call the arts into being. They come to serve his actual wants, never to please his fancy. These arts have their origin always in some enthusiasm, as love, patriotism, or religion."[36] Art was an expression of humanity, which once finished could not be repeated. This was the message of Samuel G. Ward. It was "childish to lament the absence of good painters. We should lament the absence of great thoughts, for it is the thought that makes the painters."[37] Art was a slow plant; it was more important to care for the earth surrounding it than to think about encouraging individual blossoms. "Until we again shall sit down before nature as children willing to learn," said I. B. Wright, we shall have no great art.[38] Beauty would never spring up at the plea of a legislature; not until the distinction between the fine arts and the practical arts was forgotten could true art be born.[39] If art was to be beautiful, reality must be beautiful also; men must recognize the elegance and honesty of ordinary objects. If we were a nation of "lath and plaster and temporary shifts," this did not call for shame; "let our joints and beams be made beautiful, not hidden,—let our wood work show the grain of the wood for ornament, not hide it under paint."[40]

Despite contradictory demands, then, there was a certain hopefulness in the Transcendentalist view that it was wrong to stick to the old, narrow categories of art, and expect beauty to emerge by fiat. Only in a healthy society, where men's lives were unconsciously beautiful, could true art appear. It could not be

178 THE ARTIST IN AMERICAN SOCIETY

pursued deliberately, consciously, isolated from daily existence; "to seek beauty was to miss it often."[41] The "highest condition of art is artlessness," Thoreau decided.[42] Americans need not despair because Giotto and Raphael had made such giant conquests in their age of faith. "We stand all upon a Western shore, with a whole unknown world awaiting our discovery."[43]

Although such statements logically implied abandoning the careful study of Europe's old masters, Page and Cranch took European study trips, and neither Emerson nor Margaret Fuller advised artists to stay away from the Old World. But I. B. Wright suggested that if all the pictures in Italy were destroyed, "it would be like the lifting of a weight from art, which now presses it to the ground."

> The deadly hand of the past grips at the throat of genius, and a brooding nightmare palsies its efforts. . . . is vice rooted up? . . . let our artists come home. . . . Let them dare to look that truth calmly in the face. . . . that the only true lessons to be learned from the lives of the great masters are, "Trust thyself," and "Forget that any ever lived before."[44]

If indeed the best arts were "happy hits," then all technical training was to some extent irrelevant, particularly European exposure. But once more, when giving or taking practical advice, the Transcendentalists did not insist upon consistency.[45]

Besides a rather strident nationalism, Transcendentalist arguments suggested a functionalist basis for aesthetics. "Fitness is so inseparable an accompaniment of beauty, that it has been taken for it."[46] Emerson's absorption with organic principles was basic to his discussion with Horatio Greenough about theories of structure.[47] Unlike Margaret Fuller, Emerson sensed that architecture, since it afforded so many opportunities for working out his theories, might be the sphere of art most amenable to Transcendentalist proposals. Thoreau went even further than Emerson, and criticized Greenough's organic ornaments as "only a little better than the common dilettantism." Architectural beauty always grew from within, unconsciously truthful, "without ever a thought for the appearance; and whatever additional beauty of this kind is destined to be produced will be preceded by a like unconscious beauty of life."[48] Again, beauty was fundamental, not applied, and could not be produced

by surface additions or technical contrivances. America's most interesting buildings, Thoreau went on, were the log cabins and houses of the poor; the life within, not outer decorations, made them attractive and picturesque.

The Transcendentalists saw art, not as an instrument of corporate improvement or a device to make society over, but as a means of individual fulfillment and as a symbol of a people living in harmony with nature, united with the Over-Soul. Art itself might lead some to a clearer understanding of the beauty that surrounded men, but it was more important as an emblem of such harmony than as a means of achieving it. The objective was not as vital as the activity itself. The Transcendentalists most valued art energy, not art achievement, the artist's life rather than the artist's works. Not all of them were prepared to appreciate, study or even experience great art, but all saw the artist's role in society as meaningful and inspirational. "Not how is the idea expressed in stone or on canvas, is the question, but how far it has obtained form and expression in the life of the artist," said Thoreau.[49] Popular moralists who demanded pure lives as requirements for great works could get intellectual sanction from Thoreau.

Emerson also valued the artist more than the art; describing Margaret Fuller he wrote that her love of art was not, as with most Americans, technical and material, but grew from a sympathy with the artist, "in the protest which his work pronounced on the deformity of our daily manners."[50] Though it hardly fitted some of his earlier observations, Emerson was asking not for affirmation but criticism, a criticism all the more intense and significant because it was not stated explicitly but lived implicitly. If the artist was incapable of transmitting entire the thoughts which inspired him and which indicted human evils, he nonetheless absorbed the visions of a purer, more spiritual world. As Cranch wrote, in "The Artist,"

> *He breathed the air of realms enchanted,*
> *He bathed in a sea of dreamy light,*
> *And needs within his soul were planted*
> *That bore us flowers for use too bright.*[51]

Though it might take perception to discover it, the artist was a heavenly messenger, translating his communion with God and nature into symbols comprehensible to other mortals, like

"doves and ravens, who bear back to us olive boughs and flowers which we cannot analyze."[52] His whole life demanded respect, and for Transcendentalists his vocation symbolized the peace and unity which any man might attain if he stood ready to reverence the divinities of nature. The artist's material existence was as much a sign of the power of Spirit, as the rainbow was a symbol of divine forgiveness. Businessmen-patrons should remember, wrote Elizabeth Peabody, that the artist conferred the favor, for his treasure came directly from God. By constant communion and meditation, by magnanimously expending his genius "the Artist must himself become the masterpiece, which the Creator of Man had in his Idea when he breathed into him a living soul."[53] The artist was the only complete man, living the sort of life all were meant to live. Thus, while the Transcendentalists limited the possibilities in the creator's art, they extended the significance of the creator's life.[54]

Transcendentalists actually had their artist hero right among them in Cambridgeport, for no American met their description as well as Washington Allston did. Pure in life, noble in aim, he was the artist as saint. His works satisfied because he always suggested more than he expressed. Even his trees had minds which communicated with the viewer; "without losing their solid palpable existence to the senses, they seem drawn on the mind itself,—not on perishable canvas."[55] This was no nature facsimile but nature as Spirit, laden with the artist's personal associations. In Allston's failures and frustrations, caused not by an unfriendly environment but by conflicts and doubts within his own mind, the ambiguities of Transcendentalist art attitudes were objectified.[56] Although they proclaimed their passion for art activity, the paradoxes that dogged them—their insistence that the artist bring intellect to his works yet mirror nature's universal sentiments; their concern that the common stuff of life be the subject of his interest yet their obvious partiality to high art; their delight in the value of tradition together with their calls on the artist to sever his transatlantic connections— made puzzling and frustrating reading for artists and patrons of this generation.

Nevertheless, the Transcendentalist message on art and beauty resembled and reinforced the demands other critics were

making of the American artist. Like them, Emerson and his friends insisted that art was primarily a spiritual, intellectual activity, forced to apply material techniques but, as often as not, bound by the matter it exploited. They agreed that art was at its greatest when it accepted its subordinate role to nature, and that the artist's imagination and intellect were therefore far more important than his technical skills of imitation. This meant also, of course, that a life lived according to God's natural laws was far more valuable and productive than one spent learning crafts-manship in foreign academies. At its highest, art needed no abstruse study but was comprehensible in its sincerity and necessity to masses everywhere. The great days for art were not necessarily over if the grandeur of American society was about to unfold. Although art was inferior to nature as an order of being, it was still the breath of the divine Spirit, and the artist must be cherished as a representative of the ideal. Above all, the Transcendentalists insisted that true beauty, in nature or art, was neither sinful nor irrelevant but the highest tribute man could pay to his God. In Thoreau's memorable phrase, beauty was "the garment of virtue," and some even urged that it be a part of religious education.[57] "Religion makes men sensible to beauty; and beauty in its turn disposes to religion. Beauty is the revelation of the soul to the senses."[58]

Despite their inconsistent posture toward community life and the value of institutions, Transcendentalists aided the legitimization of beauty and sensory pleasure pursued by other Americans at the same time; they left, as part of their legacy, a belief in nature as the source of artistic standards and technical tuition. They also helped to diffuse the assumption that if the arts were ever to flourish again they would need a popular base. Many Americans agreed with George Bancroft that genius "will not create, to flatter patrons or decorate saloons. It yearns for larger influences; it feeds on wider sympathies."[59] American critics, ignorant of technique or the potentialities of media, eagerly embraced this emphasis on conception; they could then discuss the visual arts in literary and metaphorical terms. The arguments for simplicity and universality were also welcome, since they placed the seal of approval on whatever was im-mensely popular, no matter how sentimental or simple-minded;

like Hegelian colleagues across the ocean, Transcendentalists ran the risk of idealizing all actuality and legitimizing all activity.

Gradually, though inevitably, American art publicists moved away from the Transcendentalist position, though they were able to build on its structure. The sharpest distinction between the Transcendentalists and nineteenth-century art popularizers lay in the latter's conception of art as a reforming agent. Emerson and Thoreau believed that society itself must be changed before it could produce great art; physical improvement was emblematic, not instrumental, and therefore not the way to make the universe over. Nature needed no revision; and furthermore, proper perception of the physical world depended not on external reality but on human organization. It was foolish to expect that physical manipulation could change the human spirit. It was the other way round. The institutional apparatus which art popularizers created represented just the social arrangements Clarke and Emerson had condemned in other contexts. They stressed individual potential, not communal deportment. It is true that within Transcendentalism itself there were aggressive reformers like Bancroft, Orestes Brownson and William Ellery Channing; but even they saw artistic achievement more as a symbol than a means of reform.[60]

Other Americans, less patient, more activistic and more institution-minded, were unwilling or unable to accept the Emersonian metaphysic; they agreed that art was basically spiritual, they favored its dispersion, they admired the artist—but for different reasons. Transcendentalists praised art cultivation as an opportunity for individual insight; other art sponsors sought physical expressions which would change, not reflect, popular aspirations, which in turn would mold manners, stimulate affections and focus energies. Free from the idealist frame of the Transcendentalists, they gave material facts much greater influence, though they viewed them with much greater selectivity. Their art arguments took shape from a sense of deficiency and discrepancy also, but they sought to correct and refine, not liberate or symbolize. Their aim was the protection of institutional arrangements, and not their overthrow. Art unions and government patronage were among the methods of accomplish-

ing a national transformation; it was not necessary to probe beneath society.

Of course, many shared the Transcendentalist contempt for greedy materialism. Could the fine arts get hold of Jonathan, wrote one critic in 1847, "plodding and utilitarian as he is," they could break the spell of their "Amazonian Rival," the "coarse courtesan Utility." Then something might be done to reverse the American's progress from the "adventurous Knight and Champion of Liberty, into a mere speculator and ever-toiling earthworm."[61] The arts were elevating and needed cultivating for their "tendency to exalt individual and national character."[62] City dwellers, shut off from nature's beauties, would lose their sensibilities unless the landscapist intervened; he could help to "strengthen the domestic ties."[63] Since the American's character and manners required repose, and a "contemplation of the beautiful" always induced "a calmness upon the spirit," art objects were required everywhere.[64]

But the instrumentalist conception of art which pervaded this era went much further than pious platitudes about repose and individual character. Many of its supporters were fearful of the excesses and competitiveness pervading American life. "Our institutions," complained the Reverend Henry Bellows, an important spokesman for the conservative publicists, "are in a state of perpetual excitement and competition. President-making and money-getting. . . . We want some interests that are larger than purse or party."[65] Physical objects would help Americans improve their position in nature, their relationships to God and their ethical obligations. Naturally art had to be widespread; restricted to an aristocracy it would be operative where least needful. "Some one has said," J. T. Hoadley told a meeting of the American Art-Union, "give me the writing of the *songs* of a country and you may make its laws. I had almost said, give me the control of the *art* of a country, and you may have the management of its administration. . . . *Pictures* are more powerful than *speeches*."[66]

The operative word in Hoadley's statement was "control." If the effects of art were so momentous, all the more reason that their objectives and uses be carefully supervised and widely diffused. A Louvre, an academy, an opera house, wrote Augustine Duganne, could do little by themselves to refine the masses.

"Venus de Medicis may attract the worship of *cognoscenti,* while a horde of *lazzaroni* are gambling upon its pedestal."[67] Art's mission, like that of religion, was realized only when it flowed into "hut and prison," refining, humanizing, softening.[68] The words Duganne used—"barbarism," *"lazzaroni,"* "prison"—revealed the fears aroused by popular energies, and the anxieties art was meant to quiet. Duganne was really proposing a type of forced feeding, a conversion through sensory suffusion. His tone might have been that of a Roman emperor. "To evangelize men, first give them to eat. To refine a people, make them comfortable and familiarize their minds to the enjoyment of the beautiful."[69]

Many statements made in the decades before the Civil War indicated a similar declension of confidence in the life of the populace, but an 1859 magazine article gave the most explicit statement of this view. Entitled "The Bearings of Art Upon Elections," it noted how unwashed, filthy Americans voted for candidates in corner taverns. Reflecting on whether citizens needed better surroundings, the author's immediate response was negative; American citizens required "no stimulus of outward show to impress upon us the sacredness of a vote! We can go to the polls . . . in ragged or mended clothes." Only despots required the aid of magnificence. Here was the traditional American response to the gilded glories of European despotism. But the traditional was not the lasting response. Contemplating the new German and Irish voters flooding the country, the author changed his mind. Perhaps America has "gone too far in discarding the beneficial influence of art." A Washington or a Clay might be allowed to vote in a tavern as well as a temple, but they were rare exceptions. A few "may be able to rely upon reason alone," and survive such austerity, but more "can be impressed only through feeling."[70]

The alliance between art and conservatism could be fostered in a thousand ways. Duganne supported a government-aided National Academy of Design, but called also for handsome villas, pretty flowerpots, pleasing everyday objects. Evil habits could be eradicated "if the beautiful were oftener presented to our affections, and the refined placed within our aspirations."[71] The language of hyperbole—"this glorious land . . . yet to be the grand theatre for the regeneration of all things most dear to

social beings"—did not hide the brooding fears of barbarism which Duganne and others dreaded as America's fate.

The intensity of these forebodings, together with the observations of European travelers, helped widen the claims made for art. Words like "communion," "mission" and "divine" set the tone of artistic discussions; for its devotees, art developed many of the characteristics of a surrogate religion, fulfilling the needs and seeking the goals of many other sects. Like them, this ideology sought to inculcate a state of mind, produce a new relationship with God, intimate immortality and generally assist governors in their administration of the earthly world. Like other Christians, these art believers beheld a corrupt but not irredeemable man, surrounded by an uncorrupted nature. Valuable as a symbol for divine perfection, nature hinted at the glories of immortality; properly interpreted it was a vast allegory. By performing certain ritual activities, by spreading the gospel of love and reverence for creative achievement, the Church of Art did God's work. Like other Christians, also, art lovers debated the substance and form of their rites, and the meaning of the symbols by which men could be saved. But they agreed—even with the Transcendentalists—about the artist's divine mission. "Unquestionably he is sent of God, to lead the people forward, and to unfold to them visions of beauty. . . . He comes, often, as the old prophet of God came, in bewildered ages . . . to lead them out of bondage."[72]

Like Christians, finally, art publicists argued over the membership of their church, and whether or not, by guarding against a lapse in standards, their duty was to already converted believers. They could choose to serve the unconverted only by making up in extent what was lacking in intensity. On the whole, American art lovers opted for a denominational approach. They emphasized that the more people who came into contact with art, diluted as it was, the better; in the long run— with a little education—popular judgment would prove correct. Art was an opiate, adding to the cheerfulness with which life's burden "may be borne."[73] Some artists and critics dissented, particularly those connected with formal institutions like the National Academy of Design; they insisted on technical proficiency and traditional education, but even they were forced to proclaim their allegiance to the principle of dispersion, so

long as the criteria remained high. But those who considered poor artistic standards worse than none at all were only a minority.[74] Most Americans esteemed even the first steps toward refinement—the purchase of chromolithographs or the repainting of a house—as symbolic actions presaging eventual conversion. Thus, for different reasons, many ended up espousing a position toward popular taste indistinguishable from the Transcendentalists'.

Any analogy between art and religion has numerous lapses. The analogy indicates only the intensity called forth by the crusadelike struggle for physical beauty. Participants had a religious belief in the necessity for their task and the efficacy of their solution. Art would remake America in her original image, restore nature, and lead Americans back to their landscape and their principles. Nurture was necessary for the approach to nature, and before 1830 the landscape still seemed a hostile force. Such publicists had to transform an attitude of enmity into affectionate interest.

The crusaders varied widely in temperament and motivation. Optimists thought of man not as corrupt but corrupted, for he could be healed once brought close to the natural world that civilization had disguised. Pessimists wished to use art to restrain beastly and animal instincts, to "raise the mind of man out of the depths of his lower nature."[75] Nationalists found a cure for political corruption and social factionalism in the construction of symbolic monuments, and cosmopolites imagined that art might provide continuity with the great civilizations of history. But all shared a faith in the value of rearranging physical surroundings and applying intellect to the ordering of sensation. From the Transcendentalist position on individual expression it was not far to the notion of corporate control. Energetic thrusts against the monotony and conformity of social rules could be exploited for opposite ends; and the specific and inevitable outcome of these convictions were the giant beautification movements which captivated mid-nineteenth-century America.

Crusades for Beauty

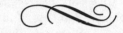

CHAPTER EIGHT

IMMENSELY POPULAR CAMPAIGNS FOR patriotic monuments, rural cemeteries and landscaped homes augmented the American commitment to manipulating the physical environment. The arguments evolved showed how art and beauty were merged with reform ideals—conservative or progressive—and transformed into an aesthetic ideology. Painting and sculpture were also suffused with ideological objectives, but they were already caught up in many different levels of anticipation and enjoyment. If the peripheral spheres of artistic activity excited so much attention, the more formal center elicited even greater support. The reflections of American travelers in Europe, the fears of moralists, the hopes of post-Transcendentalist art publicists received their final integration in these beautification drives. Old enthusiasms for social control, restraint of passions and national unanimity finally emerged in the open, aligned with the instruments to achieve them.

The demand for patriotic monuments was almost as old as the Revolution, but few large-scale ideas were executed before 1825. Plans like Giuseppe Ceracchi's scheme of the 1790s were elaborate, expensive and allegorical.[1] Designers used an extensive vocabulary of formal symbols to match the grandeur of the conceptions they sought to illustrate. The ideal required a complex physical embodiment to demonstrate its profundity. By personifying each section of the monument, history, philosophy, religion and prophecy could join in narrating its message. Greek muses, Roman gods, Egyptian hieroglyphics and Masonic regalia mingled indiscriminately in the plans, though these great allegorical themes would have been lost on ordinary citizens, had they been realized in construction.

In the 1820s, 1830s and 1840s the demand for monuments grew and American visual design moved toward simplicity and a more concentrated, intensive experience. The complicated

intellectual processes necessary for the appreciation of allegory were abandoned for the immediate delight and shock of recognition which a few well-known symbols could elicit. Such symbolism was so pervasive among Americans that remote pictorial resemblances made many works of art unexpectedly into patriotic monuments. Mrs. Trollope told of an American who when confronted with a painting of Hebe being carried to heaven on Zeus's eagle inquired, "What the devil has Hebe to do with the American eagle?"[2]

The shift toward simplification occurred within the city of Baltimore. Its appellation, "City of Monuments," signified the pride of its inhabitants in the city's patriotic markers. In September, 1815, a monument was dedicated to memorialize the city's defenders who fell in 1814. Designed by a French-born architect, Maximilian Godefroy, it involved a seventeen-foot-high statue of Baltimore, formed from representations of Juno and Cybele, a crown in one hand, an antique helm in the other and an eagle perched along her side. The whole structure was to be forty-seven feet high, supported by a base covered with still more complicated symbolic compositions.[3]

By contrast, another monument dedicated that same year in Baltimore (planned by Robert Mills who would become the architect of the Washington Monument) consisted of a single Greek column, standing free to express the idea of commemoration. Completed in 1829, this column was a foretaste of monuments to be erected in other cities—simple, abstract, concentrating energy and attention on the one symbolical gesture. Mills himself had written that "in true art there should be no themes difficult of interpretation, nothing obscure," for the best architecture was read with fluency. The *"personality of a structure . . . should appeal before the beauty of line or ornamentation."*[4]

The theme of simplicity concerned many Americans. James Longacre, an engraver who wished to use Indian symbols on American coins, wrote the Secretary of the Treasury in 1851 that on small coins no device could be "at once conspicuous and striking unless it is simple—complexity would defeat the object."[5] Montgomery Meigs, superintending government construction, wrote Thomas Crawford, who was planning the monument to liberty which stands atop the Capitol, that many American sculptors were sending home objects unsuitable to

American taste. "We are not able to appreciate too refined and intricate allegorical representations," he explained, and pleaded for sculpture to appeal "not to a class but to mankind." Crawford sent back his entire agreement. "The darkness of allegory must give place to common sense."[6]

The movement away from elaborateness gained among painters also. Rembrandt Peale, describing his huge "Court of Death" in the 1840s, two decades after its completion, suggested that it was "an attempt to introduce pure *figurative* painting, in the place of obscure personifications and obsolete symbols, as hitherto employed in allegory." The painter's eloquence, he continued, must not move as slowly as words, but "strike the heart at once as with an electric glance."[7] Laymen seconded the notion that allegory was unwise. A Bowdoin College professor, visiting Oxford and examining some sculptured allegories, concluded that the mind was "disturbed and diminished by the thoughts being divided between the consideration of the object in itself, and its relation to the moral or other meaning which it is intended to convey."[8] And George Hillard, looking at a monument by Canova, proposed an insuperable objection to allegory: was it not "a purely mental notion? Can there be such a thing as an allegory to the eye? Does a young female become Charity because she supports the feeble steps of an old man, and another Virtue, because she looks upwards?"[9]

Concentration, however, involved greater risks than the older intellectualism; it was absolutely vital that the one gesture be properly interpreted. The single idea to be symbolized needed careful selection, as did the corresponding image. In a large allegory individual elements might be susceptible to misinterpretation without ruining the total effect, but if the new monumental symbols were not understood immediately, then construction itself was useless. Consequently monument builders and publicists became involved in a long series of debates, quarreling over the relative merits of obelisks, columns, pyramids and arches, arguing their appropriateness, associations and effectiveness as symbols of power, peace, unity or patriotism. The most articulate discussions centered around the two greatest ante-bellum monuments, the one to the Bunker Hill victory in Charlestown, and the great shrine to Washington. Granite

obelisks were used for both, but public debate swirled about the choices.

The first monument on Bunker Hill was erected by a Masonic lodge in 1794, on the spot where Dr. Joseph Warren was killed. But after the War of 1812 a movement grew in Boston to purchase the battlefield and erect something more impressive.[10] By the middle of 1823 the Massachusetts legislature had granted a group of prominent New Englanders, including Daniel Webster, Edward Everett and Colonel Thomas H. Perkins, a corporate charter. The monument committee extended a tradition dating from the construction of Washington's official buildings in the 1790s, when it inserted newspaper advertisements offering a cash award for the best design.[11] Although the committee favored a column, in a separate circular it referred approvingly to pyramids and obelisks, proposing to rescue such forms from the service of despotism. "Providence, which has given us the sense to observe, the sense to admire, and the skill to execute these beautiful works of art, cannot have intended that, in a flourishing nation of freemen, there should be no scope for their erection."[12]

But it was not easy to rescue visual forms from tyrants' whims; much of the controversy about these symbols concerned their earlier usages. Robert Mills wrote from South Carolina in 1825 that he preferred the obelisk to the column because of its greater antiquity; it also furnished a better surface for inscriptions.[13] But some years later the sculptor, John Frazee, criticized the Bunker Hill obelisk precisely because of its origin; Egyptian architecture was the "architecture of tyrant kings—of severe and despotic dynasties; it therefore can never harmonize with the glorious principles of republican achievement, nor with . . . Christianity." Gothic, with its "flouncing tinselry," had "even less claim upon republican sympathies than the Egyptian style." Frazee charged that gothic public buildings like New York University and the Smithsonian Institution in Washington were disgraces to republican taste, and quoted Benjamin West in his support.[14] Only the Greeks offered the proper combination of democratic associations and visual grandeur.

The design for Bunker Hill—claimed variously by Mills and Horatio Greenough—won approval only after a bitter dis-

pute about the alternative advantages of the column and the obelisk; a special committee was appointed to settle the issue. Both Edward Everett and General Dearborn favored the column, Dearborn proposing the Column of Trajan as a basis for the design.[15] Some bystanders criticized both approaches. William Austin, a Boston lawyer, proposed a building as the commemorative device; it would contain a lecture hall, athenaeum and art gallery. William Ladd, president of the American Peace Society in 1826, suggested a mausoleum, objecting to pillars *and* obelisks. Both were *"trophies* of victory" which would excite in visiting Englishmen "feelings of mortified pride, hatred and revenge."[16] A sepulchral monument, however, would have no such effect, and in time might even become Boston's Westminster Abbey. And in the event of war, concluded Ladd, the obelisk might well furnish assailants with a quarry for building materials.[17]

The obelisk was finally chosen over the column because, as Horatio Greenough explained, it was complete in itself; the column normally stood beneath the weight of a pediment and supported an entablature. It was taken out of a created unity to become a new and inappropriate whole when it was utilized as a monument.[18] The committee on the monument's form included among its members such Boston art experts as Gilbert Stuart, Washington Allston, and the architect, Alexander Parris. All felt the force of Greenough's arguments. Greenough, like Longacre, Meigs, Hillard and Crawford, opposed the idea of recondite allegory. Consulted as to the appearance of the national coinage, he objected to the law which required an eagle, a figure of liberty and the name "Liberty" written out to appear together. It was barbarous to have images which the masses could not immediately recognize. "They who fancy that real freedom depends in any way upon such puerile adhesion to an antiquated and childish conception," might learn differently if they glanced at Florence. The city's great tower still bore the magic word *Libertà*, though it was now ruled by hereditary tyrant-princes.[19]

But monument publicists were less certain than Greenough that the choice of symbols had little to do with the maintenance of political freedom. Aesthetic discussion no longer centered around good taste or the naturally appropriate as it had in the

eighteenth century. Jefferson's concern, for example, lay with ensuring that the senses were presented with the ideal itself and not with a particularized corruption. He had no uncertainties, however, about the nature of the visual ideal, nor did he doubt that its perception would elicit universal agreement. But in the nineteenth century, with physical reality overlaid by a network of symbolical meanings and historical associations, it was impossible to establish an isolated aesthetic ideal; the historian and archaeologist had to work with the architect and designer to verify and validate symbolic content. And then all had to take account of the critical public reaction—conscious and unconscious—to their choice.

For as the search for proper historical associations led to greater stylistic variation in public and ecclesiastical structures and monuments, the choice of style itself began to imply political commitments. A writer in *The United States Magazine and Democratic Review* condemned the construction of gothic churches in America; the "gray moss of centuries, the clothing ivy, the irregular antique street, the humble hovel, the cloister pale, the stately palace, the dignity of age, the splendor of rank, the pomp of an establishment," these institutions were foreign and despicable to Americans. But, he added slyly, perhaps there were Americans who would not object "if some, at any rate," were added to the national domain.[20] Not all symbolism was historical, but if monuments were to be functional and fulfill their inspirational purposes, traditional associations might get in the way unless designers were careful to check them out.

Specific debates over appropriateness did not necessarily indicate just why patriotic monuments were needed at all. A society turns to an extended reliance on symbolism to prop up sentiments which require support, or to resharpen distinctions which have grown ambiguous. Symbols may serve, also, to proclaim an allegiance to a cause, a principle, or a creed in danger of being forgotten. They unite memory and action, reinvoke old loyalties and motivations. So the old soldier proudly wears to his reunions the ribbons of former campaigns, or the conservative clings to an outdated piece of wearing apparel. Symbols can be gestures, statements of reproach at the distance opened up between the actual and the ideal, whether that ideal lies in the past or the future. They are not simply anachronisms, for

old soldiers do not wear their medals as soon as they return home, and Americans did not begin monument-building as soon as the Revolution was concluded. In each instance a moment of realization was necessary, a sense of some wrong to be righted, some gesture to be made.

Patriotic monuments formed such gestures. Appeals for their construction were significantly coupled with woeful jeremiads concerning the state of national morality. As early as 1810 petitioners urging a monument to George Washington were fearful that "inattention to the fame, and insensibility to the merits of those who magnanimously projected, and laboriously achieved our liberties, may be justly viewed as indications of the decay of that public virtue which is the only solid and natural foundation of a free government." If indeed such inattention indicated a "degenerate people," then "ruin to the commonwealth" was inevitable.[21]

A generation later men feared that more than Washington's memory had been lost; national principles themselves seemed forgotten. Art was a means of coping with the problem. Monumental art, said one American, would "bring before us in our daily walks the idea of country in a visible shape. It would impersonate her to us as a kind mother. . . . We have no king— no court—no imposing forms and ceremonies, to serve as the external signs of this idea of country. It is so abstract . . . we almost forget it. We need something tangible, to cling to. . . . We need the outward types."[22]

Such confessions indicated real declension; the idea of nationhood required physical props if it was to be effective. Americans were no better than Frenchmen or Italians, governable only when their senses were satisfied. The failure of democratic ideals was proven by the tone of social life. "Imperial Rome, in the worst days of her vice," cried George W. Bethune, a warm friend to the cause of art and monuments, "had more voluptuous and beastly excesses; but never, do I believe, could she have exhibited such cold-blooded craft, and guile, and grinding cruelty. . . . Never, perhaps, did the lust of gold rule the world more despotically."[23] It required more courage to rise above such materialism and pursue a virtuous life than it took to "conquer cities."[24]

In the 1830s and 1840s many Americans observing the

collapse of democratic institutions in various parts of the world, reverted once again to the views of the Founding Fathers that no formal arrangement of authority was sufficient to ensure human rights. The level of virtue, the national temper, the degree of patriotism, all were much more important. In an 1838 oration the Transcendentalist art lover, Frederic Hedge, pointed to the absence of violence and excess in the American Revolution as proof that America owned no a priori, theoretical, "bubble" constitution. True governments could not be formed; they had to grow. In words recalling those of Thomas Paine, Hedge claimed it would be just as impossible to "establish a Republican Government in despotic Turkey, as it would be, at the present moment, to establish an absolute Monarchy in the United States."[25]

But there was no guarantee that this state of affairs would continue. Artificial aids were required quickly. Since, as another Fourth of July orator explained, the energy which lay at the heart of any nation "must either grow or decay," nurture was imperative, the nurture of "Truth and Justice, Intelligence and Virtue, Piety and Religion."[26] For years past, a "merciless spirit and practice of grasping accumulation . . . the reckless spirit and practice of lawless insubordination to law and order," had prevailed. Signs of a diseased public life, of class and sectional divisions and of private selfishness were everywhere. In asking why, orators produced their own answer. What "visible monument exists of a National Government? What is there to call out our patriotism by exciting our pride? What spot, where the rich and the poor can meet and connect themselves by the common feeling—this is my country?"[27] Washington was to be beautified, adorned with exquisite buildings and inspiring statuary; a national library, a national university, public baths on every street, colossal images of republican heroes, and a network of railroads to bring thousands daily to the shrine were the means John Whipple suggested to counter the dangerous trends.

That same year another Independence Day orator urged government art patronage as a device to soften savagery and allay passion, "to check the growing tendencies to insubordination, and to render all classes of citizens more humane, peaceful and happy." It was, after all, rare to find "men devoted to

the fine arts," among "the rioters and disturbers of society."[28]
There was no safeguard so necessary to liberty, cried C. Edwards
Lester, as "the patriotism of our public men." When would gov-
ernment "learn that patriotism can never be so inflamed among
the masses . . . as by covering the consecrated soil of the nation,
and surrounding the Capitol with the Statues and Monu-
ments of illustrious men?"[29] In a grandiose vision he imagined
young Americans striding up broad avenues "on either side of
which stood in colossal bronze, the great Heroes of the Revolu-
tion," with senators strolling through rows of patriotic statues
as they went to vote, the rotunda of the Capitol bursting with the
images of American Presidents.

The Bunker Hill Monument Committee was either more
modest or less imaginative than Lester, but it shared his objec-
tives. Monuments, its members asserted, had the power to
nourish nationalism and excite patriotism. The American gov-
ernment was "a government of opinion; but it is one of senti-
ment still more." The years were passing away, and glorious
national traditions were descending "more faintly to our suc-
cessors."[30] Monuments were owed no less to posterity than to
ancestors. They could become the cement of patriotism, holding
individual elements and succeeding generations together in a
grip of virtuous emotion. Proponents described minutely the
reactions of young and old on confronting monuments; the
patriotic ritual grew steadily more stylized. Intellectual agreement
and rational persuasion were no longer effective enough to com-
mand loyalty to the American Dream; the senses had to be feted
also, for only the prospect of eternal (and objective) commemora-
tion could persuade the ordinary citizen that his country's free-
dom was worth his own life. This was ultimately what heroic
patriotism would mean.

Participation in the monument campaigns, like other as-
pects of the crusade for beauty, had a sacerdotal quality; Sarah
Josepha Hale of the *Ladies' Magazine* and Mrs. Lydia Sigourney
of Hartford were free with their poems. Mrs. Hale recalled the
Roman women who gave up their jewels to ransom their city
and the Israelite women who offered their valuables to build
the temple; the implication was clear that Americans prepared
to make similar sacrifices for the Bunker Hill obelisk could
claim sisterhood with such illustrious predecessors.[31] The same

sense of mission was evident in the pride of Solomon Willard, superintendent of construction, who assured the commonwealth that "no graduate from our penitentiary or foreigner has been employed. The workmen are Americans; natives of neighboring states; some are relatives of those who fought on Bunker Hill and inherit a genuine spirit for the work. Thus far there has been an uncommon degree of harmony among them."[32] Even building the monument stimulated virtue and order.

Demands that state and national governments appropriate money for such memorials were also attempts to deny the charge that Americans were money pinchers. Money expended on monuments proved the existence of republican generosity and idealism.[33] The monument thus became not merely a symbol of patriotism but an instance of civic munificence and selflessness. Just as handsome decorations on a house marked an owner committed to the cultivation of beauty, so national monuments displayed a people whose highest values were spiritual. The monument commemorated both the event itself *and* the generation which remembered it. As Edward Everett promised, it would exist "for the admiration of posterity, ages after every vestige of the ordinary disbursements of the State shall have passed away; teaching the children of Americans . . . that the people of Massachusetts of this generation are resolved that the gallant deeds of their fathers shall not pass uncommemorated."[34] The choice of style was important because the monument bore witness "to the good taste and judgment of those who erect it."[35] Thus the gesture was beautifully circular: the monument gave physical life to an abstraction and helped perpetuate a set of sentiments; and its own construction called forth the feelings it would symbolize in later years. Monuments would lure out the natural affections so often restrained by the taut, materialistic environment civilization had built for itself, and reemphasize the spiritual purpose of the community.

Monument-building quickly became a subject of great interest. Contemporary magazines and newspapers were filled with correspondence relating to plans and designs; fund-raising committees issued frequent reports of their progress; engravings and lithographs celebrated projects even before they were completed; guidebooks went into enormous detail about costs, dimensions and difficulties of construction. The Washington

Monument Association managed to sustain its undertaking for decades, until at last the structure was completed and open. As in other enterprises dependent on public support, feelings of municipal rivalry were aroused to shame communities into enthusiasm. Here was a way for Americans to put their mark on an ageless continent which had so few impressive evidences of civilization. This mark could not be tawdry or transitory; it had to reflect the power and self-confidence of a great human effort. Size and durability were therefore immensely important. Our monument *"will be the highest of the kind in the world,* and only below the height of the Pyramids. . . . No traveller will *then* inquire for the battleground. The monument will endure until the foundations are shaking. . . . It will stand uninjured to the ends of time."[36] Nervously awaiting the judgment of history, Americans asked what they possessed that "would save us from oblivion, should we be blasted like the Nations of Asia, and the tide of ages in their desolation sweep over us? I know of nothing but the Monument at Bunker Hill."[37] Busts and portraits were individual attempts to conquer time and achieve immortality; here were national efforts to escape cyclical doom, to fix the American's signature forever.

The archaeological aspect of the monument campaigns led inevitably to revised attitudes toward the native landscape. When patriots called for an art and literature to echo the magnificence of American nature their bombast was actually an attempt to come to terms with their gigantic forests and rivers, to design productions worthy of so magnificent a setting. But only great abstractions could equal the landscape; human things, particularly the small wooden houses, unpainted or covered with bright colors, the flimsy log fences, the rickety churches, the ugly railroad tracks, seemed cheap and insubstantial. The gap between the ideal and the actual was painfully obvious in the gap between the natural and the artificial. In the early nineteenth century, after two hundred years of settlement, the mark of humanity remained weak alongside nature's might. In England, Emerson was asked many questions concerning the American landscape; he found them difficult to answer. Nature lies sleeping in America, "overgrowing, almost conscious, too much by half for man in the picture, and so giving a certain *tristesse.*

. . . and on it man seems not able to make much impression.
There, in that great sloven continent . . . still sleeps and
murmurs and hides the great mother, long since driven away
from the trim hedgerows and over-cultivated garden of Eng-
land."[38] American nature held the "presence of strong forces,"
its "rough nature is masculine," so different from the "shaved,
beardless, effeminate look" of cultivated country.[39]

But such power and grandeur required complementary hu-
man efforts; it was all the more necessary to build wisely and
proudly. Society could no longer merely deface, it had to orna-
ment and endear the natural landscape. With their giant monu-
ments, Americans had made such an attempt; art presented
its first statement. After art came nature's term, a sign that
Americans were reconciled with the land they were forced to
conquer, and prepared to recognize its unspoiled power. This
might mean restraint, or conservation, or reverence, but it de-
manded, at a minimum, a feeling of attachment to the soil itself.

While Americans abroad noticed how Europeans protected
their natural landscape, Europeans traveling in the United
States commented on the pervasive indifference to trees and
natural scenery. William Blane, amazed that the hills of Cin-
cinnati were stripped of their magnificent foliage, observed
that an American had no idea that wooded ground could be
admired. "To him a country well cleared . . . seems the only one
that is beautiful."[40] Englishmen found American towns naked
and cold because they lacked trees and parks. Mrs. Hall
charged that Americans viewed trees as enemies, cutting them
down with avidity.[41] And Isaac Weld, basking in the beauty
of the Chesapeake countryside, reflected sadly on American
astonishment at his pleasure. "To them the sight of a wheat
field or a cabbage garden would convey pleasure far greater
than that of the most romantic woodland views." Because so
many trees had required removal before planting crops, people
looked upon them "as a nuisance," indeed took "an unconquer-
able aversion to trees."[42] Americans admitted dejectedly that
few countrymen appreciated natural beauties: foliage meant
fuel, hills provided building materials, streams existed to give
fish.[43] Fashion did not attend natural scenery.

After 1830, however, such comments began to disappear
as Americans learned to view their landscape with new interest.

The growth of cities, an increasing repugnance to the man-made landscape, expanded travel, the popularity of European poets like Wordsworth, the nostalgia of migrants from country to town, the conquest of the natural environment—all helped to endow trees, lakes, rivers and mountains with a new beauty. Suddenly they became an alternative to the less happy features of urban life and mechanized work. The formal product of this era of reconciliation with nature was the school of landscape painters. Among the less formal results was the rural cemetery movement, making giant strides in the 1830s and 1840s, based upon needs and arguments which also appeared in other campaigns of beautification. Joining the love of nature which Transcendentalists exemplified to a desire for visual improvement which the monument-builders expressed, here was still another instance of artistic reform designed to improve the moral character of American life.

Until this era, human burial was traditionally in crowded, nondescript churchyards, often surrounded by the bustle of growing cities; or, less happily, charnel houses were used. Interment was usually an austere, utilitarian procedure, relieved by religious services and sometimes by elaborate monuments. Few were concerned with the physical beauty of the body's final resting place; the dead would not care and the living—their eyes on a future life more glorious than any intimations of the terrestrial landscape—did not care either. It seemed futile, even vain, to worry about the situation of graves or the design of cemeteries.

But as hopes of future immortality grew less distinct, the living began to demand more certain means of communion with the dead. Anxiety produced a search for proof of an afterlife. This urge took one form in the spiritualist movement; its table-rappings and mediums enjoyed tremendous popularity in the middle third of the century. Another product of this concern was the greater physical interest in the dead. It was impossible to visit crowded and dirty churchyards with any sense of repose or beauty. Urban demands even made it necessary to move ancient bones from one gravesite to another. Dank, depressing, overgrown graveyards conjured up images of despair and decay; the English variety provided Dickens with some of his most horrific descriptions.

The demands of the living soon took hold. College students and clergymen forecast the new interest. Rural cemeteries "are not for the dead. They are for the living," Henry Bellows orated at a Harvard Exhibition in 1831.[44] Theodore Dwight echoed the thought, as he proposed that gravesites be planned "with reference to the living as well as the dead."[45] One after another new cemeteries were built throughout the country; the first landscaped cemetery of importance was Mount Auburn, established in Cambridge during the 1830s. Shortly thereafter came Greenwood in Brooklyn, Green Mount in Baltimore, Laurel Hill, the Woodlands and the Monument Cemetery—all in Philadelphia—Mount Hope in Rochester, Harmony Grove in Salem and the Albany Rural Cemetery.[46] As their names implied, these institutions comprised unspoiled tracts of parkland; they ranged from fifty to two hundred acres in size. The cemetery corporations sold plots to lot holders, who would eventually become the stockholders.[47] From the proceeds, grounds were landscaped and improved, gatehouses and chapels built, and careful maintenance established on a permanent basis. Rural cemeteries were to be places of beauty and tranquillity, secluded spots where bereaved relatives and friends could combine affectionate respect with a love of nature. There families could gather on sunny days, communing with the landscape to show their love for God and their remembrance of the dead. Called by one sponsor, "Rural Gardens for the Dead,"[48] these cemeteries were often managed by gardeners and landscapists; the major force behind Mount Auburn was Dr. Jacob Bigelow, an officer of the Massachusetts Horticultural Society. The tract had originally been purchased for botanical experiments.

The rural cemetery was envisioned as an open-air church where nature's hand alone would dominate. Some visitors may feel, wrote Nehemiah Cleaveland about Brooklyn's Greenwood Cemetery, that its entrance was too modest and too small. But they would be wrong, he explained, for the cemetery owners did not want art to raise false expectations. "If the artificial portal be deficient in dignity," coming as it did from a sense of modesty, "not so will you find that of Nature. You are now in a vestibule of her own making. Its floor is a delicious greensward; its walls are the steep hill-side; lofty trees with their leafy capitals, form its colonnades. . . . a great primeval

temple."[49] Nature as the great architect was also the theme of another cemetery sponsor, J. H. B. Latrobe, who read his "Hymn" at the dedication of Green Mount in 1839:

> *We meet not now where pillar'd aisles,*
> *In long and dim perspective fade;*
> *No dome, by human hands uprear'd,*
> *Gives to this spot its solemn shade.*
> *Our temple is the woody vale,*
> *It shrines these grateful hearts of ours;*
> *Our incense is the balmy gale,*
> *Whose perfume is the spoil of flowers.*[50]

Because nature, according to many contemporary theorists, inspired all architectural forms, it was appropriate for cemeteries to turn to her originals instead of to artificial imitations. Artistic delights, of course, could be added; Greenough, Thomas Crawford and Henry Kirke Brown were among the sculptors commissioned for monuments.[51] Philadelphia's Monumental Cemetery bore its name because of a Washington-Lafayette memorial, and Laurel Hill purchased some famous statuary by the English sculptor, Thom.[52] But nature's voice was loudest. The sections and avenues of the cemetery were forest retreats: Sylvan Pond, Willow Avenue, Indian Ridge. The pompous monuments of European cemeteries were condemned as effusions of vanity. Expense was not necessarily an evil, but florid elaborateness was. The cemetery testified to a hopeful love for God and creation; it symbolized a religion of joy. Nature was inherently beautiful, defying dreary churchyards by flowering even there. How much better it was to seek out such comforts deliberately, to enhance religious love and relieve doubts about God's benevolence.

Some of the cemeteries became so lovely that critics warned about excessive beauty; it was wrong to hide all the painful realities of death.[53] Awe and solemnity were necessary ingredients. Nonetheless, emphasis remained on nature's attractiveness and beauty. "My affection is for the country," cried John Pendleton Kennedy at Baltimore's Green Mount. He commended his fellow Marylanders for selecting beautiful sites for their own tombs, testimony to a "rational, reflecting piety; it tells of life unhaunted by the terrors of death."[54]

The rural cemetery movement displayed the characteristics

of other artistic crusades. As in the monument movement, archaeology and history played their part; brochures for cemeteries were filled with references to the burial customs of Egyptians, Hebrews, Greeks and Indians, emphasizing that proper respect for the dead was an age-old, universal trait. Wilson Flagg's volume on Mount Auburn, one of the most elaborate of such works, included sections entitled, "Ancient and Modern Tombs," "Ancient Funeral Practices," "The Sepulchres of Thebes," "Ancient Interments in Great Britain," and a general history of human burial practices. The past not only validated the reform, but provided for its specific practices.[55]

The theme of art as a bridge to nature recurred in these campaigns as it had among the Transcendentalists and as it would for believers in landscape gardening and painting. Properly arranged, cemeteries can be "made subservient to some of the highest purposes of religion and human duty. They may preach lessons, to which none may refuse to listen, and which all that live must hear."[56] In a chapter entitled "The Moral Influence of Graves," Wilson Flagg remarked that "to a mourner who has never been inspired with a love of nature, the rural cemetery may present a new gospel of consolation."[57] The primary task remained "to combine the works of nature and art" in a manner conducive to solemnity and grandeur. Here "Taste and Art join with Nature herself," wrote Nehemiah Cleaveland, "in adorning the last home of the loved. . . . here the man of business . . . would often reassure his hesitating virtue."[58] "To the matchless beauties of nature," wrote another, "let us continue to add the skill of the sculptor . . . the florist . . . the architect."[59]

Cemetery publicists, like the Transcendentalists, considered nature superior to art as a symbol of Spirit. Religion had no more pleasing doctrine, wrote Flagg, than the faith which viewed "all material objects as the representations of something more beautiful and divine existing in the spiritual world."[60] Each part of nature bore an emblematic significance, particularly flowers, which symbolized immortality. It was even suggested that fine trees replace marble monuments as gravestones; as men advanced in civilization they prized "nature more and art less."[61]

Every detail fell into place in the scheme of a return to unspoiled nature. Wild flowers were preferable to domestic

blooms, since the latter "always suggest the ideas of art, and of something that is to be bought and sold."[62] Violets, columbines and anemones should replace peonies and hydrangea bushes. The attempt to initiate spontaneity and cultivate wildness involved careful planning, but this paradox did not trouble cemetery promoters. Flagg even suggested that it might have been better if Sweet Auburn had had no trees when purchased; young ones could have been planted with room enough to allow for lateral expansion, and this would have presented a more naturally pleasing scene. Fences and hedges could be outlawed and wild birds encouraged to come and sing. Yet Flagg insisted that "affection, that loves to see the dead surrounded with images borrowed from nature and the skies, cannot . . . be cheated by its own artifices."[63] Of course this is essentially what was happening.

The same concern with man-made symbolism, the same simplification and concentration of allegorical forms linked the rural cemetery movement with the monument campaign. Too many emblems diluted the effect and destroyed the poetry. "Over a tomb we want a simple emblem, for a device, not an allegory; a sentiment, for an epitaph, not a sermon."[64] The Reverend Mr. Farley agreed, but he was one of many speaking out against Egyptian and Greek symbols—the inverted torch and the broken column—which from past associations were not appropriate to Christian burial.[65] George Templeton Strong was delighted that the "revised Pagan style" did not prevail at Greenwood. "I only noticed one pair of inverted torches and not a single urn or flying globe. . . . This recurrence to heathen taste and anti-Christian usage in architecture or art of any sort is or should be unreal and unnatural everywhere."[66] Even the principle of differentiation was introduced. Different ages, sexes and professions were distinguishable in life; distinctive monument forms could honor them in death: slender tablets for young girls, obelisks for public officials, pillars for those dying in old age.[67]

The note of self-congratulation at the selflessness of cemetery creators was another recurrent theme. "Little as the Christian Spirit is tied to outward form," wrote T. D. Woolsey, "it can not but rejoice to see ornaments of architecture in the house of His worship which it would not approve of elsewhere."[68] Cemeteries, like churches, were meant to be beautiful; human

bodies were God's temples and it was appropriate that "a portion of the wealth which is lavished on palaces for the living" be appropriated to "adorn the habitations of the dead."[69] Decoration symbolized "our love of virtue." Like patriotic monuments, carefully tended gravesites testified to American morality and a willingness to spend money and energy glorifying revered ancestors. The dead made the living more virtuous by inspiring such acts of piety.

The rural cemetery also convinced doubters that Christianity could be allied to true beauty; appeals to the senses, as visitors to Europe and Transcendentalists had already discovered, were not necessarily the snares of Satan. Cemeteries were more than "delightful indications of a purer growth in our national character than politics and money-making."[70] They showed how close a connection existed "between taste and morals"; every "pure ideal of religion and virtue grows in beauty by the food upon which it feeds." The rural cemetery thus became "the means to a great end."[71]

The cemetery movement also articulated an old desire to identify with the land itself, to establish permanent, irrevocable and perceivable roots in the country's soil. It was a simple but fundamental need: to establish burial grounds which the next urban improvement campaign would not move aside or leave to molder. In the promotion literature, references to nomadic peoples like the Arabs were frequent, always with the comment that *even they* had managed to set aside durable sanctuaries for their dead. Were Americans so mobile that even their bones could find no undisturbed rest? Were they so heedless of the call of memory that alone among the world's civilizations they failed to reverence the remains of their ancestors? Were they so deeply at war with their natural environment that they would not even plant flowers above the loved dead, or at least choose spots of natural beauty for burial? Proponents of rural cemeteries asked these questions sadly, until successful results convinced them otherwise.

The cemetery crusade, with its emphasis on tradition, reverence and objectified morality, appealed particularly to conservatives. Even the thematic commitment to nature was attractive, for these reformers did not conceive of the natural as new, untried or radical. Nature's adherents could call upon history,

memory and permanence as readily as could the advocates of
European art. Nature was unchanging except for human devasta-
tions, and these Americans needed visual memories and signs of
their own past. Happy are those, Wilson Flagg lamented, whose
paternal homes remained unchanged, and who could return to
them in their old age, to rest in the memories of youth. Un-
fortunately, however, most citizens spent their lives "moving
from place to place," and had nothing to remember but a
schoolhouse or a once familiar walk. Even these were revolu-
tionized, and "nothing is left that is sacred in one's memory,
save the blank surface, where he vainly endeavors to picture
to his mind the absent landmarks."[72] As a man who put enor-
mous energy into both the rural cemetery and landscape gar-
dening movements, Flagg confessed that his happiness depended
greatly on external things. His spirits and hopes were nurtured
by the sight of old accustomed places. "Memory is not wholly
the result of a voluntary effort. The power of recollection de-
pends greatly on suggestions from outward objects."[73]

Other men also expressed a desire for a sense of memory
and history. "Why is it that we turn thus from the future to
the past? . . . we turn from the ideal of what may be, to the
certainty of what has been. There is no abiding place for the
wing, when it becomes weary of its flight; all before is wide,
illimitable space, and we turn back with relief to the record
of events."[74] There was something in this of Thoreau's affec-
tion for the humble cottage, picturesque only because of the
life that had gone on within, beautiful as a *record* of experience.
And something also of the monument builder's hopes for a
growth of nostalgia in a physically preoccupied nation. It was
time for memory to receive an equal voice alongside of hope.

Appropriately enough this was the generation which dis-
covered that America did have a natural past and that the New
World was not really so new. When Europe was peopled by
savages, centers of culture had existed in the Mississippi Valley,
according to the pioneers of American archaeology.[75] The first
scientific data collections about the Indian's past were made in
this era; the soil held secrets which put Europe's to shame.
William Cullen Bryant, the glorifier of nature, the celebrant of
England's rural cemeteries and the critic of America's tradi-
tional "naked rows of graves," also spoke with wonder of the

Indian mounds that dotted the Mississippi Valley. They were signs that

> *A race, that long has passed away,*
> *Built them;—a disciplined and populous race*
> *Heaped, with long toil, the earth, while yet the Greek*
> *Was hewing the Pentelicus to forms*
> *Of symmetry, and rearing on its rock*
> *The glittering Parthenon.*[76]

Here was a means of establishing continuity with the cycles of human history. Timothy Flint, a tireless New England missionary who traveled throughout the West, hurled his defiance at Europeans and Easterners who described America as a raw, uninteresting country. America had no old abbeys, or towers, or dungeons, he admitted, but in the Indian mounds she offered great scope for the imagination and the contemplation of the past. "The men, their joys, their sorrows, their bones, are all buried together. But the grand features of nature remain. . . . The forests, the hills, the mounds, lift their heads in unalterable response, and furnish the same source of contemplation" that they had to earlier generations. America was an old country after all, where "age after age has rolled away, and revolution after revolution passed over."[77] Why should Americans look to other climes for history when Europe in its infancy was matched by "a race, perhaps, far mightier than they. . . . Greece, with its classic lore, Rome, with its faded splendor, Egypt, with its colossal grandeur, cannot furnish more to awaken these high emotions, than our own land."[78] No matter that the archaeologists offered little evidence for such sublime fictions; the need for romance and identification propelled these fantasies as high as anyone's dreams might reach.

With nature offering history and mystery as well as beauty, Americans expiated their devastations against her—the jagged, man-made wounds into the benevolent land, the ditches, fences, railroads and highways. These were still raw and ugly, and needed to be healed and disguised. Men wished a return to harmony with a once hostile environment; having been mastered it could now be won more amiably. In covering up the dead with trees and flowers, in adorning their final homes in the soil, such a reconciliation had been begun. "Let us go to the resting-places of the dead, where the turfs lie in verduous heaps,

and the flowers of the field scatter their incense. . . . Here will the gentle mother receive us, and when we can no longer be comforted by reason or philosophy, she lulls us to rest by the assurances of religion."[79]

The same desire for the integration of art and nature, soil and citizen, was served by still one other reform group. Artistic improvement was also pressed into the service of conservatism and patriotism, and made part of a comprehensive vision of American society in the rural architecture and landscape movement, best symbolized by its great leader, Andrew Jackson Downing. In a short career of about ten years, his books, articles and designs achieved a popularity so enormous that they helped change the shape of the American countryside and affected the taste of generations.[80]

Downing's theories involved a familiar blend of Transcendental art principles with specific conservative social goals; his close friendship with the man whose career bridged Transcendentalism and social conservatism—George William Curtis of Brook Farm and the Genteel Tradition—symbolized his attachments. Downing was no mere democrat, seeking to extend the powers of the millionaire to the laborer; his interest in the diffusion of his values centered on their uses as pacifiers and social controls. Time after time he and his followers stressed the political morality of good architecture, in accents often resembling those of Ruskin but with particular applicability to the United States.

Americans needed good houses, these architects argued, because tasteful dwellings were instruments of civilization and awakened a desire for refinement. "So long as men are forced to dwell in log huts and follow a hunter's life, we must not be surprised at lynch law and the use of the bowie knife." When "smiling lawns and tasteful cottages" appeared, then "order and culture" had been established. Homes were the nurseries of moral health, the guarantors of the "purity of the nation."[81] City life could sharpen character, Downing admitted, but only in handsome rural homes could the best social life be established. The hearth was to be a center for the good and the beautiful; family life would then nurture the highest character and the most ennobling pursuits.

Both Transcendentalists and social conservatives repeated these sentiments about the influence of country homes. Emerson proclaimed the need to "disgust men with cities" and arouse a passion for rural life; "bringing out by art the native but hidden graces of the landscape" formed the necessary means. Anyone who endeared the land to its inhabitants was performing a patriotic service, for proximity to the soil—in farming, mining, hunting or daily life—generated patriotism. "How much better when the whole land is a garden. . . . we must regard the *land* as a commanding and increasing power of the American citizen."[82] A supporter of Downing's beautification campaign spoke of it as a means of counteracting the "restlessness and disposition to change which is characteristic of our people." It would check "our passions for luxuries of all kinds."[83] Would American boys leave the country, asked another, "if the roof-tree of home thus blossomed," if vines and shrubs graced the ancestral American manse?[84]

Beautiful homes and gardens were "an unfailing barrier against vice, immorality and bad habits."[85] "Can we conceive a voluptuary loving to put his hands to the real work of gardens?" asked one follower; only in tropical countries, he answered. Crimes were committed by men with no property in the soil, and the great corrupters of society were the "homeless, the itinerant speculator, the restless vagabond."[86] Much earlier, Theodore Dwight had demanded that Americans renovate their houses. Lowering ceilings, tearing off silks and gildings and decreasing room scale were devices for holding families together. If houses were comfortable and handsome "how many a fireside might be daily and nightly gladdened with circles of well-taught and affectionate brothers and sisters, instead of being devoted to frivolous morning calls."[87] Careful selection of furniture and personalized interiors would mean a "more careful culture of *home associations,*" said Nathaniel Parker Willis, and considering "the facility with which families break up," this would be a highly desirable improvement.[88] Downing added his own emphatic agreement. "If you would keep pure the heart of your child, and make his youth innocent and happy, surround him with objects of interest and beauty at home."[89] Landscape gardening and rational architecture would save that most fragile of American institutions, the family.

And it was for a settled, organic and hierarchical society that these reformers worked. Downing favored a system of differentiation, dividing rural homes into three grades: villas, cottages and farmhouses. Each structure was designed for a different class, and the worst sin against good taste was the attempt of one sort of house to try to resemble another, or one social class to live like another. Each was proper and dignified in its place; otherwise it was an insult to truth, the basis for beauty "no less in houses than in morals."[90] The villa belonging to a man of wealth, filled with books, pictures and statuary, was appropriately superior to the cottage of an industrious farmer or artisan. A cottage dressed in the ornaments of a villa violated propriety as sharply as did a worker wearing the "diamonds that represent the superfluous wealth of his neighbor."[91] The shadowy memory of sumptuary legislation cast itself across the length of Downing's architectural theorizing.

The landscape movement's social, as well as visual, ideals were English. Calvert Vaux and Gervase Wheeler, architects who spread Downing's conceptions throughout America, were both British emigrants; all drew heavily on the work of John Claudius Loudon, Uvedale Price and William Gilpin. Their goal was an English rural life, one which left time to work out a gentle, cooperative relationship between art and nature. Downing's Natural Man was no Adam, wandering about a garden of delight in pristine innocence; he was a creature of cultivation and culture, at home with the latest European books, decorating his mansion with objects of art, using his fields not for hunting but for quiet (and elegant) communion with the Creator of nature's refinements.[92] These were men who had quit the bustling competition of city life for places of rural retreat, men with leisure time at their disposal and "competent means of luxurious independence," men who "rationally blended" rural tastes and metropolitan refinements.[93] Communities in the Hudson Highlands, where N. P. Willis' Idlewild, and the homes of Downing, Paulding, Gouverneur Kemble and other gentlemen of taste gathered together, typified Downing's ideal, as did the cluster of wealthy Philadelphians in Germantown, "adorned with elegance and supplied with all the conveniences of a city . . . with none of the annoyances of town, but quiet, country scenery, gardens and trees everywhere."[94]

Downing's success showed how Transcendentalist aesthetics might be placed in the service of conservative goals. He shared with others of his generation a faith that God's nature was grander than man's art, and actually began his career as a gardener, turning to architecture much later. Downing continued to search for a way to harmonize the house with the landscape and to avoid human challenges to natural scenery. No bright colors or stark outlines were permissible; the building was meant to blend into its site. Thoreau, interpreting a poem by Emerson, had written that "man's works must lie in the bosom of Nature, cottages be buried in trees, or under vines and moss, like rocks, that they may not outrage the landscape."[95] This was Downing's attitude also; nature must not take second place to an inherently inferior beauty. In any event, all beauty was "much enhanced by a due concealment, rather than a bold display of its attractions. Gleaming through a veil of soft green foliage, we are led to magnify its charms, from there being something pleasing suggested, which is not seen."[96] Downing advised Americans to follow English tastes and allow the grounds to outshine the house.[97] This meant that art and nature were never to confront each other nakedly. Vases and sundials were to be set near the house, not "in a distant part of the grounds, where there is no direct allusion to art."[98] Like the era's European travelers and the cemetery promoters, Downing and his supporters worked for a "harmonious union of nature and art."[99]

And like the Transcendentalists, the rural enthusiasts believed that men would learn to love nature as they grew familiar with art. Downing did not hesitate to teach even farmers about the beauties of nature through gardening and architectural ornamentation. "Now, although we do not expect farmers to possess a gallery of pictures or statuary, yet they have a scarcely less instructive field open to them while tastefully disposing their gardens and grounds, in studying the various developments of beauty that occur."[100] Schemes of landscaping might even help by their very expense. Wilson Flagg insisted that paintings were admired only because of their cost. "Nature has always been unfashionable, because she is cheap."[101] This was one anomaly a high-priced architect could quickly end.

Like the Transcendentalists again, Downing denied that art's highest power was facsimile reproduction; rather it was

a seizure of "the subtle essence" at the heart of nature. He also believed that every "outward material form is a symbol or expression of something which is not *matter,* and which, rightly understood, gives us the key to the power with which that form immediately and without reflection, acts upon the sense of beauty."[102] Thus the twisted or wreathed column was the natural emblem of an embrace, and its use in a building would symbolize affection. A fourteen-thousand-dollar villa denoted conservatism, culture and intellectuality by its exterior alone. "We see refined culture symbolized in the round arch, with its continually recurring curves of beauty, in the spacious and elegant arcades, inviting to leisurely conversations, in all those outlines . . . suggestive of restrained and orderly action."[103] It was helpful to symbolize the character of the family who lived within a house, and great care was taken to ensure that this correspondence was a true one. Libraries indicated intellectuality, handsome parlors presumed generous hospitality, while picture galleries expressed a love for the beautiful.[104]

But if virtues could be articulated, so could vices. "A house built only with a view to animal wants," wrote Downing, "will express sensuality instead of hospitality."[105] A home revealed the character of the man who built it; the perceptive observer easily detected expressions of pride or egotism. Domestic architecture reached perfection only when it expressed the beauty and truth of the builder's life.

But Downing and his followers did not wish to state all truths, and their selectivity revealed the ideology harnessed to these artistic reforms. Any evidence of the manual activity involved in the upkeep of estates was to be kept out of sight. Lawns were to be mowed and walks swept by "invisible hands," at night or when the family was out.[106] Downing's own home lay just above a town and a well-traveled road. "But so skillfully were the trees arranged, that all suspicion of town or road was removed. . . . You fancied the estate extended to the river."[107] Downing made no objection to the use of wallpapers which imitated grained-oak wainscot; his honesty was a principle to use when appropriate.[108] For not all nature was beautiful; here he parted company with Thoreau, though not with all the Transcendentalists. "A head of grain, one of the most useful of vegetable forms, is not so beautiful as a rose; an ass,

one of the most useful of animals, is not so beautiful as a gazelle."[109] Without delving too deeply into aesthetic theory, Downing made it clear that beauty was intrinsic in certain objects and that his rules would help cultivate the taste necessary to perceive it.

Though the landscape movement was not philosophically altogether consistent, it was a pragmatic working-out of the life pattern these men wished for the leisured, genteel and refined America of their imaginations. Direct imitation of foreign building styles was forbidden, but not their adaptation. All depended once more on appropriateness. Elizabethan structures, recalling the "hearty hospitality" of Tudor England, or Italian villas bringing to America the ease of the Mediterranean were fine; but "a villa in the style of a Persian palace" replete with domes and minarets was clearly unsuited to American life.[110] Downing sympathized with those natural conservatives, "wisely distributed even in our democratic government," who wished to surround themselves with the forms of earlier ages. "If we see such men copying in their dwellings the forms and ornaments of old English or Italian architecture, because they really live more (internally speaking) in Saxon thought or Italian art than in our own age . . . it is fitting and good for them, however unmeaning for the many."[111] Presumably no American would wish to live (internally speaking) in Persian or Chinese philosophy.

Inconsistencies did not bar Downing's affection for the imitated style. This was probably why his books enjoyed such popularity; the settled, rural existence, every villa with its large library and entrance lodges designed for opening gates from the inside ("service of this kind is less cheerfully performed in this country than in Europe"), presented an attractive prospect, more of a general social ideal than an architectural aesthetic.[112] In Downing's universe, all men lived in the beautiful countryside, each satisfied with his villa or cottage, envy and pretension buried forever. Downing wished not every man a democrat, but every democrat an aristocrat—so far as was possible. He wrote of the "inextinguishable rights of a superior organization in certain men and races of men which Nature every day reaffirms, notwithstanding the socialistic and democratic theories of our politicians."[113] He was no ordinary popularizer, but one whose

heart lay in the great villas, and whose allegiance rested with their owners.[114] Just as Downing yearned for a "homely and modest, though manly and independent" yeomanry, so he sought to create an upper class with ties to the country. In the best English tradition, prosperous landed interests would counteract the "disposition to change which is characteristic of our people," and place society on steadier supports.

His followers agreed. Sidney George Fisher, related to most of Philadelphia's great families, at home with the Ingersolls, the Powells, the Logans and the Dickinsons, found the popularity of Downing an indication of American "advance in refinement."[115] Filled with contempt for democracy, for money-getting and ambitious parvenues, Fisher respected only birth and breeding. Early impressions, he felt, were too powerful to be "removed by the influences of after life," and so gentlemen were born and not made.[116] It was appropriate for Fisher to worship landed estates like Stenton, the home of Pennsylvania's Logans and Dickinsons. Houses of this sort had "the prestige of time and the associations of one family." They were the natural source of aristocracy, "founded in nature" and "necessarily connected with the hereditary ownership of land."[117] Instinctively and consciously Fisher and Downing realized that the stability and order they worshiped could be protected only by the creation of landed classes committed to their own continuity, and by the strengthening of permanent rural ideals. Reformers like Jefferson, or Nathaniel Hawthorne's Holgrave, were convinced that only movement, change and equality could assure the primacy of the present. "If each generation built its own houses," said Holgrave, "that single change, comparatively unimportant in itself, would imply almost every reform which society is now suffering for." Better that capitols, courthouses and churches should be built of perishable materials and "crumble to ruin" every twenty years, "as a hint to people to examine and reform the institutions which they symbolise."[118] Downing and his followers hoped to cut off just this sort of radicalism by their beauty campaigns and by focusing attention on the hearth as the center of all natural conservatism, they were only following an ancient formula.

Refined taste itself differentiated. With showy designs becoming "base, common and popular" because the owners of

steamers and hotels "from motives of policy" were far more lavish than any private person could be, private taste had to take another form. The "only resort for a gentleman who wishes his house to be distinguished by good taste, is to choose the opposite course," and that meant restraint, as taught by Downing.[119] Enthusiasts for the rural landscape movement regarded every evidence of interest in refined decoration as a body blow against the forces of utilitarianism and materialism. The sight of vine-covered cottages pleased "because mere utility would never lead any person to plant flowering vines."[120] Since architects and carpenters would never plant them, they had to be the contribution of the resident family. Well-kept grounds indicated an attention "to other than mere animal enjoyments," and proclaimed a family with spiritual commitments.[121] Costly patriotic monuments proved selflessness and idealism; handsome estates did the same. "Nothing is more remote from selfishness than generous expenditure in building up a home," wrote Henry Ward Beecher. "A man who builds a noble house does it for the whole neighborhood, not for himself alone. He who surrounds his children with books, refines their thoughts by early familiarity with art, is training them for the State."[122]

At his death Downing left a rural America dotted with the Tuscan villas and picturesque cottages he helped to popularize; nearby were the rural cemeteries and monuments which allied interests supported. Public-park designers of the next generation, like Frederick Law Olmsted, trod upon the road he cut out, and horticultural establishments grew rich with new business. Downing's most enduring legacy was his identification of aesthetic reform with a set of ethical and social ideals, his rural commonwealth of men of honor whose rationality was strengthened by the natural beauty which architect and gardener had assembled. Art and architecture retained their communal significance; artistic preferences, like national ideals, were too important to be personal. "Whoever builds . . . an unsightly house, insults the community, wrongs his neighbors . . . detracts from the common weal."[123] The American landscape was too beautiful and influential to allow any individual the right "to disfigure some noble scene by an unharmonious dwelling."[124]

The beautification campaigns that swept mid-nineteenth-century America were supported by visions of an ideal society

which could be symbolized—and propelled—by the planning of sensory appeals. Its publicists shared some of the rhetoric and commitments of the Transcendentalists, who had waved aside beautification devices, however, as trivial in so basic a reform campaign. But the activists, the promoters of landscape cemeteries and rural villages, of art galleries and parks, of monuments and city plans, were members of an impatient generation, unwilling to believe with Thoreau that only Athenians could create an Athens. The arts would not wait for Spirit to create them, but must be pressed into the service of the ideal they symbolized. Once more, artists and designers were called upon to wage war on the forces of materialism, impiety and indifference. Out of the materials of their lives as well as of their art, came the justifications for the new social engineering.

Artist Images:
Types and Tensions

CHAPTER NINE

As THE CRUSADES FOR BEAUTY gained momentum toward mid-century, their artist beneficiaries were ascribed romantic powers as magicians who could stimulate and satisfy the cravings for visual delight. Until the 1830s artists' life patterns were neither publicized nor idealized. For most Americans the figure of the artist remained indistinct, or at least exotic and European; distance lent mystery and charm, but it also symbolized estrangement. In the next thirty years the attention of the community and the energy of the literary imagination created a clearly differentiated role and life style for the artist in America. Novels, poems, short stories and obituaries all made contributions, as did new professional periodicals. A satellite community of critics, poets, patrons and journalists added color and excitement. As his achievements circulated through the country the fictional artist began to diverge significantly from his genuine counterpart; indeed, mythic images stimulated imitation and further confused the artist's status. Biography became both a recollection of the past and a prophecy of the future. By the 1860s artists had won a claim to creative consideration and popular attention.

The writers who offered this publicity remained self-consciously aware that the artist's role was barely noticeable. As one critic put it in 1847, there was "a peculiar interest in tracing the history of what is comparatively neglected; and advocating the claims of a pursuit, as well as vindicating the merits of a class of men whose quiet and isolated, but noble and humanizing occupations, are constantly overshadowed by more engrossing and material occupations."[1] In fact, understatement and neglect provided much of the initial charm, for the world respected an artist much "as it would an anchorite."[2] Artists were particularly important to clergymen and moralizers as living embodiments of dissent. The ranks of art publicists

filled with social conservatives anxiously seeking an alternative to national materialism and competitiveness.[3] The artist life became an allegorical rendition of the true way, a means of berating the national conscience, or, more positively, a justification for democratic energies. Artists also bore the heavy load of didacticism burdening American art objects; social and political tensions as well as art enthusiasm fed public interest.

But although the American artist could assume the role of community redeemer, a mediator between the worlds of nature and of man, his actual success led in time to his symbolic failure. For as artists sold their paintings and statuary and blended with the community, as they achieved financial security and a louder voice in cultural affairs, their growing wealth, conservatism and social respectability directly contradicted the idealized artistic virtues. It is significant that James Russell Lowell loved "reading the *early* letters of men of genius. In that struggling, hoping, confident time the world has not slipped in with its odious consciousness, its vulgar claim of confidentship. . . . As we grow older, art becomes to us a definite faculty, instead of a boundless sense of power."[4] Eventually even the publicists would come to terms and create more modern and realistic artistic heroes, but they would never satisfy the older ideals. The artist life came to stand for more than dissent and single-minded devotion; successful creative achievement to later eulogists meant an allegiance to majority values in the self-help tradition. Businessmen-artists, Horatio Alger geniuses with the habits of successful merchants or manufacturers were held up to public approval, though they never invaded the field of fiction, in a heroic capacity, as they dominated biography.

Problems of survival forced a business consciousness on American artists right from the start; even in the eighteenth century, entrepreneurial skill was often more crucial than artistic talent. But the journeymen sign painters, the touring panorama-producers, the lithographers, engravers and limners never achieved heroic stature. They lacked one quality which linked professionals in the worlds of big business and art: risk-taking. The leap into the unknown, the gigantic gamble with the future, required great courage and a self-confidence easily transformed into the bluster and egotism of a Phineas T. Barnum. No net

below would cushion the fall if professional and financial dis-
aster resulted. Artists and businessmen shared Jacksonian Amer-
ica's braggadocio, the gigantic schemes and energy characteristic
of commercial men on the make. They were translatable with
the same vocabulary. Sculpture "requires a self-reliance equal,
almost to Kepler's." A man giving himself up to art was "no
small part of a hero." He needed a strong character and "ro-
bust powers." Americans made good sculptors precisely because
of their "bold, strenuous habit of action."[5] Romanticized artists
could share their idealized virtues with independent entre-
preneurs; points of tension arose as novelists, biographers and
poets discovered that romanticism might do for the world of
art, but not for the world of industry. They then had to choose
between the two.

Before the Civil War only a handful of fictional artists
came to life in America, and before about 1840 they were
Europeans. Idealists with mysterious names and doubtful par-
entage, they lived in intrigue or squalor. The hero of a typical
short sketch in the *New York Mirror,* Theodebert Monier, was
an enthusiastic French artist, who ended his own life after a
series of vain struggles against fate.[6] Theodore S. Fay's novel
of early nineteenth-century cosmopolitanism, *Norman Leslie,*
provided another such figure in a young Italian sculptor, Angelo.

Angelo is the prototype of the young romantic, a profes-
sional "melancholy and intellectuality" dominating his physical
appearance. Slender and lithe, his labors are obviously "not
of the body but of the mind." His work is done "beneath the
expanded forehead," his face "high and classical. . . . Pale, noble,
intelligence. . . . Large black eyes . . . women would have found
in him the dangerous faculty to feel love in its most passionate
moods. . . . His hair was profuse . . . rich auburn masses about
his white, blue-veined temples. . . . a *beau ideal* for genius."[7]
Angelo's frail, delicate exterior disguises profound strength, a
power which enables him to cope with the strenuous demands
of his art. His companions are "divinities of the past" like
Phidias and Praxiteles, and thus his sensibility is honed to a
finer edge than ordinary experience could produce. His chisel
and brush confer "an immortality which nature refused," and
Angelo becomes as powerful as a god. Driven by energy, genius
and passion, he is "dangerously gifted with capacities both for

happiness and misery," a man of mystery as well as beauty.[8] He belongs to a fellowship which possesses "a halo . . . of genius and ambition," extending even to the most aged and inferior members.[9] Those who grasp at dreams and inhabit the realm of the ideal put to shame even the wealthiest of their fellow men.

The best known of the mysterious European artists created by American fiction at this time was himself the product of a painter's imagination—Washington Allston's Monaldi. Monaldi possesses many of the qualities which endeared Allston to his own contemporaries: gifted with a superhuman patience, modesty and benevolence, he abhors competition as "unworthy a true artist; nay, he even doubted whether any one could command the power of his own genius whilst his mind was under the influence of so vulgar a motive."[10] Genius never competed because it could stand no comparison. "Gentle" yet "commanding," Monaldi is "wholly free of pretence [sic] and affectation."[11] Like Angelo he speaks with "the mighty dead of the fifteenth century," seeking to graft their gifts on to his own. And like Allston he gains public recognition through his combination of personal modesty and artistic skill: a Renaissance master gracing the modern era.

But the novel is more than a paean to genius. An envious, villainous friend, Maldura, tricks Monaldi into believing that his wife has been unfaithful. If Maldura suggests Iago, Monaldi imitates Othello and stabs his innocent wife. Under the impression that he has killed her, Monaldi loses his reason, recovering it only on the eve of his death. Allston's novel is a parable on the misuse of artistic energy, for Maldura, the wicked friend, is a poet. His life proves that "without virtue, the love of praise is a curse," and that "distinction is the consequence—not the object, of a great mind." Envy and jealousy were sure marks of a spurious love for excellence.[12]

The lesson was clear. With the dangerous power any artist possessed he required more virtue and self-control than other men. If, like Angelo, he was capable of greater happiness or misery, he was also capable of working greater good or harm. Talent was useless without character; indeed, true talent could not belong to those with evil passions. Maldura's character and intellect—and hence his artistic skills—were inferior to Monaldi's.

Burdened by this moral ambivalence, these exotic artists

were surrounded by mysterious people and strange events. Everything heightened both interest and temptations. Joseph Holt Ingraham's 1846 tale, "The Hand of Clay. Or, The Sculptor's Task," contained horror enough to satisfy any lover of the gothic.[13] The "most beautiful woman in Italy," the Countess Isabel di Valoni, is stabbed to death at her marriage; guards manage to cut off the hand of the escaping assassin. On inspection the hand turns out to be a woman's, and the thwarted bridegroom dies after seeing it. The reader is then introduced to a young German sculptor, Frederick Rother, a student of necromancy and metaphysics, but "wedded to his sublime art."[14] Interrupted in his studio while reading Swedenborg, Rother confronts a mysterious, hooded stranger, who is later revealed to be Mesmer, the great hypnotist. Mesmer takes the sculptor to a beautiful, one-handed woman, and orders a new hand of clay. In Mesmer's power, Rother creates the hand, binds it to an arm and then is astonished to discover "a living member result from the operation.[15] Soon thereafter the sculptor awakens from his nightmare, the inevitable result of too much reading.

Ingraham's story, weak ending and all, touches on an ancient theme: the artist as magician. The ability to create images had always been associated with magic, and the greater the artist's skill the more dangerous and disturbing became his power to create. Like most other fictional artists of the era, Ingraham's figure is flat and one-dimensional, a stage prop rather than an actor. But his inclusion in an anthology devoted to mystery tales indicates the suggestiveness of the artist's association with the occult, even in the nineteenth century. With its brooding, piercing and introspective qualities the artistic intelligence might be in contact not only with the spirit of nature or the old masters, but with forces of darkness as well.

Nathaniel Hawthorne's "Prophetic Pictures" explored still more explicitly the artist's vulnerability to evil alliances. His painter, a gifted European visiting the colonies, was so talented that simple folk feared his power. His profound insights frightened men who "were inclined to consider the painter as a magician, or perhaps the famous Black Man of old witch times, plotting mischief in a new guise."[16] Undisturbed by rumors that this painter was prophetic, Walter Ludlow and his betrothed

order their portraits. When the artist recognizes "a fearful secret," his pride and egotism lead him to forecast it in his work. The artist's conceit, nourished on dreams of professional grandeur, is the real villain. "It is not good for man to cherish a solitary ambition," warned Hawthorne, as artistic egotism leads to the act of horror which closes the story. Prophets might forecast the future, but as painters they were powerless to avert the disasters they could predict.

It was to be expected, then, that the Faust theme would continue to appear in artist stories; in 1838 the *New York Mirror* published a tale about a German artist in Italy who sells his soul to the devil for a magic pencil.[17] Prominence, fame, even love result from the bargain, but the reader is assured that eventually Ernest Hartmann will belong to the fiend who had trapped him.

Other artists were also connected with scenes of horror and deception. A son uses the portrait of his father's corpse to trap a guilty assassin, and provokes a confession by the painter's skill. The artist feels "an irresistible power" guiding his hand, while he remains "the agent of an unknown director."[18] Another painter is locked in a church tomb, "undergoing agonies of delirium while waiting for deliverance."[19] Many of the tales picked up from British magazines like *Frazer's* or *Chambers's Journal* touched on similar themes: insanity, suicide, depression, megalomania and unrequited love. In one, an older artist attempts to hurl the pupil who defeated him in a competition off some church scaffolding to his death on the pavement below.[20] In another, a disappointed English artist decides to commit suicide because he lacks the sublime talent. The horror of frustrated genius titillated American readers as they read Morton Sheridan's lament of the "melancholy waste of all the faculties of a strong mind . . . unwearied industry, stern perseverance, unswerving will," all of which had proven vain and ruined his life. "Like the arch-tempter," art insisted on the sacrifice of his soul, but unlike the devil it did not keep its promises.[21]

Although indigenous artist types appeared in American fiction, the Europeans remained. So many scenes of American artist life took place abroad and so many native artists had studied there that many novels were set on two continents, if

not confined to Europe alone. The American artist heroes
were generally the same exquisitely organized, sensitive, hand-
some creators as their European colleagues, and lent them-
selves easily to melodrama.

Emerson Bennett's dime-store thriller, *The Artist's Bride,*
added to its title's allurements scenes of rape, seduction,
murder and prostitution. The book's hero, Julian St. Cloud,
is a painter. Though the scene is Philadelphia, and Julian
a native American, the French name is appropriate to his pro-
fession. Julian's introduction includes the inevitable phrases
associated with the artist's physiognomy. Seated carelessly,
"the soft, white fingers half buried in a mass of black, wavy,
glossy hair," the hero muses dreamily. "His face was pale, sad,
thoughtful, but very handsome. The well-turned lips and chin
—the straight, chiseled nose—the dark, full, dreamy eyes—
and the high, broad, white forehead" present a picture of beauty
and intellect.[22] Dressed completely in black with a "broad collar,
à la Byron," Julian is as much a *"beau ideal* of genius" as
Theodore Fay's Italian Angelo, and bears as little resemblance
to the sturdy, backwoods sign painters and mechanics who made
up the profession in America as they did to Lord Byron. When-
ever St. Cloud appears, he is surrounded by the appropriate
phrases: "pale, classic features," "large dreamy eyes," "slender,
graceful form"; a softness, elegance and almost feminine pas-
sivity pervade the artist's personality. Moreover Julian is intro-
spective and depressed. His sorrow is rather assumed than ex-
plained, "his mind burdened with grief, care, trouble, and
study—a poetical dreamer by nature—he had mingled little
in the natural world, but had lived mostly in the world of
his own creation . . . a sad and lonely pilgrim on the high-
way of life."[23]

Artists like St. Cloud so resembled the classic man of
feeling—submissive, gentle, subdued—that writers used them to
denounce materialism and the reckless pursuit of wealth. Julian
has no money but is determined to avoid the cheating neces-
sary to acquire a fortune. "The world sets a value upon a man's
purse, rather than his brain," he cries, and "honest, virtuous
poverty must stand uncovered and shivering . . . while gilded
vice stalks by in jeweled ermine." Nonetheless, he would not
change his talents for gold, "even though I be doomed to

starve."[24] "What do you call poverty," asks another artist. "My art will bring us consideration enough—which is the main end of wealth after all."[25]

The spiritual universe housing the artist gives money no value and virtue cannot be bought. But sometimes evil-minded and materialistic men seek to disguise themselves beneath the purity of the artist's visage, and make their vices more palatable. The chief villain in *The Artist's Bride,* Leon Dupree, seducer, rake and murderer, tries to gain his way into feminine hearts by buying St. Cloud's portraits and pretending that he has painted them himself. No one who painted so beautifully could be guilty of personal vice.

Other artist types were as sensitive as St. Cloud, but more aggressively intelligent and insightful. In George W. Curtis' *Trumps,* the artist figure bears the suggestive name of Merlin, a man "whose eyes were accustomed not only to look but to see."[26] Handsome, passionate, alert, he sings as he works, dressed "in a cotton velvet Italian coat, illimitably befrogged and bebuttoned."[27] Merlin's dedication contrasts nicely with a churlish businessman, Abel Newt, whose only theme is Trade. Newt's artist hero is Benjamin West but "he was an exception, and besides he lived in England. I respect Benjamin West. . . . He made a good thing of it."[28] For less successful artists Newt has only contempt. Curtis, like most of his fellow novelists, glorified artistic virtues at the expense of mercantile ideals, and Newt served as a convenient foil. In later years, however, writers would not be so scornful of business values, and their artist heroes would appear with traits once despised and ridiculed.

As authors grew aware of the variety of the artist community, more Promethean and aggressive artists marched through their works. But through the 1850s the passive, delicate and introspectively spiritual type dominated fiction. He might be the languorous, philosophical Ernest Carroll, whose romance with a Venetian Countess rambles through Florence, Venice, Vienna and endless water cures.[29] Or he might be the spiritual and intellectual Princeton undergraduate, Clarian. In any event he remained soft and feminine, with a "broad, smooth forehead . . . soft skin . . . ripe, womanly mouth. . . . His hair of the purest chestnut hue, rich and silken . . . eye

. . . large and dark, tender, rather sad. . . . womanly traits he
had . . . brought up like a girl at home."[30] Artists like Clarian
worshiped art as a divinity, and "only ask the god to reveal
to them his unveiled effulgence."[31]

The feminine aspect of the artist's personality became so
intrusive as to create uncertainties about his sex. In Theodore
Winthrop's *Cecil Dreeme* the title character is an artist who
turns out eventually to be a woman disguised as a male to
escape an evil genius. Winthrop outlined the varieties which
the New York art world of 1860 was capable of offering, "a
painter of the frowzy class, with a velvet coat, a mop of hair
and miles of beard"; "a man whose art is a trade, who paints
a picture as he would daub the side of a house"; and "the
true Artist, a refined and spiritualized being, Raphael in look,
Fra Angelico in life, a man in force, but with the feminine in-
stinct."[32] Winthrop left no doubt about his partiality for the
poetical romantic.

Associations between artists and women took a variety of
forms. Often, as with Clarian and Dreeme, the artist's per-
sonality or appearance was feminine; at other times the in-
fluence of a mother or sister was crucial to the blossoming of
his genius. Women possessed the ability to perceive true talent;
and like artists their special insights and moral purity exempted
them from other conventions. Some writers granted their
artists more aggressiveness, and created ardent, masculine lovers.
"A bird tied to the muzzle of a gun—an enemy who has writ-
ten a book . . . is not more close upon demolition . . . than the
heart of a lady delivered over to the painter's eyes, posed,
draped and lighted with the one object of studying her
beauty."[33] But this was exceptional; usually the woman was the
aggressor and the artist a passive object of desire.[34] Some writers
varied the point by surrounding painters with the carefree in-
nocence and safe sensuality of childhood. Artists were "like
children, lured on by the scent of flowers in a green and
pleasant meadow."[35]

Neither writers of fiction nor biographers, despite their
appreciative descriptions and emotional vocabularies, allowed
romantic artists free rein. In America, where the need to justify
any action's healthfulness remained pervasive, life was to bear
witness to the ennobling power of art. As saintly martyrdoms
testified to the measure of religious devotion, the artist's life

itself legitimized his art. William Dunlap's tactical calls for respectability were broadened into a strategy enforced by the entire art world. Artists sullying their personal image would damage their professional reputations and also, by implication, the good names of their colleagues. Work could not be separated from character.

The Reverend Edward P. Roe's *Barriers Burned Away,* a great evangelizing novel of a slightly later era, made this point with untiring emphasis. The heroine's strivings for artistic perfection are thwarted by her selfish desires. "I fear I shall never reach true art," she muses. "I can only win admiration."[36] The hero's spotless character, on the other hand, leads him to an instinctive perception of the beautiful; moral purity alone enables him to distinguish originals from reproductions. When the heroine begs, "how—how am I to gain this magic power to make faces feel and live on canvas?" the author's answer is short and appealing. "You must believe," he explains simply.[37] No compromises are possible; only remorse and purification by the experience of the Chicago Fire—when the barriers are literally burned away—can solve this problem. The lesson of *Monaldi* remains popular thirty years later. Character, discipline and morality are the keys to artistic success, for the center of the artist's shrine is so sacred that only those with pure hearts can enter.

Frederic S. Cozzens also emphasized the need for artistic purity in *The Sparrowgrass Papers.* A penniless English girl who wishes to return home agrees to pose nude for the life class of the National Academy. Despite embarrassment there is no danger. "Thou white chastity! Amid that blaze of eager eyes now fastened upon thy beauties, there is not a soul so base as to harbor one evil thought of thee! Here, where 'art's pure dwellers are,' thou art secure as in a shrine!"[38] To allow serpents in this Eden would be shameful.

The control of sensuality in art was both a moral and an artistic necessity. American patrons and critics scanned the hundreds of sculptured nudes their countrymen produced for the slightest sign of lewdness or immodesty. The personal lives of the sculptors could often provide the first clue to faults which would automatically disqualify the work from the sweepstakes for greatness.

The charge of lewdness was more than a literary concern;

it operated occasionally as blackmail to keep unwanted pictures out of exhibitions or to smear the reputation of some artist or critic. The rejection of a painting by the National Academy provoked a furious correspondence in the New York press of 1843 and involved the participants in a savage swirl of charges and countercharges. With the painting supposedly rejected for indecency, one writer explained that its critics were the same overmodest prudes who hung muslin on Horatio Greenough's "Chanting Cherubs." The easiest reply to this was to insist that the National Academy did not exist to satisfy the "salacious cravings of libertine fancies."[39] Even prominent writers were not exempt. Nathaniel Parker Willis, who dared attack the American Art-Union for its encouragement of mediocrity, found himself accused of an immoral interest in art, and the journal he edited described as a *"lying-in hospital* for the relief of crude and romantic conceptions."[40] Willis' notion of advanced art was supposedly "a highly colored picture of a naked female,—in the most meretricious style of French art."[41] The alarmed journalist was forced to protest that he had a wife and daughters, and publicly refuted the charges made against his moral character.[42]

Artists seemed exposed to excruciating temptations. Hawthorne insisted that it was impossible for nineteenth-century men to produce chaste statuary. He wrote in *The Marble Faun* that moderns were "as good as born in their clothes, and there is practically not a nude human being in existence. An artist, therefore . . . cannot sculpture nudity with a pure heart, if only because he is compelled to steal guilty glimpses at hired models."[43] The artist's character and desires, even in situations over which he had little control, still determined the quality of the work. Hawthorne's difficulty in accepting the sensual aspects of art's appeal was directly related to his suspicion of the artist himself.

Major literary figures like Hawthorne and Henry James, and minor ones like Nathaniel Parker Willis and William Ellery Channing, agreed that although artistic experiences were universal, artistic personalities could not be stereotyped. Nevertheless, certain common themes did emerge. Willis and Channing both wrote classic explorations into the predicament of the young American artist, struggling against family, friends

and kind intentions to achieve a place. The need for definition—
of social class, nationality, skill—emerged as the clearest artistic
problem, and the artist himself became a figure of courage and
integrity, neither a clay saint nor a dissolute profligate but
an idealist who discovered his strength in the effort to create.
The transcendence of stereotypes was the ripest mark of the
artist's integration into the national imagination. Channing's
effort at definition, "The Youth of the Poet and the Painter,"
appropriately serialized in four issues of the Transcendentalist
organ, *The Dial*, attacked convention, boredom and the failure
of men to see the poetry of reality.[44] Written entirely in letters,
Channing's romance is filled with musings about art, idealism
and personal mission. A would-be poet, Edward Ashford, and a
would-be artist, James Hope, leave college to develop their
talents. Hope—whose name at the start should be Despair—
lacks the courage to assert himself against his mother's insistence
on respectability and high income. The risk of following an
artist's life is difficult to assess, for he might sacrifice all in
order to achieve mediocrity. At last Hope discovers that the
risk itself legitimizes his desire. "I must be all or nothing;
and in fully feeling this, I found my right to become a painter.
He who truly aspires to the loftiest, has the consolation of
knowing he can make no failure."[45] The need was for high
aims; compromise would never satisfy the young artist.

American institutions offer little help. Instead of the
cloistered, dedicated community they hoped to discover in col-
lege, Ashford and Hope find only student-machines memorizing
information. They are destined to be isolated reformers; the
"centre of their creed consists in the disavowal of congrega-
tions," a friend explains, "and they wander solitary and alone,
the true madmen of this nineteenth century."[46] Conventionally
organized society offered the artist little, according to Channing,
but occupational alternatives were all discouraging. The profes-
sions were impossible. Lawyers stared at juries and talked "a
great deal about nothing"; doctors cut up carcasses; merchants
had to "look wise and ride in a carriage." All that America
could offer was nature, and friends advised the painter to take
his canvas and wander through fields and groves. This was
what Claude and Salvator had done.

But young artists could not accept passivity; they required

competition, abrasion, contest. "I am fearful of degenerating
into a half-formed amateur, if I do not seek after the absolutely
best productions which remain," confesses Hope. European
travel was frightening; the sight of masterpieces could dis-
courage and depress. Yet he longs for "a stern trial of my right
to be an artist, a period of study and starvation. I feel I must
go alone, and work out the problem by myself." The same dread
of barbarization which led painters like Matthew Jouett to
fear rural isolation stimulated young artists to search for great
models on which to stretch. Europe held such examples; there
artists would not be isolated from colleagues of any era. "Never
before did I know what it is for a country to have a Past."[47]

The resolution of the artist's problem was more optimistic
in Nathaniel Parker Willis' *Paul Fane.* In this early study of
American innocence confronting European sophistication, a
would-be artist resists his father's preference for the ministry
or a business career. Art was "learned by studies verging on im-
morality," and produced only "small and uncertain profit."
Paul's mother helps the boy paint secretly in the attic, and a
childhood intimate, Mary Evenden, who admires art as a spir-
itual weapon against life's deadening materialism, encourages
him further. "Better a more slender livelihood, the daily indus-
try of which should ennoble heart and mind . . . than larger
wealth, the struggle for . . . which must demean the intellect,
and leave Nature's best gifts without culture." Again the women
are most enlightened and perceptive. Paul must study in Europe;
he needs "the collision with other schools."[48]

Paul Fane typifies many other fictional American artists.
Handsome, sensitive and dedicated, he is perhaps more aggres-
sive than the others. His European trip involves much more
than an art education; a chance snub by an English visitor
shakes Paul's confidence in his own social position. Only by
proving himself in a more stratified society could he restore this
lost self-confidence. "Was he of coarser clay than some other
human beings? . . . The thirst to know his relative rank of na-
ture—to gauge his comparative human claim to respect and
affection" strikes him like a fever.[49] For novelists like Willis,
artists allegorized all American uncertainty and enthusiasm in
class-ridden environments. Artists, like Americans, were free
agents; owning "that free independence for which the class is

remarkable, they had separated themselves equally from the noble and ignoble—disqualified by inward superiority from association with the one, and by accidental poverty from the claims cultivation might give them upon the other."⁵⁰ Their mobility, freshness and idealism made them agreeable companions, but forced them into endless subversion of class discriminations.⁵¹

Paul Fane contains a whole community of artist types. Cruder, less gifted Americans seem to be working their way into the art world—businessmen-entrepreneurs, far removed from the intellectual dreaminess of youths like James Hope or Fane. Bosh Blivins, a college chum, is such an artist. He learns a bit of drawing from Fane and quickly becomes a scene painter to a drama company touring the Mississippi Valley. After looking about, Blivins discovers a market for patriotic and pious pictures; his own works find a ready sale. With demand increasing, he raises his prices, and hoping for fame rather than artistic improvement, he decides to go to Italy. Religious farmers and ambitious politicians contribute funds for the European visit. "And, by due return of the merchantmen with cargoes of oil and wine from Leghorn, came home scores of Blivins' masterpieces from Florence, which stood, splendid witnesses of republican appreciation of native talent, on the mantel-pieces of the glorious West."⁵²

Willis compares Blivins with Fane constantly, much to the latter's advantage. Like any other businessman, Blivins produces what the market consumes. "Why not paint what they *ought* to like, and so help people to better taste?" Paul asks.⁵³ But Blivins insists that public improvement is not his aim. Willis was using the novel as a vehicle to defend the romantic artist and his high ideals; this was consistent with his earlier attacks on the American Art-Union, which he charged with cheapening true genius. "If the choice is inevitable between the *many mistaken* and the few true artists," wrote Willis, "we must, for once, differ from the great republican policy which so charitably governs the Art-Union—'the greatest happiness of the *greatest number*'—and, to the cause which best serves the true and few, give our sympathy."⁵⁴ Willis was nervously aware that this went counter to democratic precedent, but he persisted in his defense of polished, European art achievements.

When the managers of the Art-Union declared their intention to encourage American art simply because it was American, he, with some other critics, insisted that taste must be improved before it was diffused, and that the morals and manners of artists were less important than their achievements. The artist, says Fane, "must be more loved for his genius than his person. The productions of his pencil must be more endearing than his manners or social accomplishments."[55] Conventional rules of appearance were not sufficient guides to talent.

Disenchanted, Fane discovers that Europe's aristocratic institutions often block proper appreciation. Real merit matters less in Europe than social status, for Europeans "think by classes." Only democrats can judge artists properly. Willis' attacks on popularization were thus not denials of a democratic art, but warnings about its possible vulgarization. With all its institutional drawbacks America still offered artists more hope than did Europe. The "temple of Art" was more complete in the Old World, but individuality was more easily smothered. In Europe the artist was merely "a brick—bricks sustaining him below, but immovable bricks pressing on him from above—in America he is the tent pitched in the desert, with the sunshine and air all around him."[56] The absence of confining traditions, the infinite potentialities in the individual's horizons, made America as promising as it had seemed fifty years earlier, when starry-eyed poets predicted the rise of a new Athens.

A generation later Roderick Hudson still proclaimed this faith, though Henry James was more ironical than Willis. "He didn't see why we shouldn't produce the greatest works in the world. We were the biggest people, and we ought to have the biggest conceptions. The biggest conceptions of course would bring forth in time the biggest performances. We had only to be true to ourselves . . . to fling Imitation overboard and fix our eyes upon our National Individuality."[57] Where James—and Hawthorne—differed from Channing and Willis was in their abhorrence of the misuse of artistic energy, and in their flirtation with the value of more limited and practical objectives. Sam Singleton, a modest painter, is something of a quiet hero in *Roderick Hudson;* matter-of-fact, equable, without either the fires of genius or its despairs, he manages to create art without wearing down his gifts. But Roderick, beset

by fears and ambitions, burns out before producing. The faculty of creation was "a double-edged instrument" which might often be "priceless, inspired, divine," but could just as often turn "capricious, sinister" and "cruel." Hudson broods about the future "if the watch should run down" and his capacity for genius exhaust itself. Thousands of artists were men "of two or three successes; the poor fellows whose candle burnt out in a night. . . . Who shall say that I am not one of these? Who shall assure me that my credit is for an unlimited sum?"[58] James's conclusions are not clear; Hudson's brief glory may be wasted, but it reaches an intensity greater than Singleton can ever produce.

Hawthorne was similarly ambivalent. He praised the sacrifice of Hilda in *The Marble Faun,* who abandons her original art for copying. There was something "far higher and nobler" in giving up great ambitions and choosing "the better and loftier and more unselfish part."[59] But at the same time Hawthorne condemned artists who compromised their ideals or accepted diluted values. The businessmen-sculptors in the famous dinner scene of *The Marble Faun* were smart, practical, even rich, but they were not poets. Though marble granted immortality, to such craftsmen it was "merely a white limestone, cut and worth two or three dollars per pound; capable of being shaped by them or their artisans and sold at a higher price."[60] Pleasant, agreeable, hard-working men they were, but far from the dedicated religious poets of Hawthorne's imagination. The true artist found satisfaction only in his art, not in popular applause or financial reward. The world could "never say the fitting word" which would properly pay the artist. He who converted earthly into spiritual gold could receive no ordinary recompense; "the reward of all high performance must be sought within itself or sought in vain."[61] How artists were to evaluate their achievements without any checks of opinion, and how his conclusion would prevent ambition from ruining the lives of mediocre creators, Hawthorne never explained. Fearing unbridled egotism, he still could not fetter it with popular verdicts. Despite the danger, creation without high ideals was hardly worthwhile; success undermined personal dedication, though persistent failure might invite professional collapse. Suspicions of artistic personality notwithstanding, to take no

risks was to have no art.[62] The consequences of idealism might be tragic but no better prospects were in sight.

Though their perception of the risk was often less profound and their articulation less illuminating than either Hawthorne's or James's, Channing, Willis and Winthrop sensed the dangers in the artist life; they ended also by affirming its essential health. These writers of fiction opposed a variety of frauds: the businessman-artist, the affected, would-be aesthete, the ignoramus disguised behind the mask of allegory and the mythical but inarticulate nature lover. This was more than mere rhetoric. Aware that the excitement of art attracted many youngsters, writers outlined the trials, toils, and disappointments of most young artists, along with the poverty and disapproval they endured. Novelists pointed out the foolishness of the effort unless backed by strong individual genius. But they also depicted the artist's reward: the exaltation, the spiritual strength, the professional communion. To those who sought escape from conformity and materialism, art was a royal route, but one beset by dangers.

The objective pattern of American artistic advancement— the crude, energetic mechanics who moved in half a dozen years from backwoods farms to European capitals, proclaiming their own genius all the while—met almost unanimous disapproval. Writers of fiction demonstrated their attitude in two ways. Fictional artist heroes were quiet, elegant, well-read gentlemen, generally modest and refined, whose speech displayed no accent and whose boasting was a clue to the size of their hopes or the nature of their fears, not an indication of vulgar egotism. Beyond that, these writers vigorously attacked the clowns, the ill-educated boors, the mechanical mass-producers of art with heavy-handed anger. Nonetheless, the materialistic Bosh Blivinses reflected the backgrounds of American artists more accurately than the Roderick Hudsons and Paul Fanes.

The most explicit condemnation of these capitalistic art producers appeared in Henry P. Leland's *Americans in Rome*. Leland passed a whole range of artist and patron types before his readers, and heaped most of them with ridicule. First came the mass-producing American sculptor, Chapin, a thinly veiled portrait of Hiram Powers. "They call his studio a shop, and they call his shop the Orphan Asylum, because he manufac-

tured an Orphan Girl some years ago, and as it sold well, he
has kept on making orphans ever since."[63] Chapin mouths a
canting, infuriatingly complacent view of art and himself, com-
bining unbelievable ignorance with unquenchable self-confi-
dence. He is a caricature of every backwoods Praxiteles, and his
vices are American virtues writ large. The Orphan was made
"accordin' to the profoundest rules of art. . . . The figure is
six times the length of the foot; this was the way Phidias
worked." The Greeks were "splendid old fellows" but did not
portray domestic life and so were far from "developing *hum*
feelings. They worked for a precious few; but we do it up for
the many."[64] Chapin and his friends have trouble pronounc-
ing English; they leave the *g*'s off the ends of words and use
ch's instead of *t*'s. No work of art is sacred for them. Chapin
castigates the "A-poller Belvidiary" for having his hair brushed
incorrectly. His inventiveness and Yankee ingenuity lead him
to devise a way of fixing drapery that involves hanging muslin
on statues and shooting syringefuls of starch and glue all over it.
Chapin is even searching for a way to cut statuary by steam.

The same qualities which aroused American travelers to
ridicule their connoisseur compatriots—shrewdness, ingenuity,
greed, self-education—drew Leland's ire. Ignorant literalism is
supplemented by a scholarship so pretentious that its ludi-
crousness undermines all allegory and symbolism. Chapin's Or-
phan sits on a light chair; "*that* shows the very little support
she has in the world. The hand to the head shows meditation;
and the Bible on her knee shows devotion." The low-necked
dress, however, was fortuitous; the model happened to have a
handsome neck and shoulders.[65] An allegorical figure, who
looked like "a dropsical Cupid with winged shoes," was named
Enterprise by Chapin. The "two little ruts at his feet represent
a railroad; the arrow, showin' he's sharp, points ahead . . . the
bag in his hand represents money . . . the pen behind his ear
shows he can figger; and his short shirt shows economy."[66]
Objections to his skill Chapin counters by asserting he "spent
three weeks once, dissectin'; and for more'n six months I didn't
do anything during my idle time, but dror figgers."[67] Naturally
he contends that genius is innate; his own career offers the most
dramatic proof.

Though Leland is most bitter about Chapin's philistinism

he seizes upon other shams like Artaxerxes Phlamm, the Mystic Artist, who emphasizes the imagination and is poles apart from Chapin's literalism. Phlamm hides his total incompetence behind a torrent of mysterious references. Self-confidence suits his personality and he delights in criticism of others. The "old masters were humbugs; they weren't mysterious; they had no inner sight into the workings of Naychure." When laymen find nothing recognizable on his canvases, Phlamm accuses them of lacking faith. An artistic combination of Barnum and Mme. Blavatsky, this mystic speaks only in riddles. Blue is "the negative to the warmth, the balance to the scales, the one thing needed on which to rear the glorious fabric that Naychure reveals to the undimmed vision of man."[68]

Leland's attack on philistinism and romanticism is climaxed by his hero, a humbler artist who works without pretension. Charles Gordon, designer of patterns for an American calico mill, is held in contempt by most of the artist community. "A New-Yorker by birth, consequently more of a cosmopolitan than the provincial life of our other American cities will tolerate," Gordon is polite, refined and well educated. Though he started out wearing "long hair" and believing he looked like a love-starved genius, Gordon becomes a successful calico painter, received by the best society, by men who close their doors on the "bohemians of Art" for all their "airs, long hairs, and shares of impudence."[69]

Artists like Chapin and Phlamm were making art "the laughing stock of all refined and educated people," wrote Leland. Agreeing partly with Hawthorne, he felt that these clumsy butchers had killed painting and sculpture for modern times. But art itself was not dead; when an artist finally "turns out a stove that will beautify and adorn a room, instead of rendering it hideous," he will have begun a true artistic renaissance.[70] The formal arts of design no longer held a monopoly on visual beauty.

Leland's effort and his double-barreled attack mirrored the aesthetic dilemma and marked a transition away from romantic values. It was ironic that a generation or two after the American artist had managed the climb up from artisanship he was told that his earlier estate was more honorable after all, and that

the formal arts were as dead to America as the applied arts were vibrant. Leland's pessimism was more extreme than that of other writers. The industrious, inventive, poorly educated tycoon who set himself up in art manufactures was the butt of most of them. Authors were less aroused, however, by the fraudulent mystics, decked out in the costume of illustrious predecessors, but without talent or intelligence. The novelty of this second attack emphasized the new, businesslike values which art publicists were presenting in the 1850s and 1860s.

In the two previous decades biographers, eulogists and novelists were able to accept the earlier, romantic profiles. The two great artist heroes of this era—Washington Allston and Thomas Cole—fitted in easily with the passive, feminine, introspective personalities of their fictional counterparts. Their lives contained the proper amount of grief and depression, and an appropriate sense of frustration hung over both careers; Cole died while in his forties and Allston's last years in Cambridgeport were disappointing and anti-climactic. Many critics tearfully sentimentalized the artist's vicissitudes in a hostile, materialistic community. Cole and Allston were ideal foils to the selfish, egotistical society the moralizers described, for both were composites of the saint and martyr.

Allston's admirers stressed his physical appearance as well as his personality. C. Edwards Lester wrote that Allston's eyes were "large and lustrous, and the first sight of the Painter made the stranger feel that he was a remarkable man. Even as he glided in his unpretending way along the street, there was an abstractive, an unearthly air about him that often made the careless stop."[71] The painter-poet, Thomas Buchanan Read, wrote after meeting Allston that he felt himself in the presence "of a being whose mind was too pure to mix in the groveling things of Earth. . . . his long white hair curls from the top of his forehead. . . . his eyes are quite full and dark."[72] If ever any man was "a painter in his appearance," the *Democratic Review* commented, "that man was Allston; his language, the tones of his voice, his gestures, were polished and refined. . . . [with] a certain patient expression, as if he had devoted more of his life to labor than most men."[73]

Allston was not merely a saint, but a well-bred gentleman-saint. His genteel South Carolina background, his modest

inheritance and his Harvard education refuted charges that
American artists were ill-bred boors. C. C. Felton spoke of
Allston's "kindly urbanity of manner," and his conversation,
always "uttered in a voice of singular sweetness and power,
his high-bred, unaffected and most gentleman-like demeanor,
and the Attic purity and felicity of his wit."[74] Read described
him as "the perfect gentleman." His life did not exemplify
struggle, competition or mobility; it showed rather how a man
could rise above materialism and surround himself with pure
thoughts.[75] He "paints not for fame" so that his life was devoid
of selfishness and "a perfect refutation of the pernicious theory,
that a great man must work out the purposes of his existence by
a constant warfare against his fellow man."[76] His was, said Mrs.
Peabody, "a holy life."[77] Writer after writer stressed Allston's
Christian devotion. Each day's studio labor "was an offering of
devoted praise and incense to his maker." Every painting became
an effort to read "the thoughts of God."[78] In a sermon preached
upon Allston's death, the Reverend C. W. Ware wrote that he
commended both art and religion to his countrymen, by his
talent and piety. "We cannot be sufficiently grateful that the
influences that shall flow from so great a name, will be distinctly
religious. . . . His studio was a temple . . . made sacred by pious
and exhausting efforts to fulfill his high vocation as a Chris-
tian."[79] Evil thoughts were inconceivable from Allston. Lester
reported that the artist once did a beautiful painting which,
while perfectly moral, "might be perverted to evil associations."
Allston immediately returned the gold and burned the picture.
"And yet the Painter was poor."[80]

Allston's last days were particularly moving because of "a
very visible and rapid growth of his religious character."[81] He
glided away swiftly and left some so bereaved they lost all their
aesthetic inspiration.[82] "In ill health . . . poverty . . . sequestered
from social excitement, and keeping industrious every day," he
was still the dedicated creator, "desiring only his art, self-
devoted, the world forgetting."[83] No writer of novels could have
wished for a subject more moving, edifying and inspiriting to
nineteenth-century Americans. Reality held even more romance
than fiction.

Thomas Cole, less celebrated than Allston, was still the
best-known New York landscapist of the 1840s, and publication

of his life by the Reverend Louis Noble in 1853 brought him further, if posthumous, fame. Cole's biographer portrayed him as "a saintly man, a paragon of virtue," and passed quickly over details which diluted this image.[84] Like Allston's eulogists, Noble detailed Cole's physical appearance, which was modest and benevolent rather than extraordinary or eccentric.[85] Cole's whole substructure was "faith always deeply religious."[86] His later career, with its emphasis on large-scale religious allegories like "The Cross and the World," lent itself admirably to the biographer's piety. One reviewer explained that Cole found art to be "a shrine at which he knelt devoutly, and in singleness and purity of heart"; he held it as "the highest of privileges that he was permitted to consecrate himself to the service of God and his fellow man."[87]. Another reflected that like "all great and good souls" Cole was "fond of playing with children." He was of a quality with "Dante and Milton," a great and pious epic poet.[88]

Cole's personal character suited the romanticizer admirably. He was sensitive and often depressed, easily moved, even by weather conditions. His isolated and unhappy youth, said Tuckerman, made him keenly alive to impressions of all sorts.[89] Cruel treatment by early patrons, his wanderings through the West and his voluntary identification with American nationalism (like Allston he turned his back on a European career) lent a tragic interest to his life. One critic spoke of his early work in a narrow garret, "the only fit abode for the artist and the poet. . . . No great work of art was ever executed in a palace."[90] Another, George Washington Greene, an American diplomat who befriended many artists, sketched Cole as a martyr to public taste. This great master painted little pictures to live; such frustration "when his mind was teeming with great compositions, had broken his health." Greene offered a short but inclusive profile of the sensitive spirit at war with the world, another Paul Fane, Roderick Hudson or James Hope.

> Few think what a wasting power this longing for better things has, and how the mind, constrained to live in an atmosphere which is not its own, exhausts its strength in little efforts, loses the relish of present enjoyment because it sees nothing to look to in the future, strives, struggles, resists; escaping now and

then to its own world, to shudder and shrink . . . dis-
heartened by the bitter consciousness that it has the
capacity to do great things which it will never be per-
mitted to do.[91]

Greene's description was too bitter for Noble, whose book
appeared at a time when artists began to gain applause for
their conventionalities rather than their eccentricities. Noble
emphasized the purity of his hero's life, and his total respecta-
bility. Profanity and irreverence displeased Cole, and "indelicacy
of language or manner offended him. He felt it degrading to
speak of the licentiousness so often indulged in by foreigners in
Rome. Passion and appetite never led him astray. The light
wines of the country he used sparingly, but rejected all ardent
spirits and tobacco in every form."[92] Cole's purity was so power-
ful it was transferable. Noble reported that an American lady
following him through art galleries experienced no embarrass-
ment in viewing nudes; she trailed Cole "as she would have
followed a child."[93] Noble stressed Cole's simplicity and lack
of affectation in terms which contrasted with the Allston eulogies
of an earlier decade. "In his dress he was perfectly neat, but
plain, and without the least appearance of singularity. In
nothing did he affect the artist and the genius. He was in Rome
what he was at home, simply Cole."[94]

Cole and Allston also exemplified the value of industry
and hard work; their devotion received high praise. But their
sensitivity, high character and absorption in the life of spirit
received most attention. Cole was less striking than Allston;
passers-by did not stop on the street to watch him nor did lady
friends gush over his beauty. But both were selfless, intense
and suffering idealists, lonely though good-humored hostages to
America's artistic future.

Artists of intense spirituality and sensitivity did not go out
of fashion in the 1840s. Thomas Dunn English, describing a
Philadelphia painter, Peter Rothermel, was surprised to find him
tall and bronzed, looking like a lawyer or engineer. "As a general
rule," English reported to his readers in 1852, "artists, until
Time puts his decaying powder into their hair, have a peculiar
appearance, by which the *caste* may be recognized, each bearing
a kind of dreaminess in his manner."[95] Henry Dexter, the
sculptor, recalled the surprise of a governor's wife on his own

1. THE AMERICAN ARTIST BEGINS: "West's First Effort in Art."

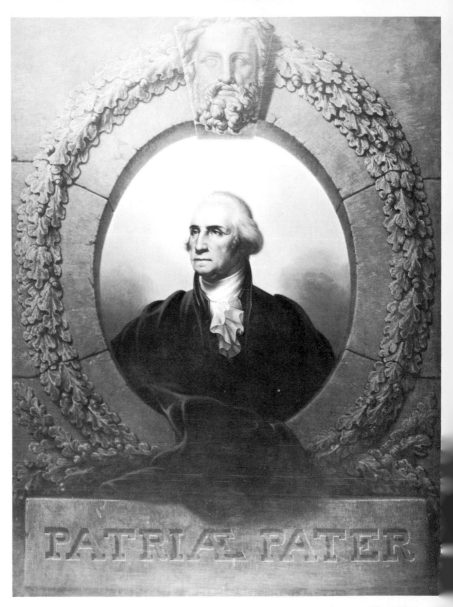

2. THE PATRIOTIC PORTRAIT: Rembrandt Peale's "George Washington."

3. THE OFFICIAL IDEAL: Arlington House, the home of James Bennett.

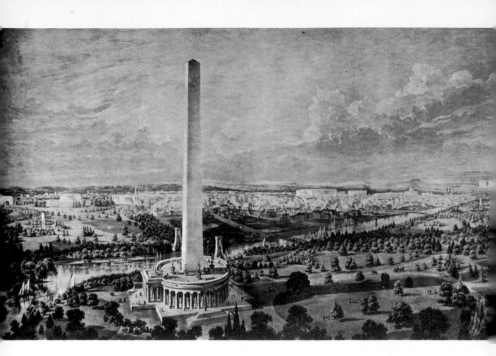

The Washington Monument

4. TWO SYMBOLS OF PATRIOTISM

The Bunker Hill Monument

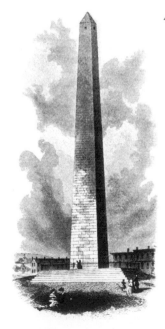

5. A GARDEN OF GRAVES: Forest Pond, Mount Auburn Cemetery.

6. RATIONAL ENJOYMENT: Idlewild, the home of Nathaniel Parker Wil

Andrew Jackson Downing

7. TWO CELEBRANTS OF SUBURBIA

Nathaniel Parker Willis

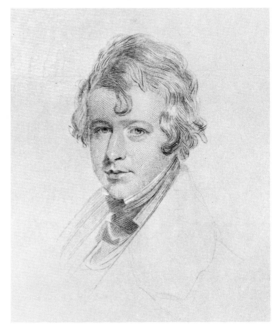

8. THE TURN TO LANDSCAPE: Thomas Cole's "Sunny Morning on the Hudson River."

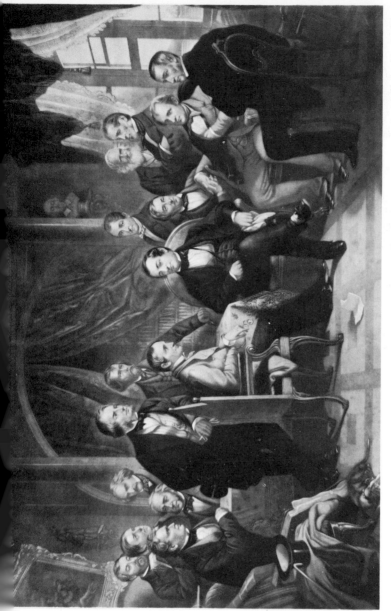

9. THE LITERARY COMMUNITY: left to right, Henry T. Tuckerman, Oliver Wendell Holmes, William Gilmore Simms, Fitz-Greene Halleck, Nathaniel Hawthorne, Henry Wadsworth Longfellow, Nathaniel Parker Willis, William H. Prescott, Washington Irving, James Kirke Paulding, Ralph Waldo Emerson, William Cullen Bryant, John Pendleton Kennedy, James Fenimore Cooper, George Bancroft.

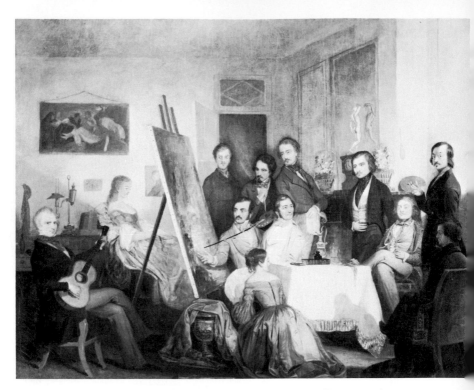

10. AMERICANS ABROAD: Thomas P. Rossiter, "A Studio Reception of American Painters, Paris, 1841."

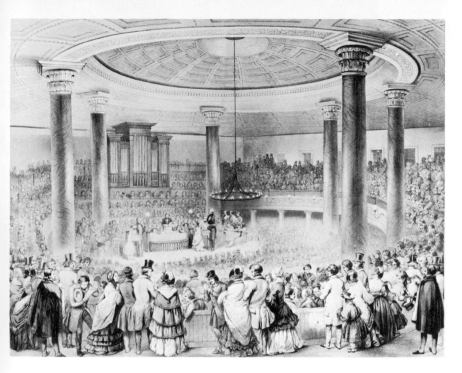

11. An American Art-Union distribution . . .

and one of its presidents, Prosper M. Wetmore.

12. ROMANTIC ARTISTS

Thomas Cole

James De Veaux

13. An artist entrepreneur, Hiram Powers . . .

and one of his products.

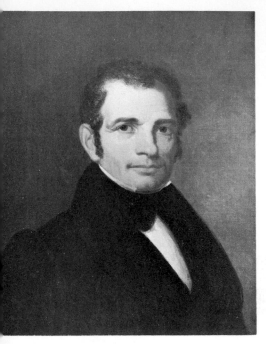

Luman Reed Marshall O. Roberts

14. PATRONS, LAY AND CLERICAL

Rev. Orville Dewey Rev. Edward N. Kirk

15. The Pennsylvania Academy of the Fine Arts

ARTIST HOMES

New York University

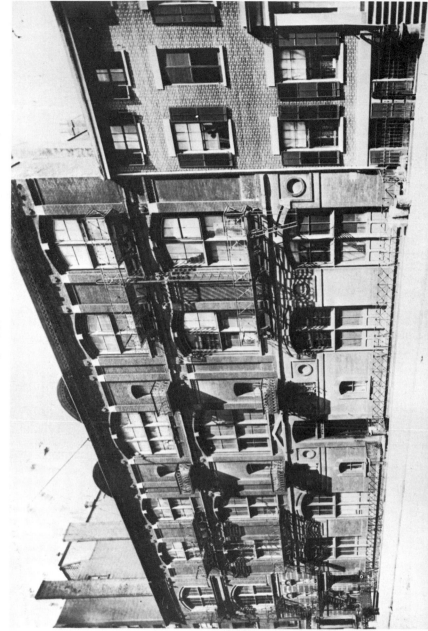

16. PROSAIC PARNASSUS: The Studio Building, 43-55 West 10th Street, New York City.

neat and ordinary appearance.[96] The belief that American artists conformed to a specific physical type indicated that artists had achieved a more conspicuous place in community life, with traits distinctive enough to arouse levels of expectation.

Critics still spoke in hushed, reverent tones of the artist's working place, "the hallowed stillness of the studio in which the miracle of art has been achieved." The brush was guided by a "Sacred Inspiration."[97] Watching an artist work was a religious experience: "Suddenly his pencil shed the hue that relieved . . . his heart and my own; and Joy has enveloped us, begirt us both at the same moment as with a sun-beam. There was a spiritual light around us."[98] The neglected artist preached, in his isolation, "a silent homily to the mere devotee of gain."[99] Clergymen spoke of "the sensitive organization of those whose pursuit it was to embody and represent the grand and beautiful; of the liability to extreme fluctuations of spirits thence resulting . . . of the fearful crises of emotion incident to such a nature and career."[100] The ideal artist was not necessarily protean and quicksilver; Tuckerman stressed the serenity of beauty, and denied that great art required a "fine frenzy." Painters and sculptors had "many intervals of repose" and exerted a conservative influence on society. They advised us to "cherish the beautiful and true, as our best heritage," and reminded us of the "eternity of genius, and the true dignity of man."[101] American romanticism was tamed and tranquilized, reaching its apogee in the quiet joys of the landscape painter, finding respite in "some shady nook." "Here is no discord," breathed Christopher Pearse Cranch, "no anxiety, no heart-weariness, no grovelling appetites, no morbid fear of the world . . . here is peace and rest."[102]

Tuckerman and Cranch emphasized the quiet joys of art; Noble and Mrs. Peabody stressed its ennobling, religious qualities. And soon others were pointing to its need for industry, steadiness and respectability. Through the 1840s the introspective, melancholy artist dominated biographies and eulogies as he did fiction. Hiram Powers—later a symbol for artistic materialism—was described in 1845 as a spiritual ascetic; his "figure is tall . . . long black hair . . . full of expression. The forehead is fair and high. The eye kindles and flashes. . . . a man of energy and genius."[103] His biography followed a "child

of poverty through the sports of boyhood, the sad privations and golden dreams of youth, through vicissitudes that weary and lacerate the heart."[104]

But a change was coming, fully revealed by the 1850s. The frail aesthete, however he charmed novelists and some clergymen, was by no means universally admired. Some of the more popular journals sought to prick the balloon of artistic affectation. Artists had no privileged seats at life's banquet, they cried, and must prove their value before getting fair shares of the feast. Art was a business like any other; poor artists deserved failure, for they dragged down more talented colleagues. Tears were wasted on the unsuccessful; they should switch to another occupation. Editors and journalists were probably more vociferous in this view than novelists, but soon fiction began to echo their feelings. Great artists were perhaps born geniuses, but only industry and common sense could gain them success. Slowly the business ethic began to replace older ideals.[105]

"Confessions of a Young Artist," a story which appeared in *Putnam's* in 1854, proclaimed the new message. The typical art career was once again outlined, couched however in tones of unmistakable irony.[106] As a child, the hero is impressed by a family portrait, and then "bewildered with delight" at seeing a historical work, "Jephtha Meeting His Daughter." The choice of such a ponderous Biblical subject to couple with an intense childhood experience was an intentional parody of the universal artist biography. The boy copies it on a barn door where it is admired by friends, and in the tradition of Zeuxis deceiving birds into pecking at his painted grapes, the family dog actually snaps at Jephtha's heels.

After an encounter with a touring artist the boy travels to New York, certain he "was the great American artist." He has managed to gather money by itinerant portraiture at two dollars a bout, following in fiction the road of many real artists. Idolizing his own work, the youth expresses contempt for Copley but is quickly taken with a Sully which his teacher, Mr. Ochre, terms a "waxy little thing." After a time the boy decides he has learned enough and opens his own studio for female immortalization. With an old clay figure, a skylight, an easel and a maulstick, he is ready for business. But although he sends portraits to the Academy exhibition, no one visits his studio. The

young artist declares that "there is no genius for art in this country. Rosewood and buhl are more valued than genius. Oh Italy. . . ." Even his great masterpiece, "Iphigenia as Priestess at Aulis," provokes only laughter. At last the young man becomes aware of his lack of ability, and begs his teacher, Ochre, to take him back. But repentance is not enough for artistic success. Ochre refuses to teach him further, and advises him to leave the field. "Would it not be wiser to choose an occupation in which you will be master of your faculties, than one in which you will be the victim of endless hopes, delusions and disappointments?" Convinced by now that he lacks great talent, the boy goes into business and finds it interesting and satisfying. "I was happier while actively employed among other men, than when waiting . . . in vain, in my lonely studio."

The author was warning misfits that an unsuccessful artist enjoyed few pleasures. To those whose youthful idealism made them seek an alternative to law or business, the lesson was, "Beware!" Ambitious but uneducated young artists, fanned to enthusiasm by the applause of relatives and friends, met disaster when building careers on average talents. The groping for huge classical subjects when simple, intimate ones could not be executed; the turn to older lands; and the tendency to blame an indifferent public for individual failures were common reactions among unsuccessful artists. The spirit of the story—and of *Putnam's* editorial policy—was one of hostility to artists who lived in the past, expecting bountiful patronage as a *droit de place*. In earlier centuries, the editors admitted, artists were teachers and painted for the masses; naturally they were rewarded. Contemporary artists, however, had become decorators. Madonnas were *de trop* in America, but painters persisted in turning them out. If the Academy would tell its members "that to be useful men and good citizens, to be good providers for their families, and to give themselves comfortable positions in society, they must abandon all the fol-de-rol which they . . . read about 'high art,' and be content to fulfill their true mission," without looking for commissions other than upholsterers or silversmiths receive, they would be much better off.[107] Those who wrapped themselves in ancient robes, demanding dignity as well as wealth, deserved both poverty and contempt.

Putnam's was agitated as much by the buying public as by

artists who worshiped grand ideals in a materialistic age, but the *Cosmopolitan Art Journal* constantly preached the business ethic to artists and praised without exception the taste of America's buying public. As the organ of an association founded to distribute art objects after a court order disbanded the American Art-Union, this journal insisted that all artists "of *real merit*" had patronage "quite equal to the liberal living of a prudent person." Those who suffered were probably "improvident or careless in business matters," or dissipated "spend-thrifts in the way of 'fast' horses and hot suppers." And occasionally there were blind idealists who refused commissions. Artists might be good fellows but the *Art Journal* refused to condone their abusing the public "for its want of taste in not purchasing every picture offered—good, bad, or indifferent."[108]

This lay-controlled association took a common-sense view of art. If prices fell, the best thing to do "would be to paint fewer pictures, and thereby command better prices. Art will be as inevitably governed by the laws of taste as silks and corner lots."[109] It attacked the "old fogies" who felt that giving "market value to all works of the studio" was cheapening. "Fence up such old grannies," sneered the association. "What have all their 'high art' ideas accomplished. . . . Literally *nothing*. In their hands art bade fair to become mummified, and it needed the fire of emulation—the spirit of competition which the *commerce* in art engendered" to arouse American talent.[110]

Such a view was stated boldly in a short story, "Life's Illusions," that the magazine published in 1856.[111] Although Paul Graham has the outward appearance of a romantic artist—handsome and slender with long, black hair and an "apollo-like" mouth—it only increases the irony of the story, for he is an impoverished, lazy and egotistical painter who abuses the world for not perceiving his genius and attacks sitters for their vanity in ordering portraits. His landlady's daughter Ella, hard-working and unselfish, bent on improving herself by learning the piano, falls in love with the young artist. But Paul, after receiving seventy dollars for a portrait, spends it on champagne and cigars for his fellow artists. The whole caste fritter away their time in beer, songs and grumbling. "What do these clod-hoppers know about art?" Paul says of the public. "In their eyes, it is a mortal sin for a man to devote himself to any thing but the accumulation of money."

Paul is a flirt as well as a cad; after grabbing Ella's help he seeks the hand of a town belle and is properly rejected. His response is typically exaggerated as he blames everything but himself. A friend, who could support himself by drawing for wood engravers but insists on keeping at great historical works which no one will buy, expresses the opinion of Paul's associates. "We are all martyrs in our devotion to our beautiful mistress, ART. We give up the hope of worldly honors. . . . At least, we despise the world more than it does us."

Although Paul becomes a fashionable artist, his extravagance and vanity lead him to drop portraiture for history; income and clientele soon disappear. A complete wreck, he is saved by the landlady's daughter whose piano-playing keeps both of them alive. With an ending worthy of Samuel Smiles, Paul learns humility and industry, and finally marries his Ella. "The illusions of an undisciplined mind have given way to the calm realities of a happy and useful life; he says that if it is much to be an Artist, it is more to be a Man!"

"Life's Illusions" turns on their heads all the images which glamorized the romantic artist. Introspection and meditation become laziness; great ideals and reverence for the old masters seem foolish bombast; personal self-confidence appears as egotism; eccentricity of dress and habit is dissipation; and total allegiance to artistic ideals means only undisciplined selfishness. The self-sacrificing, poverty-stricken, idealistic American artist was by now so well established in the public mind that he could become a figure of satire. The style of the artist's life was more important than the contours of his art, and that style meant respectability, conventional and ordered. Such writers considered discipline and integrity more important than inner vision or grandeur of conception. Artists could not luxuriate in the heady conviction that soul-contemplation would yield them the position of a Titian or Rembrandt. Constant study and careful discipline, when added to a generous endowment of talent, were the only means to greatness.

C. W. Elliott's fictional artist of 1848, Jack Langton, is another who emphasizes the need for discipline and application, and re-emphasizes the point made in *Putnam's*. When Langton begins to paint he gives his genius free range, wandering about the "regions of fancy and imagination." Believing that "art came out from genius—not study," he owns a limitless self-

confidence in his future. Although he could have been a good portrait painter, he spurns this career and curses "the undiscerning public, who would spend their money in gay, signboard pictures, rather than encourage 'high' art."[112]

Gradually Langton learns his needs; he reads history and tries self-education but his pictures become nervous and mannered. Then he seeks a knowledge of nature by hiring himself to a farmer, scrutinizing animals, plants, weather and light. But his landscapes remain mannered. Finally he goes abroad, spending three years in Italy. He does not become idle, though "so many young men consider [it] artistic." It was easy "to persuade myself, when I was tempted to loiter away a fine day on the hills, that it was in the pursuit of art; but I could not so easily persuade myself at night that I had caught it."[113] Still striving for perfection, Langton does improve, moving "from the simplicity and faith of childhood . . . through doubt and denial," and finally looks out upon the promised land. His artistic skill is now the result of reason and experience, the product of a long, severe and taxing education.[114]

According to writers like Elliott the road to artistic success was lengthy and dangerous, and it did not lie through pretension. The art world, it seemed, was more like the economic than the political universe; success depended not on equal but on unequal abilities. Genius would always have a running start. But these critics were equally insistent on the need for industry and application. To the man who gave most of himself, most would be returned, and study was a necessary—though not sufficient—condition for artistic triumph. This was something of a heresy in an era which considered special skills or intelligence unnecessary to the performance of most jobs; but it had long been the view of prominent American artists. Silk purses could never be made from sows' ears, at least in painting and sculpture. Institutions like the American Art-Union, which sought to increase the number of artists and broaden the base of their patronage, were labeled masks for mediocrity. *Putnam's* argued that they interfered "with the principle of *laissez-faire*, which is as essential to a vigorous and healthy development of genius in art as in everything else."[115]

Successful members of the Academy who had a vested interest in keeping down the number of competitors also ob-

jected strenuously to what Thomas Cummings called a forced "inflation." Art had become too highly stimulated, he wrote in the 1860s, in phrases which an American artist of the previous generation would have found unthinkable. To be successful, art "should be of natural, not artificial growth, should be let alone, like other trades, to be governed by the rules of supply and demand."[116] Those who brayed that art unions hung pictures "scarcely fit to hang in a horse stable," and who sneered at the pretensions of merchant amateurs and *"rich ignoramuses"* often acted from a variety of private motives—envy, revenge, personal hostility—but they were vindicating the artist's expertise even while they undermined his right to eccentricity.[117] Established artists and conservative journals welcomed genius but insisted it be patterned, controlled and conform to communal standards.

By the 1850s the artist life was no longer merely a foil to materialism and economic selfishness; it had been captured to exemplify the virtues of industry and material success which dominated the business community. While the artist of calculation, narrow education and crude background was scorned by earlier novelists and biographers, the artisan-artist was no mere clown to later writers. He was a figure of strength, a competitor who, by constant striving, had demonstrated the value of the work ethic, and carved a place for himself among the achievers of the day.

These writers repudiated also the clumsy boors who set their allegorical traps for traveling compatriots in Italy; the Bosh Blivinses were as much caricatures as the Paul Grahams, and industrious, respectable artists did not have to be materialistic clowns. It was the emphasis which was so changed; the chief target of abuse was no longer the commercial stereotype, but the romantic mystic. The greatest danger to artistic success was not lack of sensitivity but lack of application. Art unions, the institutions which supported some of the least talented artists, were no solution for these critics. They desired quality just as the romantics had, but they valued discipline and competitiveness even more.

Poverty was no badge of pride for these new artists, save as a brief youthful experience; the rags, poor food and physical squalor of romantic garrets were conditions to move away from,

not to put up with. The saintlike artist, prone to martyrdom and misunderstanding, remained popular and apart from the new commercial image, but business types gained more respect as time passed, and the affected bohemianism of many artists met with disfavor. Only a few clergymen and novelists held out against the trend. They often used the artist life as a means of awakening the money-dominated souls of businessmen and were reluctant, therefore, to discover the same goals animating successful artists that drove wealthy merchants.

The ideal artist became increasingly a man who made money, enjoyed fame and deserved consultation on matters of general interest. His materialism was tempered, perhaps, by a professional benevolence and otherworldly orientation, but he remained hardheaded, the provider of a family; his feet were solidly on the ground. Periodicals like the *Cosmopolitan Art Journal* sought to convince artists that this was their proper social role, while opponents of the art unions tried to prove that art was like any other business. This was a strange alliance— successful artists and commercial philistines—but logical under the circumstances. The skills of famous landscapists and por- traitists—efficiency, salesmanship, pricing shrewdness, innovation —bore out those critics who suggested that American artists needed more, not less, of the business ethic.

The sensitive, delicate romantic never disappeared entirely from the pages of art journals and newspapers, but he no longer had the field to himself; artists coming of age in the late 1840s and 1850s were urged to adapt their profession to practical needs, to share the goals and wealth of respectable portions of the community. The one tie that still united all artist types, how- ever, was an obvious and articulate religious faith. The romantic and the businessman remained Christians. Truly successful artists, even if they shed some saintlike qualities for commercial values, retained—in the eyes of followers—a robust Chris- tian faith and an alliance with spiritual forces. Theirs was a divine mission and faith was as needful as skill.

The 1850s witnessed also a renewed emphasis on conformity and respectability. The artist, the *Cosmopolitan Art Journal* admitted, was "emperor in his atelier," but this was just why he needed to stay far from bad thoughts and low company. Any artist who claimed "immunity from social usages and proprie-

ties," or the right to "irregularity of conduct" was betraying his trust. "The public has a right to expect a pure and upright life from the minister of the Gospel; why not a right to call for the same purity" in the life of a man who preached from the canvas or marble?[118] Even *The Crayon,* a short-lived journal edited by artists and much less critical of romantic values than the *Cosmopolitan Art Journal,* warned that genius should not be given a wide license. As religion was judged by the priesthood, so "the artist and his Art must forever go together in some measure; and the artist who banishes himself from the support of the good and true, degrades his works with himself."[119] All had agreed that the artist needed good morals, but he had once been allowed latitude in manners; by the 1850s this was less possible. Now that the eccentric characteristics of artists as a group had been noted and described, many laymen found them unpleasant.

In 1858 the *Atlantic Monthly* extended the theme of limitation to suggest that artists must be subject to communal laws. The author of a eulogy on Thomas Crawford insisted that art was anything but a frenzied mystery; it was rather the result of steady industry. The lesson of Crawford's career was that "earnestness of purpose, consistency of aim, heroic decision of character" made up the only way to success; "spasmodic effect or dalliance with moods" produced nothing but emptiness. The artist life could be neither vague nor casual. Students in Italy must learn that will intensifies thought, and "action controls imagination." The melancholy ruins of Italy, "the dreamy murmur of fountains . . . the aroma of violets and pine-trees . . . all that there captivates soul and sense, must be resisted as well as enjoyed;—self-control, self-respect, self-education are as needful as susceptibility."[120] Though the events of an artist's life were no longer marvelous, they were still interesting. "How the executive are trained to embody the creative powers, through what struggles dexterity is attained, and by what reflection and earnest musing and observant patience . . . original achievements . . . grow mature"—this was the rational fascination of the artist's life, not mysterious ecstasies or fitful introspection.[121]

Another critic discovered that the peculiar glory of American sculptors lay in their having been "emphatically self-made men."[122] This was not a peculiar glory, of course; it belonged by

rights to most successful Americans, in business or politics, but it indicated the growing emphasis on sustained discipline which the artist life had come to exemplify. Emanuel Leutze was praised by one writer for his rationality and industry; "neither his conversation, his appearance, nor his work displayed any undue amount of imagination, or capability on his part of being led astray by his fancy."[123] Hannah Lee took issue with Sir Joshua Reynolds' warning that art and marriage were often incompatible, at least at the start of a career. "How many have been cheered, supported, animated, by their partners in life, and found in home the sweetest reward of toil!" The artist should marry and have children like all other men.[124] In 1856 Francis Carpenter was praised by Willis' *Home Journal* for being the "most symmetrically constituted, safe, and sure of any of our portrait-painters."[125] His biographer portrayed Carpenter as moral, industrious, efficient and upright.[126] Later in the century Henry Dexter was admired for never casting "so much as a sidelong glance into the risky realm of Bohemia," for he was "strictly temperate, economical" and "provided for his family."[127] Journalists advised young artists to be conventional and popular. You can survive poverty, Clarence Cook advised a young painter, but "poverty is bad, not good. It may, like all evil, do good for a time, but its creative, or health giving powers are soon exhausted." It was no good to turn from the world, to sink into isolation. Watch your manners, your dress and your script, "take the tide as it turns, it will surely bring you in to port." "Don't simply *ask* the world, urge it, bully it."[128] The creator was to grapple with reality, mingle with mankind and master his own destiny. This was the way of art.

It is easy to make too much of this shift in emphasis. Artists continued to personify sensitivity and spirituality; peculiarities and extravagance remained part of their setting. From Europe stories of the struggles of young Americans and their martyrdoms to illness and overwork added to the romantic interest of the art career. And the emphasis on conventional respectability and adherence to social norms can be traced back to the 1820s and pioneers like William Dunlap, whose conservatism resulted from the artist's uncertain status in the eyes of dignified ministers and merchants.

Nevertheless, the increasing financial resources of American

artists, their new-found prestige as members of the community, the growing conservatism of the institutions they had organized and now governed, these helped the secularization of the artist ideal and its ultimate absorption into the success ethic of post-Civil War America. American writers had always placed limits around the artist's energies. But the increased emphasis on the profession as an area where industry could triumph over adverse circumstances, as merely another avenue to wealth and success, less distinguished by its divergence from other routes than by the dramatic qualities of its rise, aided the transformation immeasurably.[129] The fictional artist of romance, handsome and magical, was gradually replaced by the honest, hard-working, straightforward and respectable professional, whose religious values made him a fruitful symbol for moralizers. The quality of the artist life in the 1840s and 1850s, and its increasing self-confidence and growing preoccupation with business values, show how well this new image reflected reality. The artist had moved from saint to preacher, and his studio had declined from a shrine to a pulpit. Thus the art community faced its audience on the eve of the Civil War.

The Pattern of
Artistic Community

❧

CHAPTER TEN

I~ THE TWO DECADES before the Civil War, as professional self-consciousness and energetic leadership realized many of the hopes of an earlier generation, the artistic community grew clearly articulate. Generous patrons made this era the brightest and most hopeful moment in the history of American art, and the nation's artistic capital became centralized in New York. But with new privileges came new problems: material success brought unexpected perils and factionalism followed prestigious advancements.

The explosion of interest created journals like *The Crayon*, the *Cosmopolitan Art Journal* and the bulletins of various art unions; general periodicals gave increasing space to the activities of American artists, also. *The Christian Examiner*, *The Atlantic Monthly* and *The North American Review* featured a stream of commentary.[1] Under the supervision of a painter, Thomas Addison Richards, *The Knickerbocker* became an illustrated journal for the first time, and *The Independent* broadcast the comments of a well-known critic, Brownlee Brown. The *Home Journal*, edited by Nathaniel Parker Willis, and *Putnam's Monthly* further directed the public's attention to native creators.

The development of an art market and a dramatic rise in sales held even more interest for professionals. In 1850 the United States imported less than forty thousand dollars' worth of art from Europe; twenty years later the figures had passed the half-million mark, and America had begun to reexport art from its Eastern ports to England, France, Canada and the British West Indies.[2] Art auctions also jumped, more than quadrupling in three decades.[3] The collecting fever that had begun in the 1840s formed the basis for further auctions in the 1870s and 1880s. Firms sprang up to handle art sales, the most prominent of which was Henry H. Leeds of New York.[4] Leeds sold a number of famous collections, including the holdings of Charles

M. Leupp of New York. The ten thousand dollars this sale achieved indicated the high value attached to the work of native painters. Particularly in the late 1850s, Henry Leeds confided, prices rose steadily; it took four evenings for him to complete his domestic art sales and even European buyers competed for the treasures.[5]

Artist journals sought to persuade businessmen that paintings and statuary were "the most profitable personal securities a merchant can hold," reliable physical assets in this world and valuable spiritual holdings in "the books of the world to come."[6] Auctioneers were so effective that *The Crayon* urged artists to rely on them for sales instead of their own studios. Thomas Rossiter auctioned off his canvases in 1859 for almost six thousand dollars, and three years later Jasper F. Cropsey, a Hudson River landscapist, made even more money.[7] Many artists used the money made at auctions to finance trips to Europe.

New art associations and academies also testified eloquently to this growth of interest. In 1856 collectors and painters helped form the Washington Art Association, one year after the artists of Maryland had organized their own society.[8] The Artistic and Literary Society of St. Louis first met in 1856, while almost seven thousand people paid twenty-five cents apiece to see a great exhibition in New Haven two years later.[9] Similar activities took place in Brooklyn, Albany, Pittsburgh and Charleston.

Educational opportunities for professionals and laymen also expanded. In 1851, New York's Stuyvesant Institute ran a six-part lecture series, featuring Henry James, Sr. on "The Universality of Art," and George William Curtis on "Contemporary Art."[10] The School of Design for Women sponsored talks by ministers on the value of art.[11] Schools and institutes of design were founded all over the East in the 1850s as states and municipalities began to require drawing classes in the public schools. The Pennsylvania Institute of Design held its first annual exhibition in 1857, seven years after the establishment of the city's School of Design for Women.[12] Industrialists grew increasingly interested in the commercial value of trained artists, spurred on by the South Kensington Museum and its schools in London.[13] Even the nude could now be studied without too much protest; the Graham Art School of the Brooklyn Institute, organized in 1858, had this as one of its major functions.[14]

Artists themselves began to demonstrate a new sense of mutual responsibility, and a more successful emphasis on professional dignity. The Artists' Fund Societies multiplied and changed characteristically. The 1835 charter of the Philadelphia Society extended relief to its membership in times of sickness or adversity. But the Artists' Fund Society of New York, founded twenty years later, felt a broadened sense of obligation; two treasuries were set up, one for Society members and the other for any artists whose families might be in difficulties.[15] New York's leading painters contributed their works for the benefit of the profession as a whole, members or non-members.

A series of court cases further aided artistic independence. One involved Thomas Sully and the Society of the Sons of St. George.[16] The points at issue concerned the artist's right to exhibit a commissioned picture before delivering it to his client, and his power to sell or exhibit copies afterward. A board of adjudication maintained the artist's absolute right to reproduce his pictures or make use of any preliminary studies. A picture was not like any other chattel, the property of the purchaser when ordered and partly paid for. The idea belonged to the creative mind which had originated it and could never be wholly transferred.

Professional artists benefited further from an 1862 case in which the purchaser of a store argued that a valuable oil painting was a business "sign" and hence a fixture. The court denied his claim; an artistic achievement could not be considered a commercial fixture.[17] Architects also began to protect their status, turning to the courts for aid. Richard Morris Hunt's 1856 suit for a commission fee established the principle that architects, as professionals, were entitled to proper remuneration for their work.[18] *The Crayon* reported gleefully that legal action forced a picture manufacturer who copied a W. J. Hays painting without leave to pay costs and damages. Artists were reminded that they could copyright paintings by depositing photographs in the clerk's office of any United States district court.[19]

Even politics became an artistic concern. When the Pennsylvania Academy of Fine Arts was threatened with a state tax law from which it had been exempted for fifty years, its artists turned to New York for legal advice.[20] In March, 1858, the

first national Artists' Convention met in Washington, forming itself into a permanent association with annual meetings.[21] Some artists disparaged the new institution as a waste of energy, but Congress was quickly bombarded by petitions for duties on foreign art and for increased public commissions.[22] Major art organizations quickly appointed delegates to the Convention and in 1859 President Buchanan commissioned three professional artists to superintend the decoration of the Capitol.[23]

The need for unity was also emphasized. Despite their considerable differences, New York's three major art associations, the National Academy, the American Art-Union and the New York Gallery of Fine Arts, managed to keep a dialogue open; in the late 1840s and early 1850s the three presidents addressed the annual supper preceding the National Academy Exhibition.[24]

Artists no longer brooked professional injuries. When Edward L. Carey of Philadelphia asked Thomas Cole to take back a landscape he disliked, Cole refused. Portraits were returnable, he explained, but not works of the imagination. "When you gave me the commission you were acquainted with my pictures," he wrote Carey, who had left the subject to the artist. "I fulfilled my commission conscientiously and considered myself to be entitled to the remuneration. I cannot take the picture back and give another in place of it for that would be establishing a serious precedent."[25] Cole offered to paint another picture for a nominal price, but the artist's dignity and creative freedom were too important to be bartered away. A Philadelphia merchant complained that artists were "an irritable race" who "think their dignity is wounded" when they were not given control of association funds; but it was just this irritability and quickness to take offense which was responsible for their self-government.[26]

Artists, therefore, received much better treatment from their clients. Asher B. Durand's correspondence files reveal the extraordinary respect he inspired in his admirers. Letters requesting paintings were couched in the humblest terms. A rural attorney wrote that he had begged a friend "to intercede with you on my behalf in regard to a small picture."[27] He promised to prize any painting Durand offered as more than mere "furniture." Another suppliant insisted that he and his wife con-

sidered their Durand painting "the central point of all our possessions."[28] Writers addressed him as the greatest landscapist in the country, and pledged to begin collecting only if he would start them off.[29] Transplanted Easterners wished to revive "the glorious scenery" of their childhood, while others predicted that a Durand painting would be "the only well executed picture of any size in our new city of some 40,000 people."[30] Newly formed art associations scraped funds together to make their first purchase, and patrons from Baltimore, Philadelphia, Boston and St. Louis wrote in after seeing one of his canvases.[31] Young artists sought instruction and older ones paid compliments. Some merely wanted to add his autograph to their collections.[32]

Artists responded eagerly to such blandishments. Jervis McEntee wrote that he always felt "under particular obligations to assist in establishing art exhibitions in places where pictures are not in the habit of being shown," and sent a canvas on to Albany.[33] And Daniel Huntington agreed to complete Henry Inman's congressional commission after that painter's death, as much for the honor of the profession as for his personal fame.[34]

Along with increased respect came a higher social status. Henry James, Sr. contrasted pure and applied artists in an 1851 lecture; men paid tailors and masons to work for them, though they did not seek their society. "But it is the reverse with the Artist. He has been from the beginning always a very suspicious individual in the moral regard. . . . Yet, whether he be naughty or virtuous, we seek him and honor him . . . for what he represents, and never dream that money can pay for his pictures."[35] In 1865 William Cullen Bryant recalled the time when men "would almost as soon have thought of asking a hod-carrier to their entertainments as a painter." Things had changed so much ("artist's studios are frequented by distinguished men and elegant women") that Bryant warned young artists not to be spoiled by attention.[36] Even a crusty Philadelphian like Sidney George Fisher found time to accept a party invitation by Thomas Sully, though he was not entirely happy about it.[37]

Commerce paid its tribute to the muses also. In 1858 the Baltimore and Ohio ran a four-day excursion trip for painters and photographers; Kensett, Thomas Rossiter and other artists

and amateurs from several cities traveled down the scenic route, stopping for sketches and photographs.[38] Artists spending summers in the mountains and along the New England coast turned whole communities into popular resorts. At North Conway dozens of artists' white umbrellas dotted the landscape as painters dominated the area's social life. "It puts on none of the airs of fashion. All hands don their rustic clothes, and ramble unrestrained on the mountains. . . . In the daytime the artists receive . . . visits from the ladies . . . and in the evening, they all meet to flirt and gossip. Artists are a gay, jovial, careless set."[39] A correspondent from West Campton, New Hampshire, claimed that his community was just as favored as Conway. Several New York artists were vacationing in West Campton, including Asher B. Durand and Thomas Addison Richards, along with Boston painters like Samuel Gerry and John Pope.[40] Artists had no need to go down the Rhine or among the Alban hills to spend pleasant vacations with their colleagues.

Successful artists were not only men of distinction but occasionally men of wealth as well. Those on top raised their prices with the season. Frederic Church increased his fees from one winter to another until he demanded twelve hundred dollars for a four-by-six-foot painting.[41] Thomas Sully produced more than twenty-five hundred pictures in his long career, for which he received a quarter of a million dollars; he averaged more than thirty-five hundred dollars a year.[42] Henry Inman was getting five hundred dollars for half-length portraits, and one thousand dollars for full-lengths.[43] Durand, Kensett, Cole, Hicks and Huntington also reached this level, though artists rarely attempted to compose such large works without specific commissions.[44] Even lesser-known artists were able to charge three hundred dollars or more for medium-sized studies. In 1860 European paintings still took the highest prices, but native artists could attain comfortable incomes.

Despite these status improvements, some families continued to grumble at discovering in their midst a youngster with artistic ambitions. George Inness was put into a grocery store by his merchant father, who finally allowed him to study drawing after a series of commercial disasters indicated that the boy would never be a businessman.[45] W. R. Barbee, a Virginia-born sculptor, was punished by his parents for slipping off to carve blocks

of soapstone; following the pattern of other Southern artists, Barbee studied law to get enough money for a European trip.[46] And William J. Stillman, landscapist and editor of *The Crayon*, sadly recalled his father's insistence that he attend Union College. This deferred his artistic training during "precisely those years when facility of hand is most completely acquired and enthusiasm against difficulties is strongest."[47] Other parents tried to divert artistic talent into more remunerative channels. Attempting to "strike a bargain with imperious nature" the fathers of Elihu Vedder and Albert K. Bellows placed their boys under architects.[48]

Such discouragement was not universal. Bellows' biography was used by one writer in urging parents to gratify a child's natural bent. Everywhere, he wrote in 1859, we see fine artists who are poor lawyers, and poor artists who could be good lawyers, men "*misplaced* . . . in all professions and occupations, chiefly owing to the fact that the tastes and wishes of the child are not consulted in the determination of the life-calling."[49] Parents grew more permissive about art training and occasionally actually nourished it. Mayor Flagg of New Haven encouraged the artistic ambitions of his three sons. The fact that the Flagg family was related to Washington Allston helped quite a lot. Frederic E. Church, also Connecticut-born, was taught drawing and coloring as a youth with his father's good wishes; a friend intervened to make sure he was instructed by Thomas Cole.[50] David E. Cronin remembered his mother's arguments for art, promising fame and love "long after I had crumbled into dust—the most seductive prospect that my imagination could then hold—to be numbered among those individuals . . . who live after they are dead."[51]

Another indication of the rising status of the profession was the growing number of "artist families"; generational continuity was assured as children decided to emulate their parents. The eccentric exception of the Peales in the eighteenth century was repeated many times in the nineteenth. The children of Asher B. Durand, Thomas Cummings, Robert W. Weir, Thomas Sully, John Sartain, Henry Inman, Thomas Doughty, William Wetmore Story and James R. Lambdin became artists in their own right. The Sullys, Suydams, Agates, Harts, Frankensteins, Osgoods, Terrys and Haseltines produced several artist members

of the same generation; Alfred T. Agate and Frederic S. Agate both became members of the National Academy, and the genre painter, William Sidney Mount, had two brothers who painted.[52] There were many advantages for an artist who emerged from one of these families. Besides the informal instruction which was a part of their upbringing, they had easy introductions to fellow artists, contacts with future patrons, membership in professional societies and even the opportunity to take a suitable studio. John F. Weir was able to get into the Studio Building through the intervention of his father's artist friends.[53] John Durand, who helped his father in many business capacities, used his position to good advantage when he edited *The Crayon*. Members of the same generation working together could share studios and publicity, and if one became better known he was able to help the others; William Sidney Mount was tireless in trying to aid his brother Shepard.

The growth of interest in art was recognized by entrepreneurs, native and foreign. By the 1850s Bostonians had the opportunity to buy paintings and prints from more than half a dozen establishments.[54] Dealers, who had by now grown apart from art suppliers, continued to sell picture frames and looking glasses, but courted retail art sales by increasing their exhibition space. Some, like Williams and Everett, handled painters on a regular basis, guaranteeing an income in return for exclusive market rights.[55] To emphasize its art commitments further, this firm ran the only free gallery in the city, and sent agents to examine the output of studios in Europe and America. As a commercial institution it influenced Boston's art development sharply; artists no longer needed to rely on the Athenaeum for publicity. But picture dealers were soon drawing the ire of American artists who condemned them for making European art fashionable and degrading the lot of native painters.[56]

Like Boston, Philadelphia had a number of retail art dealers by 1860, though none with a gallery of any size.[57] James Earle and Alexander Robinson were able to lend lavishly to the Pennsylvania Academy exhibitions. Art lovers could stroll through the Free Gallery of the Art Union of Philadelphia, organized in 1844 and dissolved a decade later. Until this gallery was established, wrote George W. Dewey in 1851, "there were no galleries or stores, in the city of Philadelphia, for the exclu-

sive purposes of the exhibition and sale of American works of art."[58] Carvers, gilders and looking-glass salesmen dominated the shops (which usually lacked good light) where artists deposited pictures for sale. The Free Gallery, however, stimulated the looking-glass stores to further exertions, and four of them improved their exhibition arrangements.

Both Philadelphia and Boston paled into insignificance as art markets when compared with New York City; here the strongest exertions were made to stimulate sales.[59] Of the half million dollars' worth of art imported from Europe in 1858, New York's share was almost four hundred thousand dollars. Philadelphians and Bostonians may well have bought some of the art New York imported, but they probably bought it in or through that city.

With its large resident artist community, fine port facilities and an active group of local patrons, New York was the natural center for this commerce, and a stiff competition developed to capture the lion's share of the market. The 1840s was the crucial decade. The American Art-Union then enjoyed its greatest success, and a large European house, Goupil, Vibert and Company, tried to compete by organizing the International Art Union on Broadway. Backed by prominent citizens like Asher B. Durand and Nathaniel Parker Willis, this institution planned to establish a permanent free gallery of European art. William Schaus, Goupil's agent, managed to enlist the aid of William Sidney Mount, who was angry at the American Art-Union and interested in the engraving facilities which Goupil, Vibert offered.[60] The firm flourished though its art union did not, and two of its agents, Schaus and William Knoedler, established their own outlets; the promise of the American market made it impossible for the parent firm to keep its employees tied to its apron strings.[61] At least half a dozen prominent art dealers worked in New York at this time, featuring the output of American and European artists, selling prints, medals, bronzes, artists' materials and books.[62]

It was easier to view art in New York than anywhere else in the country. The National Academy held the best-known exhibition in the United States, and the galleries at the American Art-Union—which continued to operate in the building after the Union was dissolved—contained a wide sampling of

American works. In addition to the New York Gallery of Fine Arts, formed in 1844 from the collection of Luman Reed, Thomas Jefferson Bryan's holdings offered further variety. The Düsseldorf Gallery exhibited the works of German artists, and the Spingler Institute, a school for young ladies, had an extensive free gallery on its premises. Moreover, there were frequent temporary exhibits.[63] The Artists' Fund Society of New York held a number to raise funds, and the Crystal Palace Exhibition, New York's version of the London extravaganza, displayed the works of famous European contemporaries.[64] Private citizens like William Aspinwall and Marshall O. Roberts, following in the footsteps of Luman Reed, erected galleries attached to their own homes and frequently invited public visits.

By the 1850s New Yorkers had access to reasonably sophisticated art education and criticism. Goupil, Vibert's exhibits of French art, *The Literary World* explained, had freed Americans from dependence on the "warped" opinions of English critics.[65] The *Cosmopolitan Art Journal* was similarly grateful for an 1859 exhibition of European works at the National Academy; it urged local artists to study the paintings of Lessing, Isabey, Millais and Landseer. "The day has gone by when a poor painter can become popular in this country," the journal proclaimed proudly, pointing to the expanded knowledge of foreign art.[66]

New York did more than offer numerous exhibitions and opportunities for sales. It established innovations which spread rapidly to other cities, and knit the artist community closer together. One of these novelties was the Artists' Reception, a combination exhibition, concert and *soirée* which united social and artistic ambitions. In 1858 *The Crayon* announced quietly a series of "Art Conversazioni" after the European model.[67] The first such reception at Dodsworth's Building on Broadway, the home of several studios, was so successful that three more followed. New York's most famous artists produced pieces, and the guests included judges, city officials and clergymen. "We do not know how Art can be better amalgamated with our social system," *The Crayon* exclaimed, terming the receptions "the most serviceable institutional effort" in behalf of art for the last ten years.[68] In 1859 receptions continued at Dodsworth's and spread to the Studio Building on Tenth Street.

Bostonians held the first of their receptions in January, 1859; soon hundreds of people were attending, with music supplied by the Mendelssohn Club. Even the staid National Academy discontinued its annual exhibition supper that same year and held a reception in its place, introducing full evening dress.[69] Worthington Whittredge recollected that the Academy's receptions were so popular during the Civil War that it was difficult to get a ticket, so many "fine people'" wished to attend. "They were the great occasions for the artists to show their works and meet nearly all the lovers of art in the City."[70] Less than ten years after Thomas Cummings tried to discourage an exhibitor from dressing his ushers in white cravats and kid gloves, guests at art exhibitions appeared in white tie.[71]

Not everyone was happy. Ever alert to bohemian affectations the *Cosmopolitan Art Journal* warned young artists to beware of "Reception reputations" and charged that artists gave receptions "purposely to hear themselves praised by pretty women and long-bearded men." True artists, it concluded, "are not in want of such nurseries of conceit."[72] Nonetheless, the receptions expanded immeasurably artists' social contacts, and gave moral support to their cause. The excitement of formal dress and concert music reinforced the glamour of the studio. Even ordinary exhibitions grew more dramatic; Frederic Church, with his flair for the theatrical, placed his "Heart of the Andes" in a spectacularly lit setting, daringly showing it at night.

The excitement of New York's art life did not spread to every major city; Philadelphia artists were unable to organize many receptions before the Civil War, though not for want of trying. Joseph Harrison, an engineer and art patron, held a reception at his home in 1859 to honor Thomas Sully and Rembrandt Peale, the city's chief artistic lions.[73] More than two hundred artists and amateurs were brought together. One other reception was held, that same month, but that was all. In July, 1859, rumors appeared that Philadelphia would soon have a club for artists and their friends, something like The Century in New York. Reports continued that a studio building would be constructed "to induce artists to remain . . . instead of emigrating as many of them would otherwise do."[74] But six months later a sad announcement dispelled these hopes. *The Crayon* explained that the projected studio building and

the club "where Art was to have been occasionally talked about" had been abandoned. "The artists of Philadelphia are in consequence deserting. . . . The younger men are hastening to New York."[75]

Philadelphia's art life was far more depressed than its numerical inferiority to the New York community indicated. The corporate unity which had led Philadelphians to form America's first Artists' Fund Society was not strong enough to prevent the city's art world from fragmenting, and not influential enough to create a favorable climate for artists. Again and again John Sartain sounded a note of alarm in the 1850s. The management of the Pennsylvania Academy of Fine Arts, he insisted, did little to promote the profession's interest, and the same applied to the Boston Athenaeum. "The artists of New York happily rid themselves from this thralldom of insolent corporate patronage more than twenty years ago, and now occupy an enviable and commanding position" with the only real art academy "in the western hemisphere."[76] Philadelphia artists apparently lacked the *esprit de corps* necessary to found their own. Local artists had to send their work out of the city to get good prices, Sartain claimed, and only operations in *"foreign* art stocks" flourished.[77] He was disillusioned with the institutional guarantees which earlier generations had prophesied would create a living art. Any city can call itself an Athens, wrote Sartain, but the possession of "the finest Academy of Art" would not by itself encourage living artists. "When a city is without artists of merit, it is only because the citizens are unworthy of them."[78]

Privately, a number of Philadelphians shared Sartain's views. Joseph Sill, a merchant supporter of the artists and an active promoter of the Philadelphia Art Union, confided to his diary pessimistic thoughts about the city's cultural future. When William J. Hubbard returned after six years of painting in Virginia, Sill scribbled that he had "come to an unprofitable place for the prosecution of his art."[79] As he had expected, Hubbard's talents were ignored, indicating that "Philadelphia is not the place for an artist's success. Indeed the taste for the arts seems to be waning away in this City; and with our commerce we shall lose our refinement also. Something must be done to resuscitate our taste!"[80] The literary world was just as

depressed. George Boker, a Philadelphian who had to go to Boston to get his poetry published, told Sidney George Fisher that "one might as well bury a book in the ground as publish it in Philadelphia."[81]

New Yorkers, by contrast, crowed delightedly about the prospects for art in their city. James Jarves observed in the 1860s that New York had become "the representative city of America in art," much as Paris dominated the French art world.[82] Lavish patronage and excellent professional facilities ensured its predominance. A British correspondent wrote more than a decade earlier that "the most eminent artists in the United States reside in New York, and by far the greater number of them are natives of this state."[83] New York's art associations, its schools and academies, its community enterprises like the receptions, gave "early position and recognition to the truly deserving," wrote the *Cosmopolitan Art Journal*. "These offer a potent excuse for centralization; and it is almost imperative that a painter should come hither ere he can seal his fame."[84] As much as other Americans disliked such centralization, metropolitan endorsement would eventually prevail. If the "*lazzaroni* of Naples" validated every great European singer, why should not New Yorkers "give position to every singer, and painter, and poet, and actor in America"?[85]

Its complacency allowed New York to be charitable about neighbors' problems. In 1848 the *Literary World* extended its best wishes to the Philadelphia Art Union and urged Bostonians to start their own. The Hub possessed the nation's best collection of statuary and a large number of "first class paintings."[86] *The Crayon* also complimented Philadelphia, announcing that there was "no city in the Union which now offers superior advantages to the artist . . . provided Philadelphia once becomes fully sensible of the value of the artistic class to a community."[87]

New York's self-confidence was justified; by 1860 Philadelphia and Boston had ceased to be real alternatives to artistic residence in New York. With a few exceptions these cities contained local artists lacking national reputations, and those who did achieve fame remained because they were born or brought up there.[88] Decisions which artists agonized about in the 1830s and early 1840s were no longer necessary; either they

stayed in their native community or they moved to New York. For the art world, municipal pluralism had disappeared.

The Boston story was similar to Philadephia's, though not so surprising because of its smaller size. An 1860 directory listed almost fifty professional artists, but their leaders, like Chester Harding or Benjamin Champney, were generally native New Englanders. William Morris Hunt, who had old ties to the city, returned to Boston in the 1860s, but artists like John Pope and Winslow Homer left quickly for greener pastures. If Boston artists were less discontent than Philadelphians it may have been the effect of their informal associations; the Boston Artists' Association had been organized in 1842 under the presidency of Washington Allston, and twelve years later artists founded the Boston Art Club, which eventually included interested amateurs. Its first secretary was Alfred Ordway, a portraitist and landscapist who was also curator of the art department at the Athenaeum, a link between the artist community and its wealthy patrons.[89] Though the Art Club had no house for some years, it did manage to bring the city's artists together for social occasions and solidified professional friendships and interests.

The location of artists' studios also produced a sense of community. The directories of the 1850s reveal the presence of a burgeoning artist neighborhood near Beacon Hill, along Washington Street, Tremont Row and Bromfield Streets. By 1860 eight of Boston's fifty artists worked at 16 Summer Street, and seven others had studios on Tremont Row; not far away were the art suppliers and art dealers. Centralization was completed in 1862 when the Studio Building was erected at the corner of Tremont and Bromfield Streets. Within a year twenty-six artists and eleven architects were using the building, including William Morris Hunt and the sculptor, William Rimmer. Artists new to the city found it a godsend, for studio accommodations were notoriously hard to find and life in this art center provided a ready introduction to the entire professional community.

New York's art society was so large it required several centers. Lower Broadway contained dozens of artists' studios, along with dealers, engravers, architects and suppliers. At 346 Broadway stood the Appleton Building, owned by the publish-

ing firm and remodeled with rooms specially designed for artists on its upper floors. By 1859 eleven artists operated at this address, right near the offices of *The Crayon* and the *United States Magazine and Democratic Review*. Two influential art dealers, Williams, Stevens and Williams, and Goupil, Vibert and Company were located only slightly to the north, and side streets like White and Amity contained other artists' studios. A second artist section began several blocks uptown, still on Broadway, dominated by the studios in Waverly House and Dodsworth's Building; all told, an 1859 directory listed sixty-five painters on lower Broadway, along with the American Art-Union and the National Academy.

Two particular buildings concentrated artistic talent in New York; one of them was the old New York University building at Washington Square. This gloomy, gothic pile, the scene of adventure in Theodore Winthrop's *Cecil Dreeme*, housed more than sixty artists at various times, including George Inness, Daniel Huntington and Eastman Johnson. The building's population was transient, but when Thomas Bailey Aldrich made a visit in 1866 he met Eastman Johnson, Winslow Homer and Alexander Jackson Davis, one of New York's leading architects.[90] Artists did not monopolize the building completely, however, for they shared it with a classical school and some scientific societies.

The building which artists did monopolize, and which was the center of their social life in the Civil War era, was the Studio Building on West Tenth Street, the first such planned in America. Designed by Richard Morris Hunt and erected in the 1850s, its three-story, red brick façade disguised an artistic Valhalla. A large exhibition room dominated the ground floor, surrounded by studios, many with attached bedrooms. Several dozen other studios took up the floors above, containing some of America's most famous artists. Thomas Bailey Aldrich, who described the place in the 1860s, communicated the romance of "a little colony of poets," gathered "in the midst of all the turmoil and crime and harsh reality of the great city." It was odd that "such dreamy, aerial people should live in ordinary houses, like every-day folks," but the plain brick building housed them just the same.[91] Reflecting the travel habits of this exotic generation, their studios were filled with personal touches.

Church worked surrounded by tropical plants he had collected in South America, and William Bradford exhibited Eskimo relics found on his Arctic explorations. Nothing could be "more delicious" than the studio breakfasts, wrote Aldrich, and "no banquet-hall quite so charming as the studio, with its mellow twilight, its pictures and screens, and antique furniture."[92]

The building was filled almost immediately; John Ferguson Weir recalled that when he occupied his studio in 1861 it was the only one available. His life there was exciting and novel; Sanford Gifford gave dinners in his studio attended by literary and theatrical people. Emanuel Leutze cooked and served the birds he had just finished painting as still lifes.[93] Richard Morris Hunt ran an architectural school and sculptors used the facilities also. The Studio Building concentrated professional and social life in a handsome setting. *The Crayon* observed approvingly in 1858 that those who knew the New York studios of earlier times would be amazed at the changes. In former days the artist submitted to "small, ill-lighted dormitories, approached by filthy stairs, and situated in buildings appropriated to different and uncongenial purposes." Rooms were dilapidated, cold, dark, and filled with flimsy furniture. But new studios, especially the ones on Tenth Street, were "models of neatness, order, and even elegance," arranged "in all particulars" for artist uses. It was another mark of social advancement for artists to receive their guests in an elegant style; he "who can induce people of refinement to resort to his studio is in the fairest way to be appreciated."[94] The Studio Building's success was so great that soon there were calls for another, "a splendid investment for some capitalist," advised *The Crayon*.[95] It was not surprising that artists from all over the country were rushing in to use New York's unrivaled "executive facilities."[96]

The Studio Building did not solve every problem. Weir recalled that most of its occupants were much older than he was; the rents were probably out of reach for beginners. Young, untried artists made their own dent on New York. Thomas Butler Gunn devoted a chapter to "The Artists' Boarding-House" in his 1857 *Physiology of New-York Boarding-Houses*. Gunn pointed out that youngsters did not generally use boardinghouses; many of them ate at restaurants and spent the nights in their studios. The unheated studios were unpleasant in

winter, however, and some chose boardinghouses for the bitter months. Gunn located his artist group on Bleecker Street, not far from many studios, and described a brawling, active, high-spirited group of tenants who ran the gamut from the romantic with "long, dark hair, semi-melancholic eyes, a Vandykish beard," to the guitar-playing storyteller. Living in basements littered with cigar stumps, boxing gloves and easels the artists led a bohemian life, working, singing and boxing together in the evenings.[97] Gunn's artists ran to hear favorite singers during the opera season, and on Saturday nights attended club meetings at a German tavern (Pfaff's was a favorite spot) where they drank, sang and proved to be incorrigible punsters.

Under these circumstances it was easy for New York artists to draw together. When a Western historical painter, William Ranney, died in 1857, colleagues decided to hold an auction of his sketches and some of their own works; the proceeds of five thousand dollars were presented to his widow and children. Thomas Cummings, treasurer of the National Academy, together with Asher B. Durand and F. W. Edmonds acted as trustees; when the example spread, Cummings became president of the newly formed Artists' Fund Society of New York.[98] The way for such an organization had been cleared by other groups. The first artist society, The Sketch Club, was formed in 1827; as the club became more social its sketching declined and another Sketch Club was established in 1844. When its membership restriction proved constricting, a history painter, John G. Chapman, proposed a new and more liberal group in 1847.[99] Writers and amateurs were now included also. From this beginning emerged The Century, ten of whose forty-two charter members were highly successful artists. So great was the pressure to join that membership limits had to be continually raised. Dozens of other artists were invited to join, and it soon comprised an artistic Hall of Fame.[100] Within The Century itself a number of special clubs were born like The Authors' Club and The Architects' Club. In later years New York developed still other artist groups like The Palette and The Lotos.

New York artists were active in all sorts of professional philanthropies, offering testimonial dinners to members of the community returning from Europe, or honoring outstanding colleagues in their old age. The city's artists and art dealers

helped arrange an 1865 testimonial to John G. Rand, the inventor of the collapsible paint tube, who was old and sick.[101] Other artists tried to drum up subscriptions to *The Crayon* or help colleagues drafted into the army.[102] The most successful painters, Durand, Daniel Huntington, J. F. Kensett and Thomas Cummings, provided the New York community with sustained leadership.

Though Philadelphia artists formed some professional societies they lacked the widespread social contacts of the New Yorkers. Even their physical situation was much less attractive. Through the 1860s Philadelphia possessed no special studio building like the ones on Tenth Street and Tremont Street. Though Sansom Street was known locally as "Art Row" the city's forty-one portraitists were scattered along fifteen different streets in 1860, often far from one another.

In formal institutional terms Philadelphia matched New York. The Pennsylvania Academy was two decades older than the National Academy, and the Artists' Fund Society of Philadelphia antedated New York's by the same number of years. The Philadelphia Art Union attempted to imitate the American Art-Union's success, and informal groups like the Philadelphia Sketch Club and the Graphic Association of Philadelphia Artists met other needs.[103] But none of these could match the strength of the New York associations, in numbers or influence. Philadelphia's Art Union reached twelve hundred subscribers when the American Art-Union contained ten thousand, and the Graphic Association lacked the *éclat* of The Century.

The history of the Philadelphia Art Union dramatically indicated the city's cultural problems. Its life span was short; organized in 1844, it issued its first annual report for 1848, was incorporated in 1850 and dissolved five years later. Its course was marked by continual dissension and defalcation; Joseph Sill, an officer of the Union and active in a variety of artist institutions, recorded his disgust with the public, the artists and his fellow managers. Rather than serve with men who were "ignorant of Art, and dogmatical in act," he finally left the organization and attended the distribution meeting of the American Art-Union in New York.[104] Local artists played a greater role than New York painters in their merchant-run organization, but this was another sign of weakness. The Philadelphia Art

Union raised so little money that it had to rely on the artists' good will in donating pictures for sale; after a disastrous fire in 1851, when its engraved plates were destroyed, the Union chose professional artists to dominate its board of managers.

The subscription lists proved continually disappointing. In 1848 only about five hundred of its eight hundred members were Philadelphians; New York patrons formed a significant part of its membership.[105] Making a virtue of a necessity, the Philadelphia Art Union declared itself a national and not a local institution. Prize winners could purchase a painting with a winning ticket in any community they chose. "Much as they love Philadelphia," the managers confessed, "they love Art more."[106] This policy was contrasted proudly with the American Art-Union's localism.[107] Since so many out-of-towners were members and the Philadelphia art community was not exciting enough to entice subscribers, the Art Union offered cash awards in its annual lottery. It tried to sell local art works in its Free Gallery and in its most successful year, 1851, sold forty-three paintings for more than four thousand dollars. Artists were desperately interested in maintaining the organization, but its lack of more general support made that impossible.

The Art Union linked the era when Philadelphia competed with New York for artistic hegemony to the time of its total eclipse. When the Artists' and Amateurs' Association of Philadelphia—like New York's Apollo Association, the embryo from which the Art Union grew—held its first exhibition in 1840, its managers issued a challenge to Philadelphians. The Apollo Association of New York must be matched, for it is "attracting the notice of the artists from every part of the Union toward that city, as their best place of residence and resort." Philadelphians were to decide whether they wished to retain their painters and sculptors.[108] Joshua Shaw, George Bonfield and Emanuel Leutze joined with art lovers and dealers to arrest the trend. In 1848 Sill was still pleading with his fellow citizens. New York was not content with "its mercantile sovereignty, but is aiming to become, also, the great Patron of the Arts," he charged. Philadelphia was "once the acknowledged head of Learning and Taste." Could she regain this position?[109]

The answer came swiftly and negatively. Within a few years efforts were diverted from competing with New York to

maintaining any sort of indigenous art life. At its Thirtieth Exhibition in 1853 the Pennsylvania Academy displayed the works of one hundred artists; only thirty were resident in Philadelphia; five years later the percentage of local exhibitioners had shrunk even further.[110] Even the best known, like Bass Otis or James Hamilton, could not compete with the New York painters.

The difference between the two communities was not due merely to the deadening effect of the Pennsylvania Academy, as John Sartain charged. The National Academy became the target of objections at just the same time. Once the artist community had stabilized itself with guarded avenues of advancement and a recognized hierarchy of leadership, artists had something to fight about, and fight they did. Although *The Crayon* claimed the Academy's early advantages had disappeared with the diffusion of educational opportunities and insisted that people "care as little for an academy N. A. as they do for a college A. M.," the Academy retained an enviable position, evidenced by the bitter attacks of its enemies. "Throw open the institution to the entire body of artists," cried *The Crayon* inconsistently, "and get rid of distinctions."[111] If nothing else, the N. A. still aroused envy.

Other critics urged the Academy to unite with the New York Gallery of Fine Arts and concentrate on education; its "reactionary" leadership was scorned. Thomas Doughty reportedly remained outside its ranks because he disliked sharing "academic honors with the clique of mediocre painters who rule."[112] Thomas Rossiter wrote from Paris to *The Crayon's* editors that he wished to see the Academy remodeled into "an instructive institution of large ample privileges," not to make "artists of a prescribed class," but to grant "free liberal, gratuitous privileges to a class of youth who can be aided in no other way."[113] Some attacked Academy leadership for its mercenary inclinations and others for aristocratic yearnings. Artistic jealousies marred the power of professional self-government.

Putnam's Monthly grew particularly incensed at Academy-sponsored theories of "high art," ideals which deluded young artists and diverted them "from profitable and honest employments."[114] Carrying through the themes which their fiction explored, the editors pointed out that modern art meant more

tion of J—— B—— into the S. S. Society for the Discourage-

ment of Artistical Saps, satirized the artistic pretensions and academic pomposities of many artist organizations. Artists made solemn oaths promising that "the production of our pencils, the children of our imaginations, will cast in the shade the most noble efforts of a Raphael or a Correggio; and Young Yankee-Doodledum is destined to outstrip the world in Painting and Sculpture." Artists were told to cultivate "that wild, imaginative look" characteristic of the society's membership, and warned not to consume tobacco or lemonade.[120]

The National Academy fought back against detractors and competitors. Charles Ingham summoned Asher B. Durand back from the country in 1849. The profession, he explained, was "struggling for existence, and the time and talents of every member are required to preserve" and defend it, and "keep it from becoming a humble follower of the Art-Union."[121] Thomas Cummings despaired of the Academy's future, as the American Art-Union announced a new exhibit of its own to compete with the Academy showing. But the quarrels of New York artists were signs of strength not weakness; the Academy and the Art-Union fought over success and not failure; the Pennsylvania Academy caused contention because its professional effect was weak, not because of its exclusiveness.

Philadelphians purchased art, but they seemed to prefer the Europeans. *The Crayon* noted without criticism that the Pennsylvania Academy galleries, unlike New York's, contained a "very satisfactory" selection of European schools.[122] But elsewhere it charged that American painting was not represented as it deserved.[123] Surveys of Philadelphia patrons bore out the truth of these observations. Modern European painters like Isabey, Couture, Adolphe Schreyer and the Achenbachs dominated Philadelphia collections, as Americans like Church, Cole, Durand and Huntington characterized the holdings of Jonathan Sturges, Marshall O. Roberts, C. M. Leupp and J. M. Burt, New Yorkers all.[124]

These differences in taste and the varying success of urban artist institutions reflected more fundamental divergencies in the quality and social structure of city life. The patronage of art was tied to basic commitments and concerns and could not be isolated from its social matrix. Both Philadelphia and Boston —to a much greater extent than New York—were dominated

by narrow social elites, difficult to enter and hostile to strangers. The continuity of cultural leadership with its accompanying aesthetic conservatism and European orientation was noticeable in both cities.[125]

In Philadelphia, well-to-do professionals maintained their leadership in the Academy and the patronage world right up through the Civil War. For fifty of its first fifty-five years the Pennsylvania Academy was presided over by a series of eminent citizens, three of them jurists and the fourth, George Clymer, a cultivated merchant-banker and a signer of the Constitution of the United States.[126] The boards of Philadelphia's cultural institutions were the preserve of old and famous names: Hopkinson, Fisher, Ingersoll, Lewis, Pepper, Coates and Tilghman. These were men of high social status, wide philanthropic interests and occasional ties with the great planting families of the South; impressive educational attainments and conservative temperaments were characteristic features. A number of Academy directors, like J. Francis Fisher and George Seckel Pepper, were lawyers whose private incomes made practice unnecessary. Except for his politics, Henry D. Gilpin typified many of his colleagues.[127] The son of a prosperous local merchant, he went to school in England, studied at the University of Pennsylvania and was admitted to the bar in 1822. Gilpin was a strong Jackson supporter and eventually became Van Buren's Attorney General. Besides his presidency of the Academy he was a director of the Girard Bank, a vice-president of the Pennsylvania Historical Society and a trustee of the University of Pennsylvania. Publishing often on subjects of art, law and history, Gilpin was also an enthusiastic traveler and a friend of the great German botanist and explorer, Alexander von Humboldt. Gilpin perpetuated his name by leaving money for the erection of a gallery attached to the Academy.

Besides these locally born professionals, the directors of Philadelphia's art world included merchants from genteel backgrounds. Samuel B. Fales, who owned one of the city's finest art collections, principally of European works, was a Harvard graduate and a medical student for two years before he began an importing firm in Philadelphia.[128] Adolph E. Borie, diplomat and Secretary of the Navy, Richard Worsam Meade, a naval

agent in Spain and Charles Macalester were other cultivated merchants who took an interest in the arts.[129]

Other Philadelphia patrons emerged from poorer backgrounds and spent their lives in more prosaic pursuits. Matthias Baldwin and his partner, Matthew Baird, were two of Philadelphia's wealthiest residents. Baldwin was the son of a carriage maker and Baird the child of Irish immigrants. Their locomotive works was one of the largest in the country. Another self-made engineer with an interest in art was Joseph Harrison, who returned from railroad-building in Russia to build a mansion for his art collection.[130] Fairman Rogers was also an art-loving engineer, but his background was more typical; descended from a Quaker family, he attended the University of Pennsylvania, attained a professorship there and was responsible for the introduction of polo to America. Publishers were also natural art patrons. The Carey family, particularly Edward L. Carey, and Cephas G. Childs, an engraver and editor, made liberal purchases.[131] A number of physicians and bankers also played a role in the life of the Academy.

But the most striking feature of this patron community was its exclusions; in a commercial city of the first importance, filled with stores and small industries, only a trivial number of commercial and retail merchants, and a still smaller number of manufacturers, participated in the activities of the Academy, the Art Union and the Artists' Fund Society, or patronized local artists. They included Caleb Cope, a great dry goods importer who broke into the city's inner sanctum; William P. Wilstach, a saddlery dealer whose collection formed the basis for a municipal gallery in Fairmount Park; Hector Tyndale, a dealer in china and glass; and Joseph Sill, probably the most constant friend to Philadelphia artists.[132] The few exceptions merely pointed up the failure to mobilize this important sector of wealth and influence.

But these mercantile types were few, and unlike the New Yorkers, unable to widen art consumption or identify the leisure time of their class with the life of the studio and domestic art-collecting. Though Sill knew a good number of proper Philadelphians, he recognized that his social status was not high enough to help the artist community, and willingly deferred to

better-known figures like Joseph Ingersoll and James McMurtrie.[133] When the Art Union plan was announced, Sill invited more than forty gentlemen to the organizational meeting; only six attended.[134] One problem was that before the Civil War Philadelphia contained no club to bring artists and patrons together. And not until the founding of the Union League Club were the patrons themselves gathered in one place; of the fifty original members ten were important art purchasers. It is significant that none of the ten were professionals; all were representatives of the mercantile, manufacturing and engineering fields. If these men had gotten together earlier, artists might have found the city more congenial. But as a historian of the Union League has noted, people of "mixed society" who banded together in ante-bellum Philadelphia, committed "a daring offence against the canons of the old coteries," dominated as they were by Southern-oriented and Whiggish professionals.[135]

The Philadelphia story of exclusivism and conservatism was paralleled in Boston; as a less serious competitor with New York, with a more tightly knit artist community, this city was not as badly hurt. The proprietors of the Athenaeum were a narrower group than even the directors of the Pennsylvania Academy, and Boston's art patronage was dominated by the same families that ran the city's social and intellectual life. But urban leaders deferred more to artistic talent, and accepted in their midst a fair number of professionals. Washington Allston's friendship was valued by the most patrician Brahmin; William Morris Hunt, as the grandson of a lieutenant-governor and the husband of a Perkins, had a natural entry. William Page had contacts with the Transcendentalists and Alfred Ordway served the Athenaeum.[136]

But the great names were very powerful and often distant. When the first exhibition of the New England Art Union opened on Tremont Row in 1852, the vice-presidents included Franklin Dexter, a prominent attorney, and Henry Wadsworth Longfellow. The officers included E. C. Cabot, Edward Everett and Benjamin S. Rotch, Harvard graduate and a trustee of the Athenaeum and the Massachusetts General Hospital.[137] Other local patrons bore the names of Wigglesworth, Otis, Warren, Appleton, Shaw and Phillips; most of them were Harvard

graduates, members of the same clubs and, quite often, relatives.[138] However discouraging this close network might be to outsiders or new men, it also meant that once an artist had found a patron he was sure to find more. In 1841 Seth Cheney was about to give up the professional ghost when Mrs. Putnam ordered a portrait; her satisfaction led indirectly to more than one thousand dollars' worth of engagements, and he was soon happily painting Lowells, Grays, Forbeses and Winthrops.[139] Henry Dexter achieved the same sort of success in sculpture.[140]

Like Philadelphians, Bostonians were more noted for their European art holdings than their American, although they did support some local artists.[141] As Theodore Dwight had observed years before, they were great travelers and their visits to studios abroad saved many compatriots from financial distress. But French paintings were collected most avidly. In the late 1850s a Belgian dealer brought many French works to Boston and enjoyed good sales. William Morris Hunt's influence on Boston patrons was also French; he persuaded Martin Brimmer to buy Millet's "Gleaners" and succeeded in popularizing the whole Barbizon school.[142] The painter, J. Foxcroft Cole, eked out his income in Europe buying pictures for a good number of Bostonians. In Philadelphia and Boston many took the position that an art lover should not confine himself "to the art of a single nation, even his own. Does one buy paintings from motives of patriotism?"[143]

In New York this question might have yielded a different response. Collectors here were eager to buy American art because it *was* American, and because of their friendships with local artists. Unlike Philadelphia's well-educated professionals or the genteel men of leisure in Boston, New York patrons were often "new" men, merchants and manufacturers who had made their own money, outsiders who had profited from the city's open market for talent. The Century, an important barometer of its social and artistic life, showed by its membership how New York differed from neighboring centers: of the forty-two original members, ten were artists and ten were merchants. The next largest group consisted of authors, and they numbered only four. Three men of leisure, three physicians and two lawyers made up the categories so crucial in Philadelphia and Boston.[144]

If Gilpin typified the Philadelphia patron, and Harrison Gray Otis represented the Boston variety, the great New York merchant, Marshall Owen Roberts, could stand for many local art enthusiasts.[145] A poor boy who began by clerking in a grocery store, he started his own business while still in his teens, and it prospered exceedingly. He was soon active in steam navigation and railroad ventures, associating with Cyrus Field and Peter Cooper in laying underwater telegraph lines. A Henry Clay Whig and later a Republican, Roberts was emphatically a self-made man. "Pluck, plod, and probity have made Marshall O. Roberts what he is," wrote a biographer, adding that his assets included a fortune of more than ten million dollars and an extensive art gallery.[146] Roberts brought respectability to the art world; he frowned on card-playing and theaters, and justified his art indulgences by throwing his gallery open to the public.

Business and kinship knit a whole group of New York patrons together; Luman Reed, his son-in-law Theodore Allen, and his partner, Jonathan Sturges, were all generous friends to the artists.[147] Charles M. Leupp, a leather merchant, and his father-in-law, Gideon Lee, who took him into partnership, were also important patrons.[148] Leupp lent the National Academy money during a period of crisis and spent a vacation traveling in Europe with another artist friend, William Cullen Bryant. Like Lee and Sturges, Leupp was born outside of New York.

Other mercantile patrons included Thomas Faile, a wholesale grocer, Ogden Haggerty, Robert M. Olyphant, a china merchant who formed a superb group of American paintings and A. T. Stewart, the famous retailer.[149] Their ranks were swollen by manufacturers and industrialists.[150] These business-men proved useful connections to the art world. They might perform trivial but useful favors like getting a traveling painter excused from jury duty.[151] Or they could literally save artists from the edge of starvation. Publishers like Fletcher Harper and William Henry Appleton were also active patrons, though neither played the role in New York that Edward L. Carey did in Philadelphia.

A number of professional men and politicians were, of course, active art supporters: John A. Dix, governor of New York, John Wakefield Francis, who often attended sick artists

and authors without fee, John Austen, an attorney. There were
bankers like Samuel Ward, who commissioned Thomas Cole's
"Voyage of Life," railroad kings like John Taylor Johnston, and
writers like Bryant, George P. Morris and C. F. Briggs.[152] But
the merchant-patrons provided the core of the group before the
Civil War and set its tone. They corresponded with artists,
entertained them, aided them financially, visited their studios
and joined their associations. Many were trustees of the New
York Gallery of Fine Arts, members of The Century and man-
agers of the American Art-Union. Half a dozen were honorary
members of the National Academy, elected by the artists them-
selves.[153]

Many of the relationships were marked by great enthusiasm
and generosity. Robert L. Stuart wrote Asher B. Durand in
1857 that he had included a check for thirteen hundred dollars.
"Very much pleased with the painting. I have made the check
for more than I mentioned to you."[154] Henry G. Marquand,
going abroad for a year, asked Durand for a sketch as a recollec-
tion of artist friends. He confided it would be a "source of great
delight" to show these fine examples of native art to Euro-
peans; he purchased American art extensively, and for a time,
almost exclusively.[155] By 1867 New York led all other cities
in the richness of its American holdings; the New York His-
torical Society, the National Academy and at least a dozen major
private collections demonstrated the city's affection for native art.

New York had become the nation's leading art center not
merely because of its wealth and numerical superiority, but by
its openness and energy, and the eager enthusiasm its newly made
businessmen took in the success of local talent. New York
demonstrated also the fallacy spread by so many art publicists
in the early years of the century: that living art communities
could be built around academies and old-master collections.
By 1860 Boston, Philadelphia, Baltimore, Washington and Cin-
cinnati all had fine private collections, many of which were open
to artists and laymen. They contained, in proportion, more
distinguished European art works than New York could offer.
But these static, inert manifestations of interest were not enough
to attract professionals or improve the level of local production.
The presence of masterpieces was insufficient by itself; it was

taking the European letter and expecting the spirit to follow. Only New York supplied the color, the excitement, the local institutions and friendships that a vibrant artists' colony needed.

But even New York was not enough for some artists; Europe beckoned to some of them still. Their exposure to its charms and resistance to its wiles formed what was probably the greatest compliment paid to the American art world before the Civil War.

Artists' Dreams

and European Realities

～

CHAPTER ELEVEN

Despite the growing complexity and comprehensiveness of artistic communities in the United States, European study in the 1840s and 1850s still attracted many professionals. Buoyed up by sustaining dreams, American artists retraveled to the Old World in hundreds, forming colonies not only in Rome and Florence, the traditional artist meccas, but in Paris, Düsseldorf and Munich also.[1] European apprenticeship became a recognized part of the career pattern and ceased to be the pioneering activity it had been for an earlier generation. Before the Civil War, however, American artists did not become expatriates. Except for a small group of sculptors, they returned home to live out their lives and follow their callings, with occasional return trips in later years. All its enticements notwithstanding, European residence presented many hazards, and by 1860 life in New York offered enough compensations to make it a successful competitor for the artist's favor. The failure of any large-scale expatriate movement among these ante-bellum travelers was still another demonstration of the American artist's acceptance of his community's values, and his integration into native culture.

Rome and Florence remained the most popular art centers for Americans right through 1860.[2] In Rome, famous sculptors like William Wetmore Story, Thomas Crawford and Harriet Hosmer were joined by painters like George Loring Brown, William Page and J. F. Kensett. Florentine art life was sweetened for Americans by the studio of Hiram Powers and—until his death in 1852—by the workshop of Horatio Greenough. Just as the Caffé Greco brought foreign artists together in Rome, Doney's became their center in Florence. Between 1830 and 1875 more than two hundred American painters and sculptors worked or studied in Italy.[3]

This exodus caused mixed feelings among native critics and patrons. William Dunlap, though a staunch nationalist,

considered travel a necessary experience for any artist; seeing the work of Sully, Morse and Allston, products of European training, he argued that "after the proper course of study and at a proper age" American artists should visit "and study the wonders of European art."[4] Henry Tuckerman, Dunlap's biographer-successor, was somewhat less enthusiastic. He agreed that the "spirit of calm, progressive labor," the indispensable food for the artistic temperament, was easier to acquire in a European atmosphere, but he disagreed with the prevalent notion that "a true painter . . . is necessarily to improve by a visit to Italy." Study abroad was often fatal to an artist's individuality, for it could lead to servile imitation.[5] The trip might improve taste, Tuckerman concluded, but not execution. Several other observers, William Cullen Bryant among them, objected to any extended European residence.[6] Indeed, a number of artists, notably Erastus Dow Palmer and Henry Dexter, both sculptors, and William Sidney Mount, the genre painter, refused to study abroad. According to his biographer, Dexter believed that before art could become universal, it must be the expression of "a confined and individual civilization, race, climate," and this required prolonged and isolated work at home.[7] Mount declined a number of offers to go abroad without personal expense, observing that "originality is not confined to one place or country . . . thank God."[8]

Even some of those who made the trip expressed their doubts. Sanford Gifford, painting in Paris, wrote home that prolonged study of one school might be dangerous to a painter's spirit and originality; variety and a strong will were necessary for an artist to resist Europe's wiles. "As to myself," Gifford conceded, "perhaps I do not surrender myself sufficiently to the influence of the art I find about me."[9] Such was the penalty of watchfulness. Worthington Whittredge, who spent some years in Düsseldorf and Italy, considered lengthy residence abroad a bad thing and a threat to the distinctiveness of American art. "A man is of no use who does not have faith in the heritage of his own country."[10] And Asher B. Durand looked "with weariness and indifference" on the sights of his European tour; he wished "the business of this trip was finished," for he found much of the great art he had traveled so far to see to be disappointing.[11]

The dominant assumption was, in any case, that the artist eventually would return home. The greatest danger was damage to artistic integrity and native style. "It cannot be wholesome to the mind to be forever in the presence of artificial models of perfection," wrote one tourist.[12] Bryant's famous sonnet, addressed to Thomas Cole before the artist sailed for Europe, revolved about an eloquent plea to keep "that wilder image" bright. It is less impressive, however, if one recalls that Cole had spent only a decade of his life in America, emigrating from England with his family when he was nineteen years old. The European virus, unlike the smallpox, was not less deadly to those once infected.

Nonetheless, this was an aesthetic, not a political virus. Most American artists who visited Europe before the Civil War were not fleeing their homeland but seeking to extend their talents and undergo a ritualistic initiation into the artist life. John G. Chapman wrote rapturously of the joys of Italy and the privileges of its artists; but he added that only if it had been the land of his "home, and attachments" would he wish to remain there.[13] And for every caviler opposing foreign study there were several supporters insisting that it was impossible to form a school of American artists by keeping them in a country devoid of artistic traditions and poor in *objets d'art*. "Let Art find its masters when it will, and choose what it will, Gog or Magog, prophet, saint or devil," cried the *American Whig Review;* its mission must be purified and supported all the same.[14] Like beauty and truth, art was cosmopolitan. And as religion "in its best state is the same in Jerusalem and New York, so of Art—it is the same in its great, first principles."[15] By limiting the similarity to principles, critics could encourage artists to study historical variety without fear of a loss of virtue or vision.

Students abroad proclaimed to the world the glory of American life and the fulfillment of its promises. Their residence in Europe was serving a patriotic function. Forty years of public life, wrote one correspondent, did not make Daniel Webster as famous in Europe as his statue by Hiram Powers. "I say it is from American *studios* in Florence, and Munich, and Dresden, and Rome—from European centres rather than from the American circumference—that the names, and services,

and writings of American statesmen are first beginning to radiate through inner Europe."[16]

The trip itself, if it involved prolonged study, represented an investment of time, energy and money which often sealed the aspirant's choice of profession; some might hesitate about career plans before making this plunge, but it was difficult to renounce the choice once so much effort had been expended. Study abroad was the final legitimization of decisions made earlier in America, although it involved hazards and risks which threatened the initiate. Greenough reported that several students had returned home soon after their European arrival, discouraged to find that so much work still lay ahead of them. Only the strongest could survive. "I tell you what, it takes a great deal of resolution to work through the elements in a foreign land with one's milk teeth unshed and with little money."[17] And Harriet Hosmer wrote her patron from Rome that if the public "knew but one-half the difficulties an artist has to surmount, the amount of different kinds of study necessary, before he can see the path even beginning to open before him," there would be less censure of artists for their slow progress.[18]

The presence of so much great art inspired but also depressed the ambitions of young students; many came to feel that these heights were insuperable. George Hillard shrewdly observed in Rome that "the inward faculty is often paralyzed and discouraged by the too great abundance of external instruments and faculties." Profusion could act as a narcotic rather than a stimulant; art excellence was attainable by "active effort," not through "passive impressions."[19]

The shrewdness of this insight was confirmed by many artists. Seth Cheney, portraitist and engraver, wrote home to his brother that "one feels his deficiencies so sensibly, that it [sic] sometimes has the effect of disheartening him."[20] It was not merely the profusion of masterpieces but the sense of one's own insignificance that hurt. Worthington Whittredge wandered about the Italian galleries "in a most despondent state of mind. For the first time in my life I realized that the great works of art . . . were not landscapes. . . . It was constantly recurring to me that I was 'but a landscape painter.' "[21] Others cursed their delay in getting started. A young painter, James De Veaux,

felt it was "useless to attempt anything when such master pro-
ductions are staring and mocking scornfully at your feeble
efforts." He had arrived in Rome too late. Only in earlier years
"when the warm springs of my being were flowing freely . . .
when I knew no bounds to my ambition, and no undertaking
was too great for me," could he have met the challenge. Now
"it strikes a chill to my heart. . . . What is your soaring dome to
me. . . . I tell you it is too late."[22] Even the self-confident
Horatio Greenough felt twinges of doubt as he noticed the in-
difference of Italians to fine works of sculpture. If such was
mediocrity, "how presumptuous, then, in me, to hope to ac-
complish aught worthy of the art!"[23]

Mental depression brought other dangers; if mid-century
artists were better educated and more adept than the provincials
of the early nineteenth century, they were also more sophisti-
cated and self-conscious, aware of the many failures strewn about
them, less daring because less ignorant. Conditions of travel and
study had improved, but the pattern of emotional illness and
physical collapse which Benjamin West set in the middle of the
eighteenth century was repeated frequently in the next hundred
years. A surprising number of artists became seriously ill in
Europe, and many died there. Some had been ill before they
arrived, the trip representing either a last, desperate attempt to
regain their strength, or some ultimate tribute to the power of
art. But others, depressed or unduly excited by the masterpieces,
working feverishly to fulfill orders from home or seeking to cram
as much experience as possible into a short period of time, suf-
fered breakdowns which lowered their resistance and made them
susceptible to Italian malarial fevers. In summing up Benjamin
West's progress—"the change of scene, the presence of works of
first-rate excellence, and the anxiety to distinguish himself,
preyed upon him; sleep deserted his pillow, a fever followed"—C.
Edwards Lester capsuled the experience of many.[24]

Disease was not always the result of overwork, as pious
eulogizers insisted. Since one aspect of the romantic syndrome
was personal suffering, biographers did their best to relate pain
to professional duties. Henry Inman, who died shortly after
completing an English trip, was "the victim of aching thoughts
and suffering suppressed."[25] His heart was found distended to
twice its natural size, caused by unfair and ignoble criticism and

a lack of financial support. J. F. Cropsey was prostrated by "close study and pecuniary disappointments."[26] Shobal Clevenger, the sculptor who studied with Powers in Florence, lost his health from "too intense devotion to his art."[27] Thomas Crawford's brain fever was "the effect of over excitement and intense application," while Frederick S. Agate's disease was caused by "his intense devotion to his work."[28] Without this misfortune, wrote a biographer, Agate would have become a great painter, but he lost his ambition along with his health.

Exaggeration helped make martyrs out of Crawford and Inman, whose deaths related only incidentally to their European study, but the great number of artists seriously ill in Europe—Washington Allston, Horatio Greenough, Paul Akers, James De Veaux and Edward S. Bartholomew among them—indicated that the trip was really a dangerous one. Sickbed scenes became the convention of artist biographers. Worthington Whittredge, smitten with "Roman fever" was given up for lost, but nursed back to health by the painters Sanford Gifford and Frederic E. Church.[29] A Philadelphia painter, Samuel Bell Waugh, was watched over by Thomas Crawford and James Edward Freeman until he pulled through.[30] Crawford himself was nursed by an American diplomat, George Washington Greene.[31] And J. F. Kensett was restored to health through the good services of his fellow painter, Thomas Hicks.[32]

The outstanding artist-martyr of this era, the victim of his own idealism and Italian despotism, was James de Veaux, a Southern portraitist. In the heart of winter he was refused entry into the Papal States for want of a proper passport; forced to make his way back along the Italian coast, he died from a chill developed en route.[33] Immortalized by his physician patron, Robert W. Gibbes, De Veaux's tragic end made such an impression on this generation that C. Edwards Lester chose him as one of his eight *Artists of America* in 1846, an honor he gave others like Gilbert Stuart, Benjamin West and Washington Allston.[34] The deathbed scene was particularly edifying, a compound of pain and piety. De Veaux spoke constantly of religion, urging on his acquaintances "the importance of preparing for a dying bed whilst in health, as few would probably have the same time afforded them, with which he was favoured." His friends emerged from the sickroom overcome and weeping.[35]

Martyrs like this gave the profession a truly heroic stature, and demonstrated novelists' assumptions about the artist's trials in a hostile world.[36]

European study was not, of course, a trial of misery for all, and most American artists did not collapse of pain or a lingering disease. As a group, artists probably enjoyed the same share of health that other professions possessed; working on an old theme, critics suggested that artists actually lived longer, partly from their greater serenity and proximity to beauty.[37] But the pleasures of the artist's European interlude have been so exaggerated in succeeding decades that it is necessary to recall the trials which made the journey exciting and hazardous. Publicized misfortune, persecution and neglect added interest to many artists' careers which would have been barren of romance without them. By titillating Americans who remained safely at home, biographers and eulogists created a minor pantheon of heroes and martyrs to whose memory American artists of later generations could repair in moments of despair. And though the martyrdoms often contained more wishful thinking than reality, loneliness, depression and illness were familiar companions to many artists studying abroad.

This new generation of travelers found European taverns, studios, and lodging houses peopled by American colleagues, many of whom were friendly, or at worst, indifferent. But the youngsters also discovered a more sophisticated, expensive and bewildering social world than their predecessors had known. Europe was still less costly than America, and models, materials and tuition were much more accessible. But the cheapness of artistic existence there, always exaggerated, had virtually disappeared by the 1840s. Smaller communities like Florence or Düsseldorf were obviously less expensive than Rome and Paris, but Margaret Fuller warned that artists needed at least one thousand dollars a year for life abroad, and added that Europe was measurably cheaper only for the rich. American patrons were often inadvertently guilty of great cruelty; having "read essays on the uses of adversity in developing genius . . . they are not sufficiently afraid to administer a dose of adversity beyond what the forces of the patient can bear."[38] *The Crayon,* trying to encourage artists to work at home, suggested that Rome was no longer less expensive than New York, even for sculptors.[39]

Life in the artistic enclaves of Paris, Rome, Düsseldorf and Florence was often happy and satisfying; the new friendships and revived sense of professional solidarity, the steady growth of technical abilities, the sketching trips and boisterous vacations, and the parties and conversations formed a fund of experiences which could be recalled nostalgically for years to come, and help perpetuate artistic identity even back in America. Artists lived "so closely together" in Europe, that "being acquainted with one" meant acquaintance with all.[40] Sanford Gifford and Caleb Bingham reported delightedly on conditions they found in Düsseldorf. Exhibitions were exciting, the artists sociable. "The manners of the artists are very kindly, simple and unaffected. A true brotherhood seems to reign among them," wrote Gifford.[41] Bingham thought Düsseldorf but a small place compared with large American cities, "yet I question much if there can be found a city in the world where an artist, who sincerely worships Truth and nature, can find a more congenial atmosphere, or obtain more ready facilities in the prosecution of his studies."[42] Even Paris, which Bingham found too large and unfriendly, appealed to young Americans. "To an American art student," wrote David Cronin, "it is the paradise of the earth."[43]

There were Americans to meet as well as Europeans. Making his first trip in 1846, Christopher Pearse Cranch quickly grew friendly with Kensett, Powers, Greenough and Cropsey.[44] Bingham reported that Emanuel Leutze treated him like a brother.[45] American painters in Paris organized an O.M.C. or Out of Money Club, and Benjamin Champney, a New England landscapist, found life among the Americans in Rome jolly and friendly.[46] The concentration of talent allowed artists to meet writers and men of importance whom they would have found difficult to encounter at home; tourists made the rounds of the studios, competing to find just which young American artist had the most promising talent, and could be touted as a personal discovery on arriving home. Many Americans were introduced by Europeans to the concept of an artistic community, and to the delights such association brought with it. These experiences helped make artistic life at home more cohesive and interesting.[47] European clubs and academies made a striking impression in the earlier decades when professional societies at home were small and weak, but by the late 1840s and 1850s artist societies al-

ready existed in America, and as they grew stronger, the European experience became less novel.

The increase of the number of Americans abroad led to bickerings and jealousies, the natural product of any confined group of competitors. Sculptors like Powers, Crawford and Greenough were often at each other's throats seeking lucrative government contracts, while detractors spread unfavorable gossip.[48] Hawthorne considered artists' quarrels to be even more bitter than literary disputes, for artists depended on a much smaller group of patrons. "Thus, success in art is apt to become partly an affair of intrigue; and it is almost inevitable that even a gifted artist should look askance at his gifted brother's fame."[49] The art they expected would hang "in clusters" and "be eaten from the trees" was not so easily plucked when many others were after the same fruit.[50]

The assertion that exposure to active government patronage and impressive institutions like the French Academy at Rome encouraged artists to demand that their own government set up more scholarships, purchase works of art for museums, and support their careers in the international arena is open to question.[51] Many artists did adopt these attitudes. After wandering through the Luxembourg, Sanford Gifford asked when will "our Government ever be persuaded to buy works of art for the education and refinement of the people?"[52] But such questions were asked not only by artists but by tourists who visited Europe for much shorter periods of time. Approaching the problem from the view of the consumer rather than the producer, they urged government patronage on economic and political grounds, as well as for artistic reasons. One such visitor, discovering that English, German and French artists resident in Rome all had their own life schools, gave enough money to the Americans to set up their own.[53] A critic in the *North American Review* urged private citizens to found a school for American artists in Europe.[54] Voluntarism and calls for communal responsibility in art matters did not depend on study abroad for their expression.

Nor did a realization of the value of artistic productions require a professional viewpoint. Bayard Taylor observed that Italian masterpieces helped that nation "earn from year to year the bread of an indigent and oppressed people. This ought to

silence those utilitarians at home, who oppose the cultivation of
the fine arts, on the ground of their being useless luxuries."⁵⁵ A
single Raphael was a rich legacy for a great city.⁵⁶ Horatio Stone,
president of the Washington Art Association, pointed out that
a Rubens canvas, the "Descent from the Cross," which cost
originally about three hundred dollars, had become Antwerp's
chief source of wealth. "The number of visitors that annually
visit Antwerp and that picture is immense; each pays his fares
to the railroads, at the hotel, and leaves something at the
church, and many purchase souvenirs."⁵⁷

As the number of American artists in Europe increased,
it grew less easy for individuals to repeat the fantastic social
and professional successes which almost any competent Ameri-
can enjoyed before the 1830s. Some still managed it; G. P. A.
Healy's Parisian triumphs recalled the feats of Chester Harding,
and sculptors like Crawford and Powers were strewn with Euro-
pean honors, holding eminent places in the international artist
set. But others found it much more difficult, and occasionally
took out their hostilities in ill-tempered attacks on the more
successful.

Worthington Whittredge recalled that at Düsseldorf it was
easier for him "to obtain entrance into the best families of the
place" because he had arrived there as the agent of some Cin-
cinnati art patrons. Unlike most of his colleagues, he had money
to spend.⁵⁸ Albert Bierstadt, on the other hand, was so poor
that he felt it necessary to refuse dinner invitations, for he was
unable to reciprocate. Wealthy artists like Frederic Church were
rare exceptions—in Whittredge's terms, "fortune's favorite from
the beginning." Church "never knew what poverty was nor had
occasion to solicit letters of recommendation to send to his
parents to pacify them and assure them that he had talent and
would succeed."⁵⁹

European travel did not lessen anxiety about money. Artists
in Italy welcomed the seasonal changes which forecast the com-
ing arrival of wealthy tourists. Sculptors, who usually had large
orders on hand, were less nervous than painters, who relied on
quick sales. "The necessity of selling our work made us bestir
ourselves in society, and in making the acquaintance of all the
strangers we could, who had come to town."⁶⁰ But even sculptors
brooded about costs. Harriet Hosmer explained that when "one

has a name" sculpture could produce a good income, but "one must spend a good deal of money before one can hope to make" a fortune. "A painter has no expense of the kind; he buys his canvas and his paints, which cost little, and he is made; but from the time a sculptor begins, he finds that without funds he is at a standstill."[61] A certain, if moderate, income could be more useful than a large, though fluctuating, one.

Despite their problems American artists found European life quite attractive, and lengthy stays abroad frequently produced some contempt for native culture and a sense of antagonism toward patrons. It was easier to condemn America from a distance as a money-mad civilization which treated its artists as men of small importance than to launch charges while at home. "I wish you were out of America," William E. West wrote to Thomas Sully. "It is my opinion that you would make three times as much money here . . . as in Philadelphia, and live better on three times less."[62] America, wrote Greenough, who spent most of his productive years in Florence, acts toward her artists like "a hen who has hatched ducklings. She cannot understand why they run to the water instead of thriving upon the dunghill."[63] James De Veaux was amazed at the deference paid by Europeans to artistic talent; at home "his sensitiveness was constantly experiencing . . . mortifications, here he felt a confidence in his position as an artist."[64]

Other artists felt their greatest shock on returning home; it was sudden enough to force open resentments which hitherto they had kept to themselves. Christopher Pearse Cranch, arriving in New York after his European journey, was struck for the first time by the unpleasant aspects of the American physiognomy. "There was a certain hard, weary expression around the mouth, a quick shrewdness of eye. . . . Every one seems anxious and worried." American want of manners contrasted with the suavity and elegance of Continentals. Even Broadway seemed "shorn of its glory! How houses, which I once looked upon as very large, had dwarfed and dwindled away!"[65] Benjamin Champney was glad to see his family once again, but "everything seemed so dull and prosaic in Boston, that a discouragement came over me. No one seemed to care much for pictures," and the treasures of connoisseurs were only fake old masters covered with varnish and dust.[66] George Loring Brown returned to Bos-

ton to be depressed by a lack of sympathy and brotherhood which made him long for a return to Italy.[67]

It was not merely the loss of boon companions or old masterpieces; work itself was difficult in America. William Wetmore Story, who became a permanent expatriate in 1856, found the very atmosphere of his native city unpleasant. "Every twig is intensely defined against the sky. The sky itself is hard and distant. Earth takes never the hue of its heaven. The heart grows into stone."[68] And Worthington Whittredge, though he decided to remain at home, found his landscape ideals irretrievably European. He went sketching in the Catskills but entered scenery very different from Europe's, with "no peasants to pick up every vestige of fallen sticks . . . no well-ordered forests, nothing but the primitive woods. . . . I think I can say I was not the first . . . painter of our country who has returned after a long visit abroad and not encountered the same difficulties in tackling home subjects."[69]

Story and Cranch were exceptional in their bitterness, perhaps because they enjoyed a higher social position and a better education than most of their colleagues; the deference they demanded as artists and their contempt for native materialism was partly a function of their instinctive disdain for popular attitudes. But other artists were exhilarated by Europe without resenting their home culture. Europe became a stage for American artists where they could act out an age-old drama, sustained by the audience reactions of friends and visitors, aided by the vast sets which history and nature had conspired to produce. With the exotic trappings of a picturesque daily life adding to the power of their role, artists became increasingly reluctant to stop the performance as the decades passed.

The European experience was important not merely because of the presence of art treasures or the availability of patrons and colleagues; by the 1850s, with some limitations, America met these needs. It was rather that the artist abroad was fulfilling the great classical dictum that personal contiguity to the great, the good and the true led to their assimilation and eventually to their re-expression. Artists became new Raphaels by living the lives of old Raphaels, and this meant a constant immersion into the atmosphere breathed by the old masters. For these artists *ideal* was a noun rather than an adjective, a condition discover-

able only by making the commitment of total imitation. Living the artist life on hallowed ground led to the production of great art. Horatio Greenough insisted that he stood for Greek principles, not Greek things, but the former could be absorbed only through the latter. Even a lifetime of immersion was not enough. Certain that environments and associations which produced greatness in the past must continue to do so in the present and future, American artists were stupefied by the ineptitude of contemporary Italian artists. It was absolutely amazing, wrote Thomas Cole, "that, surrounded by the richest works of the old schools," the Italian palette had become so meager, and their painting so poor.[70]

The spontaneity and lack of self-consciousness about European art life appealed to American artists who could work only after painful, deliberate and forced efforts. The old masters did not sit down, "as the modern artist too often does, with a preconceived notion of what *is* or *ought* to be beautiful." [71] They simply created. An artist's success depended on his mental and moral habits, which his associations and surroundings conditioned. And here America disappointed some of her traveling artists. It was not for institutions that they yearned, mere artificial stimulants to art achievements, but for a totally different atmosphere. Putting up with America as a necessary evil, Christopher Pearse Cranch longed for Italy. "Here, surrounded by a selfish, commercial, money-making, rushing, driving, and wholly conventional community, what can an artist do?"[72] New Yorkers and Bostonians might satirize vulgarity and flit in and out of studios to encourage their artists, but they treated these visits only as brief interludes in their throbbing daily lives. In Europe the artist's task seemed more central and comprehensive.

Had this dissatisfaction with American life been widespread, ante-bellum artists would have been seriously alienated from their native society and more critical of it. But this was not the most common reaction, and even Cranch relented, though he retained his tone of patronizing hostility. Artists had grown too strong in America to succumb to the mercenary instincts of their patrons. "They can't keep us from having a good time with those [with] whom we sympathize, and there are not a few of those here, and we can at least laugh at their ridiculous position, when their backs are turned."[73] Thomas Rossiter wrote home

from Paris that he longed "to be back again with my shoulder at the wheel, for there is much to be done at home which can only be accomplished by artists making themselves formidable by numbers and influence."[74] Henry Kirke Brown was enchanted with Rome and called it a "Paradise of artists," but he still wished to return to America to help form a native school.[75] And Cephas G. Thompson told William Cullen Bryant that he anticipated spending another year of study in Rome, but could not deny "that I have at times a great longing for home and home-associations."[76]

With all its problems and discouragements, American life remained preferable to this generation of artists, whose duty lay in their own country. Less than a dozen prominent painters moved permanently to Europe before the Civil War, and their stays were often determined by personal factors: Luther Terry's marriage to Thomas Crawford's widow; William Stanley Haseltine's desire to be near his sculptor brother; George Catlin's capture of a European market for his exotic Indian studies. America remained their home, and American society—philistinism, materialism and bustle included—was still more congenial than any they discovered in Europe. Save for a few of the best-born and highly educated, most artists, even the semi-expatriates, hoped to return eventually to the United States. After twenty years in Florence, Hiram Powers still voiced the hope to "go home," home being the hills near Cincinnati.[77] Powers never returned—the money he could make in Europe kept him there— but he betrayed no feeling of estrangement with his native land or antagonism toward its values. On the contrary, tourists found his Americanism stronger, and occasionally more offensive, than the most ardent patriot could desire.[78] Europe was a way station to success, but not the depot. Six months of study and exhibition there, felt some, would solve the problem of selling paintings to visitors, or even of sending them back home.[79] "If you were ten years younger," C. F. Briggs wrote to William Page, trying to arrange the painter's career, "I would . . . send you to Rome and bring you back via Paris and London. Fame may sometimes be acquired by chance, but rarely."[80] The great pilgrimage had become a tactical maneuver in the strategy of professional competition. Europe could certify an American success.

Most artists were not yet dissenters; their artistry was not

intended to demonstrate their disagreement with democratic, republican values, and few of them believed their own country would constrain serious work, after they had mastered the basic skills. Their major quarrel concerned their own support, and this was a natural and universal dilemma for artist communities. Professional self-consciousness had emerged in America under the guidance of the most "philistine" portion of the population: merchants, bankers, industrialists and businessmen. Where it had grown most rapidly, as in New York, the more cultivated elite of lawyers and connoisseurs had little to do with artistic advancement. Artists defended their self-government and public support by accepting most of the objectives and opinions of their generous commercial friends. These included the notion that art had an important contribution to make in the improvement of society, and that the artist's duty lay not to himself but to the republic. Success itself brought many artists closer to a state of conservative self-satisfaction. The sense of indispensability and importance which such patronage supplied appealed to many professionals; it dignified their calling and helped rescue it from the contempt of utilitarians.

The failure of large-scale expatriation or obvious alienation to develop before the Civil War owed something to the artists' identification with native culture, and something else to the community life which large cities like New York offered to them. Ultimately, however, it rested on the fact that the art career had become legitimized in America on the highest level and recognized as desirable in a democratic society. Artists had become pedagogues, moralizers and inspirers of great importance. The dependent profession's needs for assimilation and support had led to its ultimate tribute: in one final gesture before the Civil War, American ministers of the Gospel turned to art. Their reflections, during and after the conflict, apotheosized these servants of the spirit.

The Final Tribute

CHAPTER TWELVE

ON THE EVE OF the Civil War, American artists had attained physical prosperity and social respectability: patriotic patrons placed orders for their landscapes and history scenes, benevolent organizations served professional needs, clubs and societies organized their leisure time, dealers marketed their products. And from the most conservative bastions of order and morality, America's Protestant clergy, came a final tribute of encouragement and gratitude. Artists were admitted to full equality in the vast benevolent alliance forged to improve the nation's manners and morals. The great Civil War itself seemed only to intensify the need for the spiritual balm of art. Artists echoed clerical hopes, and meant their work to support idealistic objectives. Though the costs of this alliance were hidden, they remained real. The academicism of American artists in the last years of the nineteenth century, the increasing distance the profession stood from the interest and enthusiasm of the mass public, and the growing distrust of their achievements were by-products of this entente. But for a brief moment, America's native school basked in the warmth of community approval and clerical blessing.

By the middle of the nineteenth century, American clergymen were outdoing themselves and most other professions in propagating art ideas, urging aesthetic improvement and proclaiming the artist's American mission They did so despite the fact that their legacy from more orthodox days had been hostility or, at best, indifference to the graphic arts. Protestant ministers had long been suspicious of many ordinary forms of entertainment and recreation. Opera, balls, late suppers, athletic contests, horse-racing, gambling, novel-reading and the theater were the targets of anguished jeremiads.[1] They symbolized idleness, worldliness, frivolity and sensuality, and even in the nineteenth century many rural clergymen continued to issue their denuncia-

tions. But in the two decades before the Civil War these atti-
tudes underwent a remarkable change.[2] Many ministers came
to terms with competing forms of expression by interpreting
them as alternative routes toward moral improvement. Since
American Protestantism had, for much of the nineteenth century,
been moralistic rather than pietistic in its goals, this transfor-
mation was not completely unexpected.

A series of sermons published in the 1840s and 1850s
by Congregationalist, Unitarian and Presbyterian ministers
confirmed this trend. Baptists and Methodists held more con-
servative attitudes toward recreation, but even they occasionally
joined in the process of revision. Ministers seemed particularly
concerned with repudiating what they considered was an un-
fortunate though historically necessary Puritan inheritance. Ed-
ward Everett Hale, speaking in Worcester in 1855, directly con-
demned antipathy toward pleasure; just as men had abandoned
the theology of flesh mortification, so they must discard suspicion
toward pleasures of the senses. "We believe that God wants the
education of the whole man,—body, mind, and soul,—that to
God's eye, therefore, the hours of rest are worth as much as the
hours of labor."[3] Prejudices against amusements, said an an-
nouncement of Pennsylvania Friends, had their roots in an un-
pleasant asceticism. "To fit ourselves for heaven it is not neces-
sary to make ourselves uncomfortable on earth."[4] Religion did
not contract, but rather expanded, human capacity for earthly
enjoyments. God's world, said George W. Bethune, "is no enemy
of ours. . . . It cannot be that the Creator, who has given us
senses so exquisitely susceptible, and has surrounded us with
so many sources and occasions of delight, filling the world with
beauty, grandeur and variety," is pleased by human revulsion
from the joys of music or nature. Man, after all, had been
born in a garden, surrounded by delightful sounds, smells and
sights.[5] Frederick W. Sawyer, the most vigorous clerical ad-
vocate for amusement, found it absurd that the churches had
declared war on the senses. It was "almost like resisting a
natural law" to refuse to make use of the eyes and ears in
instruction or entertainment.[6]

Most clergymen insisted that with permission or without
it men would seek amusement; it was a natural and inexorable
need, and the only problem was whether it would be met under

direction and with beneficent results, or whether it would
take less healthy and more sensual forms. "If we have religion
without amusements," pointed out· the Pennsylvania Friends,
"we must also have amusements without religion."[7] Physically
and emotionally Americans were going to seed. Wealthy, pro-
gressive, democratic America contained a dulled, deadened and
unhappy population. We present to the world, said the Rever-
end James Corning, "the melancholy picture of a nation
blessed with resources of knowledge, invention and enterprise
unparalleled . . . yet wearing out and running into premature
senility."[8] Laughter was a positive good, not a frightening de-
generation. God is not only to be worshiped in sickrooms, the
Reverend J. H. Morison reproved. "We mistake the genius of
our religion altogether, when we confine it to the sombre side
of life."[9]

Planning and commitment were necessary to end this un-
happy condition. "System, system, system is the great law of
progress," cried the Reverend Mr. Sawyer. "If amusements are
worth having at all, they are worth having upon system."[10]
Art galleries, supervised public entertainment, more holidays,
emphasis on competitive sports, picnics, parks, concerts—these
were the only ways to restore health, ensure good humor and
promote happiness among the general population. Europeans
seemed to manage matters better. In phrases closely resembling
the observations of their traveling compatriots, American min-
isters pointed to the examples set in London, Paris, Munich
and Rome. European governments did not charge for amuse-
ments; they invited their citizens to stroll through beautiful
parks or wander in great art galleries, thus promoting social
solidarity and public taste. Placed in daily contact with "their
superiors," the lower classes developed "a taste for those graces
of person, attire, and attitude, which they there see. delineated
in such perfection."[11] The same benevolence which the travelers
developed toward absolutist institutions because of their atten-
tion to these needs, appeared in contemporary sermons. An
American traveler through Germany, Frederick Sawyer reported,
was so charmed by the way in which peasants spent their
evenings there "that he was almost tempted to doubt the
superior excellence of our republican over their aristocratic
form of government. He seemed to question whether their ap-

parently more social and joyous dispositions than those of our population, might not spring, legitimately, from the absence of all political care."[12] Sawyer disagreed, but with enough qualifications to leave the opposite notion safe in the minds of his congregation.

In particular, ministers began to explore the connections between moral feelings and taste; cultivation was favorable, not threatening, to a high level of national morality.[13] Beauty was replacing cleanliness in its proximity to godliness. More than happiness or health, clergymen desired spiritual progress. Beauty was immortal and reverenced; it could serve religion well. "If we want to drive far from us, vice and crime—if we want to outbid the wine-cup and the gaming-table, we must adorn. We must adorn our parks and gardens; adorn our churches and public edifices. We must have something to claim the attention, to mould the taste, to cultivate."[14] Ministers grew intent upon making American artists their active allies in their fight for men's souls. The clerk of the Presbyterian Synod of Albany and Troy, after viewing Rembrandt Peale's "Court of Death" in 1846, reflected that the "affinities between Religion and the Fine Arts" were "very far from being generally understood or appreciated. . . . They are mutual supports . . . produce parallel, not antagonistic states of mind"[15] Seven years earlier *The Christian Keepsake and Missionary Annual* had featured an article entitled "The Reciprocal Influence of Piety and Taste." The author concluded that a man in sympathy with the work of poets and painters would be "a better Christian" than his fellows who ignored or attacked the arts.[16] The *Yale Literary Magazine* selected for its Townsend Prize Essay in 1855 a study of the value of art to Christianity; the essay insisted that art was a "moral alphabet" and a symbol of the divine.[17] Thus Transcendentalist values had permeated even orthodox New Haven. Emerson, Thoreau, Cranch and Margaret Fuller could not have disagreed with this intellectual position. Their objectives and views were not so very different from the attitudes of orthodox clergymen. The artist "is writing inward beauty on the outward," wrote a Transcendentalist critic in the 1840s, "and thus unconsciously doing *his* part toward bringing the poles of the earth into harmony with the poles of heaven."[18]

Ministers praised the artist's function, in substance as

well as in metaphor. "God himself," said the Reverend Dr. Osgood, in what was obviously a compliment to both sections of the analogy, "is the Master Artist."[19] Art was "a fifth evangelist . . . a preacher, the most penetrating and convincing."[20] Numerous articles proclaimed "the sisterhood of art and religion," and suggested that it was "only through a succession of beautiful beings whom we have *seen* . . . that we mount to the highest conception of the *unseen* Beauty . . . God."[21] Such enthusiasm had material as well as psychological rewards. Artists began to work on church commissions, for times had changed since Samuel F. B. Morse dejectedly observed that American painters would get no support for their scriptural canvases from American ministers. F. W. Edmonds, Henry Kirke Brown and Robert W. Weir did paintings, designed windows and carved bas reliefs for some of New York's most fashionable churches, a foretaste of the revival of religious art after the Civil War.[22]

Clergymen also often thought of themselves as artists, and urged painters and sculptors to consider themselves ministers. "Is there not something quite kindred between your profession and ours?" the Reverend Samuel Osgood asked the artist audience of *The Crayon*. Ministers were "very fond of the society of artists," and the profession had no more devoted supporters than "educated clergymen."[23] Poetry emphasized the new connection; in 1854 *Putnam's* ran "The Painter's Portfolio," a lengthy poem whose subject concerned a disappointed painter who had become a priest.

> *I turned to the sole art I could pursue.*
> *Shaven and habited in this dark hue,*
> *I serve at the high altar as you serve*
> *Your lofty Muses. My thoughts never swerve*
> *From this artistic ritual.*[24]

When pressed, of course, some clergymen were careful to place limits around their enthusiasm. Mark Hopkins admitted that past ages which had cultivated the arts had often been dissolute and corrupt. The old luxury theme had not entirely died in America, nor had suspicion of connoisseurship and affectation. "What better resource has an ordinary person who has money, and who wishes to be distinguished in the fashionable world, than to become a patron of the fine arts?" asked Hopkins.[25] Poetry, music and art, as beautiful as they could

be, wrote J. H. Morison, required the guidance of religion, and "only lead us into the paths of death when they withdraw from her guidance and demand for themselves the worship which is due to God alone."[26] For this reason some clergymen stressed the beauties of nature as opposed to the glories of art; while vice was often the result of art collecting, a taste for gardening had never corrupted anyone, Hopkins pointed out.[27] But this problem was easily met, as it had been in the rhetoric surrounding the monument and rural landscape movements. Art taught the citizen how to appreciate the sublime natural world. Gazers in a gallery could never return to their original darkness, said *Putnam's Monthly.* "He who has seen can never be as if he had not seen."[28] And the Reverend Samuel Osgood, opening an exhibition of the American Art-Union, met the issue head on. High art, he insisted, educated men to the beauty of nature. A visitor to New Hampshire would find its inhabitants unaware of its grandeur. "Only he who has been under the influence of art, sees nature." As his closing sentiment, Osgood offered, "Art, the interpreter of Nature, Nature, the interpreter of God."[29]

Clergymen were not the only group nervous about the relationship between art and religion; a few artists were at least equally alert to the implications. In 1863 the Reverend Henry Bellows, an active art publicist and eager friend to many artists, declared that one "cannot have true Freedom without true Religion and true Art . . . nor true Art without true Liberty and true Religion. These things go together, or else not at all."[30] But Daniel Huntington, as a competing professional determined to maintain his own autonomy, insisted that art and religion were as distinct as "Beauty and Goodness." Art could be either holy or wicked; a depraved art could corrupt.[31] Bellows would have insisted that true art could do only good, for this was part of his definition, but the artist himself pointed to the potentialities of evil, to underline the creator's personal contribution to moral welfare. If great art always produced beneficial effects, then the artist himself mattered little. Other critics saw the harnessing of art to religion as a "degradation," making artists the servants either of ethics or theology.[32] The painter would destroy his universality by illustrating dogma which a following generation might find erroneous or outdated. But

this disagreement was not a common one; few artists cared to dispute the fact that great art must be moral, and would have agreed that they, like religious leaders, had a mission "to communicate to others what God has shown to them."[33]

Clerical support of the arts rested on much more than amateur interest. Prevailing cultural ignorance and a widespread popular desire for a remedy offered clergymen a chance to resurrect their corporate influence on national culture. In Colonial America, ministers had spoken out on all matters: scientific, literary, political and religious. With liberal educations and pulpit platforms at their disposal, they were natural community leaders. But a growing denominationalism, an increase in clerical itineracy, the diffusion of information and a growing intellectual isolation weakened their influence. Laymen turned to lawyers, merchants, politicians and the popular press for cultural counsel. Ministers had taken stands against popular literature and the arts for so long and were so closely associated with antipathy to theaters and the opera that many assumed hostility would be their only response to the new American arts.

In the middle third of the century, however, new types of ministers ascended American pulpits, particularly among Episcopalians, Congregationalists and Unitarians. Cultivated men of the world, liberally educated in European philosophy, they were determined not to return to isolation, but were intent upon reclaiming ancient dignities by coping with the problems of community recreation and social leadership. With their university educations, urban culture and fashionable congregations, this ministerial elite enjoyed many advantages. Congregations happily granted them the means and leisure to travel extensively, and their travel writings suggested their new sympathy for visual manipulation and sensory control. They discovered new means of stimulating religious conviction and conservative social behavior. Accustomed to intensive reading and extensive writing, they formed a natural corps of lecturers, eager to spread news of the nation's cultural achievements and the relationship between taste and morals. Daily and hourly clergymen spoke out on painting, poetry, sculpture, commerce, education or international relations. Periodicals and pamphlets perpetuated their speeches for posterity and circulated them to their countrymen.

With their pedagogical bias the clerical lecturers headed

for schools like New York's School of Design for Women. Within twelve months E. H. Chapin, T. Starr King and Henry Ward Beecher all spoke there. George W. Bethune discussed "Art in the United States" for the *Home Book of the Picturesque,* while the Reverend E. L. Magoon wrote on "The Religious Uses of Music" for the *Southern Literary Messenger.* Frederic Hedge, Samuel Osgood and W. R. Alger addressed Bostonians on subjects like "Life as a Fine Art" and "Christian Art in its Relation to Protestantism."[34] This lecturing grew so pervasive that *The Crayon* felt a modest protest was necessary. Since clergymen were "requested to lecture on everything," audiences interested in art should seek other authorities. Frequently, ministers were insufficiently familiar with the art world to do a creditable job; the editors suggested themselves as possible substitutes.[35]

But ignorance could not stop the clergy; there were simply too many opportunities to speak. The eulogies and biographies, the solemn ceremonies like the openings of art exhibitions and museums, the endless invocations and benedictions at banquets and dedications, were all occasions for expressing aesthetic opinions. Many ministers seized these opportunities to praise cultural philanthropy as a promising alternative to dangerous amusements and an engine to retard the vulgar influences of materialism. The *nouveaux riches* became a particular target— those wealthy adventurers who lacked "the education which teaches the better value of money."[36] Their ostentation, their "glaring furniture" and their ceaseless yearning for fine clothes and fancy balls threatened their sanity, the health of their families and the welfare of the community. Ministers saw in the spread of good taste and sound architecture a means of strengthening important institutions which seemed in peril.[37] Like Downing and his literary friends, they believed that the "happiest place in the world for young people ought to be their own home," and this meant providing beauty and amusement.[38] Juvenile depravity would increase, readers and listeners were told, if more energy were not directed toward enhancing home associations.

Their professional goals allowed clergymen to associate with artists without losing prestige or dignity; this activity was justified on the same missionary grounds that ministers interested in social work would use in later decades.[39] Orville Dewey and

W. R. Alger attended the artistic receptions in Dodsworth's Buildings. Many of them dropped in at the studios, and were active in the management of art unions; Bellows, Chapin, Charles Hackley, Cyrus Mason and George Potts were all honorary members of the National Academy. Clergymen abounded at Fletcher Harper's informal Monday-night dinners, along with artists and writers, while men like Henry Ward Beecher, Henry Bellows, O. B. Frothingham and E. H. Chapin were constant in their attendance at the salon of the Cary sisters.[40] Bellows and Orville Dewey even became founders of The Century.

Some ministers went further still. "We may find, today, in any eastern city," the *Atlantic* wrote complacently in 1860, "members of the liberal clergy at an opera, and sometimes at a play."[41] Henry Bellows even invited W. M. Thackeray to lecture on "Hogarth, Smollett and Fielding" at his Broadway church.[42] John Steinforth Kidney, an Episcopalian minister, was a good friend of Thomas Cole's and served as an honorary secretary for the American Art-Union; the Reverend William Ware of Augusta, Maine, appeared at an artist's resort to spend his vacation, a volume of Ruskin's *Modern Painters* tucked under his arm. Some ministers purchased art extensively. The Reverend Gorham Abbott adorned his girls' school with the work of famous native painters, while E. L. Magoon's holdings of native art formed one of the most important collections in New York. As a Baptist minister, Magoon ran some risk in associating himself with the art world. "His taste and high culture" did not aid his career, Matthew Hale Smith pointed out.[43]

Magoon's denomination was not well represented among the clerical patrons. Bartol, Bellows, Hedge and Osgood were all Harvard Divinity School graduates; Orville Dewey attended Andover, but he soon became a Unitarian. While he was studying at Harvard, Christopher Pearse Cranch heard lectures by James Freeman Clarke, Dewey, Bellows, William Henry Channing and Ezra Stiles Gannett, art publicists and good Unitarians all. There were also several Presbyterian art supporters, notably two graduates of the Princeton Theological Seminary, George Bethune and Edward N. Kirk.

Clerical art interest was generated by many motives. Con-

cern for the morals of the wealthy, the men who set the tone
for the rest of society, was an immediate stimulus. Henry
Ward Beecher approved of collecting and fine architecture be-
cause the "power of mind at *the top of society* will determine
the ease and rapidity of the ascent of the bottom."[44] Others
made a philosophical commitment to artistic expression as an
approximation of divinity. Some ministers, caught in the rigors
of an occupation that could be as deadening as law or com-
merce, found release consorting with artists whose lives obeyed
different and less regular rhythms. Others discovered in art
history a secular means of continuing interests developed in
the university, and they delighted in the publicity and exotic
overtones which participation in art society brought. A few of
these clerics were wealthy and substantial; George W. Bethune
was of the "British Bishop order—that sort of bishop . . . who
used to hold a fat diocese and dispense divinity in lawn sleeves."[45]
Occasionally, as in the family of the Reverend William H.
Furness, a Philadelphia Unitarian, a minister's children be-
came artists, while disappointed ministers like Jared Bradley
Flagg chose an art career as a substitute, or disappointed artists,
like W. J. Bolton, became ministers.[46] So closely tied did the
professions seem—in purpose and function—that migration from
one to the other was easy and natural.

Whatever their motives, clerical publicists supported the
conservative, successful artists, and favored the institutionaliza-
tion of the artistic impulse. They devised arguments for gal-
leries, museums and academies which bore the same implica-
tions of social control that lay patrons stressed. Frederick Sawyer,
like others of his generation, quoted with approval the old
maxim, "Give me the making of a people's songs and I care
not who makes their laws."[47] Religion, art, labor and amuse-
ment were "only means to an end, designed to make us devout,
grateful, contented and happy."[48] Edward Everett Hale sug-
gested that towns appoint committees on public amusements, re-
sponsible for concerts, dances and all other entertainments.
"Let the law of the State take that ground, that the public
ought to provide public entertainment and oversee it just as it
provides public education and oversees it."[49] By making town
officers liable for damages if lascivious entertainment appeared,
Hale hoped to stop profitable immorality. He approved of

ancient Athens, where "the government always took the position of the father of a family, who 'chooses to know where his children are.' "[50] The need for these instruments of control was demonstrated by the increasing factionalism and heterogeneity of the native population. The New England village, with more people, wealth and knowledge than ever before, saw vice and crime increasing.

> Where there ought to be brotherly love, there is nothing but strife. Where there ought to be a band of Christians worshipping one God, in peace and unity, the stranger and traveller shall look down on a village, torn with religious dissensions; with one schoolhouse, no library, no reading-room, no hospital . . . no museum, no . . . rural games or sports, no Mayday festivities . . . no public garden, no public walks or promenades, no riding school, no gallery of art.[51]

Nothing, in short, to recreate the community, in all the senses of the word. In its place were grogshops, hotels and barren meeting houses.

The complex arguments concerning art as a social contrivance and an artifice appropriate for conservative social and religious purposes were nowhere better discussed than in Henry Ward Beecher's one foray into fiction, his post-Civil War novel, *Norwood*. Though written a decade after most of these other comments, Beecher's novel was fully representative of the antebellum debate, and it focused on the value of artistic energy. Beecher's remarks directly concerned the capture of the senses by government and religion, and he approved of their exploitation.

His protagonist, Dr. Wentworth, observes that in Europe, amusements were "the bribes which governments threw to the people for their political rights. Fiddles were cheaper than ballot boxes."[52] Reacting against that pattern, New England Puritans turned their backs on all amusements, which they considered inconsistent with human freedom. Throughout the book Dr. Wentworth argues for adornment, for trees and gardens, handsome homes, patriotic monuments and exciting college commencements as legitimate means of introducing variety and excitement into ordinary life.

As a Protestant clergyman, however, Beecher still shied away from certain forms. A friend, Judge Bacon, describes his wondrous experiences in York Minster—"the same thing befell me on the first time that I stood at Niagara." But when Bacon speaks of the benefits that the spread of Romanism would bring to America in the form of its magnificent cathedrals, Dr. Wentworth disagrees. Institutions, customs, architectural forms, were "the outworking of the inward spirit of an Age." When that spirit dies, it is vain to try to reproduce it. "We might as well attempt to bring back ancient manuscripts . . . instead of printed books. . . . It is this very blunder that they commit who attempt to reproduce the art-spirit of a period long gone by, by copying its dead forms."[53] Wentworth's objection is not merely one of expediency; after admitting that the old cathedrals would soon lose their effect, he defends the Puritan impulse for its very austerity. "Elsewhere, cathedrals, festive days, and gorgeous ceremonies sustained men's belief. It is hardly possible to make barrenness more bare of all appliances for the senses than was New England. Yet there arose in the popular mind a vast and stately system of truth."[54]

But when asked if he believes in mass religious awakenings, Wentworth replies affirmatively. It was not a legitimate objection to say these things were "got up." "Is not education 'got up,'" Wentworth argues. "Is not art culture 'got up'? . . . Why should men be afraid to speak of moral states as the result of deliberate and intentional effort? Why should not men apply the term education to moral faculties as well as to others? and study for moral results as they do for social or esthetic? Are not the moral sentiments subject to laws as much as any other parts of the mind?"[55] Truths were not perceived until they aroused a whole community and received "the force of a glowing enthusiasm. Not only is the power of a truth thus disclosed, but a community is knit together."[56] There was no shame in arranging for such public improvements.

Art was, then, an instrument of unification, reconciliation, education and control. The artist was simply another sort of minister; indeed Wentworth asks a young artist who doubts his own ability not to enter the Church's service, but to remain an artist: "You can seek the moral benefit of society by your art, as really as by sermons, and probably with far greater success.

. . . your profession is, Christianly considered, the education of the community by the ministration of Beauty."[57]

Here was the ultimate tribute to the artist, to his ability to perform a legitimate, republican function in aiding the governors of the state to promote virtue and oppose vice. Utility was not opposed to the cause of the arts; it furthered and justified them. In a slightly more vulgarizing fashion, Henry W. Bellows pronounced the same theme; truth, liberty, learning, art, piety, they all have an economic value. Is it "a flaw in the title of Religion, that she is the cheapest police, as well as the most priceless possession of society. . . . Is poetry affronted when the public exchequer pensions genius and song for the patriotism they promote. . . . Faith, and heroism, literature and art, are worth money, and therefore there is no peril in resting their support on their practical value."[58]

And what of the artists? Were they disturbed by the justifications of Beecher and Bellows, contentions that art must ally itself with religion, must carry out certain social themes and ultimately prove itself by its material value to the community? They were bothered very little. The long history of dependency and indifference which had characterized the profession, coming to life by the 1840s partly because of the efforts of conservative and clerical patrons, made moral autonomy less important than physical independence. And even if the dynamics of professionalization are ignored in this instance, the views and commitments of most American artists disposed them to accept their moral role. Many painters and sculptors were men of orthodox and even intense religious piety. Thomas R. Gould, the sculptor, though he was bitter about formal Calvinism, asked God to "make and keep me pure," and help quell impulses toward vice and lechery.[59] George Loring Brown determined not to paint any more on the Sabbath; he wished to think of something beyond this earth.[60] Samuel Waldo expressed the same views.

Many artists insisted that art's mission was religious and that great artists had to be men of purity. An artist's success, said Thomas Cole, depended on his mental and moral habits. In words recalling the definition of a Puritan saint, Cole asserted that "an artist should be in the world, but not of it; its cares, its duties he must share with his contemporaries, but

he must keep an eye steadfastly fixed upon his polar star, and steer by it."[61] George Inness spoke of the "purity of the artist's motive in the pursuit of art." He admitted that no one's motive could be absolutely pure, for environment affected all men. *"But the true artistic impulse,"* he insisted, *"is divine."*[62] And Asher B. Durand, at the height of his professional greatness, contended that artists could not "serve God and mammon, however specious our garb of hypocrisy; and I would sooner look for figs on thistles than for the higher attributes of Art from one whose ruling motive in its pursuit is money." This servility was only slightly worse than art's prostitution merely for the "sensuous gratification of the eye." Color, form, designs, could all be manipulated for theatrical effect, and reduce the canvas to but empty decoration. "But, fortunately for Art, such is not its true purpose, and it is only through the religious integrity of motive by which all real Artists have ever been activated," that its great influence on mankind could be maintained.[63]

With its eager acceptance of the notions of its clergymen backers, America's artist community seemed securely established on the eve of the Civil War. It had done well in the seventy years since Independence. At least a dozen American cities boasted of galleries and associations; collectors extended patronage from coast to coast; successful artists enjoyed public respect, while professional organizations achieved national recognition. Whole schools of landscape painters and portraitists had developed, while troops of sculptors competed in Italy with the best neoclassicists of Europe. Every artistic center of the Western world contained American artists who presented American history to a world audience. Merchants and industrialists vied with the titled aristocracy of Europe for the purchase of contemporary art.

On a spiritual level, art had been legitimized to an extent incomprehensible to the Revolutionary generation. In that period of war and crisis the pursuit of art was condemned as wasteful, vain and enervating, using up scarce supplies of money, diverting energy from more appropriate tasks and effeminizing and emasculating the population. But art's final tribute came at the height of America's greatest crisis of the nineteenth century, the Civil War. In the midst of the conflict,

with the human and financial costs of the war staggering citizens in all sections, so hardheaded and conservative a figure as Henry Bellows announced that he "rejoiced" to see "works of luxury, of peace, and of beauty going on in a time of civil war." Art asserted the "irrepressible nature" of American civilization, and perhaps implied its ultimate redemption.[64] If he had a fortune to give away, said Bellows in this time of calamity, he would establish "not a hospital, nor a school, nor a church— but a band of music, of the highest and purest character, whose sole function should be to play in the Central Park a certain number of hours of every day in the year." Beauty, which could refine "even Religion itself," would harmonize and unite the factions of the nation.[65] James Jackson Jarves not only promoted the cause of art during the war, he also suggested that previous indifference was partly responsible for the carnage itself. "We are justly suffering for preferring commercial gains to justice, the meaner to the nobler motive. . . . We deliberately built on sand, while stone was ready to our use!"[66]

But this bright and promising situation had much more meaning for successful artists than for unknowns. The favorable conditions for art in the 1850s disguised a tightening of opportunities for the younger artists, and a set of circumstances which often became desperate. The growth of visual reproduction had educated the population to a level that would not allow tolerance for the bumbling, immature efforts of beginners, as it had in decades past. The prospects of support through itineracy and the gathering of a cache of capital for European study were much dimmer than they had been. Moreover, the glut that art-union patronage had called forth left young artists without immediate sources of income after the breakup of these institutions. There was no one to whom artists like L. R. Jacobs of Bath, Pennsylvania, might turn.

> I am one of the young Artists and want to no if there is any chance for me to be benefited by your society. I am one that Has not any Instruction from No One. Not in the Least. . . . Nature has bin my principle Guide.[67]

Young painters like Robert Newman of Tennessee were still inspired by Cunningham's *Painters and Sculptors*, as generations of predecessors had been, but without money they felt "a

cold chill . . . a sensation akin to fear," as they thought of their future careers.[68] Photography was an additional menace to the poorly trained portraitist.

Ironically enough, the growth of private fortunes hurt young American artists, though not their more famous colleagues. The Philadelphia pattern of preferring fashionable European art to American work spread quickly after the Civil War, even to New York City. Greater reliance on art importers and collecting for fashion replaced the earlier search for local talent and the excitement of personal discovery. The reflected glory of accepted masterpieces was more attractive than the uncertainty of unknowns. Businessmen and financiers borrowed the fame of established artists for moral and social support. This reversed the older dependency relationship, when young artists had leaned on merchants for social status. Patrons of the Gilded Age aroused the contempt of satirists and art lovers who condemned their vulgar extravagances and crude taste.[69]

In the deepest sense, art's ultimate legitimization—its ability to exist without one—was never achieved in nineteenth-century America. Despite—and because of—appeals of clergymen, conservative ideologues and fervent moralizers, the arts remained tied "to the aid of necessity."[70] Necessity was no longer the existence of a national state, as it had been in the late eighteenth century; it had become a larger, more ambiguous and more diffuse ideal, a moral community unmarred by crime and vice, where citizens learned the restrained virtue appropriate to a great republic. The accomplishments demanded of American designers were so great that their achievement could never succeed on these terms. Art did become a part of national life, but as one of many mercenary agents on an errand of moralizing. The quest to institutionalize creativity and perpetuate spontaneity, to gauge and justify the levels of artistic productivity just as industry and commerce were measured statistically, was doomed from the start. As patronage became a masque in which hopes, fears and ambitions played out appointed parts, it became the object of suspicion by masses not fortunate enough to enjoy the luxury of such idealizing.

To say all this is not to accuse wealthy art lovers or enthusiastic ministers of dishonesty or fraud. Many were devoted and sincere. The protectors of a cultivated tradition

shared the vitality of their dreams with adherents of a national vernacular. And on many levels the gains were impressive and substantial. The energy of the American artist community testified to that. But the early need to legitimize impaired the actual performance; the American artist would be left with the conviction of things undone and goals unrealized. Before the Civil War this disillusionment was rare; artists and patrons shared the same ideals and were optimistic about their achievements, past and future. But a later generaton would feel embarrassment and guilt for the awe-inspiring naïveté of this native school. The result was an aversion to remobilizing the high hopes which had been doomed to oblivion and disappointment. Such disillusionment is not a part of this narrative and must be continued at another time. But it would be wrong to end this success story without a hint of the failures to come. The costs of professionalization and legitimacy were high in a democratic society, even if hidden. The artistic enterprise would bear perpetual reminders of this condition.

Selected Bibliography

Bibliographic comments on special subjects are scattered throughout the notes. What I should like to indicate here are some sources from which I benefited and which should be helpful to those interested in pursuing further the history of American art. A complete list of sources is on file with my dissertation, "The Artistic Enterprise in America, 1790–1860," at the Widener Library, Harvard University.

Though they did not form the basis of my research, manuscript collections offered invaluable assistance to my formulation of the problem, and provided documentation for many of my arguments. The autograph collections formed by Americans of the late nineteenth and early twentieth centuries were particularly fruitful. The Archives of American Art in Detroit, now engaged in filming, gathering and generally centralizing these collections for the use of interested scholars, is performing a great service. Where I have viewed microfilms of manuscript collections, I have so indicated.

Following the Bibliography, in the Notes section, brackets [] are used where the author's name did not appear in the original publication; they are also used to indicate copyright dates where not printed.

Abbreviations used in the Notes section are as follows:

AAA Archives of American Art
BPL Boston Public Library
HSP Historical Society of Pennsylvania
MHS Massachusetts Historical Society
NYHS New-York Historical Society
NYPL New York Public Library

American Art-Union Papers and Clipping Book. New York Historical Society.

Artists' Fund Society Minute Books. Historical Society of Pennsylvania.

George Loring Brown Account Book. Boston Museum of Fine Arts.

Bryant-Godwin Papers. New York Public Library.

Chamberlain Collection. Boston Public Library.

Thomas Cole Papers. New York State Library, Albany; Archives of American Art, Detroit. Photostatic copies in the New York Historical Society.

Clarence Cook Papers. New York Public Library. Microfilms in the Archives of American Art.

Thomas Crawford Papers. Archives of American Art.

Dreer Collection of American Artists. Historical Society of Pennsylvania.

Asher Brown Durand Papers. New York Public Library.

The Diary of George Durrie. Archives of American Art.

Albert Duveen Autograph Collection. Archives of American Art.

Charles E. Feinberg Autograph Collection. Archives of American Art.

Sanford Robinson Gifford Papers. Archives of American Art.

Thomas R. Gould Journal and Memoranda Book. Houghton Library, Harvard University.

Robert Graham Autograph Collection. Archives of American Art.

Gratz Collection. Historical Society of Pennsylvania.

History of Art Manuscripts. Archives of American Art.

Huntington Manuscripts. New York Historical Society.

Miner Kilbourne Kellogg Papers. Archives of American Art.

Lewis-Neilson Papers. Historical Society of Pennsylvania.

James B. Longacre Papers. Library Company of Philadelphia. Microfilms in Archives of American Art.

The Diary of Jervis McEntee. Archives of American Art.

William Sidney Mount Papers. New York Historical Society.

New York Public Library Art Division Files.

New York Public Library Miscellaneous File and Art Boxes.

John Neagle. Bound Pamphlets and Reprints. Historical Society of Pennsylvania. Microfilms in Archives of American Art.

Louis L. Noble Manuscripts. New York Historical Society.

Willam Page Papers. Archives of American Art.

Pennsylvania Academy of the Fine Arts Minute Books. Historical Society of Pennsylvania.

Pennsylvania Academy of the Fine Arts Records. Pennsylvania Academy of the Fine Arts. Microfilms in Archives of American Art.

Charles Roberts Autograph Collection. Haverford College Library. Microfilms in Archives of American Art.

Sartain Family Papers. Historical Society of Pennsylvania.

The Diary of Joseph Sill. Historical Society of Pennsylvania. Microfilms in Archives of American Art.

Thomas Sully Journal. Historical Society of Pennsylvania.

John Ferguson Weir Papers. Archives of American Art.

Claude W. Unger Collection. Historical Society of Pennsylvania.

Those interested in discovering more comprehensive listings of sources in American art history can turn to a number of bibliographies. One of the most complete can be found in George C. Groce and David E. Wallace, *The New-York Historical Society's Dictionary of Artists in America, 1564–1860* (New Haven, 1957). An older but still useful bibliography was compiled by Frank H. Chase for William Dunlap, *A History of the Rise and Progress of the Arts of Design in the United States*, Frank W. Bayley and E. Goodspeed (eds.) (Boston, 1918), III, pp. 346–377. Mary W. Chamberlin, *Guide to Art Reference Books* (Chicago, 1959), is also helpful. For the period before 1820 the bibliography by Wendell D. Garrett and Jane N. Garrett in Walter Muir Whitehill, *The Arts in Early American History, Needs and Opportunities for Study* (Chapel Hill, 1965), is a model of its kind, annotated with perception and discrimination. For architectural history Sarah H. J. Simpson Hamlin, "Some Articles of Architectural Interest Published in American Periodicals Prior to 1851," Talbot Hamlin, *Greek Revival Architecture in America* (New York, 1944), pp. 356–409, is suggestive. Finally, *The Art Index*, published serially since 1929, contains the most complete guide to recent scholarly contributions in all phases of art history.

Biographical encyclopedias have been indispensable for this work, and without the Groce and Wallace *Dictionary* I would have been lost indeed. The classic *History* by William Dunlap, and Henry T. Tuckerman, *Book of the Artists. American Artist Life* (New York, 1867), were both invaluable. Ulrich Thieme and Felix Becker, *Allgemeines Lexikon Der Bildenden Kunstler von der Antike Bis Zur Gegenwart* (Leipzig, 1907–1950), 38 vols., retains importance. For the identification of patrons and artist friends I have relied on standard works like Allan Johnson and Dumas Malone (eds.), *Dictionary of American Biography* (New York, 1928–1936), 20 vols.; James Grant Wilson and John Fiske (eds.), *Appleton's Cyclopaedia of American Biography* (New York, 1887–1918), 8 vols.; and *The National Cyclopedia of American Biography* (New York, 1898–1906), vols. I–XIII. State and local cyclopedias like *The Biographical Encyclopedia of Pennsylvania of the Nineteenth Century* (Philadelphia, 1874), provided unexpected mines of information.

The writings of nineteenth-century artists and writers were basic

to my study. A number of modern, annotated editions of their efforts have been published in the last few years; some of them were particularly helpful, and among them I include James Jackson Jarves, *The Art-Idea*, Benjamin Rowland, Jr. (ed.) (Cambridge, Mass., 1960); Louis Legrand Noble, *The Life and Works of Thomas Cole*, Elliot S. Vessell (ed.) (Cambridge, Mass., 1964); Horatio Greenough, *Form and Function: Remarks on Art*, Harold A. Small (ed.), (Berkeley, 1947); Horatio Greenough, *The Travels, Observations, and Experiences of a Yankee Stonecutter* (New York, 1852, reprinted Gainesville, Fla, 1958); *Observations on American Art, Selections from the Writings of John Neal (1793–1876)*, Harold Edward Dickson (ed.), *Pennsylvania College Studies*, XII (State College, 1943); *The Autobiography of Colonel John Trumbull, Patriot-Artist, 1756–1843*, Theodore Sizer (ed.), (New Haven, 1953). Forthcoming republication of selected works of Andrew Jackson Downing and Frederick Law Olmsted by the Harvard University Press and the Cornell University Press respectively will meet further needs. Many journals and correspondence collections have been published in serial form by state or local historical societies. These are referred to in the notes, but among the most interesting are "Letters of Hiram Powers to Nicholas Longworth, Esq., 1856–8," *Quarterly Publications of the Historical Society of Ohio*, I (April–June, 1906), pp. 33–59; "The Recollections of John Ferguson Weir," Theodore Sizer (ed.), *The New York Historical Society Bulletin*, XLI (April, July, October, 1957), pp. 109–141, 351–375, 459–482; "The Journal of John Blake White," Paul R. Weidner (ed.), *South Carolina Historical and Genealogical Magazine*, XLII (1941), pp. 55–71, 99–117, 169–186, XLIII (1942), pp. 34–46, 103–117, 161–174; and "The Autobiography of Worthington Whittredge," John I. H. Baur (ed.), *Brooklyn Museum Journal*, I (1942), pp. 5–68. The outstanding collection of original sources gathered by Charles L. Sanford, *Quest for America, 1810–1824* (Garden City, 1964), represents a perceptive effort to integrate art documents into a larger historical setting. Those interested in looking at older, non-annotated artist recollections will find especially fascinating Thomas Ball, *My Threescore Years and Ten, An Autobiography* (Boston, 1891); Seth Eyland (pseud. for David E. Cronin) *The Evolution of a Life* (New York, 1884); *Selections from the works of the late Sylvester Genin, Esq., in Poetry, Prose and Historical Design* (New York, 1855); Chester Harding, *My Egotistigraphy* (Cambridge, Mass., 1866); G. P. A. Healy, *Reminiscences of a Portrait Painter* (Chicago, 1894); John Sartain, *The Reminiscences of a Very Old Man, 1818–1897* (New York, 1899); William J. Stillman, *The Autobiography of a Journalist* (London, 1901), 2 vols.; and Elihu Vedder, *The Digressions of V.* (Boston, 1910). Two old letter collec-

tions, Jared B. Flagg, *The Life and Letters of Washington Allston* (New York, 1892); and *Samuel F. B. Morse, His Letters and Journals,* Edward Lind Morse (ed.) (Boston, 1914), 2 vols., are filled with illuminating information about artistic aspirations.

The recollections of artist friends and interested amateurs are also vital to an understanding of the nature of these nineteenth-century communities. The splendid editions of *The Diary of Philip Hone, 1828–1851,* Allan Nevins (ed.), (New York, 1927), 2 vols.; and *The Diary of George Templeton Strong,* Allan Nevins and Milton Halsey Thomas (eds.), (New York, 1952), 4 vols., make one hope that The Diary of Joseph Sill, currently in manuscript at the Historical Society of Pennsylvania, and "The Diaries of Sidney George Fisher," reprinted in recent issues of the *Pennsylvania Magazine of History and Biography,* will also be republished in book form, and allow cultivated Philadelphians an equal voice with nineteenth-century New Yorkers.

Nineteenth-century periodicals form still another great pool of information about art attitudes and professional achievements. For the early part of the century I relied heavily on the *Port Folio,* published in Philadelphia, and *The Monthly Anthology,* published in Boston. Extracts from this latter periodical are conveniently arranged in Lewis P. Simpson, ed., *The Federalist Literary Mind. Selections from The Monthly Anthology and Boston Review, 1803–1811* ([Baton Rouge] 1962). For a somewhat later period *The Christian Examiner, The Knickerbocker, The Literary World, The New York Mirror, The North American Review, Putnam's Monthly Magazine, Sartain's Union Magazine* and *The United States Magazine and Democratic Review,* all contain articles of interest on artistic matters. And, of course, both *The Cosmopolitan Art Journal* and *The Crayon* are vital sources.

The student of American art also has available a great variety of secondary sources. These are of uneven quality and often reflect more narrow antiquarian interests, or else suffer from a popularizing spirit which either sentimentalizes or boosts. Among the most valuable secondary accounts are James Thomas Flexner, *That Wilder Image: The Painting of America's Native School from Thomas Cole to Winslow Homer* (Boston, 1962); Albert Ten Eyck Gardner, *Yankee Stonecutters, The First American School of Sculpture, 1800–1850* (New York, 1945); Oskar Hagen, *The Birth of the American Tradition in Art* (New York, 1940); John A. Kouwenhoven, *Made in America, The Arts in Modern Civilization* (Garden City, 1962); Oliver W. Larkin, *Art and Life in America,* rev. ed. (New York, 1960); and Edgar P. Richardson, *Painting in America; The Story of 450 Years* (New York, 1956). All of these books contain informative bibliographies. American architecture can be studied in Wayne Andrews, *Architecture, Ambition and*

Americans, A Social History of American Architecture (New York, 1947); John Burchard and Albert Bush-Brown, *The Architecture of America* (Boston, 1961); Fiske Kimball, *American Architecture* (Indianapolis and New York, 1928); and Talbot Hamlin, *Greek Revival Architecture in America* (New York, 1944). Local historical journals like the *New England Quarterly, The New York Historical Society Quarterly, New York History,* and the *Pennsylvania Magazine of History and Biography* are filled with stimulating articles concerning local artists and art institutions. *The American Quarterly* has also consistently featured fine articles dealing with the social history of American art, while *The Art Quarterly* receives important contributions by art historians.

A growing group of scholarly biographies is bringing back to life a set of vibrant artist figures. Among the more interesting contributions have been Grose Evans, *Benjamin West and the Taste of His Times* (Carbondale, Ill., 1959); Talbot Hamlin, *Benjamin Henry Latrobe* (New York, 1955); Oliver W. Larkin, *Samuel F. B. Morse and American Democratic Art* (Boston, 1954); John Francis McDermott, *George Caleb Bingham, River Portraitist* (Norman, Okla., 1959); Robert L. Gale, *Thomas Crawford, American Sculptor* (Pittsburgh, 1964); Charles Merrill Mount, *Gilbert Stuart* (New York, 1964); Edgar P. Richardson, *Washington Allston, A Study of the Romantic Artist in America* (Chicago, 1948); Charles Coleman Sellers, *The Artist of the Revolution, The Early Life of Charles Willson Peale* (Hebron, Pa., 1939) and *Later Life of Charles Willson Peale (1790–1827)* (Philadelphia, 1947); Joshua C. Taylor, *William Page, The American Titian* (Chicago, 1957); and Nathalia Wright, *Horatio Greenough, The First American Sculptor* (Philadelphia, 1963). Despite this research, much remains to be done. Thomas Cole, Albert Bierstadt, Hiram Powers, Asher B. Durand, Worthington Whittredge, Thomas Sully and John Sartain, to name but a few, are still major artists who lack full-length modern biographies.

American art institutions and patronage have been still less adequately served. The major study of American patronage remains the outdated René Brimo, *L'Évolution du Goût aux États-Unis* (Paris, 1938) which, since nothing has yet replaced it, deserves at least translation and annotation. W. G. Constable, *Art Collecting in the United States of America: An Outline of a History* (Toronto and New York, 1964), is helpful, though too brief. Russell Lynes, *The Tastemakers* (New York, 1949), and Aline B. Saarinen, *The Proud Possessors; The Lives, Times and Tastes of Some Adventurous American Art Collectors* (New York [1958]), are also helpful contributions. Beyond that are a few biographies of collectors, but the ante-bellum patrons have not re-

ceived very much attention. There are, however, a few valuable institutional histories. Eliot Clark, *History of the National Academy of
Design, 1825–1953* (New York, 1954); Helen W. Henderson, *The
Pennsylvania Academy of the Fine Arts* (Boston, 1911); Winifred W.
Howe, *A History of the Metropolitan Museum of Art* (New York,
1913), 2 vols.; and Mabel Munson Swan, *The Athenaeum Gallery,
1827–1873. The Boston Athenaeum as an Early Patron of Art* (Boston,
1940). The essays and catalogue records to be found in three major
works, Mary Bartlett Cowdrey (ed.), *American Academy of Fine Arts
and American Art-Union* (New York, 1953), 2 vols.; Mary Bartlett
Cowdrey (ed.), *National Academy of Design, Exhibition Record, 1826–
1860* (New York, 1943), 2 vols.; and Anna Wells Rutledge (ed.), *The
Pennsylvania Academy of the Fine Arts, 1807–1870. Cumulative Record
of Exhibition Catalogues* (Philadelphia, 1955), are superb sources for
both American art and social history.

Students of American art history can also turn to European works
to gain insights into ways of treating the social history of art. Although
they are of uneven quality, the following studies may prove of value:
Malcolm Eaton, *Artists and Writers in Paris, The Bohemian Idea,
1803–1867* (New York, 1964); Francis Haskell, *Patrons and Painters;
A Study in the Relations between Italian Art and Society in the Age
of the Baroque* (London, 1963); Arnold Hauser, *The Social History of
Art* (New York and London, 1951), 2 vols.; Barrington Kaye, *The
Development of the Architectural Profession in Britain, A Sociological
Study* (London, 1960); James A. Leith, *The Idea of Art as Propaganda
in France, 1750–1799. A Study in the History of Ideas* (Toronto, 1965);
A. P. Oppe, "Art," in G. M. Young (ed.), *Early Victorian England,
1830–1865* (London, 1934), II, pp. 99–176; Geraldine Pelles, *Art,
Artists and Society, Origins of a Modern Dilemma, Painting in England
and France, 1750–1850* (New York, 1963); Nikolaus Pevsner, *Academies
of Art, Past and Present* (Cambridge, Eng., 1940); Helen Rosenau, *The
Ideal City in its Architectural Evolution* (London, 1959); Maurice Z.
Shroder, *Icarus, The Image of the Artist in French Romanticism* (Cambridge, Mass., 1961); John Summerson, *Heavenly Mansions* (New
York, 1963); Raymond Williams, *Culture and Society 1780–1950* (London, 1958); and Rudolf and Margot Wittkower, *Born Under Saturn,
The Character and Conduct of Artists: A Documented History from
Antiquity to the French Revolution* (New York, 1963). For those with
particular interest in the psychology of art, I recommend looking at
three books: Zevedei Barbu, *Problems of Historical Psychology* (London, 1960); E. H. Gombrich, *Art and Illusion, a Study in the Psychology of Pictorial Representation* (Washington, 1960); and Ernst Kris,
Psychoanalytic Explorations in Art (London, 1953). Gombrich's notes,

pp. 399–439, and his bibliography, pp. 440–441, contain many further references.

Ultimately, the success of American art historians must depend on their imaginative use of materials, and no bibliography by itself can indicate the directions of such research. However, no matter what form such efforts do take, they must integrate with more technical concerns the frames of reference our cultural and intellectual historians of the last two decades have developed. I have benefited greatly from reading many of these books, and I should like to pay my tribute along with the many they have—or will have—received from other students of American history. They include Millicent Bell, *Hawthorne's View of the Artist* (State University of New York, 1962); Hans Huth, *Nature and the American, Three Centuries of Changing Attitudes* (Berkeley, 1957); Howard Mumford Jones, *O Strange New World, American Culture: The Formative Years* (New York, 1964); R. W. B. Lewis, *The American Adam, Innocence, Tragedy, and Tradition in the Nineteenth Century* (Chicago, 1955); F. O. Matthiessen, *American Renaissance, Art and Expression in the Age of Emerson and Whitman* (London, Toronto, New York, 1941); the works of Perry Miller, most notably three seminal essays, "The Rhetoric of Sensation," "From Edwards to Emerson," and "Nature and the National Ego," published in *Errand Into the Wilderness* (Cambridge, Mass., 1956); Charles L. Sanford, *The Quest for Paradise, Europe and the American Moral Imagination* (Urbana, Ill., 1961); and Benjamin T. Spencer, *The Quest for Nationality* (Syracuse, 1957).

Notes

1 To the Aid of Necessity

1. For a comment on Jacques Le Moyne, creator of the Hellenistic Indians, see James Thomas Flexner, *American Painting: First Flowers of our Wilderness* (Boston, 1947), pp. 3–4. For a more extended discussion of these distortions see Howard Mumford Jones, *O Strange New World, American Culture: The Formative Years* (New York, 1964), pp. 27–32.

2. See Marian W. Smith (ed.), *The Artist in Tribal Society, Proceedings of a Symposium held at the Royal Anthropological Institute* (New York, 1961), *passim*, but especially pp. 3–4, 85–86, and the general bibliography, pp. 137–138.

3. Fiske Kimball, *American Architecture* (Indianapolis and New York, 1928), p. 18, contains a pertinent discussion of Colonial attempts to re-create the physical environment they left behind.

4. For example, John Evelyn, quoted in B. Sprague Allen, *Tides in English Taste (1619–1800)* (Cambridge, Eng., 1937), I, pp. 35–36.

5. See G. P. V. Akrigg, *Jacobean Pageantry, or The Court of King James I* (London, 1962), chap. XXII.

6. Peter Paul Rubens to Pierre Dupuy, London, August 8, 1629, *The Letters of Peter Paul Rubens,* Ruth Saunders Magurn (trans. and ed.) (Cambridge, Mass., 1955), p. 320.

7. Information on the status of artists in England and the patronage granted foreigners can be found in Ellis Waterhouse, *Painting in Britain, 1530–1790* (London, 1962), *passim;* and Margaret Whinney and Oliver Millar, *English Art, 1625–1714* (Oxford, 1957), p. 81.

8. Quoted in Whinney and Millar, *English Art,* p. 353.

9. This was the remark of Sir Balthazar Gerbier, himself a purchasing agent. Quoted in Whinney and Millar, *English Art,* p. 53.

10. For Puritan attitudes toward art I have relied on Ralph Barton Perry, *Puritanism and Democracy* (New York, 1944), pp. 235–239; G. C. Coulton, *Art and the Reformation* (New York, 1928), *passim;* and Joseph Crouch, *Puritanism and Art; an Inquiry into a Popular Fallacy* (London and New York, 1910), *passim.* Carl N. Degler, *Out of Our Past, The Forces That Shaped Modern America* (New York, 1959), pp. 8–11, contains a sensible discussion for the general reader.

11. See Degler, *Out of Our Past,* p. 11.

12. Waterhouse, *Painting in Britain,* p. 54.

13. The best summary of this Spanish policy is found in Jean Charlot, *Mexican Art and the Royal Academy of San Carlos, 1785–1915* (Austin, 1962), *passim.*

14. Many English travelers commented on the extravagance of American fashions and design. For a typical example see [William Newnham

Blane] *An Excursion Through the United States and Canada* (London, 1824), p. 22.

15. Though Bishop Berkeley's words were repeated by John Singleton Copley. See Copley to John Greenwood, Boston, January 25, 1771, "Letters and Papers of John Singleton Copley and Henry Pelham, 1739–1776," *MHS Collections*, LXXI (1914), p. 105. For an interesting sidelight on this metaphorical tradition see Edwin Fussell, *Frontier: American Literature and the American West* (Princeton, 1965), pp. 5–7. And for an exception to this lack of interest see a 1730 poem quoted in Max Savelle, *Seeds of Liberty, The Genesis of the American Mind* (New York, 1948), pp. 439–440.

16. John Galt, *The Life, Studies and Works of Benjamin West* (London, 1820; Gainesville, Fla., 1960), pp. 29–30.

17. John Singleton Copley to Benjamin West or R. B. Bruce, n.p., n.d., "Letters of Copley and Pelham," pp. 65–66. Jules David Prown's splendid study, *John Singleton Copley* (Cambridge, Mass., 1966), unfortunately came to hand too late to be of assistance. It promises to be definitive.

18. Copley to John Greenwood, Boston, January 25, 1771, "Letters of Copley and Pelham," pp. 105–106.

19. Charles Carroll to Charles Willson Peale, n.p., October 29, 1767, quoted in Charles C. Sellers, *The Artist of the Revolution, The Early Life of Charles Willson Peale* (Hebron, Pa., 1939), p. 85.

20. Peale to John Beale Bordley, Philadelphia, November, 1772, quoted in Sellers, *Artist of the Revolution*, p. 91.

21. Peale to Benjamin Franklin, n.p., n.d., quoted in Sellers, *Artist of the Revolution*, p. 99.

22. These sentiments, and others like them, are quoted in John Pye, *Patronage of British Art, An Historical Sketch* (London, 1845), *passim*. Barry, Rouquet, Hogarth, Du Bos, all commented on "the strange inability of the English to produce their own artists." See the introduction to a 1754 translation of De Piles, quoted in Pye, p. 41.

23. Pye, *Patronage of British Art*, p. 4; Joseph Burke, *Hogarth and Reynolds, A Contrast in English Art Theory* (London, 1943), *passim*.

24. For Reynolds and for English neoclassic aesthetics I have relied on Walter Jackson Bate, *From Classic to Romantic. Premises of Taste in Eighteenth-Century England* (Cambridge, Mass., 1949).

25. So charged William Aglionby, as quoted in J. R. Hale, *England and the Italian Renaissance, The Growth of Interest in its History and Art* (London, 1954), p. 67.

26. These categories were often quite detailed. De Piles, in 1708, offered grades for evaluating artists in composition, design, coloring and expression; perfection under this system was eighteen. Jonathan Richardson urged his readers to keep a pocketbook for recording these figures. See Jonathan Richardson, "The Theory of Painting," *The*

Works of Jonathan Richardson (London, 1792), I, p. 123. Other categorizers included Bellori, Du Fresnoy and Fréart de Chambray.

27. Sir Joshua Reynolds, *Fifteen Discourses Delivered in the Royal Academy* (London, 1906, 1928), from the Ninth Discourse, p. 155.

28. Richardson foreshadowed this attitude in 1715, insisting that an accomplished painter know several liberal arts. "A Rafaelle, therefore, is not only equal, but superior to a Virgil, or a Livy, a Thucydides, or a Homer." Richardson, *Works*, I, p. 18.

29. Reynolds, *Discourses*, from the Fourth Discourse, p. 59.

30. "A history-painter paints man in general; a portrait-painter, a particular man, and consequently a defective model." Reynolds, *Discourses*, from the Fourth Discourse, p. 55. The Seventh Discourse states most concisely Reynolds' belief in the universal permanence of specified standards of taste. See particularly *Discourses*, p. 117.

31. For a description of Colonial holdings of architectural books, some of which concern neoclassical aesthetics, see Helen Park, "A List of Architectural Books Available in America before the Revolution," *Journal of the Society of Architectural Historians*, XX (Octtober, 1961), pp. 115–130.

32. See Lewis Einstein, *Divided Loyalties. Americans in England During the War of Independence* (Boston and New York, 1933), pp. 292–293.

33. Three articles in the *Journal of the Warburg and Courtauld Institutes* debate this achievement. See Edgar Wind, "The Revolution of History Painting," *Journal*, II (1938), pp. 116–126; Charles Mitchell, "Benjamin West's 'Death of General Wolfe' and the Popular History Piece," *Journal*, VII (1944), pp. 20–33; and Edgar Wind, "West and the 'Death of Wolfe,' " *Journal*, X (1947), pp. 159–162.

34. For Benjamin West, see Van Wyck Brooks, *The Dream of Arcadia; American Writers and Artists in Italy, 1760–1915* (New York, 1958), pp. 1–2.

35. John Singleton Copley to Benjamin West, Boston, November 24, 1770, "Letters of Copley and Pelham," p. 97.

36. See the discussion in Sellers, *Artist of the Revolution*, p. 195.

37. John Singleton Copley to Benjamin West, Boston, November 24, 1770, "Letters of Copley and Pelham," p. 98.

38. Ezra Stiles, Sermons on Thanksgivings, November 20, 1760, quoted in Edmund S. Morgan, *The Gentle Puritan, A Life of Ezra Stiles, 1727–1795* (New Haven and London, 1962), p. 214.

39. For a discussion of such comment see Daniel J. Boorstin, *The Americans: The National Experience* (New York, 1965), pp. 353–355.

40. John Burchard and Albert Bush-Brown, *The Architecture of America* (Boston, 1961), p. 67.

41. The best summary of this official architecture can be found in

Talbot Hamlin, *Greek Revival Architecture in America* (New York, 1944), *passim.*

42. Reprinted in Alfred Coxe Prime *The Arts and Crafts in Philadelphia, Maryland and South Carolina, 1721–1785. Gleaned from Newspapers,* 1st ser. (Philadelphia, 1929), p. 31.

43. Giuseppe Ceracchi, *National Monument, Ceracchi an Artist of Rome* . . . [Philadelphia, 1794].

44. Frank H. Sommer, "Emblem and Device: The Origin of the Great Seal of the United States," *Art Quarterly* XXIV (Spring, 1961), pp. 57–77.

45. Marquis de Chastellux, *Travels in North America in the Years 1780, 1781 and 1782,* Howard C. Rice, Jr. (trans. and ed.) (Chapel Hill, 1963), II, p. 545.

46. Count de Mirabeau, *Reflections on the Observations on the Importance of the French Revolution . . . by Richard Price* (Philadelphia, 1786), pp. 3, 18, as quoted in Wendell D. Garrett, "John Adams and the Limited Role of the Fine Arts," *Winterthur Portfolio,* I (1964), p. 245.

47. John Adams to Abigail Adams, Philadelphia, April 27, 1777, *The Adams Family Correspondence,* Lyman H. Butterfield (ed) (Cambridge, Mass., 1963–19—), II, p. 224. Also quoted in Garrett, "John Adams," p. 246.

48. See, for example, John Adams to Abigail Adams, Philadelphia, August 14, 1776, in *Adams Family Correspondence,* II, pp. 96–97. Quoted in Garrett, "John Adams," p. 246.

49. Charles Coleman Sellers, *Benjamin Franklin in Portraiture* (New Haven, 1962), pp. 120–140, offers a full discussion of this symbolism.

50. Colonel Humphreys, "A Poem on the Happiness of America," *American Museum,* I (March, 1787), p. 252.

51. Francis Haskell, *Patrons and Painters: A Study in the Relations between Italian Art and Society in the Age of the Baroque* (London, 1963), p. 7.

52. David Hume, *Essays and Treatises on Several Subjects* (Basil, 1793), I. p. 143.

53. Quoted in Pye, *Patronage of British Art,* p. 78.

54. James Barry, "On the History and Progress of the Arts," in Ralph N. Wornum (ed), *Lectures on Painting by the Royal Academicians, Barry, Opie and Fuseli* (London, 1848), p. 90.

55. *Monthly Anthology,* IV (May, 1807), p. 245. For more such sentiments see Arthur Maynard White, "A Wild African Sand Garden," *Monthly Anthology* (November, 1806), p. 579, reprinted in Lewis P. Simpson (ed.), *The Federalist Literary Mind, Selections from the Monthly Anthology and Boston Review, 1803–1811* ([Baton Rouge] 1962), p. 69.

56. Quoted in *Monthly Anthology, IV* (April, 1807), p. 216.

57. *American Museum,* I (March, 1787), p. 206.

58. *New York Gazetteer and Country Journal,* November 16, 1784, as quoted in William Kelby, *Notes on American Artists, 1754–1820, Compiled from Advertisements Appearing in the Newspapers of the Day* (New York, 1932), p. 22.

59. John Swanwick, "Poem on the Prospect of Seeing the Fine Arts Flourish in America," *American Museum,* II (December, 1787), p. 598.

60. *Port Folio,* VII (February, 1812), p. 143.

61. *New York Chronicle Express,* July 18, 1805, quoted in George Gates Raddin, Jr., *The New York of Hocquet Caritat and his Associates, 1797–1817* (New York, 1953), p. 54.

62. Quoted in Raddin, *The New York of Hocquet Caritat,* p. 45.

63. George Washington to Thomas Jefferson, Mount Vernon, August 1, 1786, *The Papers of Thomas Jefferson,* Julian P. Boyd (ed.) (Princeton, 1949–19—), X, p. 286.

64. Quoted in Thomas E. V. Smith, *The City of New York in the Year of Washington's Inauguration, 1789* (New York, 1889), p. 47. Moreover, manipulation of capitals was not new with Americans; Colbert and Le Brun attempted to make a French order in the seventeenth century. L'Enfant drew up the capitals with stars and stripes for New York's Federal Hall, while Latrobe designed the corncob capitals. See Louis Réau, *L'Art français aux États-Unis* (Paris, 1926), p. 13.

65. Calls for specific national art forms later in the century are numerous. Examples can be found in J. R. Tyson, *Address Delivered before the Washington Art Association* (Philadelphia, 1858); L. G. Ware, "The Study and Practice of Art in America," *The Christian Examiner,* LXXI (July, 1861), pp. 67–94; [G. F. Simmons] "Prospects of Art in this Country," *The Christian Examiner,* XXV (January, 1839), pp. 304–320.

66. See Allen Guttmann, "Copley, Peale, Trumbull: A Note on Loyalty," *American Quarterly,* XI (Summer, 1959), pp. 178–183.

67. For sentiments of this sort concerning poetry see *Port Folio,* 3rd ser., I (April, 1806), p. 207.

68. John Singleton Copley to Henry Pelham, Rome, March 14, 1775, "Letters of Copley and Pelham," p. 301.

2 *The Perils of Vision: Art, Luxury and Republicanism*

1. Thomas Paine, "Common Sense," *Life and Works of Thomas Paine* (New Rochelle, [1925]), II, p. 106.

2. James Madison, speaking during the debates on the Constitution, quoted in Paul Merrill Spurlin, *Montesquieu in America, 1760–1801* (Baton Rouge, 1940), pp. 261–262. For more American comments on this subject see Spurlin, pp. 223–257.

3. Thomas Paine, "The American Crisis," *Life and Works,* III, p. 242.

4. An orator speaking at Petersburg, Virginia, July 4, 1787, quoted in *American Museum,* II (November, 1787), p. 422.

5. For a discussion of this counterpoise theory, and an emphasis on the pessimism of the Founding Fathers, see Arthur O. Lovejoy, *Reflections on Human Nature* (Baltimore, 1961), pp. 37–65. I disagree with his contention that the Constitution makers relied solely on system to control human passions. Most Colonial leaders realized no institutional arrangements could rescue a totally depraved population.

6. Edward Wortley Montagu, *Reflections on the Rise and Fall of the Ancient Republicks* (London, 1760), p. 125. For more on Montagu, and American readings of history, see Bernard Bailyn (ed.), *Pamphlets of the American Revolution, 1750–1776* (Cambridge, Mass., 1965–19—), I, pp. 20–85. Howard Mumford Jones, *O Strange New World, American Culture: The Formative Years* (New York, 1964), pp. 247–250, and notes 23–26, pp. 429–430, establishes the classical lineage of the fear of luxury.

7. Charles Louis de Secondat, Baron de la Brède et de Montesquieu, *The Spirit of Laws* (Worcester, 1802), vol. I, bks. II, VII, VIII.

8. Antoine-François Rigaud, *Morceaux Choisis de Duclos* (Paris, 1810), I, p. 151.

9. Richard Price to Thomas Jefferson, Newington Green, March 21, 1785, *The Papers of Thomas Jefferson,* Julian P. Boyd (ed.) (Princeton, 1949–19—), VIII, p. 53.

10. Elizabeth Trist to Jefferson, Philadelphia, July 24, 1786, *Papers of Jefferson* X, p. 167.

11. Abigail Adams to Jefferson, London, January 29, 1787, *Papers of Jefferson* XI, p. 86.

12. Étienne Bonnot de Condillac, "De l'Étude de l'Histoire," *Oeuvres de Condillac* (Paris, 1798), XXI, p. 160.

13. [Count Destutt de Tracy] *A Commentary and Review of Montesquieu's "Spirit of Laws"* (Philadelphia, 1811), p. 69.

14. Edward Young, *The Centaur Not Fabulous, Works* (London, 1757), vol. XV, p. 45; James Thomson, *The Seasons, Winter* (London, 1740), lines 485–495, gives a graphic picture of the effects of luxury.

15. See M. R. de Labriolle-Rutherford, "L'Évolution de la Notion du Luxe depuis Mandeville jusqu'à la Révolution," in Theodore Besterman (ed.), *Studies on Voltaire and the Eighteenth Century,* XXVI (Geneva, 1963), p. 1025.

16. Christopher Crotchet, "The Salad, No. V.," *Port Folio,* V (May, 1811), p. 407.

17. James Dana, *A Sermon, preached before the General Assembly of the State of Connecticut, at Hartford . . .* (Hartford, 1779), pp. 30–32, quoted in G. Adolf Koch, *Republican Religion. The American Revolution and the Cult of Reason* (New York, 1933), p. 244.

18. Thomas F. Pleasants, "An Oration on the Improvements of the Eighteenth Century," *Port Folio,* VI (September 17, 1808), p. 187.

19. John Adams to Thomas Jefferson, Montezillo, December 21, 1819, *The Adams-Jefferson Letters,* Lester J. Cappon (ed.) (Chapel Hill, 1959), II, p. 187.

20. Quoted in Charles Warren, "Samuel Adams and the Sans Souci Club in 1785," *Proceedings of the MHS,* LX (1926–1927), p. 323.

21. Warren, "Samuel Adams," p. 330.

22. Sylvius, "On frugality and industry . . . ," *American Museum,* II (August, 1787), p. 115. The writer praised the Chinese, Japanese and Dutch, peoples who, "knowing the necessity of economy, had wisely adopted a national dress."

23. [Tench Cox] "Notes Concerning the United States . . . ," *American Museum,* VIII (July, 1790), p. 40.

24. *Port Folio,* 3rd ser., I (January, 1816), p. 5.

25. "Journal of Josiah Quincy," *Proceedings of the MHS,* L (1916–1917), p. 452. For English concern over luxury, transmitted to Americans, see Oscar and Mary Handlin, "James Burgh and American Revolutionary Theory," *Proceedings of the MHS,* LXXIII (1961), pp. 38–57.

26. Jean Jacques Rousseau, "A Discourse on the Arts and Sciences," *The Social Contract and Discourses,* G. D. H. Cole (trans. and ed.) (London, 1913, 1955), p. 132.

27. John Adams to Benjamin Waterhouse, Quincy, February 26, 1817, *The Selected Writings of John and John Quincy Adams,* Adrienne Koch and William Peden (eds.) (New York, 1946), p. 199. Adams' suggestion that a "tribunal of criticism" try new artistic productions is reminiscent of Plato's famous remarks. For comments on the fear of art see Edgar Wind, *Art and Anarchy* (London, 1963), Essay I.

28. *Diary and Autobiography of John Adams,* Lyman H. Butterfield (ed.) (Cambridge, Mass., 1961), III, p. 185.

29. Benjamin Rush to ———, Philadelphia, April 16, 1790, *The Letters of Benjamin Rush,* Lyman H. Butterfield (ed.) (Princeton, 1951), I, p. 550.

30. "Essay on the fatal tendency of the prevailing luxuries," *American Museum,* II (September, 1787), p. 218.

31. *Diary and Autobiography of John Adams,* IV, p. 105. For a stimulating discussion of Adams and the arts see Wendell D. Garrett, "John Adams and the Limited Role of the Fine Arts," *Winterthur Portfolio,* I (1964), pp. 243–255.

32. Charles Bulfinch to his parents, Philadelphia, April 2, 1789, *The Life and Letters of Charles Bulfinch,* Ellen Susan Bulfinch (ed.) (Boston, 1796), p. 76. This was a moral, not an aesthetic, judgment. Bulfinch had already visited Europe and familiarized himself with art. See also Brissot de Warville's comment that "the ability to give encouragement to the agreeable arts is a symptom of national calamity," *New*

Travels in the United States of America, 1788, Durand Echeverria (trans. and ed.) (Cambridge, Mass., 1964), pp. 98–99.

33. An interesting parallel developed in Scotland, where men were caught between a desire for refinement and a fear that it would bring about a division of labor. The result: dissipation for the upper classes and misery for the lower classes. See John Clive, *Scotch Reviewers, The Edinburgh Review, 1802–1815* (London, 1956), p. 175. For eighteenth-century parallelism see Bernard Bailyn and John Clive, "England's Cultural Provinces: Scotland and America," *William and Mary Quarterly,* 3rd ser., XL (April, 1954), pp. 299–313.

34. John Adams to Thomas Jefferson, Quincy, April 19, 1817, *Adams-Jefferson Letters,* II, p. 510.

35. Henry Blake McLellan, *Journal of a Residence in Scotland . . .* (Boston, 1834), p. 99. For similar remarks see Reverend M. Trafton, *Rambles in Europe . . .* (Boston, 1852), p. 233; and Wilbur Fisk, *Travels in Europe* (New York, 1838), p. 45.

36. John Griscom, *A Year in Europe . . .* (New York, 1824), II, p. 350.

37. *Port Folio,* V (March 26, 1808), p. 204.

38. See, for example, Rousseau, "A Discourse on the Arts and Sciences," p. 134.

39. John S. Barbour of Virginia, speaking before the Twenty-Third Congress, December 15, 1834, quoted in Charles Warren, "What Has Become of the Portraits of Louis XVI and Marie Antoinette, Belonging to Congress?" *Proceedings of the MHS,* LIX (1925–1926). p. 45.

40. [John Sloan] *Rambles in Italy; in the Years 1816–1817, by an American* (Baltimore, 1818), pp. 149–150. See also *Observations on American Art, Selections from the Writings of John Neal (1793–1876),* Harold Edward Dickson (ed.) (State College, Pa., 1943), p. 24.

41. But for more of history's lessons see *Portico,* I (March, 1816), p. 216; and *Port Folio,* IV (July, 1814), p. 113.

42. For such a refutation see "Of the Luxury of the Romans," *Port Folio,* IV (December, 1810), p. 348.

43. *American Museum,* II (November, 1787), p. 421. See also *American Museum,* II (September, 1787), pp. 217–218.

44. John Adams to Benjamin Waterhouse, Quincy, February 26, 1817, *Selected Writings of John and John Quincy Adams,* p. 199.

45. John Adams to Thomas Jefferson, Quincy, December 16, 1816, *Adams-Jefferson Letters,* II, pp. 502–503. See also Adams to Jefferson, Quincy, February 2, 1817, *Adams-Jefferson Letters,* II, p. 507.

46. Adams to Jefferson, Quincy, January 1, 1817, quoted in *The Autobiography of Colonel John Trumbull, Patriot-Artist (1756–1843),* Theodore Sizer (ed.) (New Haven, 1953), p. 311. Also quoted in Garrett, "John Adams," p. 251.

47. Quoted in Zoltan Haraszti, *John Adams and the Prophets of Progress* (Cambridge, Mass., 1952), p. 59. Adams' refusal to believe in the correspondence of appearance and reality constituted the core of his sharp cynicism. "A deaf and dumb man may have the spirit of patriotism. . . . Eloquence is a useful talent. . . . But it is no ingredient in the spirit of patriotism." Quoted in Haraszti, p. 63.

48. Rousseau, "A Discourse on the Arts and Sciences," p. 134.

49. Griscom, *A Year in Europe*, II, p. 85.

50. Trafton, *Rambles in Europe*, p. 232. See also Fisk, *Travels in Europe*, p. 50; and [Matthias Bruen] *Essays, Descriptive and Moral; on Scenes in Italy, Switzerland and France. By an American* (Edinburgh, 1823), p. 70.

51. See [Alexander Slidell Mackenzie] *The American in England* (London, 1836), I, pp. 158–159; James Freeman Clarke, *Eleven Weeks in Europe . . .* (Boston, 1852), p. 59; Daniel C. Eddy, *Europa: or, Scenes and Society in England, France, Italy and Switzerland* (Boston, 1852), p. 67; and Henry P. Tappan, *A Step from the New World to the Old, and Back Again . . .* (New York, 1852), II, p. 229.

52. [Hezekiah H. Wright] *Desultory Reminiscences of a Tour . . .* (Boston, 1838), p. 114.

53. James A. Leith, *The Idea of Art as Propaganda in France, 1750–1799. A Study in the History of Ideas* (Toronto, 1965), p. 10.

54. Denis Diderot, "Essais sur la Peinture," *Oeuvres Esthétiques*, Paul Vernière (ed.) (Paris, n.d.), p. 718.

55. *Oeuvres complètes de Diderot*, Assezat and Tourneux (eds.) 20 vols., (Paris, 1875–77), VII, p. 369, quoted in Leith, *The Idea of Art as Propaganda*, p. 39.

56. See above, chap. I, note 28.

57. See Howard Mumford Jones, "The Importation of French Books in Philadelphia, 1750–1800," *Modern Philology*, XXXII (November, 1934), pp. 157–177; and Howard Mumford Jones, "The Importation of French Literature in New York City, 1750–1800," *Studies in Philology*, XXVIII (October, 1931), pp. 235-251. Jones comments that it is "curious that Diderot and D'Alembert seldom figure in the book lists." Many of Diderot's writings were published posthumously, and that may account for part of this lack of interest.

58. For a discussion of the French government's art plans see Leith, *The Idea of Art as Propaganda;* David Lloyd Dowd, *Pageant-Master of the Republic, Jacques-Louis David and the French Revolution, University of Nebraska Studies,* new ser., no. 3 (June, 1948), especially chap I. See also Jack Lindsay, *Death of the Hero. French Painting from David to Delacroix* (London, 1960), *passim.*

59. David used these phrases in speeches to the Revolutionary Convention, quoted in Robert Goldwater and Marco Treves (eds.), *Artists on Art* (New York, 1945), p. 205. See also Dowd, *Pageant-Master,* p. 79.

60. Dowd, *Pageant-Master, passim,* contains the best discussion of these festivals.

61. Francis Sergeant Childs, *French Refugee Life in the United States, 1790–1800* (Baltimore, 1940), pp. 19–20.

62. French commissioners to Committee of Public Safety, Philadelphia, 30 Germinal, April 19, 1795, "Correspondence of the French Ministers to the United States, 1791–1797," Frederick Jackson Turner (ed.), *Report of the American Historical Association,* II (1903), p. 646. See also P. A. Adet to Committee of Public Safety, Philadelphia, 1 Fructidor, August 18, 1795, "Correspondence of the French Ministers," p. 770.

63. For an example of this later sensitivity see Samuel S. Cox, *A Buckeye Abroad: or, Wanderings in Europe, and in the Orient* (New York, 1852), p. 352.

64. Most histories of American architecture make these connections. They are most fully articulated in Talbot Hamlin, *Greek Revival Architecture in America* (New York, 1944), *passim.* See also Jones, *O Strange New World,* chap. VII.

65. For a discussion of the neoclassic under totalitarianism see Hellmut Lehmann-Haupt, *Art Under a Dictatorship* (New York, 1954), *passim.*

66. Helen Rosenau, *The Ideal City in its Architectural Evolution* (London, 1959), p. 93. See also Emil Kaufmann, "Three Revolutionary Architects, Boullée, Ledoux, and Lequeu," *Transactions of the American Philosophical Society,* new ser., vol. 42, pt. 3 (1952).

67. Louis Réau, *L'Art français aux États-Unis* (Paris, 1926), *passim.* Ramée designed Union College in Schenectady; Stephen Hallet took part in the competition for the Capitol. See also Howard Mumford Jones, *America and French Culture* (Chapel Hill, 1927), *passim.*

68. See chap. I, note 64.

69. Commissioners to the municipality of Bordeaux, Washington, January 4, 1793, 58th Congress, 2nd session, Report No. 646, reprinted in *Documentary History of the Construction of the United States Capitol Buildings and Grounds* (Washington, 1904), p. 21.

70. Quoted in Edward Dumbauld, *Thomas Jefferson, American Tourist* (Norman, Okla., 1946), p. 15.

71. Quoted in Dumbauld, *Thomas Jefferson,* p. 15. My italics.

72. Quoted in William Alexander Lamboth, *Thomas Jefferson as an Architect* (Boston and New York, 1913), p. 72.

73. Thomas Jefferson to James Madison, Paris, September 20, 1785, *Papers of Jefferson,* VIII, p. 535.

74. Jefferson to Madison, Paris, September 20, 1785, *Papers of Jefferson,* VIII, p. 535. For more comment on the theme of permanence and the verdict of posterity see Jefferson to Benjamin Latrobe, Monticello, October 10, 1809, quoted in S. K. Padover (ed.), *Thomas Jefferson and the National Capitol* (Washington, 1946), p. 462; and Jefferson to

Latrobe, Monticello, July 12, 1812, quoted in Padover (ed.), *Jefferson and the Capitol* p. 471. See also Eleanor Davidson Berman, *Thomas Jefferson among the Arts, An Essay in Early American Esthetics* (New York, 1947), *passim.*

75. Quoted in Edward Biddle, "Girard College," *Proceedings of the Numismatic and Antiquarian Society of Philadelphia,* XXVIII (1919), p. 213.

76. See above, note 33. See also Leo Marx, *The Machine in the Garden, Technology and the Pastoral Ideal in America* (New York, 1964), chap. III.

77. "On the Architecture of America," *American Museum,* VIII (October, 1790), p. 176.

78. *Analectic Magazine,* V (June, 1815), p. 493. Another writer called upon artists to exercise a voluntary censorship to protect their infant profession. See *Port Folio,* 3rd ser., III (January, 1814), pp. 37–38.

79. See Hamlin, *Greek Revival Architecture,* chap. XII, for one of many examples of this sort of analysis.

80. Grace Greenwood (pseud. for Mrs. Sara Lippincott), *Haps and Mishaps of a Tour in Europe* (Boston, 1854), p. 33. See also Charles A. Dana's description of the White House, and his delight that "there are pleasant associations in that word white; it breathes of innocent purity and spotless virtue. . . ," Charles A. Dana (ed.), *The United States Illustrated* (New York, 1853), p. 9.

81. A century later Americans continued to identify political virtue with artistic simplicity. See Elihu Root, "The Simple Life," Charles William Moore (comp.), *The Promise of American Architecture* (Washington, 1905), pp. 39–40. In the late nineteenth century the visual decadence which had earlier stood for Europe was represented by extravagances like Boss Tweed's Court House.

82. James Fenimore Cooper, *Home as Found* (New York, 1860), p. 132.

83. For example, *Analectic Magazine,* VI (November, 1815), p. 363.

84. Charles William Janson, *The Stranger in America,* Carl S. Driver (ed.) (London, 1807; New York, 1935), p. 288.

85. Godfrey T. Vigne, *Six Months in America* (Philadelphia, 1833), p. 53. Vigne blamed the lack of splendid buildings on the absence of primogeniture and entail. See also Frances Wright, *Views of Society and Manners in America . . . ,* Paul R. Baker (ed.) (Cambridge, Mass., 1963), p. 13.

86. Frances Wright, *Views of Society,* pp. 48, 261. Some travelers actually condemned American public buildings for being overmodest. See Lieutenant Francis Hall, *Travels in Canada and the United States, in 1816 and 1817* (Boston, 1818), p. 196.

87. *Blunt's Stranger's Guide to the City of New York* (New York, 1817), p. 45.

88. *Blunt's Stranger's Guide,* p. 53.

89. Cooper, *Home as Found,* p. 24.

90. *Analectic Magazine,* VI (November, 1815), p. 364. See also *American Museum,* I (March, 1787), p. 206.

91. *Boswell's Life of Johnson* (London, 1931), I, p. 487. This is a reprinting of the third edition, published in 1799; Johnson made these remarks in 1773. See also *Boswell,* II, p. 37, and II, p. 214.

92. David Hume, *Essays and Treatises on Several Subjects* (Basil, 1793), II, p. 23. See Essay I, "Of Commerce," Essay II, "Of Refinement in the Arts," and Essay XIV, "Of the Rise and Progress of the Arts and Sciences."

93. Hume, *Essays,* II, pp. 19–20.

94. Hume, *Essays,* II, pp. 28–30. Hume insisted that only a free people could produce art and sciences, since they required law and security, the prerogatives of republics. See *Essays,* II, p. 120. A few Americans emphasized order as a condition for the arts, but American conditions, emphasizing excitement, activity and risk, led native art publicists to stress other things: friendly patrons, great events, visual stimulation in American scenery.

95. Marquis de Chastellux, *Travels in North America in the Years 1780, 1781 and 1782,* Howard G. Rice, Jr. (ed. and trans.) (Chapel Hill, 1963), II, p. 540.

96. Chastellux, *Travels in North America,* II, p. 542.

97. Chastellux, *Travels in North America,* II, p. 544.

98. William Vans Murray, "Political Sketches," *American Museum,* II (September, 1787), p. 234.

99. "Extract of a Letter by Dr. Franklin," *American Museum,* VII (January, 1790), p. 20.

100. See also Benjamin Franklin, "Consolation for America," *American Museum,* I (January, 1787), p. 7. Franklin's arguments—that luxury was not harmful and that American conditions made it exceptional—offered two reassurances. First, that American virtue was not dead; and second, that even if refinement spread, it was not entirely bad. It was a case of having one's cake and eating it too, one of Franklin's most endearing habits.

101. "An Idea of Luxury," *American Museum,* II (June, 1791), p. 338.

102. William Tudor, *Letters on the Eastern States* (New York, 1820), pp. 355–356.

103. S. B., "America by French Pens," *Port Folio,* 3rd ser., IV (August, 1814), p. 205.

104. From a speech by George Clymer, made before the Pennsylvania Academy of the Fine Arts, April 15, 1807, reprinted in *Monthly Anthology,* IV (April, 1807), p. 217. For more on the theme of art as a barrier against the "ignoble and degrading propensities which beset us," see *Port Folio,* IV (December, 1810), p. 3; *American Maga-*

zine and Critical Review, I (June, 1817), p. 130; and *Monthly Anthology,* II (July, 1805), pp. 399–400.

105. "Essay on Commerce, extracted from Fenno's *Gazette of the United States,*" *American Museum,* VII (January, 1790), p. 16. For more glorification of the trading spirit see Tudor, *Letters on the Eastern States,* pp. 109–111; and "Letter from a merchant in Philadelphia," *American Museum,* VIII (July, 1790), p. 27.

106. "Essay on the advantages of trade and commerce," *American Museum,* II (October, 1787), p. 328.

107. *American Museum,* II (October, 1787), p. 329. See also *American Museum,* VII (January, 1790), p. 17.

108. "Letter from a merchant in Philadelphia," p. 27.

109. *Port Folio,* VI (August, 1808), p. 97. A reprint of a speech by Dr. Abercrombie of the Philadelphia Academy, this article contains the most succinct and interesting idealization of the merchant's role in American society I have encountered.

110. See, for example, *Monthly Anthology,* IV (May, 1807), and its call on Boston merchants to imitate the example of their colleagues in Liverpool, London, Baltimore, Philadelphia and New York, and found an athenaeum.

111. A fulsome tribute to Roscoe is paid by Griscom, *A Year in Europe,* pp. 355–356.

112. "A Reply to Article X . . . ," *Southern Review,* IV (August, 1829), p. 71. For more samples of this debate, involving evaluations of seventeenth-century Holland, the Roman Empire, Renaissance Italy and Periclean Athens, see *Monthly Anthology,* IV (November, 1807), p. 377; *Port Folio,* 3rd ser., III (June, 1814), p. 569; *Port Folio,* V (June, 1811), p. 16; *Port Folio,* V (June, 1811), p. 15. American travelers later in the century kept up the debate. See George H. Calvert, *Scenes and Thoughts in Europe,* 1st ser. (Boston, 1863), pp. 162–163.

113. *Port Folio,* V (June, 1811), p. 17.

114. William Dunlap, "Essay on the Influence of the Arts of Design," *American Monthly Magazine,* I (February, 1836), pp. 117, 119.

115. See, for example [William Minot, Jr.], Review of Asher Benjamin, *The Builder's Guide, North American Review,* LII (April, 1841), pp. 301–305. See also M. Charles Paterson, *An Address Delivered at the Opening of the Twelfth Exhibition of the American Academy of the Fine Arts* (New York, 1836), p. 38.

116. See *Monthly Anthology,* III (August, 1806), p. 414.

117. For an example of how patriots solved the problem of national decay, which had been so vivid an image decades earlier, see Joseph R. Williams, *An Oration . . . Before the Citizens of the Town of New Bedford on the 4th of July, 1835* (New Bedford, 1835). "Those who would make us believe that we shall be swallowed in the same vortices,

into which other nations have been swept, should show us that the same elements exist in modern civilization, that existed in the civilization of other ages . . . when *this* age shall relapse into barbarism is beyond the ken of human foresight," p. 23.

3 The Burden of Portraiture

1. Theodore Bolton and Irwin F. Cortelyou, *Ezra Ames of Albany, Portrait Painter, Craftsman, Royal Arch Mason, Banker* (New York, 1955), *passim*. The title is almost sufficient in itself to indicate the range of activities many artists pursued.

2. *Pennsylvania Journal*, July 13, 1769, quoted in Alfred Coxe Prime, *The Arts and Crafts in Philadelphia, Maryland and South Carolina, 1721–1785. Gleaned from Newspapers* (Philadelphia, 1929), p. 9.

3. See, for example, Alfred Coxe Prime, *Arts and Crafts*, p. 7.

4. Alfred Coxe Prime, *Arts and Crafts*, *passim*. See also William Kelby, *Notes on American Artists, 1754–1820, Compiled from advertisements appearing in the newspapers of the day* (New York, 1922), *passim*, for many other such usages.

5. Quoted in William Dunlap, *A History of the Rise and Progress of the Arts of Design in the United States*, Frank W. Bayley and E. Goodspeed (eds.) (Boston, 1918), III, p. 234. This most important work for the early history of American art was first published in 1834.

6. Chester Harding, *My Egotistigraphy* (Cambridge, Mass., 1866), p. 33.

7. Harding admitted he soon got more elevated notions. One trip to Philadelphia and the sight of the Academy paintings was enough to convince him that this career was more important than sign-painting. *My Egotistigraphy*, pp. 33–34.

8. *The New York Review*, IV (April, 1839), p. 352.

9. Quoted in William T. Whitley, *Gilbert Stuart* (Cambridge, Mass., 1938), p. 89.

10. Quoted in Helen W. Henderson, *The Pennsylvania Academy of the Fine Arts* (Boston, 1911), pp. 92–93.

11. John A. Allston to Samuel Morse, Georgetown, April 7, 1818, quoted in Samuel I. Prime, *The Life of Samuel F. B. Morse* (New York, 1875), p. 111. Morse was so grateful for Allston's patronage that he presented him with a painting he had done earlier for a Royal Academy exhibition, "The Judgment of Jupiter."

12. Frances Trollope, *Domestic Manners of the Americans*, Donald Smalley (ed.) (New York, 1949), p. 168. See also her remarks about natural talent for painting in America, p. 346.

13. Frederick Marryat, *A Diary in America*, Sydney Jackman (ed.) (New York, 1962), pp. 236–237.

14. This story is told in John Galt, *The Life, Studies and Works of*

Benjamin West (London, 1820; Gainesville, Fla., 1960), p. 11. For another version see Henry T. Tuckerman, *Book of the Artists, American Artist Life* (New York, 1867), p. 90. Galt declares that this episode is "one of the few instances in the history of art in which the first inspiration of genius can be distinctly traced to a particular circumstance." Galt's imagination often ran away with him.

15. John Durand, *The Life and Times of A. B. Durand* (New York, 1894), p. 21.

16. [Mrs. Hannah F. Lee] *Familiar Sketches of Sculpture and Sculptors* (Boston, 1854), I, p. 204.

17. Henry T. Tuckerman, *Artist-Life: or, Sketches of American Painters* (New York, 1847), p. 121.

18. *Observations on American Art, Selections from the Writings of John Neal (1793–1876)*, Harold Edward Dickson (ed.) (State College, Pa., 1943), p. 17.

19. Dunlap, *History,* II, p. 190.

20. "Autobiography of Worthington Whittredge," John I. H. Baur (ed.), *Brooklyn Museum Journal,* I (1942), pp. 10–11.

21. Harding, *My Egotistigraphy,* p. 40. His father's objections must have been lessened when the painter presented him with a farm bought with his art profits.

22. John Albee, *Henry Dexter, Sculptor, A Memorial* (Cambridge, Mass., 1898), p. 17.

23. Albee, *Henry Dexter,* p. 39.

24. This was Henry Kirke Brown; he was apprenticed to Chester Harding. See Albert Ten Eyck Gardner, *Yankee Stonecutters, The First American School of Sculpture, 1800–1850* (New York, 1945), p. 51.

25. Samuel Morse to his parents, London, September 20, 1812, *Samuel F. B. Morse, His Letters and Journals,* Edward Lind Morse (ed.) (Boston, 1914), I, p. 85.

26. "The Journal of John Blake White," Paul R. Weidner (ed.), *South Carolina Historical and Genealogical Magazine,* XLII (April, 1941), p. 63. Interestingly enough, White condemned his own son's love for painting. See p. 117.

27. John Trumbull to Benjamin Ruggles, New Haven, December 13, 1840, *Selections from the works of the late Sylvester Genin Esq., in Poetry, Prose, and Historical Design* (New York, 1855), p. 34. Washington Allston used practically the same words in advising a Charleston sculptor, John Stevens Cogdell, to give up his art. "Do not let it tempt you to give up a certainty for an uncertainty," wrote Allston. "If by making the art your profession you are to depend on it as the means of support for yourself and family, I cannot but think you look to a very precarious source." Quoted in Anna Wells Rutledge, "Artists in the Life of Charleston," *Transactions of the American Philosophical Society,* new ser., vol. 39, pt. 2 (November, 1949), p. 136.

28. The whole story is told in the *Port Folio,* 3rd ser., II (July, 1813), pp. 85–89.

29. [Lee] *Familiar Sketches,* I, pp. 194–202.

30. *New York Gazetteer and Country Journal,* November 16, 1784, quoted in Kelby, *Notes,* p. 29.

31. For more information of this sort see George Gates Raddin, Jr., *The New York of Hocquet Caritat and his Associates, 1797–1818* (New York, 1953), *passim.*

32. Albee, *Henry Dexter,* p. 38.

33. Harding, *My Egotistigraphy,* p. 26.

34. Tuckerman, *Artist-Life,* p. 436.

35. Quoted in C. Edwards Lester, *The Artists of America: A Series of Biographical Sketches of American Artists* (New York, 1846), p. 37. Inman's exalted ideas about artists dated from his scrutiny of the brief biographies of famous painters, appended to *Tales of the Castle* by Mme. de Genlis.

36. See the brief sketch of Waldo in George C. Groce and David H. Wallace, *The New-York Historical Society's Dictionary of Artists in America, 1564–1860* (New Haven, 1957), p. 654.

37. Robert W. Gibbes, M.D., *A Memoir of James De Veaux* (Columbia, S.C., 1846), p. 11.

38. Quoted in Lester, *Artists of America,* p. 185.

39. Howard Payson Arnold, *European Mosaic* (Boston, 1864), p. 260. Arnold was sympathetic despite this criticism.

40. Thomas Crawford to Louisa Crawford, Washington, January 20, 1850. AAA. He asked his wife to entertain Henry Tuckerman, the critic, and have a relative invite him to dinner. "Something must be done. . . . This in fact is the manner I lose friends." See also Crawford to Louisa Crawford, Richmond, February 2, 1850, and Crawford to Louisa Crawford, Washington, January 26, 1850, all in the Crawford Papers, AAA.

41. For example, the review of Allston's *Lectures on Art* by [Felton] *North American Review,* LXXI (July, 1850), p. 149. Also, see the inaccurate picture of harmony among American sculptors depicted in *New York Mirror,* March 4, 1837. It placed Greenough and Powers as "compeers not rivals," in "the great struggle for eminence and immortality." And finally, see Samuel F. B. Morse's thinly veiled warning of 1830 that artists would have to establish more harmony if they were to achieve individual prosperity. Quoted in Thomas S. Cummings, *Historic Annals of the National Academy of Design* (Philadelphia, 1865), p. 43.

42. A good deal of information on the inventiveness of American sculptors is provided in Gardner, *Yankee Stonecutters, passim.* For Morse's experimentation in painting see the remarks of Daniel Huntington, in *Morse, Letters and Journals,* I, p. 436. William Page, a

portrait and history painter, was famous for his pigment experiments. See Joshua C. Taylor, *William Page, The American Titian* (Chicago, 1957), *passim*. Charles Willson Peale, and his son, Rembrandt Peale, were also active innovators in artistic techniques, and inventors as well.

43. *Picturesque United States of America, 1811, 1812, 1813, being a Memoir on Paul Svinin*, Avrahm Yarmolinsky (ed.) (New York, 1930), p. 33. Svinin observed that the "most wretched paint-slinger" got at least twenty dollars a portrait, and some who were not much better, one hundred dollars.

44. Rembrandt Peale, "Reminiscences," *The Crayon*, I (January 10, 1855), p. 23.

45. Most of the information in this paragraph comes from a reminiscence by T. B. Thorpe, "New York Artists Fifty Years Ago," *Appleton's Journal*, VII (May 25, 1872), pp. 572–575.

46. Samuel Morse to his parents, Bristol, December 22, 1814, *Morse, Letters and Journals*, I, p. 164.

47. See *Morse, Letters and Journals*, II, pp. 25–34.

48. Quoted in Lester, *Artists of America*, p. 43.

49. Quoted in Dunlap, *History*, I, p. 243.

50. Trollope, *Domestic Manners*, p. 236.

51. Mrs. Morse to Samuel Morse, New Haven, December 19, 1814, *Morse, Letters and Journals*, I, p. 159. The Reverend Samuel F. Jarvis wrote Morse from New York, January 29, 1818, warning that the wealthy of America did not yet desire painting for its own sake. The letters are quoted in Samuel I. Prime, *Life of Morse*, p. 93.

52. Morse to his parents, London, May 3, 1815, *Morse, Letters and Journals*, I, p. 177. Morse underwent the experiences of both groups of artists: the well-born who made it to Europe through family aid, and the workers who got there after itineracy. This wide basis of experience helped his artistic leadership, for he retained the respect of both of these groups, as well as the admiration of craftsmen-artists who remained at home.

53. Alvan Fisher to Charles C. Wright, Boston, March 8, 1831, Miscellaneous File, NYPL; microfilms in AAA.

54. *Selections from the Writings of John Neal*, p. 51.

55. This was the comment of Thomas Cole in the 1840s on the death of a young portraitist, Ver Bryck. Quoted in Tuckerman, *Book of the Artists*, pp. 402–403.

56. Quoted in Thomas Fitzgerald, "John Neagle the Artist," *Lippincott's Magazine*, I (May, 1868), p. 488.

57. L. Gaylord Clark, "Charles Loring Elliott," *Lippincott's Magazine*, II (December, 1868), p. 653.

58. This was William H. Beard, an Ohio portraitist. See Tuckerman, *Book of the Artists*, p. 498.

59. Svinin tells this story about Stuart's detection of insanity in a Captain Phipps; he also recounts anecdotes of Stuart's phenomenal visual memory. *Picturesque United States,* pp. 34–35. The story is repeated in Dunlap, *History,* I, p. 189.

60. Clark, "Charles Loring Elliott," p. 655.

61. Tuckerman, *Artist-Life,* p. 90. This was from a sketch of the life of William E. West who knew Byron and Shelley.

62. [Felton] *North American Review,* LXXI (July, 1850), p. 158. Thomas Crawford to Louisa Crawford, Washington, January 20, 1855, Crawford Papers, AAA.

63. *New York Mirror,* XIV (August 27, 1836), p. 70. The journalist used Greenough as an example of his contention, adding that sculpture "has become one of the pursuits of our men of education and talent."

64. Horatio Greenough to James Fenimore Cooper, Florence, August 22, 1832, *The Correspondence of James Fenimore Cooper,* James Fenimore Cooper (ed.) (New Haven, 1922), I, p. 285. See also Washington Allston to Charles Robert Leslie, Cambridgeport, August 12, 1827, Jared B. Flagg, *The Life and Letters of Washington Allston* (New York, 1892), p. 215. Allston insisted that "no artist of real eminence can be found of vulgar taste, even on subjects wholly foreign to his art."

65. Tuckerman, *Book of the Artists,* pp. 461–464.

66. Dunlap, *History,* I, p. 197. See also *Diary of William Dunlap (1766–1839)* . . . , Dorothy C. Barck (ed.) (New York, 1930), III, p. 735.

67. William Dunlap, *Address to the Students of the National Academy of Design* . . . (New York, 1831), p. 10.

68. *Diary of William Dunlap,* II, p. 489. Harold Edward Dickson, *John Wesley Jarvis, American Painter* (New York, 1949), *passim.* For even more phenomenal gains see "From Tunbridge, Vermont, to London, England—The Journal of James Guild, Peddler, Tinker, School-Master, Portrait Painter, From 1818 to 1824," *Proceedings of the Vermont Historical Society,* new ser., V (September, 1937), p. 306.

69. I have relied on *Diary of William Dunlap,* II, *passim,* for the 1819–1820 season.

70. Thomas Doughty to Henry Kirke Brown, Saratoga, July 26, 1841, Charles Roberts Autograph Collection, Haverford College; microfilms in AAA.

71. Samuel Morse to Mrs. Morse, Albany, August 27, 1823, *Morse, Letters and Journals,* I, p. 248.

72. William Dunlap to David Gillespie, Norfolk, February 9, 1822, Charles Roberts Autograph Collection.

73. Samuel Morse to Mrs. Morse, Charleston, January 28, 1821, *Morse, Letters and Journals,* I, p. 235.

74. *Diary of William Dunlap,* III, p. 703. Rembrandt Peale, Morse

and Sully, all hit hard by the depression of 1819, painted a series of dramatic subjects designed to tour the country, in order to recoup their losses.

75. See "The Journal of James Guild," *passim.*

76. "Extracts from the Diary of James B. Longacre," *Pennsylvania Magazine of History and Biography,* XXXIX (April, 1905), pp. 134–142.

77. William Dean Howells, *A Chance Acquaintance* (Boston, 1873, 1901), p. 147.

78. Dunlap, *History,* I, p. 357.

79. John Trumbull to Mrs. Trumbull, Baltimore, February 10, 1819, Miscellaneous File, NYPL; microfilms in AAA.

80. Entries for December 25th, 1845, January 1st, 1846, Diary of George Durrie, AAA.

81. See Dickson, *John Wesley Jarvis, passim,* for evidence of his dissipation. See also Dunlap, *History,* II, p. 117, for another artist who drank. The *Diary of William Dunlap* records Dunlap's experiences in controlling the drinking of the great George Cooke, a touring actor. Like painters, actor-itinerants were notable for drunkenness. See also "Autobiography of Worthington Whittredge," p. 14. Most painters were not drunkards, but many, like Dunlap, felt it necessary to be aggressively pure to withstand the temptation. Moderation was a luxury itinerants could not afford.

82. Horatio Greenough to Samuel Morse, Florence, August 20, 1832, quoted in Samuel I. Prime, *Life of Morse,* p. 217.

83. Morse to his parents, New York, November 18, 1825, *Morse, Letters and Journals,* I, p. 282.

84. Dunlap, *History,* II, p. 117.

85. *Quarterly Bulletin,* AAA, III (January, 1963), pp. 5–6. The extract is a letter from an itinerant painter, Russel D. Palmer, Clinton, Michigan, 1843, to a cousin. The editor, Mr. Garrett McCoy, comments on this arresting combination of romanticism and prosaic business virtues.

86. The story is told in *Port Folio,* new ser., I (June, 1809), p. 476. For more on Hovey see Dunlap, *History,* II, p. 220. Hovey's total production amounted to perhaps half a dozen paintings, but this was enough to qualify him for martyr status, and study in Europe. For more praise of obscure artists see *The Polyanthus,* new ser., I (March, 1813), pp. 321–323.

87. Tuckerman, *Book of the Artists,* p. 404.

88. Rutledge, "Artists in Charleston," *passim.*

89. For Edmonds see Tuckerman, *Book of the Artists,* pp. 411–414.

90. Quoted in Durand, *A. B. Durand,* p. 43.

91. Quoted in Fitzgerald, "John Neagle," p. 488.

92. Fitzgerald, "John Neagle," p. 490.

93. This painting is a somewhat unusual example of Neagle's style; according to Virgil Barker, Neagle himself "did not realize the full consequence of the innovation." See Barker's article on Neagle in *The One Hundred and Fiftieth Exhibition Catalogue of the Pennsylvania Academy of the Fine Arts* (Philadelphia, 1955), p. 39.

94. See E. A. Jones, *Matthew Harris Jouett, Kentucky Portrait Painter, 1788–1827* (Louisville, 1938). "The brush, not the law, seemed to offer the easiest way out," p. 23. James Guild alternated his likeness-drawing with bouts of professional wrestling. See "The Journal of James Guild," *passim.*

95. Samuel Morse to his parents, London, May 3, 1815, *Morse, Letters and Journals,* I, p. 176.

96. This attitude lasted a long time. See the rather interesting description in Frank Norris, *McTeague* (New York, 1899, 1964), p. 7.

97. "Liberty vs. Literature and the Fine Arts," *Knickerbocker,* X (January, 1837), p. 11. This comment was coupled with a defense of American art patronage and the diffusion of property.

98. Luke Marastan to Robert W. Weir, Rome, March 15, 1827, Robert W. Weir Papers, AAA.

99. William Dunlap to Washington Irving, New York, September 26, 1833, quoted in *Diary of William Dunlap,* III, p. 746. Irving agreed.

100. Dunlap, *History,* I, pp. 10–11.

101. Washington Allston to Reverend and Mrs. Morse, London, May 2, 1814, *Morse, Letters and Journals,* I, p. 131.

102. J. G. Chapman to Thomas Sully, Florence, July 27, 1829, Chamberlain Collection, BPL.

103. Samuel Morse to Reverend Samuel Jarvis, London, September 17, 1811, *Morse, Letters and Journals,* I, pp. 46–47.

104. Luman Reed, an active patron of the era, quoted in Durand, *A. B. Durand,* p. 116.

105. See Lillian B. Miller, "John Vanderlyn and the Business of Art," *New York History,* XXXII (January, 1951), pp. 33–44.

106. Galt, *Benjamin West,* pp. 84–90.

107. See Barbara Novak, "Thomas Cole and Robert Gilmor," *Art Quarterly,* XXV (Spring, 1962), pp. 41–53. Also see Cole to Gilmor, Florence, January 29, 1832, Louis Legrand Noble, *The Life and Works of Thomas Cole,* Elliot S. Vesell (ed.) (Cambridge Mass., 1964), p. 101.

108. Catharine W. Pierce, "Francis Alexander," *Old-Time New England,* XLIV (October–December, 1953), pp. 29–46.

109. This story is related in Cummings, *Annals of the National Academy,* p. 212.

110. See above, p. 70.

111. See the list in Samuel I. Prime, *Life of Morse,* pp. 172–173.

112. Noble, *Life of Thomas Cole,* p. 80.

113. Harding, *My Egotistigraphy,* p. 86.

114. Harding, *My Egotistigraphy,* p. 118.

115. See "Hints to Artists Going Abroad," *The New World,* VI (March 18, 1843), p. 337.

116. Harding, *My Egotistigraphy,* p. 133.

117. Nathaniel Parker Willis, *Paul Fane: or, Parts of a Life Else Untold* (New York, 1857), p. 308.

118. Harding, *My Egotistigraphy,* p. 152.

119. Miller, "John Vanderlyn," recounts but does not explain his problems with the business ethic. Rembrandt Peale to Charles F. Mayer, Boston, September 9, 1828, quoted in Charles Coleman Sellers, *The Later Life of Charles Willson Peale (1790–1827)* (Philadelphia, 1947), p. 388.

120. John Vanderlyn to John R. Murray, Paris, July 3, 1809, History of Art Manuscripts, vol. II, AAA. "The subject may not be chaste enough for the non-chaste and modest Americans, at least to be displayed in the house of any private individual, to attract the company of the parlor or drawing room, but on that account it may attract a greater crowd if exhibited publickly."

121. *National Advocate,* April 21, 1818, quoted in Kelby, *Notes,* p. 54.

122. This is the conclusion of John Joseph Lawler, "Comments on Art and Literature. From the Personal Writings of a Group of Well Traveled Early American Writers and Artists. A Critical Collation," Ph.D. dissertation, Florida State University, 1960.

123. Sanford R. Gifford to his father, Paris, December 18, 1855, Gifford Letters, AAA.

124. Samuel Morse to his parents, London, May 2, 1814, *Morse, Letters and Journals,* I, p. 132. See also John Trumbull to Edward Everett, Washington, January 12, 1817, quoted in *The Autobiography of Colonel John Trumbull, Patriot-Artist, 1756–1843,* Theodore Sizer (ed.) (New Haven, 1953), p. 369.

125. Thomas Cole to Robert Gilmor, New York, April 20, 1829, Cole Papers, NYHS. This depressing section of the letter was omitted by Noble in his *Life of Thomas Cole.*

126. Rembrandt Peale, "Reminiscences," *The Crayon,* I (May 9, 1855), p. 290.

127. Horatio Greenough to Samuel Morse, Florence, August 20, 1832, quoted in Samuel I. Prime, *Life of Morse,* p. 217. Also quoted in Nathalia Wright, *Horatio Greenough, The First American Sculptor* (Philadelphia, 1963), p. 122.

128. Rembrandt Peale to Congressman Mills, Washington, January 13, 1825, AAA. Peale was offering to sell his equestrian portrait of

Washington. He claimed that he could make greater profits exhibiting it through the country. His letter brought together all the strands of argument supporting government patronage.

129. Thomas Crawford to Louisa Crawford, Richmond, February 2 and February 13, 1850, Crawford Papers, AAA.

130. The story of the competitions for the Lafayette commissions is told in Dickson, *John Wesley Jarvis,* pp. 280–282.

131. Greenough made the comment in *American Quarterly Review,* II (March, 1828), quoted in Wright, *Greenough,* p. 50. This theme became a commonplace in American art commentary. Charles L. Sanford, *The Quest for Paradise: Europe and the American Moral Imagination* (Urbana, Ill., 1961), pp. 138–139 discusses it. For the comment of a layman, in terms similar to those of Greenough, see *The Diary of George Templeton Strong,* Allan Nevins and Milton Halsey Thomas (eds.) (New York, 1952), I, p. 225.

132. Lieutenant Francis Hall, *Travels in Canada and the United States, in 1816 and 1817* (Boston, 1818), p. 176. Hall's tendency toward romanticism pervades his whole work and is best revealed by his comment that "to think correctly on all subjects, is to feel strongly on none."

133. Washington Allston to Gulian C. Verplanck, Cambridgeport, March 1, 1830, quoted in Flagg, *Life of Allston,* p. 230. Allston suggested a scriptural subject instead, though it would take the most dedicated nationalism to find specific American content in a Biblical scene.

134. Charles Sumner, *The Scholar, The Jurist, The Artist, The Philanthropist* (Boston, 1846), p. 45.

135. *Diary of George Templeton Strong,* I, p. 225.

136. Washington Allston to John Stevens Cogdell, Cambridgeport, February 27, 1832, Flagg, *Life of Allston,* p. 257.

137. [Walter Channing] "On the Fine Arts," *North American Review,* III (July, 1816), pp. 198–199.

138. [Franklin Dexter] "Exhibition of Pictures of the Athenaeum Gallery," *North American Review,* XXXIII (October, 1831), p. 514.

139. *Cosmopolitan Art Journal,* IV (December, 1860), p. 166. This remark was made in the course of a short biography of Charles F. Blauvelt, a painter who did do genre scenes.

140. *Knickerbocker,* XVIII (July, 1841), p. 86.

141. Thomas R. Hofland, "The Fine Arts," *Knickerbocker,* XIV (July, 1839), p. 43.

142. See, for example, Samuel Morse to his parents, London, September 20, 1812, *Morse, Letters and Journals,* I, p. 85; and Morse to his parents, London, May 2, 1814, *Morse, Letters and Journals,* I, pp. 132–133. See also Trollope, *Domestic Manners,* p. 325.

143. "On the Fine Arts," p. 199.

144. Ignatius Loyola Robertson (pseud. for Samuel Lorenzo Knapp), *Sketches of Public Characters* (New York, 1830), p. 191.

145. [Dexter] "Exhibition of Pictures," p. 512. See also F. W. Edmonds' eulogy to Frederick S. Agate, a New York painter, in the *Knickerbocker,* XXXIX (August, 1844), p. 163.

146. Yarmolinsky, *Picturesque United States,* p. 34.

147. [William Tudor] "Institution for the Fine Arts," *North American Review,* II (January, 1816), p. 161.

148. Thus the name of the first American school of painting, the Hudson River School, is singularly appropriate, despite the fact that it included artists painting on several continents.

4 Professional Communities: Growing Pains

1. Theodore Dehon, "A Discourse upon the Importance of Literature to our Countrymen," *Monthly Anthology,* IV (September, 1802), p. 471; and William Tudor, Jr., "From Boetia to Attica," *Monthly Anthology,* IX (September, 1810), quoted in Lewis P. Simpson (ed.), *The Federalist Literary Mind. Selections from The Monthly Anthology and Boston Review* ([Baton Rouge] 1962), p. 217. See also *Port Folio,* I (June, 1806), p. 360; and *Port Folio,* IV (December, 1810), p. 4.

2. William Dunlap, *A History of the Rise and Progress of the Arts of Design in the United States,* Frank W. Bayley and E. Goodspeed (eds.) (Boston, 1918), I, pp. 10–11.

3. Quoted in Thomas S. Cummings, *Historic Annals of the National Academy of Design* (Philadelphia, 1865), p. 58. See also Dunlap, *History,* II, p. 234.

4. George H. Calvert, *Scenes and Thoughts in Europe,* 1st ser. (Boston, 1863), p. 162. Calvert made these remarks twenty years earlier. See also Henry D. Gilpin, *An Annual Discourse before the Pennsylvania Academy of the Fine Arts* (Philadelphia, 1827), pp. 25–26.

5. For example, "Liberty vs. Literature and the Fine Arts," *Knickerbocker,* IX (January, 1837), p. 8. This writer, however, was pleased by the princely sums he thought American artists were receiving.

6. Reverend Orville Dewey, *The Old World and the New* (New York, 1836), II, pp. 190–191. See also *Port Folio,* VIII (July, 1812), p. 19; and Benjamin H. Latrobe, *Anniversary Oration before the Society of Artists of the United States* (Philadelphia, 1811), p. 31.

7. For information concerning this dispute see Helen W. Henderson, *The Pennsylvania Academy of the Fine Arts* (Boston, 1911), *passim;* Rembrandt Peale, "Reminiscences," *The Crayon,* I (May 9, 1855), p. 290; James Thomas Flexner, "The Scope of Painting in the 1790's," *Pennsylvania Magazine of History and Biography,* LXXIV (January, 1950), pp. 74–89; [Earl Shinn] "The First American Art Academy," *Lippincott's Magazine,* IX (February, 1872), pp. 143–153.

8. Quoted in Flexner, "The Scope of Painting in the 1790's," p. 76.

9. See a supporting view by Gilbert Stuart, quoted in William T. Whitley, *Gilbert Stuart* (Cambridge, Mass., 1938), p. 140.

10. For the following paragraph I have relied heavily on Nikolaus Pevsner, *Academies of Art, Past and Present* (Cambridge, Eng., 1940), *passim*.

11. See Dunlap, *History*, I, p. 243; and C. Edwards Lester, *The Artist, The Merchant, and The Statesman, of the Age of the Medici, and of our Own Times* (New York, 1845), I, p. 109, for the negative remarks; and the constitution of the Pennsylvania Academy for the latter quotation, reprinted in Anna Wells Rutledge (ed.), *The Pennsylvania Academy of Fine Arts, 1807–1870, Cumulative Record of Exhibition Catalogues* (Philadelphia, 1955), p. 5.

12. *Monthly Anthology*, IV (May, 1807), p. 230.

13. Quoted in George Gates Raddin, Jr., *The New York of Hocquet Caritat and his Associates, 1797–1817* (New York, 1953), p. 51.

14. Hopkinson also denied that artists could manage their own business affairs. See [Earl Shinn] "The First American Art Academy," *Lippincott's Magazine*, IX (March, 1872), p. 309. See also Charles Coleman Sellers, "Rembrandt Peale, 'Instigator,'" *Pennsylvania Magazine of History and Biography*, LXXIX (July, 1955), pp. 331–342, for more on the original intentions of the Academy.

15. William Dunlap, *Address to the Students of the National Academy of Design . . .* (New York, 1831), pp. 16–17.

16. Pevsner, *Academies of Art*, p. 188.

17. Though in retrospect, some saw the Royal Academy as a great influence on industrial art. See Benjamin West to Charles Willson Peale, London, September 19, 1809, reprinted in *Port Folio*, new ser., III (January, 1810), p. 10.

18. For a sample of this quarreling see J. H. I. Browere to the directors of the American Academy of Art, New York, July 31, 1829, History of Art Manuscripts, AAA. For a contemporary observation on artistic quarreling see Ithiel Town, *The Outlines of a Plan for Establishing in New York an Academy and Institution of the Fine Arts* (New York, 1835), p. 7. Town, an architect, recommended that laymen run the institution, and artists elect its members. Finally, see John Rubens Smith to Asher B. Durand, New York, May 25, 1826, History of Art Manuscripts, AAA.

19. Horace Binney to Caleb Cope, Philadelphia, May 18, 1870, quoted in [Shinn] "The First American Art Academy," *Lippincott's Magazine*, IX (February, 1872), p. 144.

20. See the list of patrons in Theodore Sizer, "The American Academy of the Fine Arts," Mary Bartlett Cowdrey (ed.), *The American Academy of Fine Arts and American Art-Union* (New York, 1953), I, pp. 66–81.

21. For the Richmond Museum, which lasted less than twenty years, see Richard Beale Davis, *Intellectual Life in Jefferson's Virginia, 1790–1830* (Chapel Hill, 1964), pp. 225–226. The Baltimore Academy had a similarly short life. See also Anna Wells Rutledge, "Artists in the Life of Charleston," *Transactions of the American Philosophical Society*, new ser., vol. 39, pt. 2 (November, 1949), pp. 137–140. For the fees of the American Academy see Sizer, "The American Academy," p. 13. The original 1805 subscriptions were fifty dollars, so that holders received two shares when the price was halved. Ownership remained more important than philanthropy.

22. In 1807 the Pennsylvania Academy divided its property into three hundred shares of fifty dollars each. See *Charter, By-Laws and Standing Resolutions of the Pennsylvania Academy of Fine Arts* (Philadelphia, 1813).

23. Cummings in his *Annals of the National Academy* and Dunlap in his *History* go into great detail about the break. Both these writers were hostile to Trumbull; the artists felt Trumbull's insulting manner more keenly than his actions. For a letter of reassurance to Trumbull see George Cooke to Trumbull, Raleigh, February 25, 1835, History of Art Manuscripts, AAA.

24. See Charles Coleman Sellers, *The Later Life of Charles Willson Peale (1790–1827)* (Philadelphia, 1947), p. 206.

25. Benson J. Lossing, "The National Academy of the Arts of Design, and its Surviving Members," *Harper's New Monthly Magazine*, LXVI (May, 1883), pp. 852-863. The Pennsylvania Academy allowed for forty academicians who would fill their own vacancies, and elect six of their members to sit at board of director meetings. They greatly had the advantage of the New York artists.

26. Quoted in Dunlap, *History*, III, pp. 52–53. Also quoted in Cummings, *Annals of the National Academy*, p. 20.

27. Quoted in John Durand, *The Life and Times of A. B. Durand* (New York, 1894), p. 27–28. Durand charged that Trumbull was trying to re-create the Royal Academy. Actually, at the start this was the objective, conscious or unconscious, of many other artists as well. Trumbull merely realized that somehow an educated and sympathetic group of laymen must be gathered to the cause of the arts. His rigidity, of course, was fatal to his original plans.

28. See above, note 25.

29. Henderson, *The Pennsylvania Academy*, pp. 30–31. Lay members were slightly less conservative; they wanted to exhibit the statues one day a week exclusively for ladies.

30. See Richard Hofstadter, *Academic Freedom in the Age of the College* (New York, 1955, 1961), chap. II.

31. Washington Allston to Charles Robert Leslie, Cambridgeport, February 7, 1823, in Jared B. Flagg, *The Life and Letters of Washington Allston* (New York, 1892), p. 175.

32. *Act of Incorporation, Artists' Fund Society* (Philadelphia, 1835).

33. Joshua Shaw to Asher B. Durand, Philadelphia, July 28, 1838, History of Art Manuscripts, AAA.

34. *New York Mirror*, XIV (March 18, 1837), p. 304. See also *Port Folio*, IV (December, 1810), p. 29.

35. Dehon, "A Discourse Upon the Importance of Literature," p. 466.

36. Simpson (ed.), *Federalist Literary Mind*, p. 41. See also John Thornton Kirkland, *Monthly Anthology*, VII (January, 1807), quoted in *Federalist Literary Mind*, p. 144.

37. [Franklin Dexter] "Academies of Arts . . . ," *North American Review*, XXVI (January, 1828), p. 214.

38. Lester, *The Artist, The Merchant, and The Statesman*, I, p. 109.

39. "A Reply to Article X . . . ," *Southern Review*, IV (August, 1829), p. 85.

40. Quoted in Cummings, *Annals of the National Academy*, p. 29.

41. G. M., "Review of Second Annual Exhibition of the Society of Artists and the Pennsylvania Academy," *Port Folio*, VIII (July, 1812), p. 19. See also *Port Folio*, 3rd ser., II (August, 1813), pp. 125–126.

42. James Fenimore Cooper to Horatio Greenough, Cooperstown, June 14, 1836, *The Correspondence of James Fenimore Cooper*, James Fenimore Cooper (ed.) (New Haven, 1922), I, p. 358.

43. C. Edwards Lester, *The Artists of America: A Series of Biographical Sketches of American Artists* (New York, 1846), pp. 221–222.

44. James Gates Percival to James Lawrence Yvonnet, New Haven, July 18, 1823, Julius H. Ward, *The Life and Letters of James Gates Percival* (Boston, 1866), p. 171.

45. [Isaac Candler] *A Summary View of America* . . . (London, 1824), p. 446; and Godfrey T. Vigne, *Six Months in America* (Philadelphia, 1833), p. 13.

46. John Trumbull to John Quincy Adams, December 25, 1826, quoted in Dunlap, *History*, II, pp. 66–69.

47. Washington Allston to Leonard Jarvis, Cambridgeport, June 24, 1836, Flagg, *Life of Allston*, p. 289.

48. Horatio Greenough to Washington Allston, Florence, March, 1835, quoted in Nathalia Wright, *Horatio Greenough, The First American Sculptor* (Philadelphia, 1963), p. 130.

49. *Port Folio*, IV (December, 1810), pp. 13–14. See also *Monthly Anthology*, VI (May, 1807), p. 23; and *Port Folio*, 3rd ser., III (June, 1814), p. 560.

50. *United States Review and Literary Gazette*, II (July, 1827), p. 312.

51. Gulian C. Verplanck, "Address on the Fine Arts . . . ," *Discourses and Addresses on Subjects of American History, Art, and Literature* (New York, 1833), p. 150.

52. Washington Allston to George W. Flagg, Cambridgeport, October 29, 1840, Dreer Collection, box I, HSP.

53. For such comments on wealth see A. G. Magrath, *An Oration . . . Before the '76 Association* . . . (Charleston, 1841), p. 29.

54. "The Fine Arts," *Port Folio,* V (March, 1811), pp. 194–195. Rembrandt Peale also urged Americans to collect copies. See Lester, *Artists of America,* p. 215.

55. Vigne, *Six Months in America,* p. 41.

56. Willam Tudor, Jr., quoted in Simpson (ed.), *Federalist Literary Mind,* pp. 218–219. See also *Knickerbocker,* XIII (May, 1839), p. 423; and Charles Fraser, "An Essay, On the Conditions and Prospects of Painting in the United States," *American Monthly Magazine,* VI (November, 1835), p. 243.

57. Frances Trollope, *Domestic Manners of the Americans,* Donald Smalley (ed.) (New York, 1949), p. 67. Mrs. Trollope used the anecdote to demonstrate American vulgarity; its more significant point apparently escaped her.

58. Davis, *Intellectual Life in Jefferson's Virginia, passim.* See also Emily Johnston De Forest, *James Colles, 1788–1883, Life and Letters* (New York, 1926), pp. 125–204.

59. A sketch of Meade can be found in Allan Johnson and Dumas Malone (eds.), *Dictionary of American Biography,* 20 vols., (New York, 1928–1936), XII, p. 478. Among other American diplomats in Spain who formed collections were James Bowdoin and Obadiah Rich. Later in the century American diplomats in Italy, like C. Edwards Lester and George Washington Greene, were able to indulge their art interests also, though they were active in the communities of American artists abroad also.

60. For information concerning this traffic see William T. Whitley, *Artists and their Friends in England, 1700–1799,* 2 vols. (London, 1928); and William T. Whitley, *Art in England, 1800–1820* (New York, 1928).

61. *Port Folio,* 3rd ser., III (June, 1814), p. 560. See also *Port Folio* 3rd ser., II (August, 1813), pp. 124–127.

62. For a discussion of Bowdoin, Jefferson, and other collectors see W. G. Constable, *Art Collecting in the United States of America: An Outline of a History* (Toronto and New York, 1964), pp. 10–30.

63. Gulian C. Verplanck to Washington Allston, New York, May 19, 1819, quoted in Flagg, *Life of Allston,* p. 154.

64. For Verplanck see Robert W. July, *The Essential New Yorker: Gulian Crommelin Verplanck* (Durham, 1951). The names of the Bostonians I selected at random from the records printed in Mabel Munson Swan, *The Athenaeum Gallery, 1827–1873. The Boston Athenaeum as an Early Patron of Art* (Boston, 1940); and *The Athenaeum Centenary, The Influence and History of the Boston Athenaeum* (Boston, 1907). By

1827 the collection had grown sufficiently to stimulate at least one poet, W. G. Crosby, to describe the art displayed. See his *Poetical Illustrations of the Athenaeum Gallery* (Boston, 1827).

65. Taken from the *Catalogue of the Third Exhibition* . . . (Boston, 1829).

66. Swan, *The Athenaeum Gallery*, p. 118.

67. For Hone's collecting habits see Durand, *A. B. Durand, passim*.

68. *The Diary of Philip Hone, 1828–1851*, Allan Nevins (ed.) (New York, 1927), I, p. 93. Hone made a number of shrewd comments about American painters. See *Diary of Hone*, I, p. 207.

69. Samuel Morse to De Witt Bloodgood, New York, December 29, 1833, Dreer Collection, box II, HSP.

70. Alexander Robertson to Robert Gilmor, London, January 7, 1820, Dreer Collection, box IV, HSP.

71. Thomas Cole to Robert Gilmor, Catskill, July 28, 1826, Dreer Collection, box I, HSP.

72. For Gilmor's views see Gilmor to Cole, Baltimore, December 5, 1827, Cole Papers (Photostats), NYHS. For Cole's relationship with Gilmor see Barbara Novak, "Thomas Cole and Robert Gilmor," *Art Quarterly*, XXV (Spring, 1962), pp. 41–53; and Barbara Novak Deutsch, "Cole and Durand: Criticism and Patronage of American Taste in Landscape, 1825–1865," Ph.D. dissertation, Radcliffe College, 1957.

73. Cole to Gilmor, New York City, December 25, 1825, Louis Legrand Noble, *The Life and Works of Thomas Cole*, Elliot S. Vesell (ed.) (Cambridge, Mass., 1964), p. 63.

74. For Reed see Johnson and Malone (eds.), *Dictionary of American Biography*, XV, p. 453; see also James Thomas Flexner, *That Wilder Image: The Painting of America's Native School from Thomas Cole to Winslow Homer* (Boston, 1962), pp. 103–109.

75. For details concerning Reed's patronage see J. P. Whittlesey to Jonathan Sturges, Wallingrod, October 6, 1858, Durand Papers, box 4, NYPL.

76. [Thomas Cole] "Lines Occasioned by the Death of Mr. Luman Reed," *Knickerbocker*, XII (September, 1838), p. 272.

77. John Vanderlyn to Aaron Burr, New York City, April 6, 1802, Dreer Collection, box V, HSP.

78. Sylvester Genin to his father, New York, July 30, 1840, *Selections from the works of the late Sylvester Genin, Esq., in Poetry, Prose and Historical Design* (New York, 1855), p. 29.

79. Francis and Theresa Pulszky, *White, Red, Black, Sketches of Society in the United States* . . . (London, 1858), III, pp. 164–165. See also Isaac A. Jewett, *Passages in Foreign Travel* (Boston, 1838), II, p. 26. Jewett urged Americans to use but not ape Europe. Some of the arguments about the role of European masterpieces were part of a more general debate between adherents of cosmopolitanism and na-

354 *Notes to Pages 107–109*

tionalism. Perry Miller, *The Raven and the Whale, The War of Words and Wits in the Era of Poe and Melville* (New York, 1956); and Benjamin T. Spencer, *The Quest for Nationality* (Syracuse, 1957), are among the more interesting studies of the problem.

80. *Port Folio,* VIII (July, 1812), p. 27. But for a contradictory position see *Port Folio,* 3rd ser., II (August, 1813), pp. 125–126. In this latter issue nationalism was coupled with a populistic bias. "The progress and improvement of the arts in America, must not altogether depend on foreign productions. . . . Where correct morals, good education, solid sense, and unvitiated taste exist, public opinion must always be correct. . . ." Consistent editorial policy concerning the importance of popular judgment and foreign study is difficult to find, even within the same journal. A failure to think the problem out, stemming from the passivity of most Americans toward art theory, discussed in chap. I, was the primary cause for such inconsistencies.

81. Quoted in Raddin, *The New York of Hocquet Caritat,* p. 54.

82. Washington Allston to Charles Robert Leslie, Cambridgeport, May 8, 1822, quoted in Flagg, *Life of Allston,* p. 173. For Reed see J. P. Whittlesey to Jonathan Sturges, Wallingrod, October 6, 1858, Durand Papers, box 4, NYPL.

83. Nicholas Longworth to Thomas Buchanan Read, Cincinnati, October 20, 1840, "The Letters of Thomas Buchanan Read," Alice E. Smith (ed.), *Ohio State Archaeological and Historical Quarterly,* XLVI (January, 1937), p. 71.

84. Read to Thomas Campbell, Cleveland, November 10, 1840, "Letters of Read," p. 71.

85. See the comment of James De Veaux, a Southern artist, in Robert W. Gibbes, M.D., *A Memoir of James De Veaux* (Columbia, S. C., 1846), p. 12.

86. For comments on these appellations see Alfred Bunn, *Old England and New England* (London, 1853), I, p. 190.

87. [Thomas Hamilton] *Men and Manners in America* (Philadelphia, 1833), p. 180.

88. For a description of Philadelphia as the Athens of America see Harold Edward Dickson, *John Wesley Jarvis, American Painter, 1780–1840* (New York, 1949), pp. 21–22.

89. See Rembrandt Peale's comment that in 1803 "Philadelphia was the city of promise. . . ." Quoted in Lester, *Artists of America,* p. 207.

90. Van Wyck Brooks, *The Times of Melville and Whitman* ([New York] 1947), pp. 27–47.

91. [Hamilton] *Men and Manners,* p. 180.

92. *Jeffersonian America, Notes on the United States of America, Collected in the Years 1805–6–7 and 1811–12 by Sir Augustus John Foster, Bart.,* Richard Beale Davis (ed.) (San Marino, 1954), pp. 259–260. For an earlier, more favorable view of Philadelphia, see Charles

William Janson, *The Stranger in America,* Carl S. Driver (ed.) (London, 1807; New York, 1935), p. 183.

93. *The Aristocratic Journey, Being the Outspoken Letters of Mrs. Basil Hall . . . ,* Una Pope-Hennessy (ed.) (New York, 1931), p. 140. For other disparaging comments on Philadelphia see Adam Hodgson, *Letters from North America* (London, 1824), II, p. 19; Isaac Weld, Jr., *Travels Through the States of North America . . .* (London, 1807), I, p. 8; Count Francesco Arese, "Philadelphia and Baltimore in 1837, Notes written by an Italian Count . . . ," Lynn M. Case (trans.), *Pennsylvania Magazine of History and Biography,* LVII (April, 1933), p. 183.

94. See, for example [Candler] *A Summary View,* p. 485.

95. [Candler] *A Summary View,* p. 22. See also *Jeffersonian America . . . ,* p. 294.

96. [Hamilton] *Men and Manners,* p. 92.

97. William Chambers, *Things as They Are in America* (London, 1854), pp. 177, 179.

98. Theodore Dwight, *Summer Tours; or, Notes of a Traveller* (New York, 1834, 1847), p. 55. See also Achille Murat, *America and the Americans* (New York, 1849), pp. 244–245.

99. Peale is quoted in Sellers, *Later Life of Peale,* pp. 31–32. "The Diaries of Sidney George Fisher," *Pennsylvania Magazine of History and Biography,* LXXXVI (January, 1962), p. 65.

100. William Tudor, for example, felt that Boston's commercial interests led to great traveling which eventually diffused a "taste for the arts. The encouragement they receive is not indeed splendid, but it is progressive." William Tudor, *Letters on the Eastern States* (New York, 1820), p. 317.

101. Richard S. Greenough to Henry Kirke Brown, Boston, February 22, 1843, Gratz Collection, box I, HSP.

102. Sylvester Genin to his father, New York, July 30, 1840, *Selections from the works of Genin,* p. 29.

103. Cephas G. Thompson to William Cullen Bryant, Boston, August 12, 1850, Bryant-Godwin Papers, NYPL.

104. Thomas Doughty to Cephas G. Childs, Roxbury, April 10, 1830, Dreer Collection, box I, HSP.

105. Alexander Jackson Davis to Thomas B. Ashton, New York, December 26, 1837, Artists' Fund Society Minute Books, HSP. Thomas Sully to ———, Philadelphia, March 11, 1848, Dreer Collection, box I, HSP.

106. Samuel Morse to his brothers, London, May 17, 1812, *Samuel F. B. Morse, His Letters and Journals,* Edward Lind Morse (ed.) (Boston, 1914), I, p. 73.

107. Morse to his parents, London, March 12, 1804, *Morse, Letters and Journals,* I, p. 122.

108. Morse to Washington Allston, Boston, April 10, 1818, *Morse, Letters and Journals,* I, p. 197.

109. Morse to Mrs. Morse, Albany, August 27, 1823, *Morse, Letters and Journals,* I, pp. 248–249. Characteristically, Morse insisted that he desired Trumbull's place not for personal ambition, but for "a better opportunity of doing *something for the arts in our country. . . ."*

110. Morse to Mrs. Morse, New York, n. d., *Morse, Letters and Journals,* I, p. 251. The letters of Thomas Buchanan Read reveal similar fluctuations. See Read to Edwin R. Campbell, Boston, November 28, 1841, "Letters of Read," p. 79. Read eventually settled the problem by moving to Italy.

111. Even in the 1830s, however, art suppliers had problems. James Herring reported in 1839 that two of the largest dealers in New York, L. P. Clover and Del Vecchio, men who also sold looking glasses, frames and gilding, were in desperate straits. See James Herring to Charles B. King, New York, February 13, 1839, Roberts Autograph Collection, AAA.

112. Quoted in Dunlap, *History,* I, p. 235.

113. See Ralph Thompson, *American Literary Annuals and Gift Books, 1825–1865* (New York, 1936), particularly chap. V. See also Benjamin Rowland, Jr., "Popular Romanticism: Art and the Gift Books," *Art Quarterly,* XX (Winter, 1957), pp. 364–381.

114. Eugene Exman, *The Brothers Harper* (New York, 1965), pp. 163–164. This book contains a good deal of information concerning the literary world in which New York artists moved.

115. See Nicholas B. Wainwright, *Philadelphia in the Romantic Age of Lithography* (Philadelphia, 1958), *passim.*

116. See above, note 89. The number of immigrant artists who came to Philadelphia in the early part of the century was striking; by the 1840s, however, most of them made their way to New York.

117. Notably Van Wyck Brooks, *The World of Washington Irving* (New York, 1944); and *Times of Melville and Whitman* ([New York] 1947).

118. E. A. Brackett to William Cullen Bryant, Boston November 10, 1843, Bryant-Godwin Collection, NYPL. This dependency was reversed later in the century when writers began to visit Europe; the already established artist communities introduced visiting authors to local society and professional institutions. Thus artists returned old favors.

119. See, for example, "The Sister Arts; or Poetry, Painting, and Sculpture," *American Monthly Magazine,* II (October, 1836), pp. 357–365.

120. And also get them written work if possible. See Christopher Pearse Cranch to Parke Godwin, Paris, April 18, 1861, Bryant-Godwin Collection, NYPL.

121. Washington Allston to Gulian C. Verplanck, Cambridgeport,

March 29, 1830, quoted in Flagg, *Life of Allston*, p. 238. Painters had to be certain that the writers they used were sufficiently popular for their art to be comprehended. See the comments of Charles Robert Leslie concerning subject material in Charles Robert Leslie, *Autobiographical Recollections* (Boston, 1860), p. 194

122. See Exman, *Brothers Harper, passim.* Another artist-illustrator was J. F. Kensett, who made sketches for George William Curtis' *Lotus-Eating.*

123. James Fenimore Cooper to J. F. De Kay, Florence, May 25, 1829, *Correspondence of Cooper,* I, p. 169.

124. See James Russell Lowell to William Page, Philadelphia, March 16, 1845. Page Papers, AAA; and C. F. Briggs to Page, Staten Island, December 3, 1845, Page Papers. This manuscript collection contains many letters from Briggs attacking Boston provincialism and predicting to Page that it would mean total obscurity for him to remain there.

125. Lowell was friendly with Page, Cranch, Rowse and William J. Stillman, and had met Allston. See *Letters of James Russell Lowell,* Charles Eliot Norton (ed.) (New York, 1894), I, *passim.* But this paled beside the artist acquaintances of writers like Willis, Fay, Briggs and Bryant. For more on the New York art and literary worlds see J. C. Derby, *Fifty Years among Authors, Books and Publishers* (New York, 1884); and Warren G. French, " 'Homage to Genius'; The Complimentary Festival to Authors, 1855," *NYHS Quarterly,* XXXIX (October, 1955), pp. 357–369.

126. Joseph Stevens Buckminster, "American Literary History," *Monthly Anthology,* V (January, 1808), quoted in Simpson (ed.), *Federalist Literary Mind,* p. 175.

127. Willam Tudor, quoted in *Port Folio,* IX (1820), p. 466. See also *Port Folio,* IV (July, 1814), p. 51.

128. "A Reply to Article X . . . ," p. 180.

129. C. F. Briggs to James Russell Lowell, Staten Island, January 6, 1844, Page Papers, AAA.

130. Rembrandt Peale to Ithiel Town, Philadelphia, September 3, 1839, Robert Graham Autograph Collection, AAA.

131. Matthew Jouett to Thomas Sully, Fayette County, November 12, 1822, Dreer Collection, box II, HSP.

132. Horatio Greenough to Henry Greenough, Philadelphia, May 4, 1833, *Letters of Horatio Greenough to his brother* . . . Frances Boott Greenough (ed.) (Boston, 1887), p. 149.

133. Joseph Dennie, *The Lay Preacher,* Milton Ellis (ed.) (New York, 1943), pp. 20–30. Dennie wrote this in the 1790s.

134. Benjamin Welles, "The Love of Nature," *Monthly Anthology,* III (1806), pp. 285–288, quoted in Simpson (ed.), *Federalist Literary Mind,* p. 214. See also *New York Mirror,* IV (December 23, 1826), p. 173.

135. *The Diary of George Templeton Strong*, Allan Nevins and Milton Halsey Thomas (eds.) (New York, 1952), I, p. 104.

136. For the "geography" view see Daniel J. Boorstin, *The Americans: The National Experience* (New York, 1965), pp. 93–95.

137. *Jeffersonian America* . . . , p. 288; and John M. Duncan, *Travels through Parts of the United States and Canada in 1818 and 1819* (Glasgow, 1823), I, pp. 321–322, present this view.

138. James Fenimore Cooper, *Home as Found* (New York, 1860), p. 359.

139. Timothy Dwight, *Travels in New-England and New-York* (London, 1823), I, p. 446. See also II, p. 416. For observations on the problem of anti-urbanism see Morton and Lucia White, *The Intellectual Versus the City* (Cambridge, Mass., 1962); and Anselm L. Strauss, *Images of the American City* (Glencoe, Ill., 1961).

140. John Whipple, *Discourse Delivered before the Citizens of Providence* . . . [Providence, 1838], pp. 19–20.

141. Quoted in *A General View of the Fine Arts, Critical and Historical* (New York, 1851), p. 283.

142. Charles Lanman, *Essays for Summer Hours* (Boston, 1842), pp. 235–237.

143. Quoted in Durand, *A. B. Durand*, p. 141.

144. Quoted in Noble, *Life of Cole*, p. 140. His artistic destruction of a huge, flourishing city in "The Course of Empire," filled both a personal need and an intellectual convention. See also pp. 162, 195–196.

145. Dunlap, *History*, III, p. 140.

146. Dunlap, *History*, III, p. 143.

147. Dunlap, *History*, III, pp. 147–148.

148. Alexis de Tocqueville, *Democracy in America*, Phillips Bradley (ed.) (New York, 1945, 1954), II, p. 77.

149. No one study brings these themes together, though the sentimentality of the huge mass of gift books, ladies' novels, and poetic effusions has often been recognized. These themes are evident also in more serious religious, literary and philosophical thought; see the works of Channing, Bushnell, Bryant, and even the Transcendentalists. Some, like Cole, took refuge in religious formalism and ritual, as did Lanman in later years.

150. Lanman, *Essays*, pp. 33–34.

151. For Breton see Martin P. Snyder, "William L. Breton, Philadelphia Artist," *Pennsylvania Magazine of History and Biography*, LXXV (April, 1961), pp. 178–209. For the others see the biographies and bibliographies in George C. Groce and David H. Wallace, *The New-York Historical Society's Dictionary of Artists in America, 1564–1860* (New Haven, 1957). Other foreign-born artists who did interesting urban vistas include Archibald Robertson, John Rubens Smith, Wil-

liam G. Wall, J. Milbert and the Baroness Hyde de Neuville. The first picture book of New York was probably Theodore S. Fay, *Views in the City of New-York* (New York, 1831–32). For reproductions from this work, and for hundreds of other interesting city prints, see John A. Kouwenhoven, *The Columbia Historical Portrait of New York* (Garden City, 1953).

152. This impression can be tested by browsing through a book like Kouwenhoven's *Historical Portrait,* or I. N. P. Stokes, *American Historical Prints, Early Views of American Cities* (New York, 1932).

153. A similar point is made in Martin P. Snyder, "Wild and his Philadelphia Views," *Pennsylvania Magazine of History and Biography,* LXXVII (January, 1953), pp. 32–75. See particularly, p. 50. For the beginnings of a sense of modern perspective see the reproductions in Wainwright, *Philadelphia in the Romantic Age of Lithography,* pp. 36–39. Wild's panorama views are reproduced, pp. 47–48, 51–52.

154. Quoted in Whitley, *Gilbert Stuart,* p. 140.

155. *Port Folio,* IX (1820), p. 463. See also *New York Mirror,* XIV (July 9, 1863), p. 15.

156. M. Charles Paterson, *An Address Delivered at the Opening of the Twelfth Exhibition of the American Academy of the Fine Arts* (New York, 1826), p. 38. See also Charles Willson Peale's liberal remarks, quoted in Sellers, *Later Life of Peale,* pp. 131–132.

5 European Travel: The Immediate Experience

1. A growing literature is being devoted to American travel experience, but there is no fully satisfactory study of the pre-Civil War period. Paul R. Baker, *The Fortunate Pilgrims: Americans in Italy, 1800–1860* (Cambridge, Mass., 1964), is a valuable work and fills many gaps; its bibliography has been helpful, and chap. VI, "The World of Art," is particularly interesting. Cushing Strout, *The American Image of the Old World* (New York, 1963), and Foster Rhea Dulles, *Americans Abroad: Two Centuries of European Travel* (Ann Arbor, 1964), are other surveys. For the most part, I have merely browsed through as many travel books as possible. For Italy, Sergio Samek, "Bibliografia di viaggiatori stranieri in Italia nel Secolo XIX," *Annales Institutorum,* vol. X, pt. III (1938), pp. 245–265, is indispensable. Articles on individual experiences, such as Donald A. Ringe, "Bryant's Criticism of the Fine Arts," *College Art Journal,* XVII (Fall, 1957), pp. 43–54, are informative, but are usually written in isolation from the larger experiences of a generation of travelers; personal idiosyncrasies and insights achieve thereby greater credit than they actually deserve.

2. *The Diary of Philip Hone, 1828–1851* Allan Nevins (ed.) (New York, 1927), I, p. 372. Hone himself visited Europe, as part of his post-retirement education.

3. Wilbur Fisk, *Travels in Europe* (New York, 1838), p. 343.

4. See Henry Colman, *European Life and Manners in Familiar Letters to Friends*, 2 vols. (Boston, 1849), *passim*.

5. Charles Eliot Norton, *Notes of Travel and Study in Italy* (Boston, 1860), p. 180. This was the reason he offered for the lack of encouragement the best American artists faced.

6. Sanford R. Gifford to his father, May 28, 1855, Gifford Letters, AAA.

7. Daniel J. Boorstin, *The Image or What Happened to the American Dream* (New York, 1962), pp. 90–99, discusses the effect of improved travel on foreign experiences.

8. [W. M. Gillespie] *Rome: As Seen by a New-Yorker in 1843–4* (New York, 1845), p. 82. See also George Ticknor's Journal for September 22, 1816, *The Life, Letters and Journals of George Ticknor* (Boston, 1909), I, p. 109; and *The Reminiscences of William C. Preston*, Minnie Clare Yarborough (ed.) (Chapel Hill, 1933), p. 39.

9. Quoted in *The Crayon*, VI (February, 1859), p. 64.

10. Cyrus Augustus Bartol, *Pictures of Europe, Framed in Ideas* (Boston, 1856), p. 204.

11. Henry P. Tappan, *A Step from the New World to the Old, and Back Again* . . . (New York, 1852), I, p. 229. Tappan's concern lay not with the specific message of the art work, but the intensity of the experience it could provoke. See I, p. 230. The contrast with earlier travelers, like John Adams, is striking.

12. Henry Ward Beecher, *Star Papers: or Experiences of Art and Nature* (New York, 1855), p. 57. See also *Star Papers*, p. 60.

13. John W. Corson, *Loiterings in Europe* . . . (New York, 1846), pp. 193–195. Again, unlike John Adams, Corson defended his infatuation.

14. Cornelius Conway Felton, *Familiar Letters from Europe* (Boston, 1865), pp. 65–66.

15. William Ware, *Sketches of European Capitals* (Boston, 1851), p. 99.

16. Beecher, *Star Papers*, p. 14.

17. Reverend Orville Dewey, *The Old World and the New* (New York, 1836), II, pp. 106–107.

18. Walter Channing, *A Physician's Vacation; or, A Summer in Europe* (Boston, 1856), pp. 341–342.

19. Beecher, *Star Papers*, p. 48.

20. Beecher, *Star Papers*, p. 68. See also John E. Edwards, *Random Sketches and Notes of European Travels in 1856* (New York, 1857), p. 63.

21. Emma Willard, *Journal and Letters, from France and Great-Britain* (Troy, 1833), p. 54.

22. Willard, *Journal and Letters*, pp. 56-57.

23. George S. Hillard, *Six Months in Italy* (Boston, 1853), I, p 203.

24. Bartol, *Pictures of Europe,* p. 159; and *Reminiscences of Preston,* p. 80.

25. Bartol, *Pictures of Europe,* p. 159. See also Bayard Taylor's comment that "there is often times a more thrilling sensation of enjoyment produced by the creations of man's hand and intellect, than the grander effects of Nature. . . ." *Views A-Foot: or Europe seen with Knapsack and Staff* (New York, 1854), pp. 243–244.

26. George H. Calvert, *Scenes and Thoughts in Europe,* 1st ser. (Boston, 1863), p. 144. These statements were written in the early 1840s, while Calvert was defending Greenough's "Washington."

27. Caroline Matilda (Stansbury) Kirkland, *Holidays Abroad: or, Europe from the West* (New York, 1849), I, p. 212.

28. Margaret Fuller Ossoli, *At Home and Abroad, or Things and Thoughts in America and Europe,* Arthur B. Fuller (ed.) (Boston, 1856), pp. 198–199.

29 James Freeman Clarke, *Eleven Weeks in Europe* . . . (Boston, 1852), pp. 84–85.

30. Quoted in Nathalia Wright, *Horatio Greenough, The First American Sculptor* (Philadelphia, 1963), p. 99.

31. Calvert, *Scenes and Thoughts,* p. 143. See also Isaac A. Jewett, *Passages in Foreign Travel* (Boston, 1838), II, p. 296.

32. For example, W. M. Gillespie wrote that the highest art was "not the preservation of portraits of either individuals or races . . . but the embodiment of the purest and highest ideal of beauty . . . identical in all ages and countries. Sculpture realizes it in the purest and most abstract manner, rejecting color. . . ." *Rome: As Seen by a New Yorker,* p. 189.

33. See the comments of Sir Augustus Foster, *Jeffersonian America, Notes on the United States of America, Collected in the Years 1805–6–7 and 1811–12 by Sir Augustus John Foster, Bart.,* Richard Beale Davis (ed.) (San Marino, 1954), p. 258. Foster thought the outrages were caused by just this segregation.

34. John Griscom, *A Year in Europe* . . . (New York, 1823), I, p. 251. See also [Matthias Bruen] *Essays, Descriptive and Moral; on Scenes in Italy, Switzerland, and France. By an American* (Edinburgh, 1823), pp. 98–99. See also *Reminiscences of Preston,* p. 64.

35. Fisk, *Travels in Europe,* p. 366; see also pp. 152–153. Fisk's sentiments did not differ dramatically from Benjamin Silliman's, expressed a generation before. Silliman also opposed mixed parties touring sculpture galleries, Benjamin Silliman, *A Journal of Travels in England, Holland and Scotland . . . in the Years 1805 and 1806,* 3rd ed. (New Haven, 1820), I, pp. 255–256. For concern that Americans might learn to tolerate nudity, see Samuel Topliff to Mr. Dorr, Paris, March 30, 1820, *Topliff's Travels, Letters from Abroad in the Years 1828 and 1829 by Samuel Topliff,* Ethel Stanwood Bolton (ed.) (Boston, 1906),

p. 196. See also Kirkland, *Holidays Abroad,* II, p. 82; and Channing, *A Physician's Vacation,* p. 486.

36. *Reminiscences of Preston,* p. 111.

37. Willard, *Journal and Letters,* p. 62. The Louvre collection itself she thought enough "to demoralize a city . . . ," p. 134.

38. Jane Anthony Eames, *The Budget Closed* (Boston, 1860), p. 265.

39. Henry W. Bellows, *The Old World in Its New Face* (New York, 1868), II, p. 72.

40. Fisk, *Travels in Europe,* p. 193.

41. Beecher, *Star Papers,* p. 61. Beecher actually used the phrase "instant conversion" to describe his art experiences, p. 59.

42. Bartol, *Pictures of Europe,* p. 204.

43. *Life and Letters of Horace Bushnell,* Mary Bushnell Cheney (ed.) (New York, 1880), p. 150.

44. William M. Gould, *Zephyrs from Italy and Sicily* (New York, 1852), p. 237.

45. Beecher, *Star Papers,* pp. 293–294. The chapter from which this extract is taken is entitled, "Christian Liberty in the Use of the Beautiful."

46. Harriet Beecher Stowe, *Sunny Memories of Foreign Lands* (Boston, 1854), II, p. 249. See also II, p. 392.

47. Stowe, *Sunny Memories,* I, p. 185.

48. Dewey, *Old World and the New,* II, p. 193.

49. Kirkland, *Holidays Abroad,* II, p. 258. See also [Hezekiah H. Wright] *Desultory Reminiscences of a Tour Through Germany, Switzerland and France . . .* (Boston, 1838), p. 26; [John Sloan] *Rambles in Italy; in the Years 1816–1817, by an American* (Baltimore, 1818), p. 268; and Bellows, *The Old World,* II, p. 526. Wright and Sloan, early in the century, ranked Dutch art low because of their neoclassical values; later, with the coming of Ruskin and his followers, it was condemned because it lacked the touch of faith.

50. Clarke, *Eleven Weeks in Europe,* p. 308. In this passage Clarke was attacking the English school.

51. Stowe, *Sunny Memories,* II, p. 101. See also II, p. 308.

52. Nathaniel Hawthorne, *Passages from the English Note-books and Our Old Home, The Works of Nathaniel Hawthorne,* Standard Library Edition (Boston, 1863, 1891), I, p. 585. See also I, p. 153. For a treatment of Hawthorne's attitudes toward the gothic, see Maurice Charney, "Hawthorne and the Gothic Style," *New England Quarterly,* XXXIV (March, 1961), pp. 36–49.

53. Channing, *A Physician's Vacation,* p. 138.

54. Henry Blake McLellan, *Journal of a Residence in Scotland . . .* (Boston, 1834), p. 265.

55. Ware, *Sketches of European Capitals,* p. 96.

56. See above, notes 32, 39–40.

57. Nathaniel Hawthorne, *Passages from the French and Italian Note-books,* (Boston, 1871), p. 299.

58. Hawthorne, *French and Italian Note-books,* p. 76.

59. Nathaniel S. Wheaton, *A Journal of a Residence . . . in London . . .* (Hartford, 1830), p. 411.

60. Russell's itinerary can be gleaned from "Journal of Jonathan Russell, 1818–1819," *Proceedings of the MHS,* LI (June, 1918), pp. 369–498.

61. Fisk, *Travels in Europe,* pp. 323–324. Fisk favored smaller galleries limited to superior works, like the Vatican.

62. Kirkland, *Holidays Abroad,* II, p. 20.

63. See the complaints of the painter, Sanford R. Gifford, in a letter to his father, Paris, October 24, 1855, Gifford Letters, AAA.

64. [Gillespie] *Rome: As Seen by a New-Yorker,* p. 83.

65. Andrew McFarland, *The Escape, or Loiterings Amid the Scenes of Story and Song* (Boston, 1851), p. 178.

66. Stowe, *Sunny Memories,* II, pp. 159–160.

67. Stowe, *Sunny Memories,* II, pp. 160–161. See also I, p. 323.

68. Stowe, *Sunny Memories,* I, pp. 278–279.

69. See [Reverend Samuel Fisk] *Mr. Dunn Browne's Experiences in Foreign Parts* (Boston, 1857), pp. 46–47, 52, 102.

70. Stowe, *Sunny Memories,* II, p. 347. It is significant that Mrs. Stowe coupled a suspicion of the artist's intuitive gifts with an insistence that it was his duty to copy nature faithfully. Those who were impressed with art as a sphere of ideality declared the artist's duty one of origination. But Mrs. Stowe rejoiced "in the inspiring thought that Nature is ever the superior. No tree painting can compare with a splendid elm." *Sunny Memories,* II, p. 521.

71. Hawthorne, *English Note-books,* II, p. 521

72. Hawthorne, *French and Italian Note-books,* p. 111.

73. Hawthorne, *French and Italian Note-books,* pp. 331–332.

74. Hawthorne, *French and Italian Note-books,* p. 398.

75. Hawthorne, *French and Italian Note-books,* p. 170.

76. Hawthorne, *English Note-books,* II, p. 521

77. Hawthorne, *English Note-books,* II, p. 539.

78. Hawthorne, *French and Italian Note-books,* p. 317. See also Nathaniel Hawthorne, *The Marble Faun* (Boston, 1860), p. 388. Here Hawthorne notes that few amateurs, by looking at pictures, are "won from an evil life, nor anywise improved by it."

79. For Hawthorne's strictures on portraiture and sculpture see *French and Italian Note-books,* pp. 198–199; and *English Note-books,* II, pp. 528–530.

80. Hawthorne, *French and Italian Note-books,* p. 299. Hawthorne's extreme aversion to faded pictures indicates, first, a jealousy of the immortality artists achieved and, second, the normal American response to color. See *The Marble Faun,* pp. 144–145, p. 163.

81. Hawthorne, *English Note-books,* II, pp. 537–538.

82. Hawthorne, *French and Italian Note-books,* p. 159.

83. Millicent Bell, *Hawthorne's View of the Artist* (State University of New York, 1962), is the best analysis of Hawthorne's artistic attitudes.

84. Clarke, *Eleven Weeks in Europe,* p. 67.

6 European Travel: From Perceptions to Conceptions

1. [Matthias Bruen] *Essays, Descriptive and Moral; on Scenes in Italy, Switzerland, and France. By an American* (Edinburgh, 1823), p. 70.

2. [Bruen] *Essays,* p. 38.

3. *Samuel F. B. Morse, His Letters and Journals,* Edward Lind Morse (ed.) (New York, 1914), I, pp. 398–399.

4. Benjamin Silliman, *A Journal of Travels in England, Holland and Scotland . . . in the Years 1805–1806,* 3rd ed. (New Haven, 1820), I, p. 309. See also Henry Blake McLellan, *Journal of a Residence in Scotland . . .* (Boston, 1834). pp. 280–281.

5. Fanny Hall, *Rambles in Europe . . .* (New York, 1839), I, p. 65.

6. Hall, *Rambles in Europe,* I, p. 103.

7. Charles Godfrey Leland to Mrs. Charles Leland, Munich, April 1, 1847, quoted in Elizabeth Robins Pennell, *Charles Godfrey Leland, A Biography* (Boston and New York, 1906), I, pp. 102–103.

8. *The Journals of Francis Parkman,* Mason Wade (ed.) (New York and London, 1957), I, p. 138.

9. Grace Greenwood (pseud. for Mrs. Sara Lippincott), *Haps and Mishaps of a Tour in Europe* (Boston, 1854), p. 23.

10. Henry Colman, *European Life and Manners; in Familiar Letters to Friends* (Boston, 1849), II, p. 123.

11. George S. Hillard, *Six Months in Italy* (Boston, 1853), II, pp. 13–14.

12. Nathaniel Hawthorne, *Passages from the English Note-books and Our Old Home, The Works of Nathaniel Hawthorne,* Standard Library Edition (Boston, 1863, 1891), II, p. 335.

13. Nathaniel Hawthorne, *Passages from the French and Italian Note-books* (Boston, 1871), p. 87.

14. Reverend Orville Dewey, *The Old World and the New* (New York, 1836), II, pp. 198–199.

15. Harriet Beecher Stowe, *Sunny Memories of Foreign Lands* (Bos-

ton, 1854), II, p. 351. See also William Ellery Channing, *Conversations in Rome: Between an Artist, a Catholic, and a Critic* (Boston, 1847), p. 8.

16. Daniel C. Eddy, *Europa: or, Scenes and Society in England, France, Italy and Switzerland* (Boston, 1852), p. 203. See also George H. Calvert, *Scenes and Thoughts in Europe*, 1st ser. (Boston, 1863), pp. 172–174.

17. Greenwood, *Haps and Mishaps,* p. 180. Usually, however, this sort of criticism focused on St. Peter's. See, for example, (Samuel G. Goodrich) Peter Parley, *The Balloon Travels of Robert Merry* (New York, 1866), p. 180. See also Nathaniel Hazeltine Carter, *Letters from Europe . . . in the Years 1825, '26, and '27* (New York, 1829), II, p. 51; and Samuel S. Cox, *A Buckeye Abroad; or, Wanderings in Europe* (New York, 1852), p. 125, for further opposition to religious art.

18. Bayard Taylor, *Views A-Foot: or, Europe seen with Knapsack and Staff* (New York, 1854), p. 265.

19. Hillard, *Six Months in Italy,* I, pp. 120–121.

20. Hillard, *Six Months in Italy,* I, p. 263.

21. Charles Eliot Norton, *Notes of Travel and Study in Italy* (Boston, 1860), pp. 193–194.

22. See William Ware, *Sketches of European Capitals* (Boston, 1851), pp. 103, 105–106.

23. [Mary Jane Eames], *A Budget of Letters, or Things Which I saw Abroad* (Boston, 1847), p. 132; and Colman, *Life and Manners,* I, p. 188. Colman, who made the latter remark, was actually speaking of the ballet. See also Hillard, *Six Months in Italy,* I, p. 230, for similar sentiments.

24. *England in 1815 As Seen by a Young Boston Merchant* (Boston and New York, 1913), p. 38.

25. *Topliff's Travels, Letters from Abroad in the Years 1828 and 1829 by Samuel Topliff,* Ethel Stanwood Bolton (ed.) (Boston, 1906), p. 146.

26. Wilbur Fisk, *Travels in Europe* (New York, 1838), p. 156.

27. Reverend M. Trafton, *Rambles in Europe . . .* (Boston, 1852), pp. 156–157.

28. Trafton, *Rambles in Europe,* p. 317.

29. Fisk, *Travels in Europe,* pp. 156–157.

30. [Eames] *A Budget of Letters,* p. 155.

31. Horace Greeley, *Glances at Europe* (New York, 1851), pp. 197–198.

32. Colman, *Life and Manners,* I, p. 209.

33. Colman, *Life and Manners,* II, pp. 2–3.

34. [Elias Hasket Derby] *Two Months Abroad: Or, a Trip to England, France, Baden, Prussia, and Belgium. In August and September, 1843 . . .* (Boston, 1843), p. 53.

35. Caroline Matilda (Stansbury) Kirkland, *Holidays Abroad; or, Europe from the West* (New York, 1849), I, p. 238.

36. The story is told in J. T. Headley, *Letters from Italy* (New York, 1848), p. 197.

37. James E. Freeman, *Gatherings from an Artist's Portfolio* (New York, 1877), p. 137.

38. Henry P. Leland, *Americans in Rome* (New York, 1863), p. 166. See also Daniel Morley McKeithan, *Travelling with the Innocents Abroad. Mark Twain's Original Reports from Europe and the Holy Land* (Norman, Okla., 1958), p. 58, for a similar suspicion of the value of art objects.

39. Greenwood, *Haps and Mishaps,* p. 238.

40. Freeman, *Gatherings from an Artist's Portfolio* (Boston, 1883), p. 273. This was a later volume Freeman published under the same title as the one in 1877. See above, note 37.

41. Freeman, *Gatherings* (1883), p. 277. See also *The Crayon,* I (March 14, 1855), p. 170, for similar sentiments.

42. Kirkland, *Holidays Abroad,* II, p. 263.

43. See, for example, "American Painters. Their Errors as Regards Nationality," *Cosmopolitan Art Journal,* I (June, 1857), p. 116. See also James Fenimore Cooper, *Journal of a Residence in France . . .* (Paris, 1836), pp. 105–106.

44. For example, the Bunker Hill Monument. See Colman, *Life and Manners,* I, pp. 207–208.

45. Henry T. Tuckerman, *The Italian Sketch Book* (New York, 1848), pp. 489–490. This was what artists had already noticed about cities in the United States. See above, chap. IV, *passim.*

46. Augustus Kinsley Gardner, *Old Wine in New Bottles: or, Spare Hours of a Student in Paris* (New York 1848), p. 298.

47. Benjamin Silliman, *A Journal of Travels,* III, pp. 280–281.

48. See Daniel C. Eddy, *Europa,* p. 40; Willard C. George, *A Year Abroad* (Boston, 1852), p. 9; and Calvin Colton, *Four Years in Great Britain, 1831–1835* (New York, 1835), I, p. 45.

49. John P. Durbin, *Observations in Europe* (New York, 1844), I, p. 265.

50. Hillard, *Six Months in Italy,* II, pp. 19–20.

51. Particularly by Philadelphia and its copiers. See above, chap. IV, *passim.*

52. Emma Willard, *Journal and Letters, from France and Great-Britain* (Troy, 1833), p. 267.

53. George, *A Year Abroad,* p. 90.

54. *Putnam's Monthly Magazine,* III (June, 1854), p. 653. See also extracts from Robert Dodge, "Diary, Sketches and Reviews, During an

European Tour in the Year 1847," published in *The Literary World,* III (January 22, 1848), pp. 243–244.

55. Calvert, *Scenes and Thoughts,* p. 182.

56. See *The Christian Examiner,* LIII (September, 1852), p. 255.

57. McLellan, *Residence in Scotland,* pp. 138–139.

58. "Metropolitan Improvements," *The Literary World,* III (June 17, 1848), p. 385. This was part of a letter from Europe.

59. Henry P. Tappan, *A Step from the New World to the Old, and Back Again* . . . (New York, 1852), I, p. 68. See also [Alexander Slidell Mackenzie] *The American in England* (London, 1836), I, p. 244, for a discussion of the differences between Broadway and Regent Street.

60. Durbin, *Observations in Europe,* I, pp. 104–105.

61. Christopher Lasch, speaking of American travel experiences later in the century, particularly those of Jane Addams, Richard T. Ely, and Randolph Bourne, makes an analogous observation. See Christopher Lasch, *The New Radicalism in America (1889–1963): The Intellectual as a Social Type* (New York, 1965), pp. 65, 81.

62. [Charlotte Cushing] *Letters, Descriptive of Public Monuments, Scenery and Manners in France and Spain* (Boston, 1832), I, p. 66.

63. [Cushing] *Letters,* II, pp. 80–81.

64. [Eames] *A Budget of Letters,* p. 213. Some travelers regretted that the looted art which Napoleon had exhibited at the Louvre had been dispersed. William M. Gould, *Zephyrs from Italy and Sicily* (New York, 1852), *passim,* contains a series of appreciative remarks.

65. *The Reminiscences of William C. Preston,* Minnie Clare Yarborough (ed.) (Chapel Hill, 1933), p. 70.

66. Quoted in *Life and Letters of Horace Bushnell,* Mary Bushnell Cheney (ed.) (New York, 1880), 149.

67. Hillard, *Six Months in Italy,* I, p. 128.

68. George William Curtis to John S. Dwight, Naples, April 27, 1847, *Early Letters of George William Curtis to John S. Dwight,* George Willis Cooke (ed.) (New York, 1898), pp. 270–271. "A noble cosmopolitanism is the brightest jewel in a man's crown," Curtis concluded.

69. See, for example, Taylor, *Views A-Foot,* p. 265.

70. [Eames] *A Budget of Letters,* p. 279.

71. [Cushing] *Letters,* II, pp. 117–118. See also comments on American vandalism, and praise for Europeans in *The New World,* VI (June 17, 1843), p. 726.

72. William Cullen Bryant, *The Picturesque Souvenir, Letters of a Traveller* . . . (New York, 1851), p. 27.

73. Durbin, *Observations in Europe,* I, p. 42.

74. Walter Channing, *A Physician's Vacation; or, A Summer in Europe* (Boston, 1856), p. 439.

75. Channing, *A Physician's Vacation,* p. 439.

76. Tappan, *A Step from the New World,* II, pp. 292–293. For similar comments on the refining power of art see Durbin, *Observations in Europe,* I, pp. 91–92; Ware, *Sketches of European Capitals,* p. 221; Alfred Huidekoper, *Glimpses of Europe in 1851 and 1867–8* (Meadville, Pa., 1882), p. 172; Kirkland, *Holidays Abroad,* pp. 232–233; and [Oliver Jay Steele] *Letters from Europe* (Buffalo, 1859), p. 100.

77. As quoted in [W. C. Dana] *A Transatlantic Tour* (Philadelphia, 1845), p. 243.

78. Kirkland, *Holidays Abroad,* I, p. 268.

79. Nathaniel S. Wheaton, *A Journal of a Residence . . . in London . . .*(Hartford, 1830), pp. 348–349. Wheaton was an Episcopalian minister, rector of Christ Church in Hartford. At Paris and Versailles he exclaimed, "How much do the fine arts here owe to the liberal taste of Louis XIV!" Few Americans went this far; Napoleon was the limit their apotheoses of art-loving despots could reach.

80. Durbin, *Observations in Europe,* p. 267. See also [W. M. Gillespie] *Rome: As Seen by a New-Yorker in 1843–4* (New York, 1845), pp. 41–42, for the influence of artistic design in daily life.

81. Journal entry for June 6, 1833, *The Journals and Miscellaneous Notebooks of Ralph Waldo Emerson,* William H. Gilman *et al.* (eds.) (Cambridge, Mass., 1960–19—), IV, p. 188. See also IV, p. 161.

82. [John Sloan] *Rambles in Italy: in the Years 1816–1817, by an American* (Baltimore, 1818), pp. 355–356.

83. William Ellery Channing, *Conversations in Rome,* pp. 92–93.

84. Horace Binney Wallace, *Art and Scenery in Europe* (Philadelphia, 1857), p. 175.

85. Isaac A. Jewett, *Passages in Foreign Travel* (Boston, 1838) I, p. 19.

86. J. Jay Smith, *A Summer's Jaunt Across the Water* (Philadelphia, 1846), II, p. 115.

87. Tappan, *A Step from the New World,* I, p. 100. Tappan still maintained that American collecting must be the work of voluntary associations or individuals, and not of governments; he was not certain, however, that these associations could equal European results.

88. Gardner, *Old Wine in New Bottles,* p. 88.

89. American visitors were particularly impressed by the government-controlled establishments at Dresden and Limoges.

90. Kirkland, *Holidays Abroad,* I, p. 75.

91. Tappan, *A Step from the New World,* I, pp. 79–80.

92. Cox, *A Buckeye Abroad,* p. 426. See also [Steele] *Letters from Europe,* pp. 64, 100.

93. Tappan, *A Step from the New World,* I, p. 177.

94. Cooper, *A Residence in France*, pp. 88–89.

95. Ware, *Sketches of European Capitals*, pp. 260–261. See also above, note 53.

96. John Griscom, *A Year in Europe* . . . (New York, 1823), I, pp. 144–145.

97. Hiram Powers to James Gibson, Florence, November 23, 1847, History of Art Manuscripts, II, AAA.

98. Mrs. A. T. J. Bullard, *Sights and Scenes in Europe* (St. Louis, 1852), p. 232.

99. Sanford R. Gifford to his father, London, June 29, 1855, History of Art Manuscripts, II, AAA.

100. Kirkland, *Holidays Abroad*, I, p. 94.

101. Ware, *Sketches of European Capitals*, p. 167.

102. Wallace, *Art and Scenery in Europe*, p. 316.

103. Greeley, *Glances at Europe*, p. 39.

104. Charles Wilkes to James Fenimore Cooper, New York, December 9, 1831, *Correspondence of James Fenimore Cooper*, James Fenimore Cooper (ed.) (New Haven, 1922), I, p. 252.

105. *The Aristocratic Journey; Being the Outspoken Letters of Mrs. Basil Hall* . . . , Una Pope-Hennessy (ed.) (New York, 1931), p. 74.

106. *The Christian Examiner*, LIII (September, 1852), p. 255.

107. See John Joseph Lawler, "Comments on Art and Literature. From the Personal Writings of a Group of Well Traveled Early American Writers and Artists. A Critical Collation," Ph.D. dissertation, Florida State University, 1960, p. 162.

7 *Art and Transcendentalism: Beauty and Self-Fulfillment*

1. A survey of any mid-century American periodicals with an interest in the fine arts, like *The North American Review, The Christian Examiner* and *The Atlantic Monthly*, reveals the influence of Ruskin, Hegel, Cousin and Coleridge. For more on Ruskin, see Roger Breed Stein, "Art, Nature, and Morality; John Ruskin and Aesthetic Controversy in America," Ph.D. dissertation, Harvard University, 1960.

2. See, for example, Oscar Handlin, "The Significance of the Seventeenth Century," in James Morton Smith (ed.), *Seventeenth-Century America, Essays in Colonial History* (Chapel Hill, 1959), pp. 9–10; and Daniel J. Boorstin, *The Genius of American Politics* (Chicago, 1953, 1964), pp. 40–63.

3. Perry Miller, *Errand Into the Wilderness* (Cambridge, Mass., 1956; New York, 1964), p. 182. Two of the essays in this book, "The Rhetoric of Sensation," and "From Edwards to Emerson," are particularly appropriate. See also Perry Miller, *Jonathan Edwards* (Cambridge, Mass., 1949), *passim*.

4. After making this formulation I was encouraged to find the following statement: "It is just as much a work of piety to create any work of beauty—a beautiful house or shop for example—as it is to teach a class in the Sunday school; and if he demur, I turn him over to Jonathan Edwards, who in his *Theory of True Virtue* holds to substantially this doctrine. It is ordered that the dignity of human virtue shall in a great degree be dependent upon a sympathetic association with what is admirable." "Metropolitan Improvements," *Literary World,* III (June 17, 1848), p. 385.

5. See Theodore Dwight, *Summer Tours; or, Notes of a Traveller,* 2nd ed. (New York, 1834, 1847); Timothy Dwight, *Travels in New-England and New York,* 4 vols. (London, 1823); [Benjamin Silliman] *Remarks, Made on a Short Tour between Hartford and Quebec, in the Autumn of 1819* (New Haven, 1820); William Tudor, *Letters on the Eastern States* (New York, 1820); and *The Home Book of the Picturesque. Home Authors and Home Artists . . .* (New York, n. d.). The increase in domestic travel is clearly evident in Thomas D. Clark (ed.), *Travels in the Old South. A Bibliography,* 3 vols. (Norman, Okla., 1956–1959).

6. Theodore Dwight, *Summer Tours,* p. 74.

7. Theodore Dwight, *Summer Tours,* p. 157.

8. Henry T. Tuckerman, *Rambles and Reveries* (New York, 1841), p. 381. This chapter was entitled "Eye-Language."

9. As quoted in F. O. Matthiessen, *American Renaissance, Art and Expression in the Age of Emerson and Whitman* (London, Toronto, New York, 1941), p. 51. This book has been invaluable for both Emerson and Thoreau. I have also used, with varying degrees of profit, Charles R. Metzger, *Emerson and Greenough, Transcendental Pioneers of an American Aesthetic* (Berkeley, 1954); Vivian C. Hopkins, *Spires of Form. A Study of Emerson's Aesthetic Theory* (Cambridge, Mass., 1951); Joshua C. Taylor, *William Page, The American Titian* (Chicago, 1957), particularly chaps. 2 and 3; and Perry Miller (ed.), *The Transcendentalists, an Anthology* (Cambridge, Mass., 1950).

10. Quoted in Leland Schubert, *Hawthorne the Artist, Fine-Art Devices in Fiction* (Chapel Hill, 1944), p. 94. Schubert maintains that Hawthorne had a *"graphic* mind," and thought in pictures. See also Richard H. Fogle, "The World and the Artist: A Study of Hawthorne's 'The Artist of the Beautiful,'" *Tulane Studies in English,* I (1949), pp. 31–40. Fogle sees this story as affirming Hawthorne's belief in the value of art and the dignity of the artist. For a different opinion about Hawthorne's artistic commitments see Millicent Bell, *Hawthorne's View of the Artist* (State University of New York, 1962).

11. [Frederic Hedge] "Clarke's *Eleven Weeks in Europe,*" *Christian Examiner,* LIII (September, 1852), pp. 240–241.

12. Quoted in Clarence Paul Hotson, "Emerson and the Doctrine of Correspondences," *The New Church Review,* XXXVI (January, 1929),

p. 52. Emerson owed a great deal to Swedenborg, though he never hesitated to attack certain doctrines of the new creed. Margaret Fuller, Elizabeth Peabody and William Page had great respect for Swedenborg as well.

13. Journal entry for February 16, 1859, *The Writings of Henry David Thoreau*, Bradford Torrey (ed.) (Boston and New York, 1906), XI, p. 450.

14. Journal entry for October 9, 1857, *Writings of Thoreau*, X, p. 80.

15. Elizabeth P. Peabody (ed.), *Aesthetic Papers* (Boston, 1849), p. 9.

16. Quoted in Hotson, "Emerson and the Doctrine of Correspondences," p. 52.

17. [Ralph Waldo Emerson] "Thoughts on Art," *The Dial*, I (January, 1841), p. 368. To identify unsigned articles and poems I have used George Willis Cooke, "*The Dial*: An Historical and Biographical Introduction, with a List of the Contributors," *Journal of Speculative Philosophy*, XIX (July, 1885), pp. 225–265.

18. [Emerson] "Thoughts on Art," p. 372. Mrs. Peabody also made this observation about Allston's work; it was a high compliment to state that the artist did not intend all he suggested. Mrs. Elizabeth P. Peabody, *Last Evening with Allston and Other Papers* (Boston, 1887), p. 59.

19. [Emerson] "Thoughts on Art," p. 373.

20. George William Curtis to John S. Dwight, New York, December 22, 1843, *Early Letters of George William Curtis to John S. Dwight*, George Willis Cooke (ed.) (New York, 1898), pp. 139–140.

21. Ralph Waldo Emerson, "Art," *Essays*, 1st ser., *The Complete Works of Ralph Waldo Emerson*, Centenary Edition (Boston and New York, 1903–1904), II, p. 356.

22. Emerson, *Works*, II, p. 357.

23. Emerson, *Works*, II, p. 362.

24. [James Freeman Clarke] "The Portrait," *The Dial*, I (April, 1841), p. 468. See also Emerson, *Works*, II, p. 363.

25. Christopher Pearse Cranch to Catherine Myers, Louisville, November 28, 1834, in Leonora Cranch Scott, *The Life and Letters of Christopher Pearse Cranch* (Boston, 1917), p. 42. For more on Cranch, see F. DeWolfe Miller, *Christopher Pearse Cranch and his Caricatures of New England Transcendentalism* (Cambridge, Mass., 1951).

26. Quoted in Ralph Waldo Emerson, *et al.*, *Memoirs of Margaret Fuller Assoli* (Boston, 1860), I, p. 274.

27. *Memoirs of Margaret Fuller Ossoli*, I, p. 343.

28. [Sophia Ripley] "Painting and Scultpure," *The Dial* (July, 1841), p. 80.

29. Horace Binney Wallace, *Art and Scenery in Europe* (Philadelphia, 1857), p. 304.

30. *The Journals and Miscellaneous Notebooks of Ralph Waldo Emerson,* William H. Gilman *et al.* (eds.) (Cambridge, Mass., 1960–19—), IV, p. 161.

31. *Journals of Emerson,* IV, p. 131.

32. Emerson, *Works,* II, p. 353.

33. Emerson, *Works,* II, p. 351.

34. *Memoirs of Margaret Fuller Ossoli,* I, p. 341.

35. Journal entry for July 11, 1840, *Writings of Thoreau,* I, p. 167.

36. [Emerson] "Thoughts on Art," p. 377.

37. [Samuel G. Ward] "Notes on Art and Architecture," *The Dial,* IV (July, 1843), p. 107.

38. I. B. Wright, "Catalogue of the Sixteenth Exhibition of Paintings at the Boston Athenaeum, MDCCCXLII," *The Pioneer,* I (January, 1843), p. 13.

39. Emerson, *Works,* II, p. 367.

40. [Ward] "Notes on Art and Architecture," p. 107.

41. *Memoirs of Margaret Fuller Ossoli,* I, p. 341.

42. Journal entry for June 24, 1840, *Writings of Thoreau,* I, p. 153. See also the emphasis on passivity in [Emerson] "Thoughts on Art," p. 372.

43. [Samuel G. Ward] "The Gallery," *The Dial,* III (October, 1842), p. 272.

44. Wright, "Catalogue of the Sixteenth Exhibition," p. 16.

45. See Emerson, *Works,* II, p. 372.

46. Emerson, *Works,* II, p. 374.

47. See above, note 9.

48. *Writings of Thoreau,* II, p. 52. The theme of artistic unconsciousness would be carried out later by gardeners like Downing, in their advocacy of natural, casual gardens, to give the appearance of "growth" rather than cultivation.

49. Journal entry for July 11, 1840, *Writings of Thoreau,* I, p. 167.

50. *Memoirs of Margaret Fuller Ossoli,* I, p. 343.

51. [Christopher Pearse Cranch] "The Artist," *The Dial,* III, (October, 1842), p. 225.

52. George William Curtis to John S. Dwight, Concord, January 12, 1843, *Early Letters of Curtis to Dwight,* pp. 182–183.

53. Peabody, *Last Evening with Allston,* p. 29. This reminiscence was originally published under the title "Allston the Painter," *American Monthly Magazine,* I (May, 1836), pp. 435–446.

54. Emerson and Margaret Fuller took great interest in artist biographies, particularly the life of Michelangelo.

55. Peabody, *Last Evening with Allston,* p. 60.

56. Edgar P. Richardson, *Washington Allston, A Study of The Romantic Artist in America* (Chicago, 1948), presents the definitive portrait of Allston as a man torn by self-doubts rather than a victim of American materialism, the picture which late nineteenth-century eulogists like Henry James were fond of repeating.

57. Journal entry for October 3, 1859, *Writings of Thoreau*, XII, p. 368.

58. [John S. Dwight] "The Religion of Beauty," *The Dial*, I (July, 1840), p. 17.

59. George Bancroft, "The Office of the People in Art, Government and Religion," in Joseph L. Blau (ed.), *American Philosophical Addresses, 1700–1900* (New York, 1946), p. 104. See also Bancroft, "On the Progress of Civilization . . . ," *Boston Quarterly Review*, I (October, 1838), pp. 389–407, reprinted in part in Miller (ed.), *The Transcendentalists*, pp. 423–429.

60. Miller (ed.), *The Transcendentalists*, pp. 11–13, 422.

61. "Remarks on the Fine Arts," *Literary World*, II (December 11, 1847), p. 450. The author of this seven-part article addressed himself to the regents of the Smithsonian Institution, arguing for active government patronage of the arts.

62. H. J. Lobdell, M.D., "The Fine Arts," *Sartain's Union Magazine,* IX (August, 1851), p. 136. "Palsied be the hand that would deface a painting or strike down a statue!" the author cried.

63. Albert G. Remington, "The Influence of Art," *Sartain's Union Magazine*, IX (December, 1851), p. 474.

64. Wallace, *Art and Scenery in Europe*, p. 311.

65. Henry W. Bellows, *Transactions of the American Art-Union*, I (1844), p. 11. See also George W. Bethune, *The Prospects of Art in the United States* . . . (Philadelphia, 1840), p. 31; *The Journal* (Jacksonville, Illinois), October 2, 1846; and the Rutland *Herald*, August 19, 1846. These last two are in the American Art-Union Clipping Book, NYHS.

66. *Proceedings of the American Art-Union*, December, 1845, p. 14, Neagle Collection, AAA. See also Alexander Beaufort Meek, *Romantic Passages in Southwestern History* (Mobile, 1857), p. 177.

67. Augustine Duganne, *Art's True Mission in America* (New York, 1853), p. 12.

68. Duganne, *Art's True Mission,* p. 17.

69. Duganne, *Art's True Mission,* p. 17.

70. "The Bearings of Art Upon Elections," *The Crayon*, VI (February, 1859), pp. 61–62. The writer proposed to rebuild all polling places, and equip them with historical paintings and statues of statesmen. For the Irish, he suggested chapels. Citizens who dressed well at election time would be more responsible voters.

71. Duganne, *Art's True Mission*, p. 24.

72. Reverend W. S. Kennedy, "Conditions of the Development of National Art," *Cosmopolitan Art Journal,* III (September, 1859), p. 150. This view closely resembled the image of Curtis. See above, note 52.

73. *Transactions of the American Art-Union,* IV (1847), p. 21. See also *Literary World,* II (November 27, 1848), p. 405.

74. For a sample of this view see William Wetmore Story to James Russell Lowell, Bagni di Lucca, August 10, 1853, quoted in Henry James, *William Wetmore Story and His Friends* (Boston, 1903), I, pp. 268–269.

75. *Literary World,* II (November 6, 1847), p. 330.

8 Crusades for Beauty

1. Even Charles Willson Peale's modest monument which he erected in the gardens of his home about 1812 had a complicated allegorical schematization. See Charles Coleman Sellers, *The Later Life of Charles Willson Peale (1790–1827)* (Philadelphia, 1947), p. 283. Some of the elaborate symbolism was Masonic in character. See the discussion of Jefferson's knowledge of Free Mason symbols in Alan Gowans, *Images of American Living. Four Centuries of Architecture and Furniture as Cultural Expression* (Philadelphia, 1964), pp. 243–255.

2. Frances Trollope, *Domestic Manners of the Americans,* Donald Smalley (ed.) (New York, 1949), p. 67.

3. A description of this monument appeared in the *Port Folio,* 3rd ser., I (January, 1816), p. 1.

4. Quoted in H. M. Pierce Gallagher, *Robert Mills, Architect of the Washington Monument, 1781–1855* (New York, 1935), p. 105. Dedicated in 1815, the monument was completed in 1829, with a statue of Washington atop it. At this point Mills was not completely convinced of the need for simplicity, and proposed more ornamentation than the Monument Committee would accept. For more on this see J. Jefferson Miller II, "The Designs for the Washington Monument in Baltimore," *Journal of the Society of Architectural Historians,* XXIII (March, 1964), pp. 19–28.

5. James Longacre to Thomas Corwin, Philadelphia, March 24, 1851, Longacre Papers, Library Company of Philadelphia; microfilms in AAA.

6. Meigs to Thomas Crawford, Washington, August 23, 1853; and Crawford to Meigs, Rome, October 12, 1853, quoted in Robert L. Gale, *Thomas Crawford, American Sculptor* (Pittsburgh, 1964), pp. 109–110.

7. Peale had recently retouched the picture; the quotation comes from a four-page circular advertisement, a copy of which is in the Rembrandt Peale folder, Gratz Collection, HSP.

8. Thomas C. Upham, *Letters, Aesthetic, Social and Moral . . .*

(Brunswick, 1855), p. 48. There is an illuminating discussion of literary allegory and symbolism in F. O. Matthiessen, *American Renaissance, Art and Expression in the Age of Emerson and Whitman* (London, Toronto, New York, 1941), pp. 242–252.

9. George S. Hillard, *Six Months in Italy* (Boston, 1853), I, p. 572. An interesting debate about symbolism revolved around Thomas Crawford's statue of "Liberty," placed atop the Capitol. Jefferson Davis successfully objected to the statue's Phrygian bonnet, on the grounds that it was improper thus to represent the guardian of a people which had always been free. Crawford replied that it had come to mean liberty, and "as his work was intended for the people, it should speak to them in a language they would understand without an interpreter." But he lost this fight. See William J. Clark, Jr., *Great American Sculptures* (Philadelphia, 1878), p. 70; and Gale, *Thomas Crawford,* p. 124.

10. There is no adequate study of American monuments. For the Bunker Hill Monument I have relied mainly on William H. Wheildon, *Memoir of Solomon Willard, Architect and Superintendent of the Bunker Hill Monument* (Boston, 1865); and George Washington Warren, *The History of the Bunker Hill Monument Association* (Boston, 1877).

11. The premium was never awarded, due to rival claims.

12. Wheildon, *Memoir of Willard,* p. 67.

13. Robert Mills to the monument committee, Columbia, March 20, 1825, quoted in Wheildon, *Memoir of Willard,* pp. 89–90.

14. *Description of Frazee's Design for the Washington Monument, Now Exhibiting . . .* (New York, 1848), Frazee quoted a letter from West to Samuel Coates, London, March 2, 1817. Frazee's own proposal for a Washington Monument ran counter to this growing simplicity, since it involved a vast open temple, with frescoes, friezes, colossal statues and many allegorical details. For more on monument design see J. F. "The Statue and Monument to Washington," *North American Magazine,* V (March, 1835), pp. 350–352.

15. Warren, *Bunker Hill Monument Association,* pp. 164–171. The directors overruled the committee.

16. William Ladd to the directors, Minot, Maine, January 3, 1826, quoted in Warren, *History,* p. 176.

17. In point of fact, Solomon Willard, superintendent of the monument, wept in 1861 when he feared the Southern rebels, if successful, might destroy the entire monument. See Wheildon, *Memoir of Willard,* p. 253.

18. The obelisk pleased also because of its durability. See C. Edwards Lester, *The Artist, The Merchant, and the Statesman, of the Age of the Medici and of Our Own Times* (New York, 1845), I, pp. 137–138.

19. Quoted in Nathalia Wright, *Horatio Greenough, The First American Sculptor* (Philadelphia, 1963), p. 225.

20. "Church Architecture in New-York," *United States Magazine and Democratic Review,* XX (February, 1848), p. 140.

21. *Port Folio,* New Series, III (June, 1810), p. 465.

22. William Hoppin, *Transactions of the American Art-Union,* III (1846), p. 20. As an example of his meaning Hoppin referred to the sculpted lion at Lucerne, erected to honor the Swiss guards killed during the French Revolution.

23. George W. Bethune, *True Glory, A Sermon Preached . . . on the Death of Stephen van Rensselaer . . .* (Philadelphia, 1839), p. 15.

24. Reverend William Barlow, *Funeral Sermon . . .* (Albany, 1839), p. 34.

25. Reverend Frederic H. Hedge, *An Oration Pronounced Before the Citizens of Bangor* (Bangor, 1838), p. 23. Many New England orators insisted that liberty required self-control, and some even quoted John Winthrop's famous definition. Monuments were meant to aid the diffusion of such a notion. See Jonathan Chapman, *An Oration Delivered Before the Citizens of Boston . . .* (Boston, 1837); A. G. Magrath, *An Oration . . . before the '76 Association . . .* (Charleston, 1841); Benjamin Franklin Hallett, *An Oration . . .* (Boston, 1836).

26. E. J. Richardson, *An Oration . . . to the Citizens of Utica* (Utica, 1850), p. 18. Many of these orators incorporated into their speeches the pessimistic note of national life cycles. As Perry Miller has noted, these broodings formed a dark side to the optimism generally said to characterize Jacksonian America. See Miller, "The Romantic Dilemma in American Nationalism and the Concept of Nature," *Harvard Theological Review,* XLVIII (October, 1955), pp. 239–243.

27. John Whipple, *A Discourse Delivered before the . . . Citizens of Providence . . .* (Providence, 1838), p. 26. See also "Sculpture as a Means of Municipal Embellishment," *Cosmopolitan Art Journal,* I (June, 1857), p. 119.

28. Hubbard Winslow, *An Oration . . .* (Boston, 1838), p. 35.

29. C. Edwards Lester, *The Social Life and National Spirit of America . . .* (Great Barrington, 1849), p. 6.

30. Quoted in Wheildon, *Memoir of Willard,* pp. 65–66. These phrases were included in a circular published by the Standing Committee for the Bunker Hill Monument in September, 1823.

31. See Warren, *Bunker Hill Monument Association,* p. 253.

32. Wheildon, *Memoir of Willard,* p. 145.

33. Some supporters of government art patronage characterized the Founding Fathers as men who sought no material advantage in their search for political freedom. But in 1838 things were different. "Men are sent to Congress expressly to take care of commerce . . . manufactures . . . but who are elected with express reference to the care of

the fine arts, of colleges, of the moral and religious interests of our country?" "Claims of the Beautiful Arts," *United States Magazine and Democratic Review,* III (November, 1838), p. 256.

34. Quoted in Wheildon, *Memoir of Willard,* p. 166.

35. *North American Review,* II (March, 1816), pp. 329–330. The author, William Tudor, was discussing a proposed monument to Washington.

36. Warren, *Bunker Hill Monument Association,* pp. 235–236.

37. Lester, *Social Life and National Spirit of America,* p. 4.

38. Ralph Waldo Emerson, *English Traits, The Complete Works of Ralph Waldo Emerson,* Centenary Edition (Boston and New York, 1903–1904), V, p. 288. See Kenneth S. Lynn, *Mark Twain and Southwestern Humor* (Boston, Toronto, 1959), pp. 23–24, for comments on the pervasive power of the Western landscape.

39. Theodore Winthrop, *John Brent* (Boston, 1862, 1871), p. 122.

40. [William Newnham Blane] *An Excursion Through the United States and Canada . . .* (London, 1824), p. 125.

41. *The Aristocratic Journey, Being the Outspoken Letters of Mrs. Fanny Hall . . . ,* Una Pope-Hennessy (ed.) (New York, 1931), p. 56. For more comment about American indifference to trees see Lieutenant Francis Hall, *Travels in Canada and the United States, in 1816 and 1817* (Boston, 1818), p. 197; *Jeffersonian America, Notes on the United States of America Collected in the Years 1805–6–7 and 1811–12 by Sir Augustus John Foster, Bart.,* Richard Beale Davis (ed.) (San Marino, 1954), p. 104.

42. Isaac Weld, Jr., *Travels Through the States of North America . . .* (London, 1807), I, p. 39. Weld also told of traveling Americans landing on the barren northwest coast of Ireland, who expressed great pleasure at what they considered to be the beauty and improved state of the country, "so clear of trees!" I, p. 41.

43. Theodore Dwight, *Summer Tours; or Notes of a Traveller,* 2nd ed. (New York, 1834, 1847), pp. 141–142.

44. Henry W. Bellows, "Rural Cemeteries," Harvard Exhibition, October 18, 1831, Archives, Harvard University. Harvard Exhibitions in the early 1830s were replete with speeches about the improving arts. Joseph Stevens Buckminster Thacher spoke on "Respect for Public Monuments, whether Triumphal or for the Dead," at the 1832 Commencement, while others spoke on "The Comparative Influence of Natural Scenery, The Institutions of Society, and Individual Genius, on Taste."

45. Dwight, *Summer Tours,* p. 162.

46. There is no general work on the subject of American cemeteries. Hans Huth, *Nature and the American, Three Centuries of Changing Attitudes* (Berkeley, 1957), contains some helpful information, but this is confined to Mount Auburn. New England is particularly rich in

rural cemeteries; besides the ones at Cambridge and Salem, by 1842 Worcester, Springfield, Lowell, Plymouth, New Haven, Portsmouth and Nashua all boasted rural cemeteries.

47. Laurel Hill was one of the smallest, containing originally only about twenty acres; by 1846 Greenwood, with one hundred and eighty acres, was a comparative giant. For statistics see *Greenwood Cemetery, Its Rules, Regulations, etc.* (New York, 1846), p. 3.

48. The phrase appeared in [Stephen Duncan Walker] *Rural Cemetery and Public Walk* (Baltimore, 1835), p. 20.

49. Nehemiah Cleaveland, *Green-Wood Illustrated . . . by James Smillie* (New York, 1847), p. 9. Many of the books about cemeteries served as vehicles for engravers like Smillie, mixing prints, poetry and sentimentality like the gift books of the era.

50. J. H. B. Latrobe, "The Hymn," *The Dedication of Green Mount Cemetery . . .* (Baltimore, 1839), p. 15. Latrobe was the son of Benjamin Latrobe, the architect and engineer.

51. See Frederic A. Sharf, "The Garden Cemetery and American Sculpture: Mount Auburn," *Art Quarterly*, XXXIV (Spring, 1961), pp. 80–88. Crawford, E. A. Brackett, Ball Hughes, Horatio Greenough, Henry Kirke Brown and Henry Dexter were all represented in Mount Auburn. In time, cemetery promoters used the patronage of sculpture as a justification for the rural cemetery.

52. The monument to Washington and Lafayette, a superficially simple obelisk, was filled with hidden symbolism. See The Miscellaneous File (Sartain), NYPL; microfilms in AAA.

53. See the criticism of Mount Auburn and Laurel Hill in T. D. Woolsey, "Cemeteries and Monuments," *The New Englander*, VII (November, 1849), p. 489. See also, "Ornamental Cemeteries," *Yale Literary Magazine*, XXI (November, 1855), pp. 45–50.

54. *The Dedication of Green Mount Cemetery . . .* (Baltimore, 1839), pp. 21, 32.

55. Enormous efforts went into the surveys of burial practices. See [John Brazer] "Burial of the Dead," *Christian Examiner*, XXI (November, 1841; January, 1842), pp. 137–163; 281–307.

56. *Dedication of Green Mount*, p. 3.

57. Wilson Flagg, *Mount Auburn: Its Scenes, Its Beauties, and Its Lessons* (Boston and Cambridge, 1861), p. 73.

58. Cleaveland, *Green-Wood Illustrated*, p. 3. The theme of uniting nature and art was a constant one in both the landscape garden campaign and the cemetery promotion.

59. *Guide to Laurel Hill Cemetery . . .* (Philadelphia, 1847), p. 22.

60. Flagg, *Mount Auburn*, p. 9.

61. Flagg, *Mount Auburn*, p. 265.

62. Flagg, *Mount Auburn*, p. 57.

63. Flagg, *Mount Auburn*, p. 56.

64. Flagg, *Mount Auburn*, p. 100.

65. Farley was speaking at a consecration for a congregation's burial plot. Cemetery proprietors encouraged churches to buy sections for ministers and their congregations. Presumably it would make things easier at the resurrection. Quoted in Cleaveland, *Green-Wood Illustrated*, p. 67.

66. *The Diary of George Templeton Strong*, Allan Nevins and Milton Halsey Thomas (eds.) (New York, 1952), I, p. 229.

67. Flagg, *Mount Auburn*, p. 100.

68. Woolsey, "Cemeteries and Monuments," p. 501.

69. Cleaveland, *Green-Wood Illustrated*, p. 67.

70. N. P. Willis, quoted in *Guide to Laurel Hill Cemetery*, p. 174.

71. Cornelia W. Walter, *Mount Auburn Illustrated . . . by James Smillie* (New York, 1847), p. 39. Like art galleries and parks, cemeteries would also teach refinement of manners. Americans "vie with Goth or Vandal in apparent hate of cultured arts, as painting, statuary, or relief, and deface all ornaments of skill," said one writer. Cemeteries would preach greater respect for beauty. See Campeador, *Rambling Reflections in Greenwood* (New York, 1853), p. 11.

72. Flagg, *Mount Auburn*, p. 308.

73. Flagg, *Mount Auburn*, p. 309.

74. Florence, "The Past of America," in Flagg, *Mount Auburn*, p. 268. This writer then quotes from Timothy Flint's accounts of the Indian mounds in the Mississippi Valley.

75. The best short account of the Mound-Builders is Curtis Dahl, "Mound-Builders, Mormons, and William Cullen Bryant," *New England Quarterly*, XXIV (June, 1961), pp. 178–190. Howard Mumford Jones, *O Strange New World, American Culture: The Formative Years* (New York, 1964), pp. 167–174, also contains a discussion. For Indian investigations and antiquities the reader is referred to the works of George Catlin, Henry R. Schoolcraft, Lewis Henry Morgan, Timothy Flint and E. G. Squier.

76. *The Poetical Works of William Cullen Bryant*, Parke Godwin (ed.) (New York, 1883), I, pp. 229–230. This passage is from "The Prairies." In another poem, "The Burial-Place," Bryant had nature rebuke human neglect by growing roses and strawberries near neglected cemeteries. Many of his poems have death themes: "Thanatopsis," "Hymn to Death," "The Old Man's Funeral," "The Murdered Traveller," "The Two Graves," "An Indian at the Burial-Place of His Fathers."

77. Timothy Flint, *Recollections of the Last Ten Years*, C. Hartley Grattan (ed.) (New York, 1932), p. 166. The original edition appeared in 1826.

78. Florence, "The Past of America," p. 272. Some critics tried to temper this romanticization. Francis Parkman denied the Westerners were the equals of Greeks or Romans. In "the condition of this ancient people, as shown by the traces they have left behind, there is nothing which need excite any special admiration or wonderment. . . ," *Christian Examiner*, L (May, 1851), pp. 418–428. Parkman placed them halfway between barbarism and the civilization of the Mexican Indians.

79. Flagg, *Mount Auburn*, p. 371.

80. Downing, who published his first book in 1841, died in *The Henry Clay* steamboat disaster of 1852. Much has been written about him, but little that is entirely satisfactory. Russell Lynes, *The Tastemakers* (New York, 1949), chap. III, contains an interesting but superficial account. Carl Bode, *The Anatomy of American Popular Culture, 1840–1861* (Berkeley, 1959), also contains some information. Carl Carmer, *The Hudson* (New York, 1939), chap. 21, while it is short and popularized, does get closer to Downing as a person. George B. Tatum, "The Beautiful and the Picturesque," *American Quarterly*, III (Spring, 1951), pp. 36–51, is the most comprehensive study of the Downing aesthetic, but Tatum treats the movement merely as a democratization of taste. The most incisive personal portrait was prepared by George William Curtis in a preface to Andrew Jackson Downing, *Rural Essays*, George William Curtis (ed). (New York, 1869), a posthumously published series of editorials which Downing wrote while editing *The Horticulturist*. The discussion of Downing in James Early, *Romanticism and American Architecture* (New York and London, 1965), pp. 54–71, is also valuable.

81. Andrew Jackson Downing, *The Architecture of Country Houses* (New York, 1850, 1852), p. v.

82. [Ralph Waldo Emerson] "The Young American," *The Dial*, IV (April, 1844), p. 491. See also a review in *United States Magazine and Democratic Review*, XVI (April, 1845), in which Downing's plans are criticized as too expensive. Nonetheless, the critic agreed that "everything that beautifies the land, enhances its worth in the eyes of the inhabitants," p. 361.

83. *North American Review*, LIII (July, 1841), p. 259. This conservative periodical reviewed most of Downing's books and featured many articles on the subject of rural cemeteries. William Tudor, the magazine's founder, was also extremely active in the monument campaign.

84. Samuel S. Cox, *A Buckeye Abroad: or, Wanderings in Europe* (New York, 1852), p. 426.

85. Andrew Jackson Downing, *Cottage Residences* (New York, 1842, 1844), pp. 77–78.

86. "Landscape Gardening and Rural Architecture . . . ," *United States Magazine and Democratic Review*, XVI (April, 1845), p. 353. The reviewer spoke of Jesus himself preferring Olivet to the crowded

city of Jerusalem. Downing urged the religious value of cultivating the beautiful, and followers defended gardening on the grounds of piety. See *The New Englander,* I (April, 1843), with its comment that despite fears of beauty in churches, "Beauty is no foe to reverence," p. 206. See also [Horace Bushnell] "Taste and Fashion," *The New Englander,* I (April, 1843), pp. 153–168.

87. Dwight, *Summer Tours,* pp. 77–78.

88. Nathaniel Parker Willis, "On Furnishing a House," *The Rag-Bag, A Collection of Ephemera* (New York, 1855), p. 36. This was a collection of articles Willis wrote for the *Home Journal,* which he edited. In the book, pp. 121–129, is an essay on Downing.

89. Downing, *Rural Essays,* pp. 234–235. The New Theology of Nathaniel Taylor, and Horace Bushnell's Christian Nurture doctrine pointed up the importance of surrounding children with healthy, beautiful environments. See Barbara M. Cross, *Horace Bushnell: Minister to a Changing America* (Chicago, 1958), *passim.* The social and religious aims of a whole group of New England architects and designers have been perceptively explored by David P. Handlin, "Yankees in Babylon, New England Architects in New York, 1820–1860," unpublished senior thesis, Harvard University, 1965.

90. Downing, *Architecture of Country Houses,* p. 35. This doctrine also meant that country houses should not look like city dwellings.

91. Downing, *Rural Essays,* p. 247. Nonetheless, Downing's cottages often required the assistance of two servants to run. The villas needed much larger staffs.

92. Downing often suggested furniture and print purchases, referring favorably to Goupil, Vibert & Company of New York, a house which imported prints from France. See *Architecture of Country Houses,* p. 372. The animus against a *nouveau riche* mentality, which runs through much of this literature, can be seen in Willis, *The Rag-Bag,* pp. 32–36. The "raw aspect of new furniture being repulsively associated . . . with people of low origin, to whom no belongings of a home have descended, and who have suddenly become rich." See also the comments of Sidney George Fisher, "Diaries," *passim.*

93. Such was N. P. Willis' comment on Highland Terrace, a community near West Point, in *The Home Book of the Picturesque. Home Authors and Home Artists . . .* (New York, n. d.), p. 112. Willis' own home, Idlewild, was built by Downing's English partner, Calvert Vaux.

94. "The Diaries of Sidney George Fisher," *Pennsylvania Magazine of History and Biography,* LXXXVI (October, 1962), p. 461. For an evocative portrait of rural existence see N. P. Willis, *Out-Doors at Idlewild; or, The Shaping of a Home on the Banks of the Hudson* (New York, 1855).

95. Journal entry for March 7–10, 1841, *The Writings of Henry David Thoreau,* Bradford Torrey (ed.) (Boston and New York, 1906), I, p. 233.

96. George Wightwick, *Hints to Young Architects, with Additional Notes, and Hints to Persons about Building in the Country by A. J. Downing* (New York, 1847), p. 14. Downing was opposed to bright colors in building also. He tried to blend the house imperceptibly into the landscape.

97. Wightwick, *Hints to Young Architects,* p. xix.

98. Downing, *A Treatise on the Theory and Practice of Landscape Gardening* (New York, 1842, 1850), p. 420.

99. Downing, *Treatise on Landscape Gardening,* p. 408.

100. Downing, *Cottage Residences,* p. 89.

101. [Wilson Flagg] "Landscape and its Treatment," *North American Review,* LXXIV (January, 1857), p. 146.

102. Downing, *Architecture of Country Houses,* p. 346.

103. Downing, *Architecture of Country Houses,* p. 354.

104. Broad verandas suggested comfort; oriel windows symbolized enjoyment. See Downing, *Cottage Residences,* p. 21. See also W. A. B., "Ornamental Gardening," *Knickerbocker,* X (October, 1838), p. 315. This writer insisted that the "external air and appearance of a dwelling house are no uncertain indications of the character of its inhabitants."

105. Downing, *Architecture of Country Houses,* p. 24.

106. Carmer, *The Hudson,* p. 241.

107. Curtis, in preface to Downing, *Rural Essays,* p. xxxii.

108. Downing, *Architecture of Country Houses,* p. 369.

109. Downing, *Architecture of Country Houses,* p. 8.

110. Downing, *Cottage Residences,* p. 33, and *Architecture of Country Houses,* p. 27. The doctrine of appropriateness allowed a man of Dutch descent to build in Flemish or old Dutch style. Presumably a Persian family could construct minarets, as long as they had a reasoned defense for their eccentricity.

111. Downing, *Architecture of Country Houses,* p. 266. Downing did oppose direct and literalistic imitation.

112. Downing, *Treatise on Landscape Gardening,* p. 413.

113. Quoted in Carmer, *The Hudson,* p. 247.

114. Downing did everything conceivable to make villas and country life attractive for the wealthy, adding conservatories to relieve the monotony of cold winters. For his idealization of the English gentry see *North American Review,* LIII (July, 1841), p. 260. See also Horace Binney Wallace, *Art and Scenery in Europe* (Philadelphia, 1857), p. 356.

115. "The Diaries of Sidney George Fisher," *Pennsylvania Magazine of History and Biography,* LXXXVI (January, 1962), pp. 70–71. Fisher's father-in-law, Charles J. Ingersoll, had a great house; his cousin Joshua Francis Fisher built Alverthorpe, while his brother

Henry built a great mansion, Brookwood. In the area were Henry Ingersoll's Medary, Charles P. Fox's Champlost, and other estates. Fisher reviewed Downing's *Treatise on Landscape Gardening* for the *American Farmer* in 1859. His diaries are filled with expressions of contempt for the vulgar, newly rich businessmen who were destroying old Philadelphia society.

116. "The Diaries of Sidney George Fisher," *Pennsylvania Magazine of History and Biography*, LXXIX (July, 1955), p. 352.

117. "The Diaries of Sidney George Fisher," *Pennsylvania Magazine of History and Biography*, LXXXVII (July, 1963), p. 344.

118. As quoted in R. W. B. Lewis, *The American Adam, Innocence, Tragedy, and Tradition in the Nineteenth Century* (Chicago, 1955), p. 19.

119. Downing, *Architecture of Country Houses*, p. 411. Downing recommended firms for his decorative plans, like George Platt of New York, or the Salamander Works on Cannon Street, New York. See Downing, *Cottage Residences*, pp. 139, 161.

120. Downing, *Architecture of Country Houses*, p. 79.

121. W. A. B., "Ornamental Gardening," *Knickerbocker*, X (October, 1838), p. 315.

122. Henry Ward Beecher, *Norwood; or, Village Life in New England* (New York, 1867, 1868), p. 213.

123. "Landscape Gardening and Rural Architecture in America," *United States Magazine and Democratic Review*, XIV (April, 1845), p. 250.

124. Gervase Wheeler, *Rural Homes* (Auburn and Rochester, 1851, 1853), p. 57.

9 Artist Images: Types and Tensions

1. *The Literary World*, II (October 30, 1847), p. 297.

2. Alfred Huidekoper, *Glimpses of Europe in 1851 and 1867–8* (Meadville, Pa., 1882), p. 173. Huidekoper found the life of an artist a "fascinating" subject of study.

3. Henry T. Tuckerman, perhaps the most active art publicist of the century, has been described by a recent student as a forthright fighter in "the ranks of New England Whiggery." He condemned the influence of the press, the rights of suffrage granted immigrants, the *nouveaux riches*, etc. See Richard G. Elsworth, "Henry Theodore Tuckerman," Ph.D. dissertation, University of Maryland, 1959, *passim*. It is also interesting to note that many of the conservatives treated by George M. Frederickson, *The Inner Civil War, Northern Intellectuals and the Crisis of the Union* (New York, 1965), were art enthusiasts, notably George Templeton Strong, Henry W. Bellows, Frederick Law Olmsted and Horace Bushnell. Bellows' art interests were logical corollaries to his "doctrine of institutions." See Frederick-

son, chaps. 2 and 9. Other conservatives who sought patrician leadership and stronger institutions, while concerned with the progress of the arts, included Charles Eliot Norton and Theodore Winthrop. Many of them turned to art, not as an escape, but from commitments to social meliorism and belief in institutions. Added to men like Downing and George William Curtis they formed a significant sector of art supporters.

4. James Russell Lowell to C. F. Briggs, Elmwood, September 3, 1848, *The Letters of James Russell Lowell*, Charles Eliot Norton (ed.) (New York, 1894), I, p. 139.

5. [S. A. Eliot] "The Present and Future of American Art," *North American Review*, LXXXIII (July, 1856), p. 88. This theme was expressed by William Dunlap, who apotheosized Benjamin West for his courage in leaving America during the Revolution to study in the enemy's capital; there he learned how to immortalize American victories. See *Diary of William Dunlap (1766–1839)*, Dorothy Barck (ed.) (New York, 1930), II, p. 542.

6. "The Painter's Studio," *New York Mirror*, February 1, 1840.

7. Theodore S. Fay, *Norman Leslie, A Tale of the Present Times* (New York, 1835), II, pp. 46–47.

8. Fay, *Norman Leslie*, II, p. 70.

9. Fay, *Norman Leslie*, II, p. 96.

10. [Washington Allston] *Monaldi: A Tale* (Boston, 1841), p. 76.

11. [Allston] *Monaldi*, p. 85.

12. [Allston] *Monaldi*, p. 247.

13. Joseph Holt Ingraham, *The Spectre Steamer, and Other Tales* (Boston, 1846), pp. 77–84. For this reference and several others I am indebted to the kindness of Professor Howard Mumford Jones.

14. Ingraham, *The Spectre Steamer*, p. 81.

15. Ingraham, *The Spectre Steamer*, p. 84.

16. Nathaniel Hawthorne, "The Prophetic Pictures," *Twice-Told Tales, The Works of Nathaniel Hawthorne* (Boston, 1860, 1888), p. 195. See also Mary E. Dichmann, "Hawthorne's 'Prophetic Pictures,'" *American Literature* XXIII (May, 1951), pp. 188–202. Many of the formulae Ernst Kris has discovered in artist biographies of the ancient Greeks and Renaissance Italy, recur in American biographies. Biographers, travelers and novelists repeated many of the legends as they described their own heroes. See Ernst Kris, "The Image of the Artist, A Psychological Study of the Role of Tradition in Ancient Biographies," *Psychoanalytic Explorations in Art* (London, 1953), pp. 64–80.

17. "The Fiend and the Artist," *New York Mirror*, XV (February 10, 1838), pp. 256–259. The Satanic pact is another stereotype discussed by Kris. Legends of the artist as "sorcerer, magician and rebel reach back far into the mythological matrix." Kris, "The Image of the Artist,"

p. 80. For a more diffuse discussion of artist personality types see Rudolf and Margot Wittkower, *Born Under Saturn: The Character and Conduct of Artists: A Documented History from Antiquity to the French Revolution* (New York, 1963).

18. "The Painter," *New World* (October 29, 1842), p. 280. For other descriptions of the power of a canvas see Alice B. Neal (pseud. for Mrs. Haven), "The Portrait; or, the Wife's Jealousy," *The Gossips of Rivertown* . . . (Philadelphia, 1850), pp. 161–174; Herman Melville, *Pierre, or, The Ambiguities* (New York, 1852, 1963), p. 109; and N. Parker Willis, "Beauty and the Beast, or, Handsome Mrs. Titton and Her Plain Husband," *Here and There: or Sketches of Society and Adventure at Far-Apart Times and Places* (New York, 1850).

19. "The Painter," *Brother Jonathan,* II (July 23, 1842), pp. 372–373.

20. "The Painter and His Pupil: A Flemish Story," *Southern Literary Messenger,* XXIII (July, 1856), pp. 72–78. This was reprinted from *Chambers's Journal.*

21. "The Artist's Despair," *Eclectic Magazine,* I (April, 1844), p. 540. This was reprinted from *Frazer's Magazine.*

22. Emerson Bennett, *The Artist's Bride: or, The Pawnbroker's Heir* (New York [1856]), p. 163.

23. Bennett, *Artist's Bride,* p. 229. The artist's appearance is specifically contrasted with that of Herbert Raymond, a young lawyer who is "tall, muscular, ungainly," though he was "comely in the sight of heaven." *Artist's Bride,* p. 208.

24. Bennett, *Artist's Bride,* p. 63.

25. N. Parker Willis, "Two Buckets in a Well," *People I Have Met; or Pictures of Society and People of Mark* (New York, 1850), p. 56.

26. George William Curtis, *Trumps* (New York, 1861, 1873), p 125.

27. Curtis, *Trumps,* p. 244.

28. Curtis, *Trumps,* p. 41.

29. Henry Greenough, *Ernest Carroll, or Artist-Life in Italy* (Boston, 1858). Although Carroll is passive, his paramour, a Venetian countess, takes a more aggressive view of the artist life; for her the artist is a god who peoples his creations. See p. 40.

30. "Clarian's Picture, A Legend of Nassau Hall," *Atlantic Monthly,* V (June, 1860), p. 709.

31. "Clarian's Picture," p. 713.

32. Theodore Winthrop, *Cecil Dreeme* (New York, 1861), p. 58. Winthrop, killed in the Civil War, had close ties to the New York literary and artistic worlds. Stillfleet, the architect in the novel, is a picture of Richard Morris Hunt. Winthrop's portrait of the artist's life as "a dream" with "no vulgar, harsh, or cruel realities" marring it, ran counter to the many appeals urging artists to make their lives one with the multitude. See p. 67.

33. Willis, "Two Buckets in a Well," p. 59.

34. See above, note 29.

35. I. B. Wright, "Dream Love," *The Pioneer*, I (March, 1843), pp. 122–123.

36. Reverend Edward P. Roe, *Barriers Burned Away* (New York, 1872), p. 189.

37. Roe, *Barriers Burned Away*, p. 261. The novel itself, with a New Englander named Winthrop and a professor named Learned, is a crudely written plea for evangelical piety, but an illustration of the uses clergymen could make of the alliance between art and religion.

38. Frederic S. Cozzens, *The Sparrowgrass Papers or, Living in the Country* (Philadelphia, 1865), pp. 115–116. Chapter VIII contains an interesting picture of artist life in New York.

39. See "The Rejected Picture," *New World*, VI (May 6, 1843), pp. 545–546; *New World*, VI (May 13, 1843), p. 577; and *New World* (May 20, 1843), pp. 604–605.

40. *Evening Mirror*, October 15, 1849, American Art-Union Clipping Book, NYHS.

41. *New York Tribune*, n. d., American Art-Union Clipping Book, p. 63.

42. *New York Tribune*, October 17, 1849, American Art-Union Clipping Book.

43. Nathaniel Hawthorne, *The Marble Faun*, *The Works of Nathaniel Hawthorne*, Standard Library Edition (Boston, 1860, 1888), p. 133.

44. [W. E. Channing] "The Youth of the Poet and the Painter," *The Dial*, IV (July, October, 1843, January, April, 1844), pp. 48–58, pp. 174–186, pp. 273–284, pp. 427–454. Channing was the son of Walter Channing, a physician, and the nephew of his namesake, William Ellery Channing. Like one of the characters in his story, he was a poet who left college.

45. *The Dial*, IV (July, 1843), p. 55.

46. *The Dial*, IV (October, 1843), p. 180.

47. *The Dial*, IV (April, 1844), p. 432.

48. N. Parker Willis, *Paul Fane; or, Parts of a Life Else Untold* (New York, 1857), pp. 28–29. For more on *Paul Fane* and the theme it treats see Christof Wegelin, "The Rise of the International Novel," *Publications of the Modern Language Association*, LXXVII (June, 1962), pp. 305–310, and "Social Criticism of Europe in the Fiction of N. P. Willis," *American Literature*, XX (November, 1948), pp. 313–322.

49. Willis, *Paul Fane*, p. 20. Fane achieves great social success in Europe, and receives a succession of marriage proposals.

50. N. Parker Willis, "The Revenge of the Signor Basil," *People I Have Met*, pp. 189–190.

51. Many of Willis' artist stories concern problems of class and caste. In "The Revenge of the Signor Basil," an artist plots the downfall of a lady who snubbed him as a plebeian. In "The Icy Veil; or, The Keys to Three Hearts Thought Gold," a story in *People I Have Met,* an artist manages the jump to aristocratic status, while in "Two Buckets in a Well," a young painter forced by his fiancee to go into trade to make some money, feels permanently disqualified for art. "You have stamped me *plebeian*—you would not share my slow progress toward a higher sphere, and you have disqualified me for attaining it alone." "Two Buckets in a Well," p. 72. Here the artist is unqualifiedly opposed to the business ethic. I should like to thank Professor James T. Callow of the University of Detroit for pointing out to me a number of Willis' artist stories.

52. Willis, *Paul Fane,* p. 38.

53. Willis, *Paul Fane,* p. 40.

54. N. P. W., "The Two Art Unions," *Home Journal,* October 15, 1849, American Art-Union Clipping Book, p. 51. The Art-Union's response was interesting: "This fear of mediocrity in Art comes with an ill grace from a community like ours, which maintains so many benevolent institutions . . . [to encourage] mediocrity; no one affects to fear mediocrity in religion or learning, why should we fear it in Art?" *Transactions of the American Art-Union,* IV (1844), p. 5. This was written some years before Willis' charge, but in reply to similar criticism.

55. Willis, *Paul Fane,* p. 262. Fane has the typical romantic trait of seeing far below surfaces; Blivins, on the other hand, is a literalist. See *Paul Fane,* p. 338. Willis was thus taking the side of artists like Cole, in their struggles against literalistic patrons.

56. Willis, *Paul Fane,* p. 399.

57. Henry James, *Roderick Hudson* (London, 1875, 1961), pp. 41–42.

58. James, *Roderick Hudson,* pp. 182–183.

59. Hawthorne, *The Marble Faun,* p. 78.

60. Hawthorne, *The Marble Faun,* p. 78.

61. Nathaniel Hawthorne, "The Artist of the Beautiful," *United States Magazine and Democratic Review,* XIV (June, 1844), p. 616.

62. Millicent Bell, *Hawthorne's View of the Artist* (State University of New York, 1962), takes a more pessimistic view of Hawthorne's fears, and concludes that he felt that "the isolated life and aim, the exaltation of the will, the monomaniac subordination of personal feelings to impersonal goals, can yield only evil," p. 28. See also Maurice Z. Shroder, *Icarus, The Image of the Artist in French Romanticism* (Cambridge, Mass., 1961). American writers were much less enthusiastic about the capacities of romantic energy than Europeans, and hedged round even their favorable images with warnings. For still another statement about Hawthorne's attitudes toward art, one which differs

from Dr. Bell, see Paul Brodtkorb, Jr., "Art Allegory in *The Marble Faun*," *Publications of the Modern Language Association*, LXXVII (June, 1962), pp. 254–267. See particularly pp. 258, 267. Brodtkorb contends that Hawthorne's reservation about the artist is that he is often too cold, unfeeling and pitiless.

63. Henry P. Leland, *Americans in Rome* (New York, 1863), p. 35. Nathalia Wright, *American Novelists in Italy. The Discoverers: Allston to James* (Philadelphia, 1965), discusses a number of the novels here considered.

64. Leland, *Americans in Rome*, p. 37. Chapin's ungainly speech was more typical of American artists than the elegant prose of the fictional romantics. See Shobal Clevenger to Henry Kirke Brown, Washington, February 3, 1848, Gratz Collection, box 39, HSP. Clevenger was aware that he spelled badly, and begged Brown not to show the letter to anyone; he was ashamed of its appearance.

65. Leland, *Americans in Rome*, p. 37.

66. Leland, *Americans in Rome*, p. 38.

67. Leland, *Americans in Rome*, p. 39.

68. Leland, *Americans in Rome*, p. 136.

69. Leland, *Americans in Rome*, pp. 161–162.

70. Leland, *Americans in Rome*, p. 40.

71. C. Edwards Lester, *The Artists of America: A Series of Biographical Sketches of American Artists* (New York, 1846), p. 27.

72. Thomas Buchanan Read to Edwin R. Campbell, Boston, November 28, 1841, "Letters of Thomas Buchanan Read," Alice E. Smith (ed.), *Ohio State Archaeological and Historical Society Quarterly*, XLVI (January, 1937), p. 79.

73. "Washington Allston," *United States Magazine and Democratic Review*, LXXI (July, 1850), p. 151.

74. [Cornelius Conway Felton] "Allston, *Lectures on Art*, and *Poems*," *North American Review*, LXXI (July, 1850), p. 151.

75. Thomas Buchanan Read to Edwin R. Campbell, Boston, November 28, 1841, "Letters of Read," p. 79.

76. [Felton] "Allston, *Lectures on Art*," p. 151.

77. Elizabeth P. Peabody, "Life and Genius of Allston," *Last Evening with Allston and Other Papers* (Boston, 1887), p. 21. This essay originally appeared in *American Monthly Magazine*, I (May, 1836), pp. 435–446.

78. "Allston's Lectures," *The New Englander*, VIII (August, 1850), p. 446.

79. [C. W. Ware] "A Sermon . . . on the Death of Washington Allston," *Christian Examiner*, XXXV (November, 1843), pp. 270–271.

80. Lester, *Artists of America*, p. 29.

81. [Ware] "A Sermon," p. 272.

82. Mrs. Ednah Dow Cheney, *Reminiscences* (Boston, 1902), p. 131.

83. Peabody, "Life and Genius of Allston," p. 442.

84. Louis Legrand Noble, *The Life and Works of Thomas Cole*, Elliot S. Vesell (ed.) (Cambridge, Mass., 1964), p. XXXVIII. This edition is a reissue of the 1853 publication of *The Course of Empire*.

85. Noble, *Life of Cole*, p. 307.

86. Noble, *Life of Cole*, p. 308.

87. [George Washington Greene] "Noble's *Life of Thomas Cole*," *North American Review*, LXXVII (October, 1853), p. 328.

88. E. Anna Lewis, "Thomas Cole," *Graham's Magazine*, p. 340.

89. Henry T. Tuckerman, *Artist-Life, or, Sketches of American Painters* (New York, 1847), p. 117.

90. Lewis, "Thomas Cole," p. 332.

91. George Washington Greene, *Biographical Sketches* (New York, 1860), p. 102.

92. Noble, *Life of Cole*, pp. 104–105.

93. Noble, *Life of Cole*, p. 105.

94. Noble, *Life of Cole*, p. 105.

95. Thomas Dunn English, "Peter F. Rothermel," *Sartain's Union Magazine*, X (January, 1852), p. 13.

96. John Albee, *Henry Dexter, Sculptor, A Memorial* (Cambridge, Mass., 1898), p. 85.

97. John Waters, "A Word on Original Paintings," *Knickerbocker Magazine*, XVIII (July, 1841), p. 50.

98. Waters, "A Word on Original Paintings," p. 51.

99. Henry T. Tuckerman, "Art and Artists," *Cosmopolitan Art Journal*, IV (December, 1860), p. 137. Tuckerman had written this essay earlier as a chapter in *Rambles and Reveries* (New York, 1841). Tuckerman considered the artist's life a "long dream." His sketches of J. F. Cropsey, William Henry Furness, James W. Glass and Seth Cheney carried this theme through.

100. Henry T. Tuckerman, *Book of the Artists. American Artist Life* (New York, 1867), p. 423. This was a quote from the burial service for James W. Glass.

101. Tuckerman, "Art and Artists," p. 141.

102. Christopher Pearse Cranch, "The Painter in the Woods," *Sartain's Union Magazine*, X (January, 1852), pp. 44–45.

103. "Sketches of Italy," *Arthur's Ladies Magazine*, III (January, 1845), p. 63. Romantic sentiments lasted longer in gift books and ladies magazines than in other periodicals.

104. "The Artist, The Merchant and The Statesman," *United States Magazine and Democratic Review*, XVII (November, 1845), p. 341.

105. See, for example, "Dignity of Art," *Cosmopolitan Art Journal,*

I (June, 1857), p. 108; "The Artist's Heart," *Cosmopolitan Art Journal*, I (July, 1856), pp. 5–6; "An Artist's Letter to an Artist," *Cosmopolitan Art Journal*, I (July, 1856), pp. 14–15, particularly the editor's comment which insists that the "artist is a laborer, and when he labors *worthily*, it is not in this day and generation to neglect him"; and *The Crayon*, I (February 21, 1855), p. 124, for another comment which insists that the public ignores only the work of superficial artists. If an artist has a mission to perform, "the Power which gave him the mission will give him the means to perform it."

106. "Confessions of a Young Artist," *Putnam's Monthly Magazine*, III (January, 1854), pp. 39–45. All the citations are from these seven pages.

107. *Putnam's Monthly Magazine*, I (June, 1853), p. 702.

108. "Art Patronage in America," *Cosmopolitan Art Journal*, I, (November, 1856), p. 34.

109. *Cosmopolitan Art Journal*, IV (March, 1860), p. 33.

110. "The Spirit of Competition in Art," *Cosmopolitan Art Journal*, IV (March, 1860), p. 78. Another art periodical, *The Crayon*, treated the income-oriented artist with much more hostility.

111. "Life's Illusions," *Cosmopolitan Art Journal*, I (November, 1856), pp. 37–44.

112. C. W. Elliott, *Cottages and Cottage Life* (Cincinnati, 1848), p. 114. This unusual book joined a sentimental novel about the evils of city life to a series of cottage plans. Considerable discussion treats technical building problems. For a similar though slightly later view of the artist's task see the character of Frank Esel in Henry Ward Beecher, *Norwood; or, Village Life in New England* (New York, 1867, 1868), particularly pp. 221–222.

113. Elliott, *Cottages and Cottage Life*, pp. 118–119.

114. Elliott, *Cottages and Cottage Life*, p. 124.

115. *Putnam's Monthly Magazine*, I (January, 1853), p. 120.

116. Thomas S. Cummings, *Historic Annals of the National Academy of Design* (Philadelphia, 1865), p. 149. Charles E. Baker, "The American Art-Union," in Mary Bartlett Cowdrey (ed.), *American Academy of Fine Arts and American Art-Union* (New York, 1953), I, pp. 95–240, contains a good description of the Art-Union's enemies.

117. *New York Scorpion*, November 3, 1849, and *American Mail*, July 31, 1847, American Art-Union Clipping Book. See also *Sunday Dispatch*, March 11, 1849. Many critics of art unions insisted that patronage based on ignorance could do more harm by action than indifference.

118. "Dignity of Art," *Cosmopolitan Art Journal*, I (June, 1857), p. 108.

119. *The Crayon*, I (April 11, 1855), p. 225.

120. "Crawford and Sculpture," *Atlantic Monthly*, II (June, 1858), p. 76.

121. "Crawford and Sculpture," p. 77.

122. E. W. Robbins, "Our Sculptors," *American Literary Magazine Monthly*, III (December, 1848), p. 368. See also Frances Trollope, *Domestic Manners of the Americans*, Donald Smalley (ed.) (New York, 1949), p. 395. See also Tuckerman, *Artist-Life*, p. 149, where he quotes Tocqueville on American tendencies to absorb artists into the practical life of the day. "Even ideal pursuits are wrested into the service of utility."

123. Anne Brewster, "Emanuel Leutze, the Artist," *Lippincott's Magazine*, II (November, 1868), p. 538.

124. [Mrs. Hannah F. Lee] *Familiar Sketches of Sculpture and Sculptors* (Boston, 1854), II, p. 209. For a dissenting opinion see the comment of Harriet Hòsmer quoted in *Harriet Hosmer: Letters and Memories*, Cornelia Carr (ed.) (London, 1913), p. 35. Harriet Hosmer was the most prominent American sculptress in Italy.

125. Quoted in Frederick B. Perkins, *The Picture and the Men . . .* (New York, 1867), p. 16.

126. Perkins, *The Picture and the Men*, p. 17.

127. Albee, *Henry Dexter*, pp. 48–49.

128. Clarence Cook to Thomas Farrer, New York, September 25, 1861, and Mrs. Cook to Thomas Farrer, New York, May 18, 1861, Miscellaneous File, NYPL; microfilms in AAA.

129. For more on this point see Ruth Miller Elson, "American Schoolbooks and 'Culture' in the Nineteenth Century," *Mississippi Valley Historical Review*, XLVI (December, 1959), pp. 411–434.

10 The Pattern of Artistic Community

1. See *The Crayon*, VI (November, 1859), p. 356.

2. These statistics are taken from the annual *Report of the Secretary of the Treasury, Transmitting a Report from the Registry of the Treasury of the Commerce and Navigation of the United States, 1840–1865*. Until the 1850s art imports were low, though steadily increasing. The government's shifting categories make these figures difficult to evaluate; in some years art was lumped together with books; in the 1850s painting and sculpture were divided, and an additional category, American Art, presumably the work of natives abroad, was added.

3. The source here is Harold Lancour, *American Art Auction Catalogues, 1785–1942* (New York, 1944).

4. Other leading auctioneers were Leonard & Company of Boston, M. Thomas & Sons of Philadelphia, and two New York houses: E. H. Ludlow and George A. Leavitt.

5. Thomas S. Cummings, *Historic Annals of the National Academy of Design* (Philadelphia, 1865), pp. 291–292. For a list of Leupp's holdings see "Our Private Collections," *The Crayon*, III (June, 1856), p. 186.

6. *The Crayon*, IV (December, 1857), p. 377.

7. *The Crayon*, III (May, 1856), p. 158. Auctions were beginning to standardize art values. See Theodore Allen to Asher B. Durand, New York, March 2, 1844, Durand Papers, box 4, NYPL, for a discussion of the effect of sale prices on the incomes of working painters. For Cropsey and Rossiter see Cummings, *Annals of the National Academy*, p. 277; and *The Crayon*, III (May, 1856), p. 158.

8. *The Crayon*, III (July, 1856), p. 218; and Leila Mechlin, "Art Life in Washington," *Records of the Columbia Historical Society*, XXIV (1922), p. 66. Washington had no art club until 1877.

9. *The Crayon*, III (October, 1856), p. 320; *The New Englander*, XVI (November, 1858), pp. 807–808; *Catalogue of the Works of Art Exhibited in the Alumni Building, Yale College, 1858* (New Haven, 1858).

10. *The Literary World*, VIII (February, March, 1851), summarized the talks each week.

11. *The Crayon*, III (December, 1856), p. 376.

12. *Catalogue of the First Annual Exhibition of the Pennsylvania Institute of Design, 1857* (Philadelphia, 1857). The Institute had been founded two years earlier.

13. For more on the industrial design movement see Neil Harris, "The Gilded Age Revisited: Boston and the Museum Movement," *American Quarterly*, XIV (Winter, 1962), pp. 547–566.

14. *The Crayon*, VI (January, 1859), p. 26.

15. See *Artists' Fund Society Catalogue, Fifth Annual Exhibition, 1864* (New York, 1864), for their constitution.

16. The case is discussed in Henry Budd, "Thomas Sully," *Pennsylvania Magazine of History and Biography*, XLII (April, 1918), pp. 97–126.

17. Cummings, *Annals of the National Academy*, p. 306.

18. Russell Lynes, *The Tastemakers* (New York, 1949), pp. 135–136. The defendant, Eleazar Parmlee, was an eccentric art patron trying to save some money.

19. *The Crayon*, VI (March, 1859), p. 92.

20. James R. Lambdin to Asher B. Durand, Philadelphia, January 30, 1854, Durand Papers, box 4, NYPL.

21. *The Crayon*, V (1858) and VI (1859), *passim*, gives details.

22. For Durand's hostility to the Washington convention and its organizer, a physician named Horatio Stone, see a letter of his son, John Durand to ———, New York, March 12, 1858, Miscellaneous

File and Art Boxes, NYPL. The National Academy of Design refused to send a representative. See Cummings, *Annals of the National Academy*, p. 254, for a memorial to Congress asking for an art tariff.

23. They were the sculptor, Henry Kirke Brown, and two painters, J. R. Lambdin and J. F. Kensett.

24. *The Literary World*, VIII (April 12, 1851), p. 299.

25. Thomas Cole to Edward L. Carey, Catskill, August 30, 1842, Gratz Collection, box 39, HSP.

26. Entry for October 9, 1841, The Diary of Joseph Sill, microfilms in AAA.

27. Irving Browne to Asher B. Durand, Troy, February 23, 1861, Durand Papers, box 5, NYPL.

28. Henry Kirke Brown to Durand, Newburgh, February 1, 1864, Durand Papers, box 5, NYPL.

29. Mark Skinner to Durand, Chicago, January 10, 1855, Durand Papers, box 4, NYPL.

30. William B. Ogden to Durand, Chicago, May 31, 1852, Durand Papers, box 4, NYPL.

31. See James S. Walter to Durand, Baltimore, April 28, 1851, Durand Papers, box 4; and Cephas G. Childs to Durand, Philadelphia, March 3, 1844, Durand Papers, box 3, NYPL.

32. The Gratz Collection of Artists' Autographs and the Dreer Collection, both in the Pennsylvania Historical Society, are monuments to this era. So is the Chamberlain Collection in the Boston Public Library, and other collections in New York, and the Archives of American Art in Detroit.

33. Jervis McEntee to Tallmadge Evers, New York, January 21, 1862, Duveen Collection, AAA.

34. Henry T. Tuckerman to Daniel Huntington, New York, January 26, 1846, Miscellaneous File, NYPL.

35. Quoted in *The Literary World*, VIII (February 1, 1851), p. 94.

36. *Prose Writings of William Cullen Bryant*, Parke Godwin (ed.) (New York, 1884), II, p. 234. These remarks were made at the opening of the National Academy's new building.

37. "The Diaries of Sidney George Fisher," *Pennsylvania Magazine of History and Biography*, LXXXVII (April, 1953), p. 210. "A crowd of men there, for the most part vulgar and common-place. . . . There seems now no such thing as *gentlemen's society.*" But he considered Sully to be "intelligent and pleasant."

38. For descriptions of the trip see *The Crayon*, V (July, 1858), p. 208; and *Cosmopolitan Art Journal*, II (September, 1858), p. 207.

39. *The Crayon*, III (September, 1856), p. 283.

40. *The Crayon*, III (October, 1856), pp. 317–318. For more on artists' resorts see Roland Van Zandt, "The Catskills and the Rise

of American Landscape Painting." *NYHS Quarterly,* XLIX (July, 1965), pp. 257–281.

41. Frederic Church to E. P. Mitchell, New York, December 14, 1857, Gratz Collection, box 39, HSP.

42. Charles Henry Hart, "Thomas Sully's Register of Portraits, 1801–1871," *Pennsylvania Magazine of History and Biography,* XXXII (October, 1908), pp. 385–432.

43. Theodore Bolton, "Henry Inman. An Account of his Life and Work," *Art Quarterly,* III (Autumn, 1940), pp. 353–375.

44. For such prices see "The Dollars and Cents of Art," *Cosmopolitan Art Journal,* IV (March, 1860), p. 30. For European prices see *Cosmopolitan Art Journal,* IV (June, 1860), p. 82. Everard M. Upjohn, "A Minor Poet Meets Hiram Powers," *Art Bulletin,* XLII (March, 1960), pp. 63–66, also contains good information on art incomes.

45. George Inness, Jr., *The Life, Art and Letters of George Inness* (New York, 1917), pp. 11–12.

46. *Cosmopolitan Art Journal,* IV (June, 1860), p. 70.

47. William J. Stillman, *The Autobiography of a Journalist* (London, 1901), I, p. 52.

48. Elihu Vedder, *The Digressions of V.* (Boston, 1910), p. 81; and H. W. French, *Art and Artists in Connecticut* (Boston, 1879), p. 138. A number of artists still lived like businessmen-entrepreneurs. See "Some Letters of William S. Jewett, California Artist," Elliott Evans (ed.), *California Historical Society Quarterly,* XXIII (June, September, 1944), pp. 149–177, 227–246; and "Letters of George Caleb Bingham to James S. Rollins," C. B. Rollins (ed.), *Missouri Historical Review,* XXII (1937–1938), pp. 3–34, 165–202, 340–377, 484–522.

49. *Cosmopolitan Art Journal,* III, (June, 1859), p. 123. See also *Cosmopolitan Art Journal,* III (December, 1858), p. 27.

50. French, *Art and Artists in Connecticut,* pp. 127–134, 81–82. Church's father retained some reservations, however. See David C. Huntington, *The Landscapes of Frederic Edwin Church. Visions of an American Era* (New York, 1966), pp. 21–22.

51. Seth Eyland (pseud. for David E. Cronin) *The Evolution of a Life* (New York, 1884), p. 16.

52. This list is not exhaustive. Information concerning all these artists can be found in George C. Groce and David H. Wallace, *The New-York Historical Society's Dictionary of Artists in America, 1564–1860* (New Haven, 1957).

53. "Recollections of John Ferguson Weir," *NYHS Quarterly,* XLI (July, 1957), p. 351.

54. Material concerning Boston's art community has been gathered from many sources. I have found particularly helpful the *Boston Directory,* various years; *King's Dictionary of Boston,* various years; *Sketches and Business Directory of Boston . . . for 1860 and 1861* (Bos-

ton, 1860); [Mrs. Ednah Dow Cheney] *Memoirs of Seth W. Cheney, Artist* (Boston, 1881); Martha A. S. Shannon, *Boston Days of William Morris Hunt* (Boston, 1923); E. Durand-Gréville, "L'Art aux États-Unis," *Gazette des Beaux Arts*, XXIV, (September, 1886), pp. 255–264; William Howe Downes, "Boston Painters and Paintings," *Atlantic Monthly*, LXXII (July–December, 1888); and various exhibition catalogues and brochures, Fogg Library, Harvard University.

55. Other dealerships included A. A. Childs & Company, and Alden and Vose. Williams and Everett had been started, under a different name, in 1810. At an early date for such practices, they guaranteed the income of George Inness in exchange for his franchise. See Inness, *Art and Letters of George Inness*, p. 34.

56. For an early comment see Thomas Doughty to Asher B. Durand, Boston, May 6, 1833, History of Art Manuscripts, I, AAA. See also the comment of John G. Brown, quoted in G. W. Sheldon, *American Painters: With Eighty-Three Examples of Their Work Engraved on Wood* (New York, 1879), pp. 142–143.

57. For Philadelphia the following were helpful: *Cohen's Philadelphia City Directory*, various years; *Philadelphia As It Is in 1852* (Philadelphia, 1852); J. T. Scharf and Thompson Westcott, *History of Philadelphia, 1609–1884* (Philadelphia, 1884); II; E. P. Oberholtzer, *Philadelphia, A History of the City and Its People* (Philadelphia, 1922), 4 vols.; E. Digby Baltzell, *Philadelphia Gentlemen, The Making of a National Upper Class* (Glencoe, Ill., 1958); *Boyd's Philadelphia City Business Directory*, various years; *M'Elroy's Philadelphia City Directory*, various years; Nathaniel Burt, *The Perennial Philadelphians, The Anatomy of an American Aristocracy* (Boston, Toronto, 1963); Thompson Westcott, *The Official Guide Book to Philadelphia* (Philadelphia, 1875); Anna Wells Rutledge (ed.), *The Pennsylvania Academy of the Fine Arts, 1807–1870. Cumulative Record of Exhibition Catalogues* (Philadelphia, 1955); exhibition catalogues of the Artists' Fund Society; the Graff Collection; the Gratz Collection; the Claude W. Unger Collection; The Artists' Fund Society Minute Books, all in the HSP.

58. George W. Dewey, "The Art-Union of Philadelphia," *Sartain's Union Magazine*, IX (August, 1851), p. 157.

59. For New York the following were of value: *Pictorial Dictionary of Broadway* (New York, 1849); *The Crayon; The Cosmopolitan Art Journal; The Literary World; New York City Mercantile and Manufacturing Directory* (New York, 1853); Mary Bartlett Cowdrey (ed.) *National Academy of Design, Exhibition Record, 1826–1860* (New York, 1943), 2 vols.; James Grant Wilson (ed.), *The Memorial History of the City of New York* (New York, 1893), 4 vols.; Mount Papers, NYHS. Durand Papers, NYPL; American Art-Union Collection, NYHS.

60. The prospectus for the International Art Union was printed in *The Literary World*, III (December 23, 1848), p. 959. It aroused vigorous newspaper comment, and the Clipping Book of the American Art-

Union contains many editorial comments on its value. For Mount's opinion see William Sidney Mount to William Schaus, Stony Brook, August 19, 1850, Mount Papers, NYHS.

61. See *A Catalogue of an Exhibition . . . on the Occasion of Knoedler, One Hundred Years, 1846–1946* [New York, 1946]. The forward by William Henschel contains a short history of the firm.

62. John P. Ridner, S. N. Dodge, Samuel P. Avery, Emil Seitz and Snedicor were art dealers of importance in New York.

63. Information concerning galleries and exhibitions has been culled from the columns and advertisement sections of New York periodicals, and from Cummings, *Annals of the National Academy, passim.* See also W. G. Constable, *Art Collecting in the United States of America: An Outline of a History* (Toronto and New York, 1964)

64. *Association for the Exhibition of the Industry of All Nations; Official Awards of Juries* (New York, 1853). See also *Putnam's Monthly Magazine,* II, (December, 1853), pp. 580–582.

65. *The Literary World,* III (June 10, 1848), p. 367. See also *The Crayon,* V (April, 1858), p. 117.

66. *Cosmopolitan Art Journal,* III (December, 1859), p. 236.

67. *The Crayon,* V (February, 1858), p. 59.

68. *The Crayon,* V (April, 1858), p. 115.

69. Cummings, *Annals of the National Academy,* p. 270.

70. "The Autobiography of Worthington Whittredge," John I. H. Baur (ed.), *Brooklyn Museum Journal,* I, (1942), p. 43.

71. Cummings, *Annals of the National Academy,* p. 225.

72. *Cosmopolitan Art Journal,* IV (March, 1860), p. 34.

73. *The Crayon,* VI (May, 1859), p .161.

74. *The Crayon,* VI (July, 1859), p. 221.

75. *The Crayon,* VI (November, 1859), p. 349. See also *The Crayon,* VI (December, 1859), p. 381.

76. "Art Notices," *Sartain's Union Magazine,* VII (August, 1850), p. 120.

77. *Sartain's Union Magazine,* VII (July, 1850), p. 58.

78. *Sartain's Union Magazine,* V (December, 1849), p. 387. Sartain did serve as an Academy officer for a number of years, however.

79. Entry for December 6, 1843, The Diary of Joseph Sill, microfilms in AAA.

80. Entry for March 8, 1884, The Diary of Joseph Sill, AAA. See also entries for September 21, 1843, January 4, 1848 and February 28, 1848.

81. Entry for September 22, 1860, "The Diaries of Sidney George Fisher," *Pennsylvania Magazine of History and Biography,* XCVII (October, 1963), p. 431.

82. James Jackson Jarves, *The Art-Idea*, Benjamin Rowland, Jr. (ed.) (Cambridge, Mass., 1960), p. 181.

83. *The Literary World*, I (July 3, 1847), p. 517.

84. *Cosmopolitan Art Journal*, III (March, 1859), p. 85.

85. *Cosmopolitan Art Journal*, II (December, 1857), p. 30. For the failure of a single American city to dominate literature see Lewis P. Simpson, "The City and the Symbolism of Literary Community in the United States," *Texas Quarterly*, III (Autumn, 1960), pp. 97–112. See also "The Representative Art," *Atlantic Monthly*, V (June, 1860), p. 608.

86. *The Literary World*, II (January 22, 1848), p. 608. The New England Art Union was organized shortly thereafter, but enjoyed only a brief life.

87. *The Crayon*, VI (July, 1859), p. 22.

88. William E. Winner, the Lambdins, William Trost Richards and the Peales were practically all native Philadelphians; John Sartain emigrated from England at an earlier date.

89. For a brief history of the Boston Art Club see its *Constitution and By-Laws* (Boston, 1878), pp. 7–10. See also Leila Woodman Usher, "Alfred Ordway," *The New England Magazine*, new ser., XVIII (March, 1898), pp. 3–7.

90. Thomas Bailey Aldrich, "Among the Studios," *Our Young Folks*, II (July, 1866), p. 393. For more on the University building see LeRoy E. Kimball, "The Old University Building and the Society's Years on Washington Square," *NYHS Quarterly* XXXII (July, 1948), pp. 149–219.

91. Aldrich, "Among the Studios," *Our Young Folks*, I (September, 1865), p. 595.

92. Aldrich, "Among the Studios," *Our Young Folks*, I (September, 1865), p. 597.

93. "Recollections of John Ferguson Weir," p. 351.

94. *The Crayon*, V (January, 1858), p. 24.

95. *The Crayon*, VI (November, 1859), p. 349.

96. *The Crayon*, VI (May, 1859), p. 145.

97. Thomas Butler Gunn, *The Physiology of New-York Boarding-Houses* (New York, 1857), p. 177. Another description which matches Gunn's closely can be found in F. Hopkinson Smith, *The Fortunes of Oliver Horn* (New York, 1902), p. 179. Smith was an artist and novelist; his study of New York art life on the eve of the Civil War centers around a lighthearted crew of painters who brawl, box, sing, and attend life classes at the Academy. For explication see William Henry Shelton, "Artist Life in New York in the Days of Oliver Horn," *The Critic*, XLIII (July, 1903), pp. 31–40. Shelton points out that Smith describes a later period, despite his ante-bellum setting.

98. Cummings, *Annals of the National Academy,* pp. 265–266.

99. For more on the Sketch Club and The Century, see Benson J. Lossing, "The National Academy of the Arts of Design, and Its Surviving Members," *Harper's New Monthly Magazine,* LXVI (May, 1883), pp. 832–852; *The Century, 1847–1946* (New York, 1947); Eliot Clark, *History of the National Academy of Design, 1825–1953* (New York, 1954); Winifred E. Howe, *A History of the Metropolitan Museum of Art* (New York, 1913), I, *passim;* Frederick G. Mather, "Club Life in New York City," in Wilson (ed.), *Memorial History of New York,* IV, pp. 232–262; John H. Gourlie, *The Origin and History of "The Century"* (New York, 1856).

100. Of the seven incorporators of The Century in 1857, two were artists and five were patrons. In its first twenty-five years, the club elected forty-six painters and four sculptors to membership. In a sample taken of painters' cards in *The Crayon* (September 26, 1855), p. 206, twenty of the twenty-six represented were or would become members of The Century. New York's only older clubs of note were The Union, founded in 1836, the New York Yacht Club of 1844, and the New York Club of 1845.

101. The Durand Papers contain a great deal of information concerning these testimonial dinners.

102. See J. F. Kensett to Asher B. Durand, New York, August 30, 1855, History of Art Manuscripts, I, AAA; Jervis McEntee to William J. Stillman and J. Durand, Rondout, October 25, 1855, History of Art Manuscripts, I, AAA; Sanford R. Gifford to Jervis McEntee, Hudson, October 21 1860, Feinberg Letters of Artists, AAA; and a note to McEntee who was serving in the Army, New York, June 10, 1861, signed by twelve artists who sent along salmon, peaches and tobacco to make his camp life a bit more pleasant.

103. The Penn Club, which associated authors, artists, writers and scientists, was not organized until 1875. See Scharf and Westcott, *History of Philadelphia,* II, pp. 1092–1098. Note the discussion of clubs and the Philadelphia art world in Burt, *Perennial Philadelphians,* pp. 256–317; and see also E. Digby Baltzell, *The Protestant Establishment, Aristocracy & Caste in America* (New York, 1964), pp. 369–374, for a comparison of The Century with more conservative clubs in the Philadelphia pattern.

104. Entries for June 3, 1849 and December 21, 1849, The Diary of Joseph Sill, AAA. In 1853 and 1854, nine professional artists sat on the board of managers, and the executive committee consisted of two artists and one amateur. Little has been published about the Philadelphia Art Union; its *Transactions* and occasioanl articles in *Sartain's Union Magazine* have been of help. The Samuel Sartain Papers, HSP, contain a number of its official documents, and the Sill Diary provides a running commentary.

105. See *Transactions of the Philadelphia Art Union, 1848, passim.*

The Art Union was reluctant to institute a free gallery for fear of angering the Academy and interfering with its annual exhibition, but it went ahead and did so in 1849. See also *Philadelphia Art Union Reporter,* I (January, 1852), p. 146.

106. *Transactions of the Philadelphia Art Union, 1848,* p. 43.

107. See, for example, the remarks in *Sartain's Union Magazine,* IX (December, 1858), p. 498.

108. *Catalogue of the First Exhibition of the Artists and Amateurs Association of Philadelphia . . . 1840* (Philadelphia, 1840).

109. *Transactions of the Philadelphia Art Union, 1848.*

110. Pennsylvania Academy catalogues, Fogg Library, Harvard University. The conservatism of Philadelphians can be demonstrated by analyzing the works in John Sartain, (ed.), *The Amercian Gallery of Art* (Philadelphia, 1848). Of the eleven Philadelphia paintings Sartain engraved for this work, only three were landscapes. This at a time when the Hudson River School was reaching its crest of popularity. Philadelphians did historical, scriptural or sentimental works instead.

111. *The Crayon,* III (May, 1856), p. 158.

112. *Evening Mirror,* November, 1849, American Art-Union Clipping Book, NYHS. See also *Evening Mirror,* November 22, 1849; and "Our Artists Proper," *Atlas,* November 18, 1849, both in the Clipping Book.

113. Thomas Rossiter to William J. Stillman and John Durand, Paris, November 21, 1855, History of Art Manuscripts, II, AAA.

114. *Putnam's Monthly Magazine,* I (June, 1853), p. 701. For more comment on the conservatism of the National Academy see Albert Ten Eyck Gardner, *Winslow Homer, American Artist: His World and His Work* (New York, 1961), pp. 75–76.

115. *Putnam's Monthly Magazine,* I (June, 1853), p. 703. See also Frederick Law Olmsted, *Walks and Talks of an American Farmer in England* (New York, 1853), p. 214.

116. *Putnam's Monthly Magazine,* I (April, 1853), p. 471. See also above, note 71.

117. Asher B. Durand to Thomas Cole, New York, May 24, 1838, Durand Papers, box 3, NYPL.

118. Frederick G. Spencer to Joshua A. Spencer, New York, December 12, 1842, Gratz Collection, box 4, HSP.

119. John Frankenstein, *American Art: Its Awful Altitude* (Cincinnati, 1864), p. 55. Some of his sharpest barbs were directed at Cincinnati patrons and painters, but he attacked, in addition, Poe, Hawthorne, Emerson, Charles Francis Adams—indeed anyone who had ever considered his work less than adequate, or of whom he disapproved.

120. *A True Account of the Initiation of J— B— into the S. S. Society for the Discouragement of Artistical Saps* (n.p., n.d.), p. 9. The NYPL contains a copy.

121. Charles C. Ingham to Asher B. Durand, New York, September 7, 1849, History of Art Manuscripts, I, AAA.

122. *The Crayon,* VI (June, 1859), p. 193.

123. *The Crayon,* V (June, 1858), p. 179.

124. See *Sartain's Union Magazine,* VII (August, 1850), p. 58; E[arl] S[hinn], "Private Art Collections of Philadelphia," *Lippincott's Magazine,* IX (April–June, 1872), X (July–December, 1872);René Brimo, *L'Évolution du Goût aux Ètats-Unis* (Paris, 1938), *passim; The Catalogue of the Great Central Fair* (Philadelphia, 1864); *The Crayon,* III (January, February, April, June, August, December, 1856). The collections of James L. Claghorn, Henry C. Gibson, George Whitney, Samuel B. Fales, Henry C. Carey, William P. Wilstach and other Philadelphians were described in *Lippincott's.* It is true that Isabey, Schreyer, Bougereau and Zamacois represented post-bellum taste everywhere in the country, but Philadelphians took to this European art much earlier than New Yorkers. The *Catalogue* of the Central Fair held for the benefit of the United States Sanitary Commission in 1864 reveals this precedence. New York patrons represented at the Fair all owned fine American collections; Philadelphians like Wilstach, Swann and Clark were more oriented to European art.

125. Burt, *Perennial Philadelphians,* p. 322, remarks that in Philadelphia the "only really respectable approach to art is by way of the boards of institutions." See also his comments, pp. 343–348, on the longevity of this conservatism.

126. Unless otherwise noted, information on individual patrons is taken from Allan Johnson and Dumas Malone (eds.), *Dictionary of American Biography,* 20 vols. (New York, 1928–1936).

127. For Gilpin see *The Biographical Encyclopedia of Pennsylvania of the Nineteenth Century* (Philadelphia, 1874), pp. 58–59; and "Washington in 1825; Observations by Henry D. Gilpin," Ralph D. Gray (ed.), *Delaware History,* XI (April, 1965), pp. 240–250. For a perceptive eulogy of Gilpin see "The Diaries of Sidney George Fisher," *Pennsylvania Magazine of History and Biography,* XCVII (July, 1963), pp. 326–327.

128. For Fales see *Biographical Encyclopedia of Pennsylvania,* pp. 362–363.

129. Typically, Philadelphia art patrons had a wide range of more general philanthropic activities; their art interest was part of a general humanitarianism, rather than a more limited but helpful concern with art. J. Francis Fisher, for example, an Academy director, was a founder of the Pennsylvania Institution for the Instruction of the Blind; George Seckel Pepper was president of both the Academy of Music and the Academy of the Fine Arts; he left a fortune to colleges, hospitals and libraries. Charles Macalester, another patron, founded the college bearing his name in St. Paul, while John Hare Powel imported European art while condemning "the lavish and wanton expenditure upon

mere luxury, which leads to so much of the misery around us." Powel was a noted agricultural experimenter. See Henry Simpson, *The Lives of Eminent Philadelphians, Now Deceased* (Philadelphia, 1859), p. 817.

130. See Baltzell, *Philadelphia Gentlemen,* table 10, "Elite Incomes in 1864," p. 108. For an earlier discussion see *Memoir and Autobiography of Some of the Wealthy Citizens of Philadelphia* (Philadelphia, 1846). By 1860 the city contained eleven millionaires, and 1100 fortunes of $50,000 or more. It was a society which could afford art. For New York and Boston see Charles B. Spahr, *The Present Distribution of Wealth in the United States* (Boston, 1896), appendix D; and Sidney Ratner (ed.), *New Light on the History of Great American Fortunes* (New York, 1942). By 1863 seventy-nine New Yorkers reported annual incomes of more than $100,000. For Harrison see *The National Cyclopedia of American Biography* (New York, 1898–1906), XII, p. 496. Industrialists and engineers who supported art in Philadelphia tended to take a more active role in the art world than their professional friends. There is no ready list of Philadelphia collectors; the names I offer have been compiled from brochures, catalogues, auction sales reports, periodical articles, art union documents and Rutledge (ed.), *Pennsylvania Academy of the Fine Arts.*

131. For more on Childs see Nicholas B. Wainwright, *Philadelphia in the Romantic Age of Lithography* (Philadelphia, 1958), *passim.* Sill said of Carey that he "goes down to his grave with the ardent admiration . . . of many a poor tho deserving artist, whom he has fostered and encouraged. He was completely interested in the advancement of contemporary art, and the living artist was his chief care." Entry for June 16, 1845, The Diary of Joseph Sill, AAA.

132. Other important patrons included James L. Claghorn, a banker and president of the Academy; John A. Brown, another banker; and Wilson Swann, a transplanted Virginia physician.

133. See entries for March 22, 1843, and June 10, 1848, The Diary of Joseph Sill, AAA. Some of Sill's friends suggested he become president of the Art Union, but Sill felt that McMurtrie had a higher social position and thus more influence; he declined the nomination.

134. See entry for March 15, 1843, The Diary of Joseph Sill, AAA.

135. George Persons Lathrop, *History of the Union League of Philadelphia* (Philadelphia, 1884), p. 31. The club soon was forced into the older, more conservative model. See Baltzell, *The Protestant Establishment,* pp. 374–379.

136. For Hunt and Boston art life see Shannon, *Boston Days of Hunt;* and Helen M. Knowlton, *Art Life of William Morris Hunt* (Boston, 1899). For Page, Joshua C. Taylor, *William Page, The American Titian* (Chicago, 1957), is most helpful.

137. Downes, "Boston Painters and Paintings," *Atlantic Monthly,* LXII (September, 1888), pp. 386–387. Ernest Wadsworth Longfellow, the poet's son, became an artist. See Ernest Wadsworth Longfellow,

Random Memories (Boston and New York, 1922), for recollections of artistic Boston in the Civil War era.

138. For more on Boston art patrons see Harris, "The Gilded Age Revisited."

139. [Cheney] *Memoirs of Seth W. Cheney,* p. 68.

140. John Albee, *Henry Dexter, Sculptor, A Memorial* (Cambridge, Mass., 1898), p. 63.

141. For some of these holdings see Augustus T. Perkins, "Sketch of some of the losses to the Departments of Literature and the Fine Arts, occasioned by the Great Fire of Boston of 1872," *New England Historical and Genealogical Register and Antiquarian Journal,* XXVII (October, 1873), pp. 369–375.

142. See Brimo, *L'Évolution du Goût,* pp. 57–58.

143. Downes, "Boston Painters and Paintings," *Atlantic Monthly,* LXII (December, 1888), p. 785.

144. A founders' list is reprinted in *The Century, 1847–1946,* p. 299, and they are discussed pp. 3–24, 154–183. The ten artists were Henry Kirke Brown, J. G. Chapman, Thomas S. Cummings, Asher B. Durand, F. W. Edmonds, Henry Peter Gray, Daniel Huntington, Charles C. Ingham and Charles Loring Elliott, all leaders of the artist community.

145. For Roberts see *National Cyclopedia of American Biography,* III, p. 350.

146. Matthew Hale Smith, *Successful Folks and How They Win* (New York, 1878), p. 322. For an anecdote of Roberts' youthful love of art see "Autobiography of Worthington Whittredge," p. 64.

147. For Sturges see *National Cyclopedia of American Biography,* III, p. 350. For Allen see Cummings, *Annals of the National Academy,* p. 224. Allen and Sturges were brothers-in-law.

148. For Leupp see John H. Gourlie, *A Tribute to Charles M. Leupp* . . . (New York, 1860).

149. For Faile see Henry Hall (ed.), *America's Successful Men of Affairs* (New York, 1895), I, p. 229. Faile was a good friend of another patron, the inventer-industrialist Richard M. Hoe. Haggerty was a patron of George Inness. See *"The Century," Memorial Notices, 1875* (New York, 1875). Stewart, Hoe and Olyphant are described in Johnson and Malone (eds.), *Dictionary of American Biography.*

150. They included David Hunter McAlpin, Robert L. Stuart, a sugar refiner, William Henry Webb, a shipbuilder, and William T. Blodgett, a varnish manufacturer. Webb and Stuart are listed in Johnson and Malone (eds.), *Dictionary of American Biography.* For McAlpin see Hall (ed.), *America's Successful Men,* I, pp. 412–413. For Blodgett see Reverend Stephen H. Tyng, *In Memoriam, William Tilden Blodgett* (NewYork, 1875).

151. Frederic E. Church to Mr. Winthrop, New York, March 16, 1860, Miscellaneous File, NYPL.

152. This list is not meant to be exhaustive; I have tried merely to be representative. For a listing of some major collectors see Cowdrey (ed.), *National Academy of Design, Exhibition Record*, I, p. ix.

153. These associations have been gleaned from letters, manuscripts and brochures, mostly from the Durand Papers in the NYPL; the Mount Papers in the NYHS; the Chamberlain Collection in the BPL; and the Dreer Collection in the HSP.

154. Robert L. Stuart to Asher B. Durand, New York, June 3, 1857, Durand Papers, box 4, NYPL.

155. Henry G. Marquand to Durand, New York, April 23, 1851, Durand Papers, box 4, NYPL.

11 Artists' Dreams and European Realities

1. Much recent scholarship has concerned itself with American artists abroad, though most of it has concentrated on Italy. See, for example, Otto Wittmann, Jr., "The Italian Experience (American Artists in Italy, 1830–1875)," *American Quarterly*, IV, (Spring, 1952), pp. 3–15; Madeleine B. Stern, "New England Artists in Italy, 1835–1855," *New England Quarterly*, XIV (June, 1941), pp. 243-271; Margaret Farrand Thorp, *The Literary Sculptors* (Durham, 1965); Albert Ten Eyck Gardner, *Yankee Stonecutters, The First American School of Sculpture, 1800–1850* (New York, 1945); Yvon Bizardel, *American Painters in Paris* (New York, 1960); and Paul R. Baker, *The Fortunate Pilgrims: Americans in Italy, 1800–1860* (Cambridge, Mass., 1964). Besides these the recent biographies of Horatio Greenough and Thomas Crawford represent real contributions. Of course, Henry James, *William Wetmore Story and His Friends* (Boston, 1903), 2 vols., is still immensely useful. Most of this literature is descriptive, and I have not bothered to duplicate the careful reconstruction of daily life these writers have presented. Instead I have chosen to emphasize neglected aspects of the artist life abroad.

2. Among American artists in Paris in the 1840s were Thomas Rossiter, J. F. Kensett, Daniel Huntington, G. P. A. Healy and James De Veaux. In later decades George Inness, Frederic Church, Worthington Whittredge, W. A. Gay and William J. Stillman studied there. See Benjamin Champney, *Sixty Years' Memories of Art and Artists* (Woburn, Mass., 1899); William J. Stillman, *The Autobiography of a Journalist* (London, 1901), 2 vols.; "The Autobiography of Worthington Whittredge," John I. H. Baur (ed.), *Brooklyn Museum Journal*, I (1942), pp. 5–69; and Seth Eyland (pseud. for David E. Cronin), *The Evolution of a Life* (New York, 1884). All contain information on American artists in Paris and Düsseldorf. See also James Thomas Flexner, *That Wilder Image: The Painting of America's Native School from Thomas Cole to Winslow Homer* (Boston, 1962), pp. 190–194.

3. James E. Freeman, *Gatherings from an Artist's Portfolio* (New York, 1877), and *Gatherings from an Artist's Portfolio in Rome* (Bos-

ton, 1883), present particularly interesting pictures of artist life in Italy.

4. William Dunlap, *A History of the Rise and Progress of the Arts of Design in the United States,* Frank W. Bayley and E. Goodspeed (eds.) (Boston, 1918), III, p. 24.

5. Henry T. Tuckerman, *Artist Life; or, Sketches of American Painters* (New York, 1847), pp. 130–131, and *The Italian Sketch Book* (New York, 1848), p. 126.

6. See William Cullen Bryant, *The Picturesque Souvenir, Letters of a Traveller* (New York, 1851), p. 238; and William Ware, *Sketches of European Capitals* (Boston, 1851), pp. 136–140.

7. John Albee, *Henry Dexter, Sculptor, A Memorial* (Cambridge, Mass., 1898), p. 52.

8. See William Sidney Mount to Charles Lanman, Stony Brook, January 7, 1850, Mount Papers, and Mount to Goupil, Vibert & Co., Stony Brook, February 14, 1850, Mount Papers, NYHS.

9. Sanford R. Gifford to his father, Paris, February 4, 1856, Gifford Letters, II, AAA.

10. "Autobiography of Worthington Whittredge," pp. 39–40.

11. Asher B. Durand to John Durand, Antwerp, August 17, 1840, Durand Papers, box 3, NYPL.

12. Ware, *Sketches of European Capitals,* p. 136.

13. John G. Chapman to Thomas Sully, Florence, July 27, 1829, Chamberlain Collection, BPL.

14. "The American School of Art," *American Whig Review,* XVI (August, 1852), p. 148.

15. "Nationality in Art," *Cosmopolitan Art Journal,* I (March, 1857), p. 76. See also "The Fine Arts," *Knickerbocker Magazine,* XIV (November, 1839), pp. 420-424; and "The Young American Artist Leutze," *The New World,* VI (February 25, 1843), p. 246.

16. "Representative Character of American Artists," *Cosmopolitan Art Journal,* II (April, 1858), p. 137.

17. Horatio Greenough to ———, Florence, June 16, 1853, quoted in John Joseph Lawler, "Comments on Art and Literature. From the Personal Writings of a Group of Well Traveled Early American Writers and Artists. A Critical Collation," Ph.D. dissertation, Florida State University, 1960.

18. Harriet Hosmer to Wayman Crow, Rome, June 17, 1854, *Harriet Hosmer: Letters and Memories,* Cornelia Carr (ed.) (London, 1913), p. 34.

19. George S. Hillard, *Six Months in Italy* (Boston, 1853), II, pp. 256–257.

20. [Mrs. Ednah Dow Cheney] *Memoirs of Seth W. Cheney, Artist* (Boston, 1881), p. 81.

21. "Autobiography of Worthington Whittredge," pp. 33-34.

22. Robert W. Gibbes, M.D., *A Memoir of James De Veaux* (Columbia, S. C., 1846), pp. 234–235.

23. Quoted in H[enry] T[heodore] T[uckerman], "Greenough: The Sculptor," *American Monthly Magazine,* new ser., I (January, 1836), pp. 54–55.

24. C. Edwards Lester, *Artists of America: A Series of Biographical Sketches of American Artists* (New York, 1846), p. 83.

25. Lester, *Artists of America,* p. 61.

26. Henry T. Tuckerman, *Book of the Artists. American Artist Life* (New York, 1867), p. 535.

27. An extract from an article, "The Fine Arts and Artists in Cincinnati," Neagle Collection, HSP.

28. For Crawford see Lester, *Artists of America,* p. 241. See also F. W. Edmonds, "Frederick S. Agate," *Knickerbocker Magazine,* XXIV (August, 1844), p. 160. Others dying young in Europe included two sculptors, Paul Duggan and Edward S. Bartholomew. For Bartholomew see *Cosmopolitan Art Journal,* II (September, 1858), pp. 184–185. Another sculptor, Henry Kirke Brown, almost died in Naples. See Nehemiah Cleaveland, "Henry Kirke Brown," *Sartain's Union Magazine,* VIII (February, 1851), pp. 135–138. For Greenough's illness, blamed on his constant travel between Europe and America, see Tuckerman, *Artist-Life,* p. 41.

29. "Autobiography of Worthington Whittredge," p. 39.

30. Freeman, *Gatherings from an Artist's Portfolio in Rome,* p. 81.

31. See Robert L. Gale, *Thomas Crawford, American Sculptor* (Pittsburgh, 1964), p. 11, for a discussion of Crawford's hardships. Though he died of a brain tumor, eulogists did the best they could to imply that overwork contributed to his decline.

32. H. W. French, *Art and Artists in Connecticut* (Boston, 1879), pp. 99–102.

33. Gibbes, *Memoir of De Veaux,* gives the full story.

34. See also *A General View of the Fine Arts, Critical and Historical* (New York, 1851), pp. 301–307 for comments about C. L. Ver Bryck, another artist dying young; and see Champney, *Sixty Years' Memories,* p. 37, for a discussion of an American painter named Cooke, who died in Paris at an early age.

35. See Gibbes, *Memoir of De Veaux,* p. 203.

36. See French, *Art and Artists in Connecticut,* p. 114, for another martyr's eulogy. And see Lester, *Artists of America,* p. 61, for a description of Crawford's great funeral, the prominent procession "following the bier of the artist on foot, for two long miles, on a cold winter evening."

37. *The Crayon,* V (October, 1858), p. 290, reprints the section of Lanzi's *History of Painting* which summarizes artist longevity tables.

38. Margaret Fuller Ossoli, *At Home and Abroad, or Things and Thoughts in America and Europe* (Boston, 1856), p. 375.

39. "American Artists in Rome," *The Crayon,* VI (June, 1859), p. 183.

40. "Foreign Correspondence," *The Crayon,* IV (March, 1857), p. 89.

41. Sanford R. Gifford to his father, Amsterdam, June 1, 1856, Gifford Letters, II, AAA.

42. George Caleb Bingham to J. S. Rollins, Düsseldorf, November 4, 1856, "Letters of George Caleb Bingham to James Rollins," C. B. Rollins (ed.), *Missouri Historical Review,* XXXII (April, 1938), p. 343.

43. Eyland, *Evolution of a Life,* p. 91.

44. Leonora Cranch Scott, *The Life and Letters of Christopher Pearse Cranch* (Boston, 1917), *passim.*

45. George Caleb Bingham to J. S. Rollins, Düsseldorf, November 4, 1856, "Letters of Bingham," *Missouri Historical Review,* XXXII (April, 1938), p. 345.

46. Champney, *Sixty Years' Memories, passim.*

47. Thorp, *The Literary Sculptors,* pp. 26–27.

48. See Gale, *Thomas Crawford, passim,* for details of his quarrels with Powers and Story. For Powers and his angry complaints of Presidents Pierce and Buchanan, see "Letters of Hiram Powers to Nicholas Longworth, Esq., 1856–1858," *Quarterly Publications of the Historical Society of Ohio,* I (April–June, 1906), pp. 35–39.

49. Nathaniel Hawthorne, *The Marble Faun* (Boston, 1860, 1888), p. 159.

50. James, *William Wetmore Story,* I, p. 82. This book helped diffuse a number of artist myths, particularly the one concerning Allston neglected in his Cambridgeport studio. Occasionally James superimposed his own concern with the problems of creativity and expatriatism on the experiences of these earlier artists.

51. Notably Margaret Farrand Thorp, who writes that American sculptors "had not imagined that any country believed its artists such an asset to the state that national funds were as a matter of course invested in their training." "Literary Sculptors in the Caffé Greco," *American Quarterly,* XII (Summer, 1960), pp. 160–174.

52. Sanford R. Gifford to his father, Paris, May, 1856, Gifford Letters, II, AAA.

53. Gibbes, *Memoir of De Veaux,* p. 110.

54. [Miss Wheaton] *North American Review,* CLIV (January, 1852), p. 121. See also Isaac A. Jewett, *Passages in Foreign Travel* (Boston, 1838), I, pp. 6–7.

55. Bayard Taylor, *Views A-Foot: or, Europe seen with Knapsack and Staff* (New York, 1854), p. 265.

56. See also John Robinson Tait, *European Life, Legend and Landscape, by an Artist* (Philadelphia, 1859), p. 52.

57. *The Crayon*, VI (May, 1859), p. 160.

58. "Autobiography of Worthington Whittredge," p. 26.

59. "Autobiography of Worthington Whittredge," p. 28. See also Eyland, *Evolution of a Life, passim.* Church never got to Europe until he had achieved professional fame, in the 1860s.

60. "Autobiography of Worthington Whittredge," p. 60.

61. Harriet Hosmer to Wayman Crow, Rome, October 12, 1854, *Harriet Hosmer*, pp. 37–38.

62. William E. West to Thomas Sully, Florence, January 29, 1820, Dreer Collection, V, HSP.

63. Quoted in Nathalia Wright, *Horatio Greenough, The First American Sculptor* (Philadelphia, 1963), p. 229.

64. Gibbes, *Memoir of De Veaux,* p. 228. This was the observation of Thomas Rossiter. De Veaux himself disliked the "cold, calculating, grey looking spirits of our northern cities—and unfortunately these are the only points in our country where a Painter can *live.*" Quoted in Gibbes, *Memoir of De Veaux,* p. 49. See also Washington Allston to James McMurtrie, Cambridgeport, March 2, 1837, Dreer Collection, I. "The power of our art . . . cannot be known out of Italy. It is there only where you will find the existence of invisible truth proved palpably. At least, I cannot well conceive how any imaginative man, can return from Rome and Florence, without having felt that there are other truths besides such as are gotten thro the senses."

65. Christopher Pearse Cranch to the Misses Myers, New York, August 7, 1849, in Scott, *Life and Letters of Cranch,* p. 172.

66. Champney, *Sixty Years' Memories,* p. 78.

67. Tuckerman, *Artist-Life,* pp. 228–229.

68. James, *William Wetmore Story,* I, p. 298, quoted in Thorp, *The Literary Sculptors,* pp. 44-45.

69. "Autobiography of Worthington Whittredge," p. 42.

70. Louis Legrand Noble, *The Life and Works of Thomas Cole,* Elliot S. Vessell (ed.) (Cambridge, Mass., 1964), p. 124.

71. Quoted in Dunlap, *History,* III, pp. 155–156.

72. Christopher Pearse Cranch to the Misses Myers, New York, June 22, 1851, in Scott, *Life of Cranch,* p. 183.

73. Scott, *Life of Cranch,* p. 183.

74. Thomas Rossiter to William J. Stillman and John Durand, Paris, November 21, 1855, History of Art Manuscripts, II, AAA.

75. Cleaveland, "Henry Kirke Brown," p. 137.

76. Cephas G. Thompson to William Cullen Bryant, Rome, July 29, 1858, Bryant-Godwin Papers, NYPL.

77. Hiram Powers to Nicholas Longworth, Florence, January 14, 1858, "Letters of Hiram Powers to Nicholas Longworth, Esq., 1856–8," *Quarterly Publications of the Historical Society of Ohio,* I, pp. 54–55.

78. Powers' daughter recalled that her father "never made groups be-
cause they were less remunerative than single figures, and mindful of
the welfare of his family, he thought it his duty to lay by what he
could, even at a sacrifice of the added renown he might win." Ellen
Lemmi Powers, "Recollections of My Father," *The Vermonter,* XII
(March, 1907), p. 74. See also Thorp, *The Literary Sculptors,* pp. 76-78.
Powers' bust, "America," sometimes called "Liberty," was representative
of his entrepreneurial skill; he executed more than eighteen copies
of it between 1850 and 1870, selling each at a handsome price.

79. Eyland, *Evolution of a Life,* p. 89.

80. C. F. Briggs to William Page, Staten Island, June 4, 1846, Page
Papers, AAA.

12 The Final Tribute

1. See, for example, Hiram Mattison, *Popular Amusements: An Ap-
peal to Methodists* (New York, 1867); T. L. Cuyler, *Sermon on Chris-
tian Recreation and UnChristian Amusements* (New York, 1858); Rev-
erend J. T. Crane, *Popular Amusements* (Cincinnati and New York,
1869); Charles Simmons, *A Laconic Manual . . .* (North Wrentham,
Mass., 1852), p. 307.

2. A discussion of this change can be found in Albert F. McLean,
Jr., *American Vaudeville as Ritual* ([Lexington, Ky.] 1965), pp. 66–90.
For more sermons hostile to amusements see p. 229.

3. Edward Everett Hale, *Public Amusement for Poor and Rich* (Bos-
ton, 1857), p. 12.

4. *Amusements: Their Uses and Abuses. Testimony of Progressive
Friends* (New York, 1856), p. 5.

5. George W. Bethune, *Sermons* (Philadelphia, 1852), pp. 167–168.

6. Frederick W. Sawyer, *Hits at American Whims and Hints for Home
Use* (Boston, 1860), p. 55. This book brings together almost every
strand in the fabric of conservative justification for art and amusements.

7. *Amusements: Their Uses and Abuses,* p. 6. J. H. Morison, *Amuse-
ments* (Boston, 1859), explained that the Puritans, "in pulling up the
tares which the Evil One had sown . . . also pulled up many a sweet
wildflower which God had planted for the delight and comfort of his
children," p. 6.

8. James Leonard Corning, *The Christian Law of Amusement* (Buf-
falo, 1859), p. 17. Corning was a Presbyterian pastor.

9. Morrison, *Amusements,* p. 7.

10. Frederick W. Sawyer, *A Plea for Amusements* (New York and Phil-
adelphia, 1847), p. 249.

11. Sawyer, *A Plea for Amusements,* p. 158. Sawyer felt that England,
where less was done for the lower classes in the way of amusements,
was experiencing considerable social disunity because of this.

12. Sawyer, *A Plea for Amusements,* pp. 256–257. Hale thought athletics were particularly necessary in urban areas; the "tendency of city life is to make boys timid; to make them cowards." Hale, *Public Amusements,* p. 22.

13. See Mark Hopkins, *The Connexion between Taste and Morals* (Boston, 1841).

14. Sawyer, *Hits at American Whims,* p. 113. Chapter XXIII was entitled "Adorn."

15. "The Court of Death," Gratz Collection, HSP.

16. Reverend John W. Chickering, "The Reciprocal Influence of Piety and Taste," *The Christian Keepsake and Missionary Annual* (1839), p. 74.

17. E. Mulford, "The Use Made by Roman Christian Art, of Scripture Characters," *Yale Literary Magazine,* XX (August, 1855), pp. 340–345.

18. L. Maria Child, *Letters from New York,* 2nd ser. (New York, Boston, 1845), p. 215.

19. *The Crayon,* II (October 10, 1855), p. 229.

20. Cyrus Augustus Bartol, *Pictures of Europe, Framed in Ideas* (Boston, 1856), p. 200. This section of the book bears the title, "Testimony of Art to Religion."

21. "Belle Brittan on Beauty," *Cosmopolitan Art Journal,* III (December, 1858), p. 35.

22. *The Crayon,* IV (September, 1857), p. 288. See also Henry Ward Beecher, *Star Papers; or Experiences of Art and Nature* (New York, 1855), chap. XXVI, "Christian Liberty in the Use of the Beautiful."

23. *The Crayon,* II (July 25, 1855), p. 54.

24. "The Painter's Portfolio," *Putnam's Monthly Magazine,* IV (October, 1854), p. 364.

25. Hopkins, *Connexion between Taste and Morals,* p. 28.

26. Morison, *Amusements,* p. 14.

27. Hopkins, *Connexion between Taste and Morals,* p. 31.

28. "The Great Exhibition and its Visitors," *Putnam's Monthly Magazine,* II (December, 1853), p. 582.

29. Quoted in *The Literary World,* IX (September 27, 1851), p. 252.

30. *The National Academy of Design. Ceremonies on . . . Laying the Corner-Stone . . .* (New York, 1865), p. 25. These remarks were made two years before the pamphlet was published.

31. *Ceremonies on . . . Laying the Corner-Stone,* p. 53. Huntington made these remarks in 1865, concerned about the possibility that artists might glorify Confederate heroes. His disagreement with Bellows was not fundamental, of course; both would insist that the artist be moral and religious.

32. *The Crayon,* III (April, 1856), p. 114. This was in connection with an attack on Thomas Cole's allegorical "Voyage of Life."

33. [J. H. Ward] "Art and Artists," *Christian Examiner,* LXVII (September, 1859), p. 210. See also "Prospects of Art in This Country," *Christian Examiner,* XXV (January, 1839), p. 319. This article took Huntington's position, arguing that an intemperate artist might still produce attractive art. "But his art is perpetually warring with these vices, and, unless it conquers, will retreat before them."

34. This information has been culled from *The Crayon, Christian Examiner, Cosmopolitan Art Journal, Putnam's Monthly Magazine,* and other periodicals of the 1850s.

35. *The Crayon,* III (December, 1856), p. 376.

36. George W. Bethune, "Art in the United States," *The Home Book of the Picturesque. Home Authors and Home Artists* . . . (New York, n. d.), pp. 179–180.

37. See *North American Review,* LXXII (January, 1856), p. 46. See also a review by Edward Everett Hale of a book on amusements by the Reverend Henry Bellows in the *Christian Examiner,* LXIII (July, 1857), pp. 47–65. See also a review of Bellows' speech, "A Natural Theology of Art, The Moral Significance of the Crystal Palace," by the Reverend H. W. Parker in the *North American Review,* LXXIX (July, 1854), pp. 1–30.

38. Morison, *Amusements,* p. 8.

39. See the remarks of the Reverend Mr. Osgood at the opening of an American Art-Union exhibition, quoted in *The Literary World,* IX (September 27, 1851), p. 252.

40. J. C. Derby, *Fifty Years among Authors, Books and Publishers* (New York, 1884), pp. 108, 250–251.

41. "The Representative Art," *Atlantic Monthly,* V (June, 1860), p. 690.

42. See the entry for December 15–16, 1852, in the Diary of Joseph Sill, AAA.

43. Matthew Hale Smith, *Successful Folks and How They Win* (New York, 1878), p. 388. For Bartol see Samuel A. Eliot (ed.), *Heralds of a Liberal Faith* (Boston, 1910–1912), III, pp. 17–22. E. L. Magoon, Samuel Osgood, Edward N. Kirk, Fredric Henry Hedge, Orville Dewey, E. H. Chapin, George Washington Bethune and Henry W. Bellows are all treated in Allan Johnson and Dumas Malone (eds.), *Dictionary of American Biography,* 20 vols. (New York, 1928–1936); or *The National Cyclopedia of American Biography* (New York, 1898–1906). See also Henry Fowler, *The American Pulpit* . . . (New York, 1856), *passim.*

44. Beecher, *Star Papers,* p. 294.

45. John Ross Dix, *Pulpit Portraits* . . . (Boston, 1854), pp. 40–41.

This book contains short sketches of a number of other art-loving ministers, including John Pierpont.

46. For Furness see George C. Groce and David H. Wallace, *The New-York Historical Society's Dictionary of Artists in America, 1564–1860* (New Haven, 1957), p. 246. For Flagg and Bolton see pp. 63, 230.

47. Sawyer, *A Plea for Public Amusements*, p. 145.

48. Sawyer, *A Plea for Public Amusements*, p. 163.

49. Hale, *Public Amusement*, p. 15.

50. Hale, *Public Amusement*, p. 13.

51. Sawyer, *Hits at American Whims*, p. 65.

52. Henry Ward Beecher, *Norwood; or, Village Life in New England* (New York, 1867, 1868), p. 231.

53. Beecher, *Norwood*, p. 322.

54. Beecher, *Norwood*, p. 327.

55. Beecher, *Norwood*, p. 264. Beecher's anomalous views and moral confusion are revealed by the history of *Norwood* itself. Though he continued to oppose the theater as an institution, Beecher allowed the novel to be made into a play; naturally, he refused to attend it. See Marvin Felheim, "Two Views of the Stage; or Theory and Practice of Henry Ward Beecher," *New England Quarterly*, XXV (September, 1952), pp. 314–326.

56. Beecher *Norwood*, p. 265.

57. Beecher, *Norwood*, p. 302. The youthful artist, Frank Esel (again, it is difficult to say whether Beecher is punning on easel, or the German word for ass), is a typical romantic; he has learned through suffering, illness, and the rejection of his marriage proposal by the novel's heroine, Rose Wentworth.

58. Reverend Henry W. Bellows, *The Ledger and The Lexicon: or Business and Literature in Account with American Education* (Cambridge, Mass., 1853), p. 34. This Phi Beta Kappa oration contains one of the most extraordinary defenses of American materialism and the business ethic ever penned. Bellows' romanticization of the American businessman has rarely been surpassed. That it was expressed in the same place and on the same occasion as Emerson's American Scholar address, and not too many years later, occasions still more astonishment.

59. Thomas R. Gould, Journal and Memoranda, p. 244, Houghton Library, Harvard University.

60. George Loring Brown to J. H. Hall, Shrewsbury, September 1, 1837, Gratz Collection, box 1, HSP.

61. Thomas Cole to a New York art association, Catskill, February 1, 1848, reprinted in a newspaper and preserved in the American Art-Union Clipping Book, NYHS.

62. George Inness, Jr., *The Life, Art and Letters of George Inness* (New York, 1917), p. 17.

63. Asher B. Durand, "Letters on Landscape Painting," *The Crayon,* I (February 14, 1855), p. 97.

64. Quoted in Thomas S. Cummings, *Historic Annals of the National Academy of Design* (Philadelphia, 1865), p. 344.

65. *Ceremonies on . . . Laying the Corner-Stone,* p. 27.

66. [James Jackson Jarves] "Can We Have an Art Gallery?" *Christian Examiner,* LXXII (March, 1862), p. 205.

67. L. R. Jacobs to American Art-Union, Bath, January 1, 1849, Artists' Letters, I, NYHS.

68. Robert Newman to Asher B. Durand, Clarkesville, December 22, 1846, Durand Papers, box 3, NYPL.

69. See, for example [Finley Peter Dunne], "Art Patronage," *Observations by Mr. Dooley* (New York, 1906), pp. 41–42.

70. See Gustave de Beaumont, *Marie, or Slavery in the United States,* Barbara Chapman (trans.) (Stanford, 1958), p. 112; and Achille Murat, *America and the Americans* (New York, 1849), p. 260.

Index

Abbott, Rev. Gorham, 308
Academies, 10, 51, 62, 91–101, 103–104, 107, 350
Achenbach, Andreas and Oswald, 275
Adams, Abigail, 31
Adams, Charles Francis, 399
Adams, John, 16, 18, 32–34, 36, 38, 49, 332, 334, 360
Adams, John Quincy, 100
Adams, Joseph A., 112
Adams, Samuel, 32
Addams, Jane, 367
Agate family, 260
Agate, Alfred T., 261
Agate, Frederic S., 261, 289, 348
Aglionby, William, 327
Akenside, Mark, 31
Akers, Paul, 289
Albany, 57, 70, 110, 117, 255, 258, 303
Albany Rural Cemetery, 201
Alden and Vose, 395
Aldrich, Thomas Bailey, 268–269
Alexander, Cosmo, 69
Alexander, Francis, 57–58, 63, 71, 79, 112
Alger, Horatio, 219
Alger, Rev. W. R., 307–308
Allegory: 2, 9, 17–18, 188–193, 204, 235, 374–375, 378. *See also* Cemeteries; Nature; Patriotic Monuments; Symbolism.
Allen, Theodore, 280, 402
Allston, John, 59
Allston, Washington: 58, 71, 62, 77, 85, 98, 104, 107, 111, 114, 175, 180, 192, 260, 267, 278, 285, 289, 339–340, 347, 357, 371, 373, 406; "Belshazzar's Feast," 101; *Monaldi,* 221, 227; personal character, 62, 64, 117, 237–240
Alps, the, 131
Alverthorpe, 382
American Academy of the Fine Arts, 92, 94–96, 104, 110, 350
American Art Union, 183, 228,

231–232, 244, 246, 257, 262, 268, 271–272, 275, 281, 305, 308
American Farmer, 383
American Museum, 20
American Peace Society, 192
American Revolution, vii, x, 3, 7–8, 15–19, 28, 49, 78, 85, 188, 194–195, 313, 384
American Whig Review, 286
Ames, Ezra, 56–57
Amity Street, 268
Amsterdam, 154
Andalusia, 45
Andover Theological Seminary, 308
Andrea del Sarto, 90, 138
Antwerp, 128, 293
Apollo Association, 272
"Apollo Belvedere," 14, 129
Appleton and Company, 112
Appleton Building, 266
Appleton, Daniel, 112
Appleton, Nathan, 278
Appleton, William H., 113, 280
Archaeology, 158, 193, 203, 206–207
Architects' Club, 270
Architecture: 129, 176, 178–179, 256, 260, 268; modesty of in America, 46, 336; and morality, 208–216; official buildings, 16, 17, 42–45; and public opinion, 43–45, 47, 214. *See also* Beauty; Egypt; Gothic; Government Commissions; Greece; Landscape Movement; Neo-Classicism; Nature; Patriotic Monuments; Transcendentalism.
Arch of Triumph, 157
Arctic, the, 269
Arnold, Benedict, 18
Art: vii, 2, 7, 13, 22–23, 36, 38, 53, 58–59, 97, 105–106, 121, 127–129, 131, 162–163, 174, 179, 182–185, 227–228, 236–237, 257, 357, 393; American need for, 18–25; auctions of, 64, 254–255, 391–392;

Durand, Asher B.: 59, 71, 98, 106, 109, 113, 119, 257–260, 262, 281, 285, 313, 392, 402; artistic leadership, 270–271, 274–275
Durand, John, 261, 350
Durbin, John, 154, 156–157, 159, 161
Durrie, George, 72
Düsseldorf, 125, 284–285, 290–291, 293, 403
Düsseldorf Gallery, 263
Düsseldorf School, 136
Dutch Art, 362
Duval, P. S., 112
Dwight, John S., 158
Dwight, Theodore, 110, 171–172, 201, 209, 279
Dwight, Timothy, 118

Eames, Jane Anthony, 133, 151, 157, 159
Earle, James S., 261
Eddy, Daniel, 148
Edinburgh, 154–156
Edmonds, Francis W., 74, 270, 304, 402
Edwards, Jonathan: 171; *Theory of True Virtue,* 370
Egypt, 51, 188, 191, 203, 207
Ehninger, John W., 69
Elections, 184, 373
Elliott, Charles Loring, 67
Elliott, C. W., 245–246, 390, 402
Ely, Richard T., 367
Emerson, Ralph Waldo: 115, 209, 211, 303, 371–372, 399, 411; on art, 170–179, 180–182, 198–199
England, 3–5, 9–12, 19–20, 29, 38–39, 78, 80–81, 93, 125, 128, 162–163, 254, 288, 362, 408
English, Thomas Dunn, 240
Engraving: 13, 17, 61, 74, 112, 127. *See also* Lithography; Publishing.
Episcopalianism, 306, 308
European travel: ix, 37, 124–168.

See also Art; Artists; Color; Gothic; Nature; Parks, etc.
Everett, Edward, 191–192, 197, 278
Eyland, Seth. *See* Cronin, David E.

Faile, Thomas, 280, 402
Fairmount Park, 277
Fales, Samuel B., 276, 400
Fanelli, Francesco, 4
Farley, Rev. Mr., 204
Fay, Theodore S.: 115, 224, 357; *Norman Leslie,* 220; *Views in the City of New York,* 359
Federal Hall, 23, 330
Felton, Cornelius C., 129, 238
Field, Cyrus, 280
Field, Erastus Salisbury, ix
Fink, Frederick, 74–79
Fisher, Alvan, 66–67, 74
Fisher, Henry, 383
Fisher, J. Francis, 276, 382, 400
Fisher, Sidney George, 110, 214, 258, 266, 382–383
Fisk, Rev. Wilbur, 133–134, 138, 150, 361, 363
Flagg family, 260
Flagg, George W., 106
Flagg, Jared Bradley, 309
Flagg, Wilson, 203–204, 206, 211
Flint, Timothy, 207, 379
Florence, 73, 103, 122, 125, 129, 133–134, 141, 152–153, 159, 164, 176, 192, 286, 289–291, 294, 297, 407
Forbes family, 279
Foster, Sir Augustus, 109, 361
Fox, Charles P., 383
Fra Angelico, 226
Fragonard, Honoré, 38
France, 38–39, 156–157, 160, 254, 279
Francis, John W., 280–281
Frankenstein family, 260
Frankenstein, John, 274, 399
Frankfort, 125

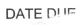
DATE DUE